MINI
APARTMENT BIBLE

TECTUM
PUBLISHERS

MINI
APARTME

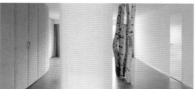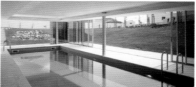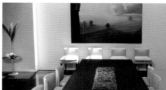

© 2009 Tectum Publishers
Godefriduskaai 22
2000 Antwerp
Belgium
info@tectum.be
+ 32 3 226 66 73
www.tectum.be

ISBN: 978-90-79761-08-1
WD: 2009/9021/12
(74)

Printed in China.

NT BIBLE

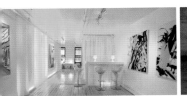 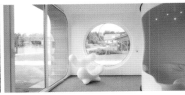

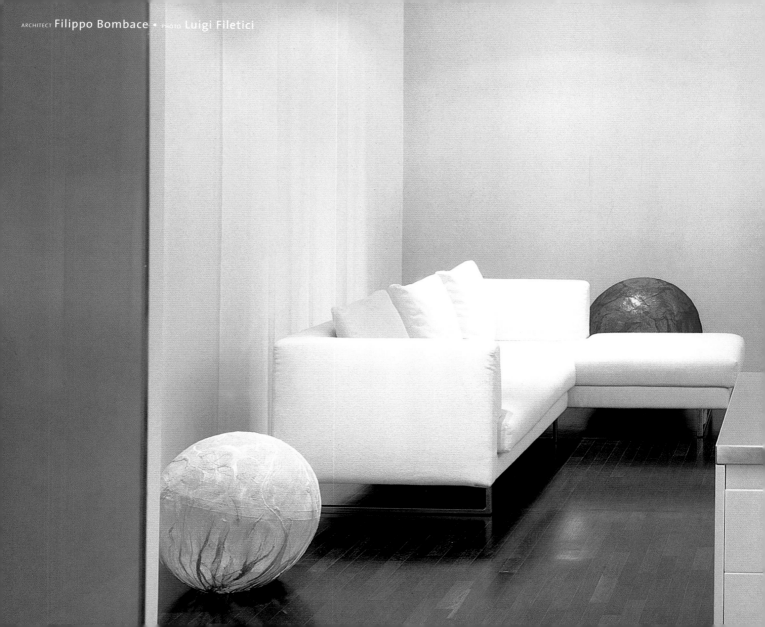

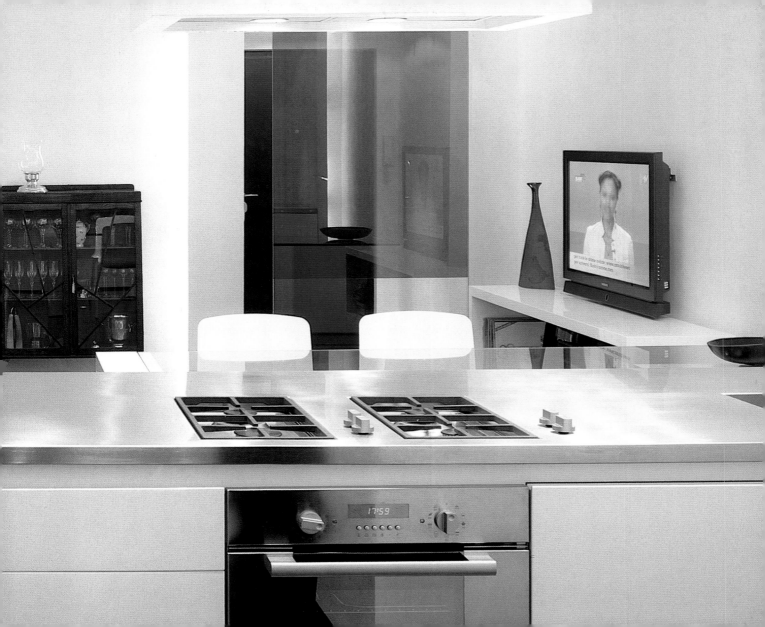

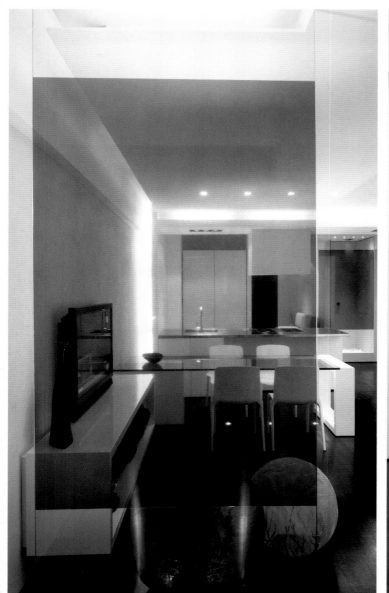
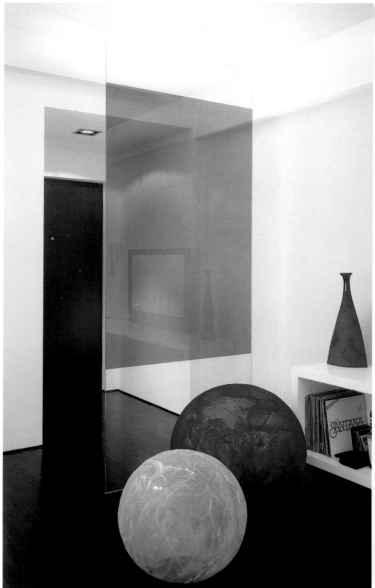

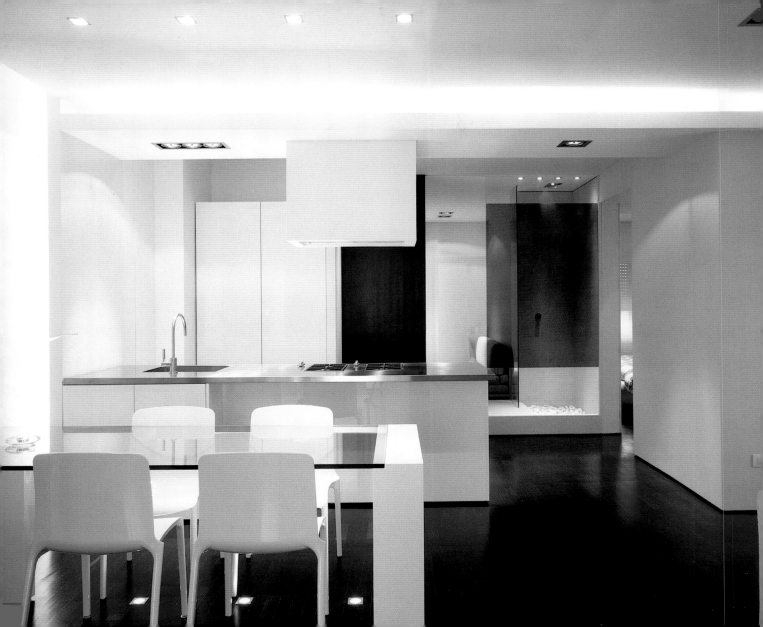

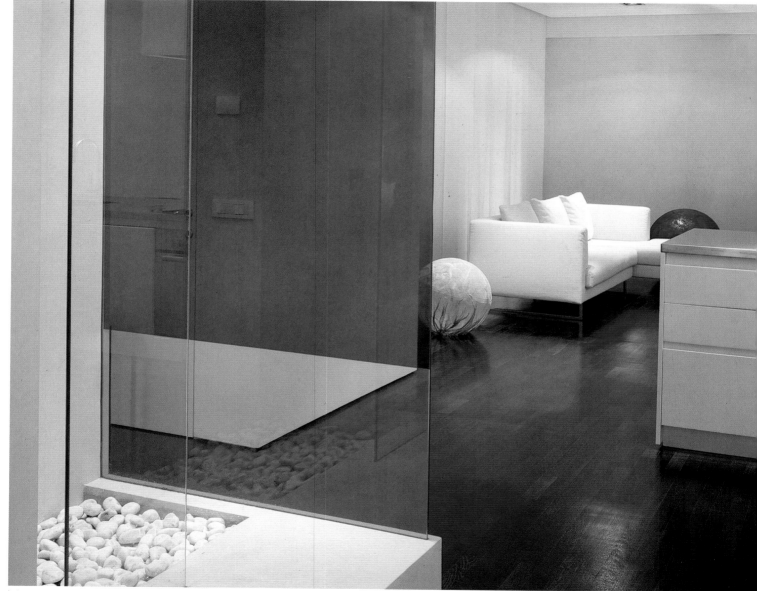

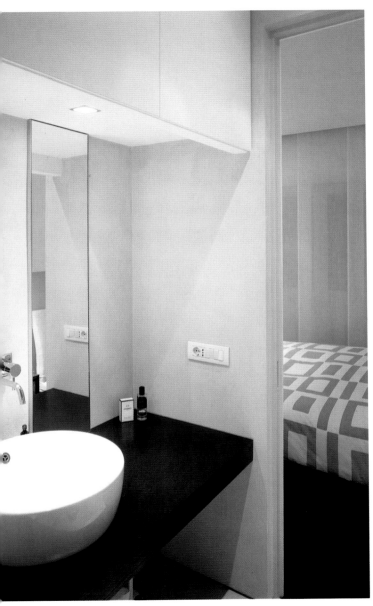
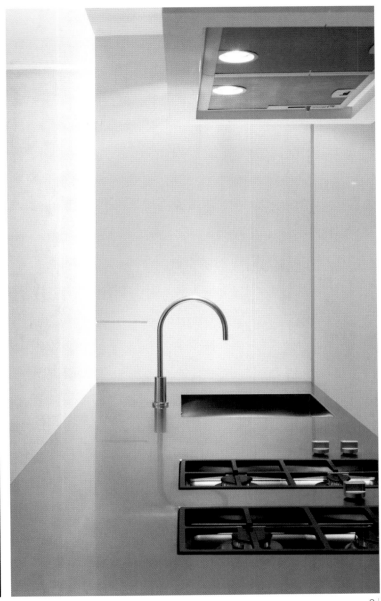

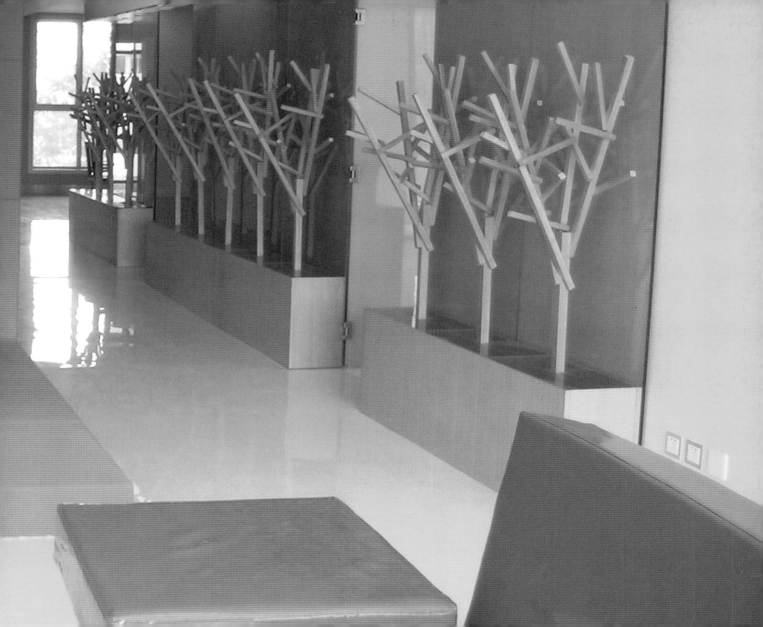

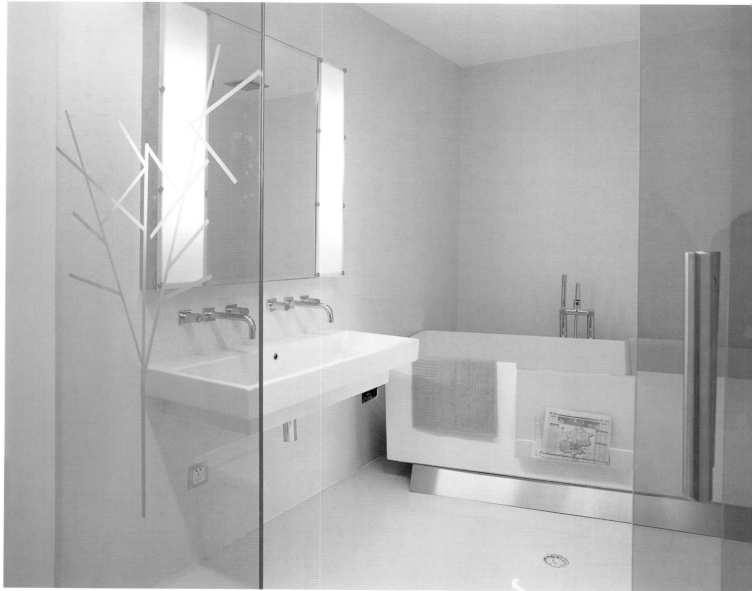

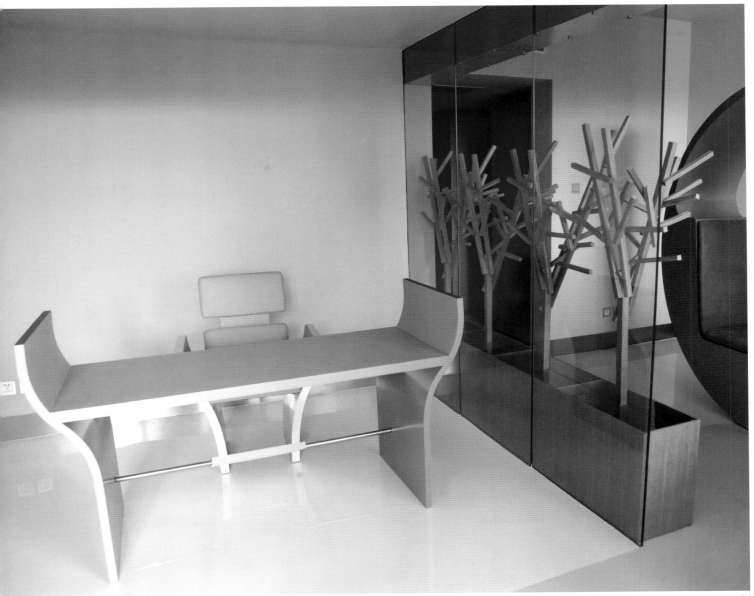

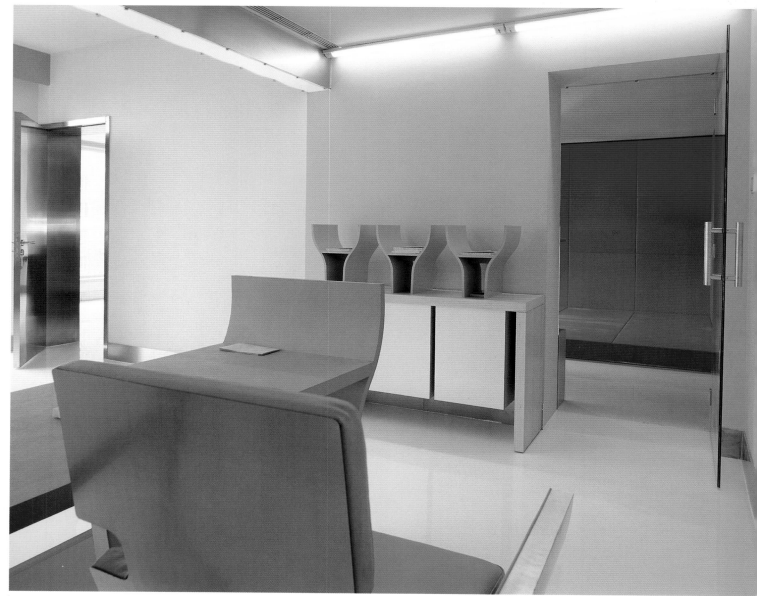

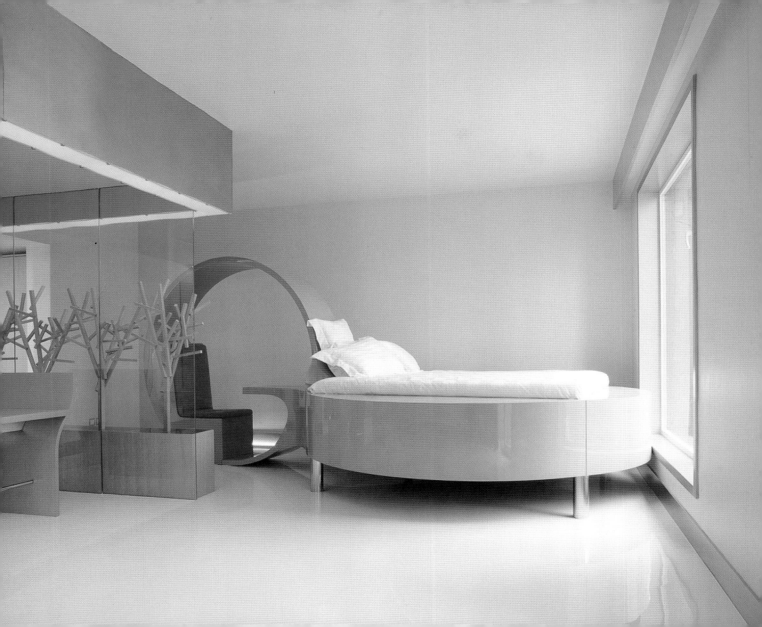

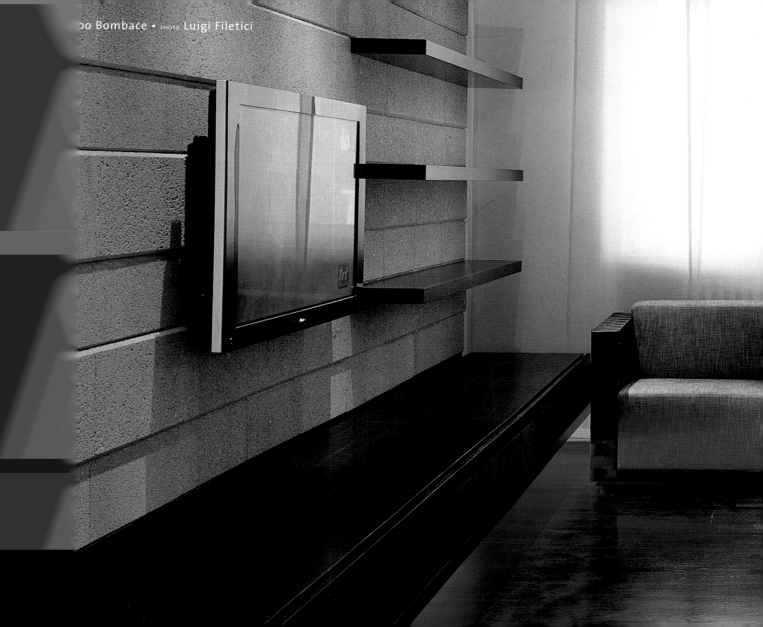

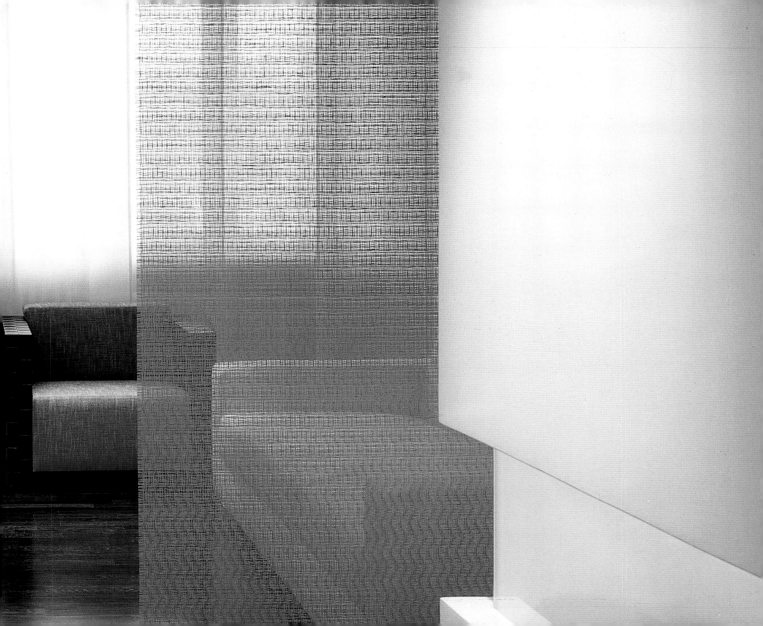

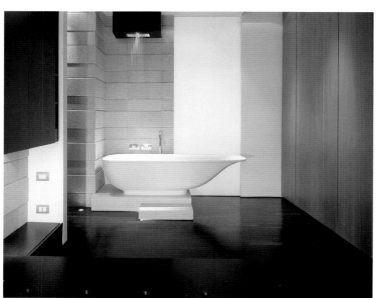
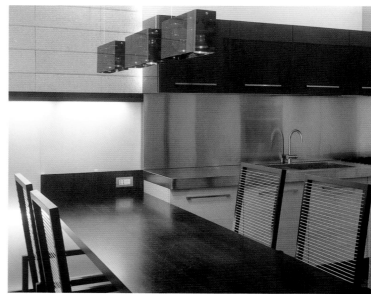
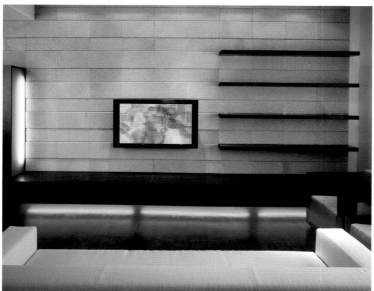

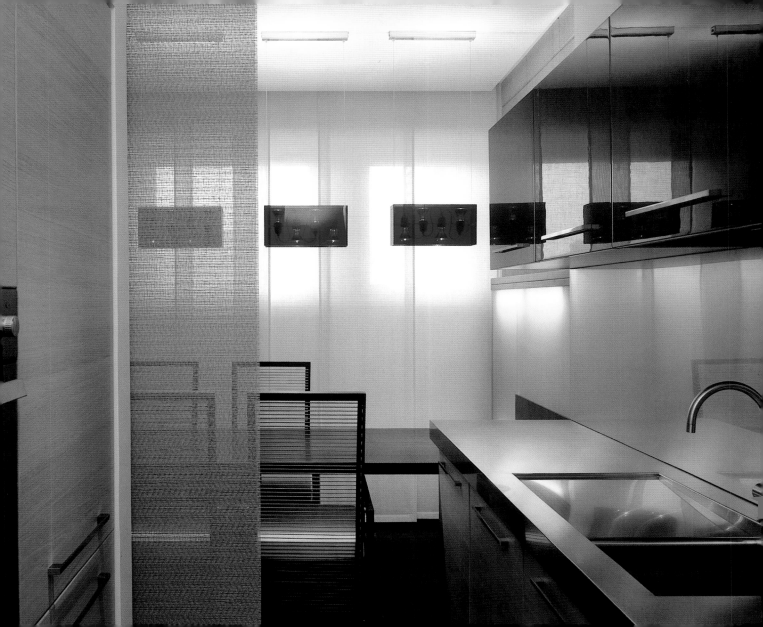

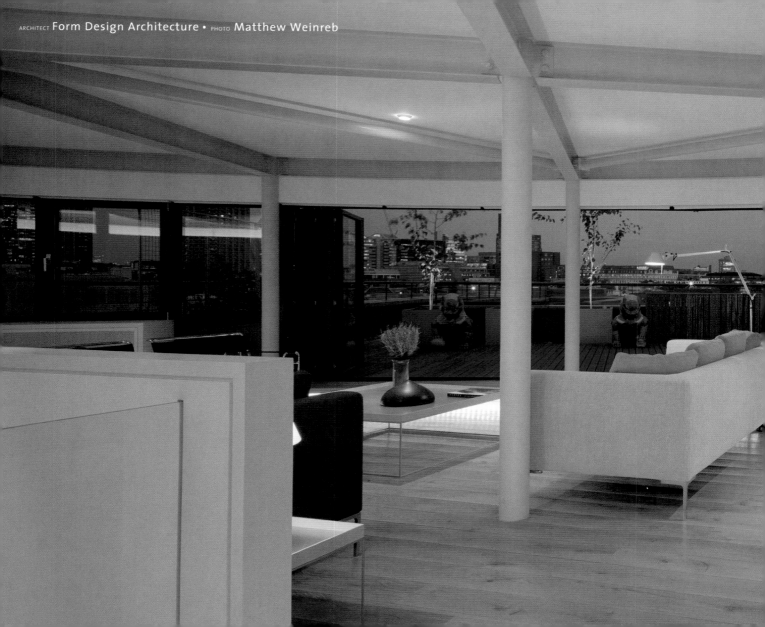

ARCHITECT Form Design Architecture • PHOTO Matthew Weinreb

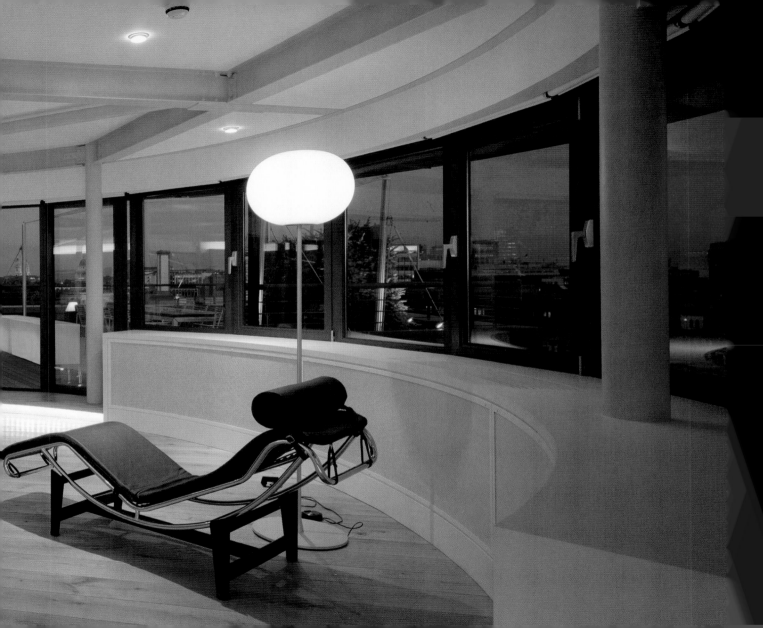

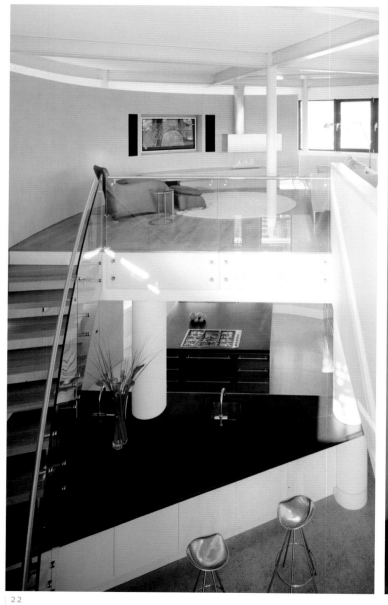
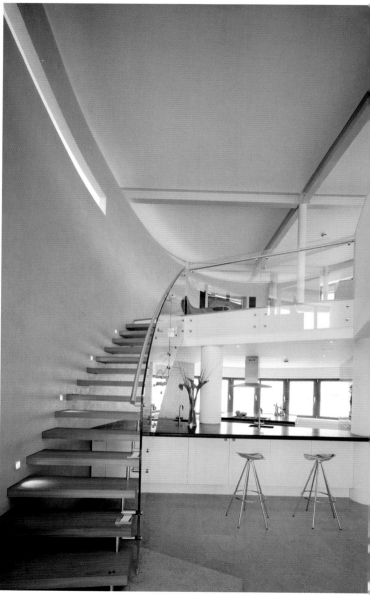

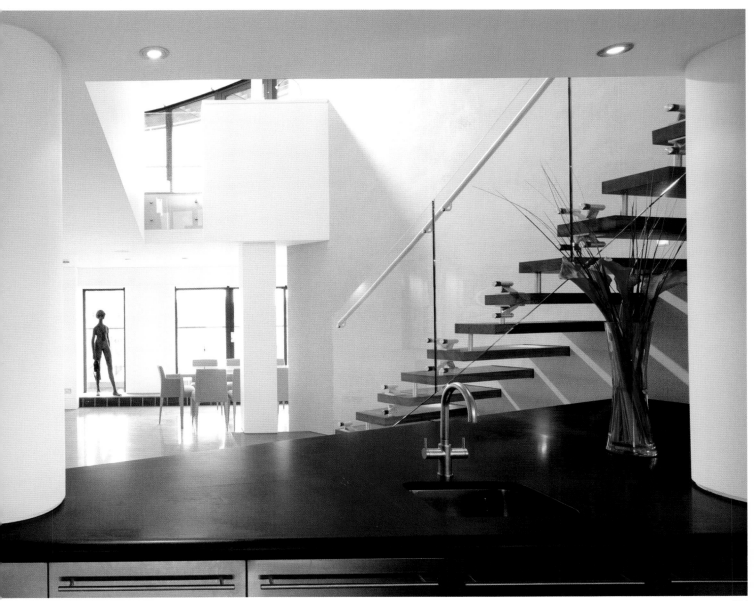

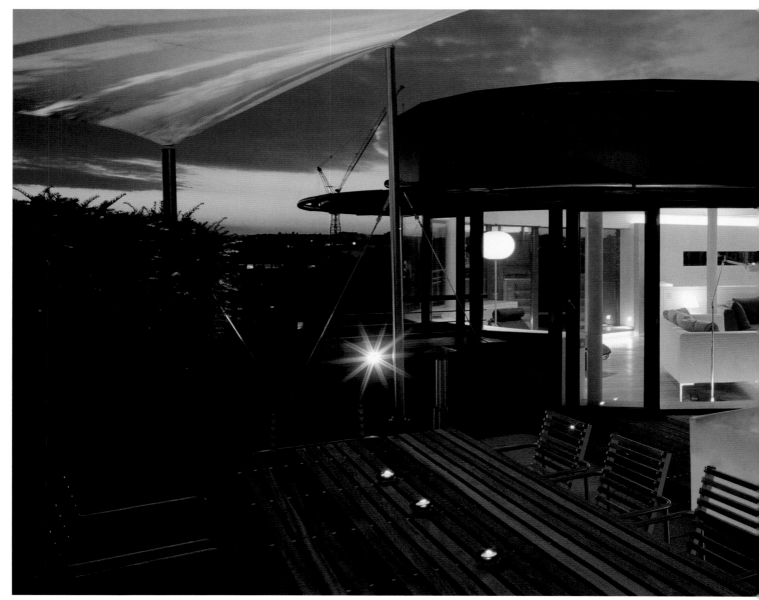

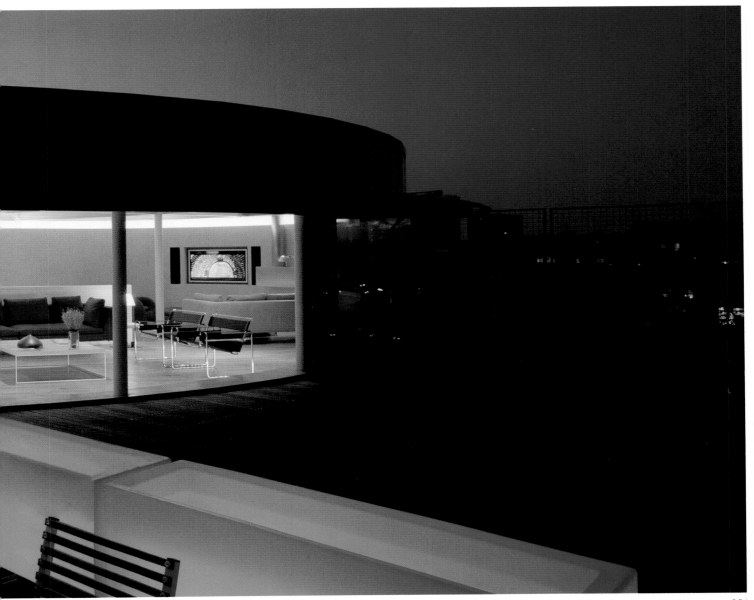

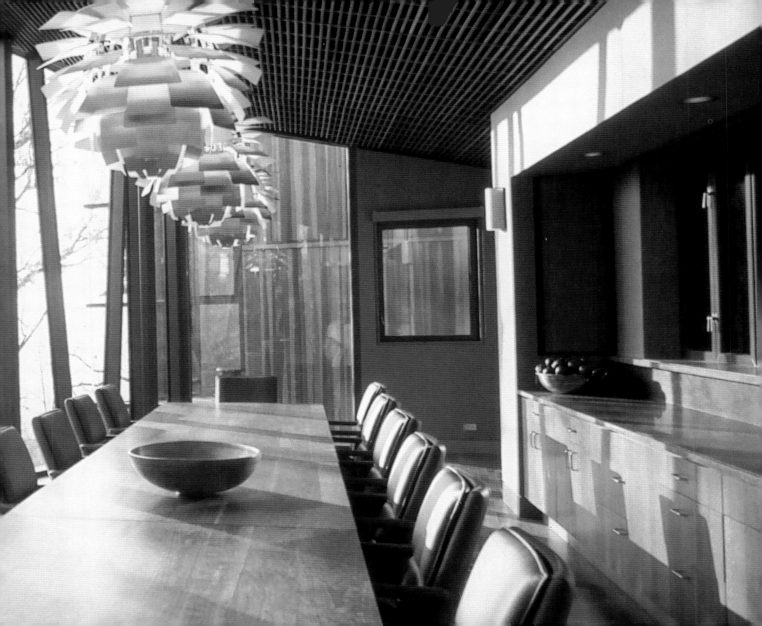

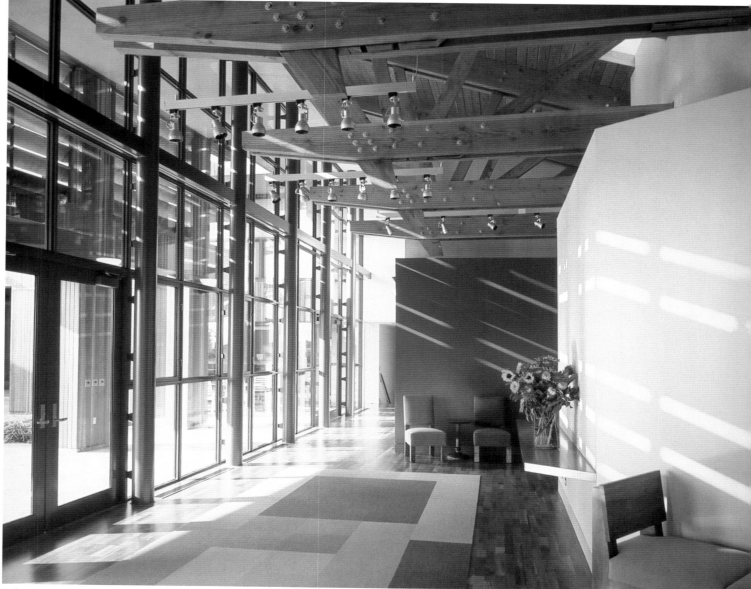

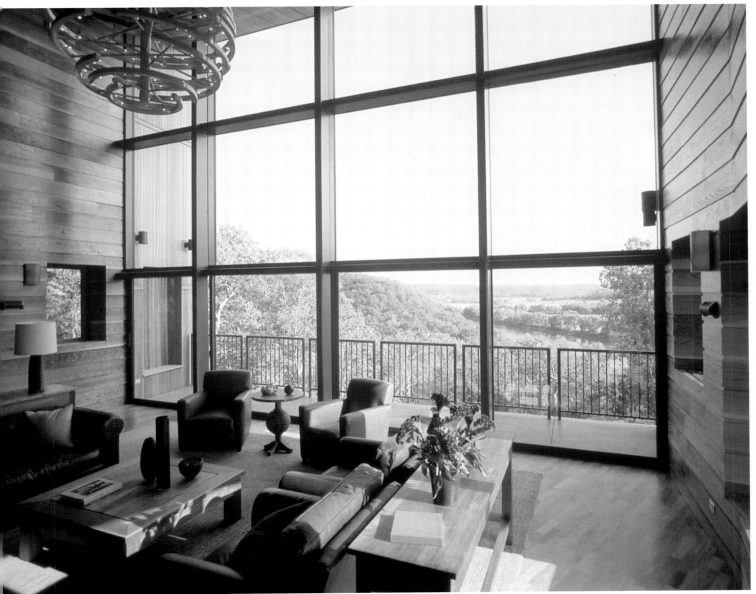

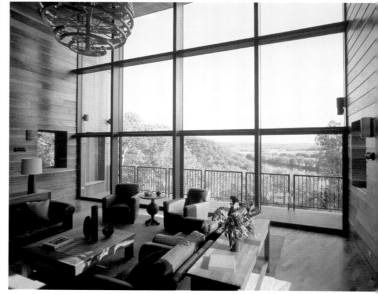
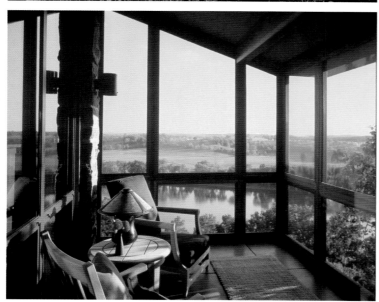
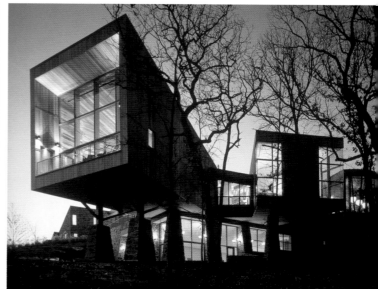

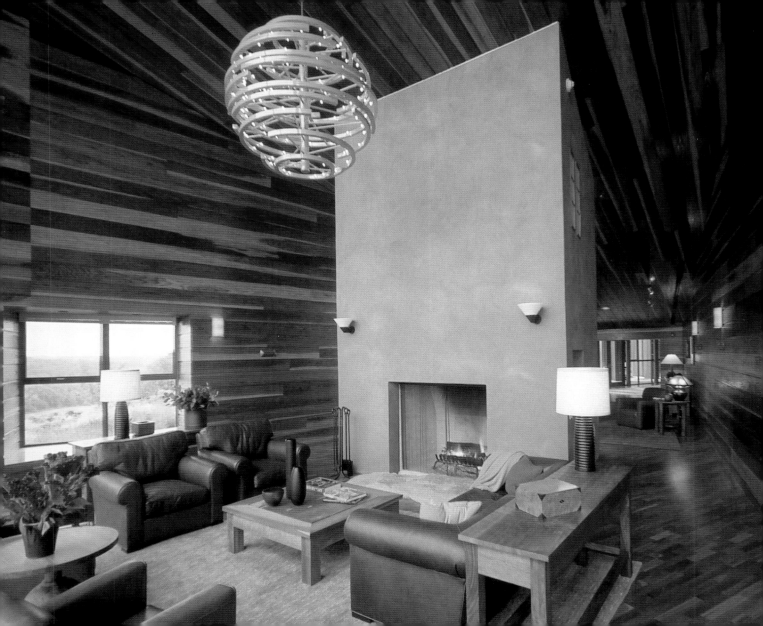

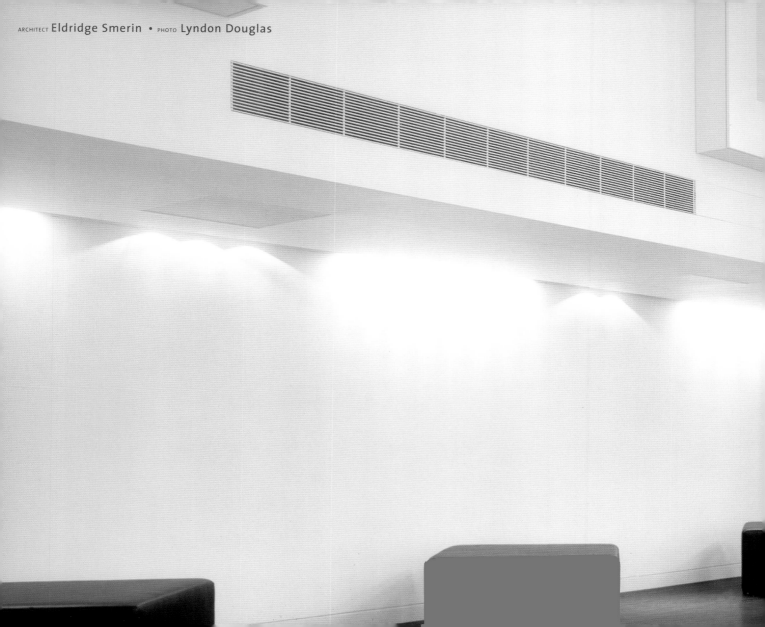

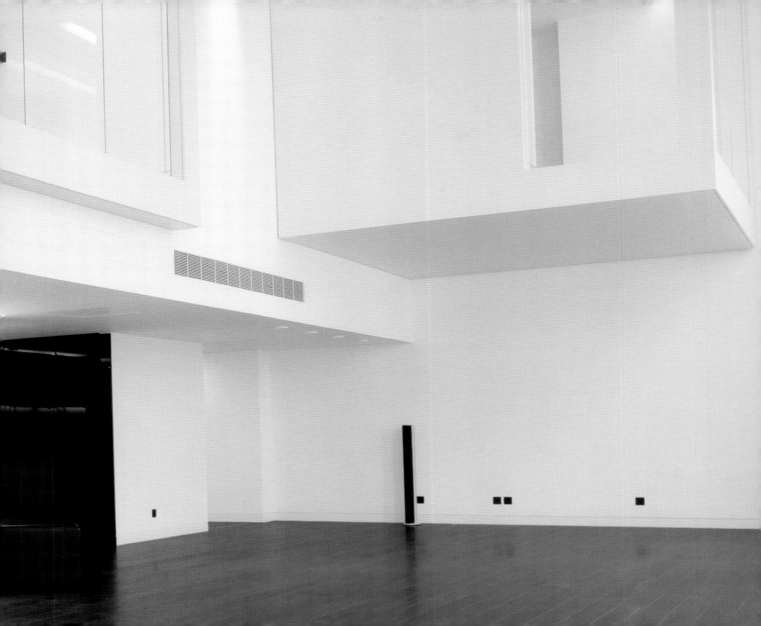

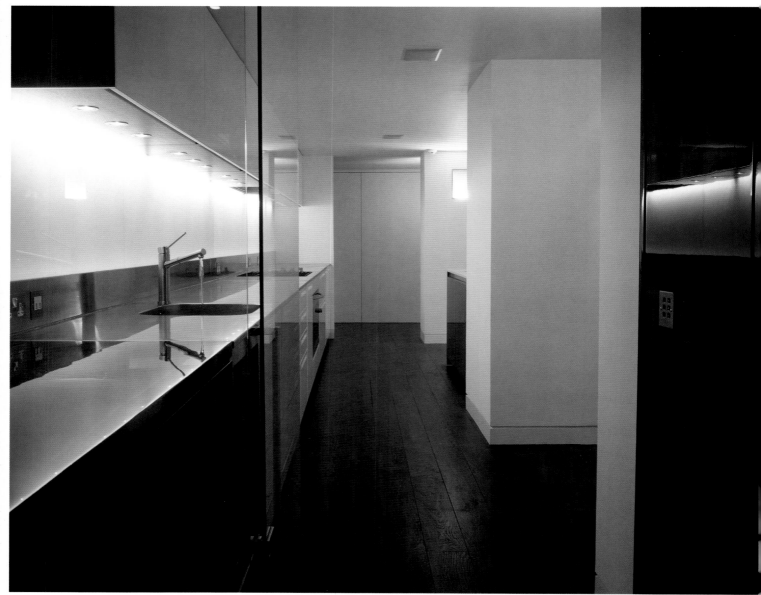

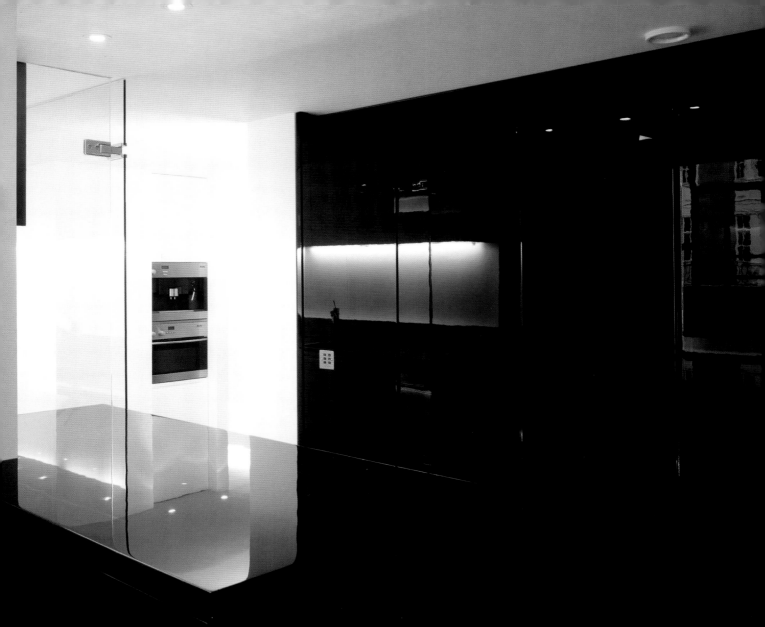

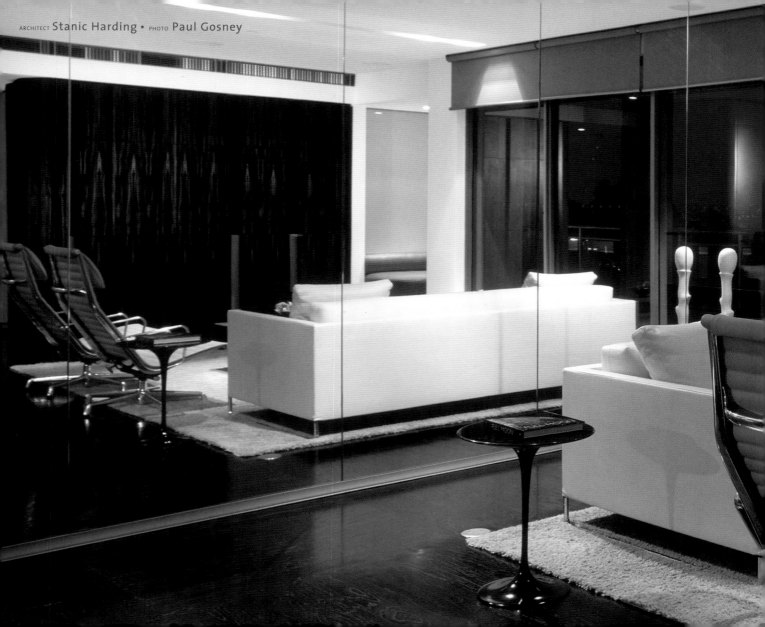

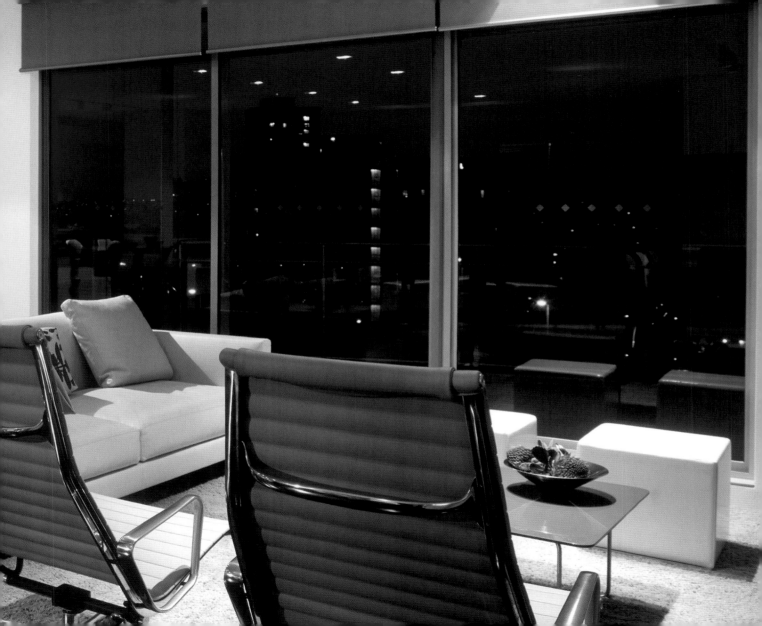

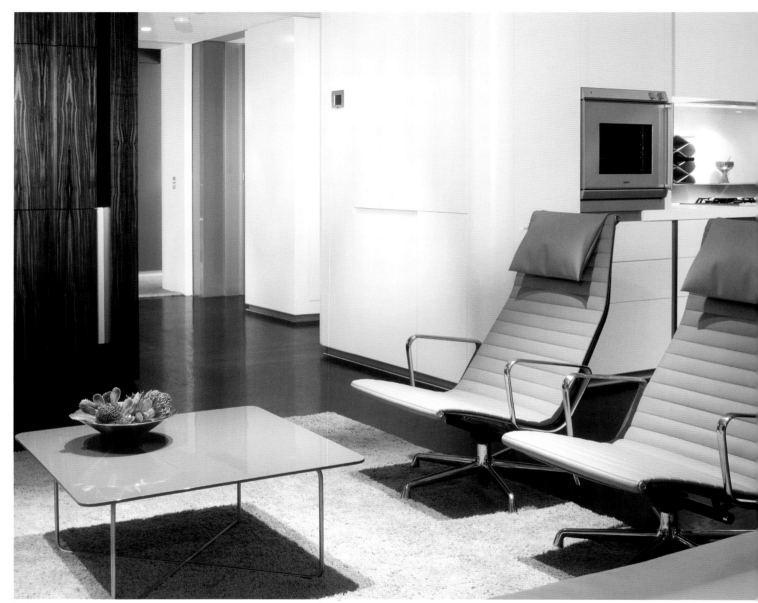

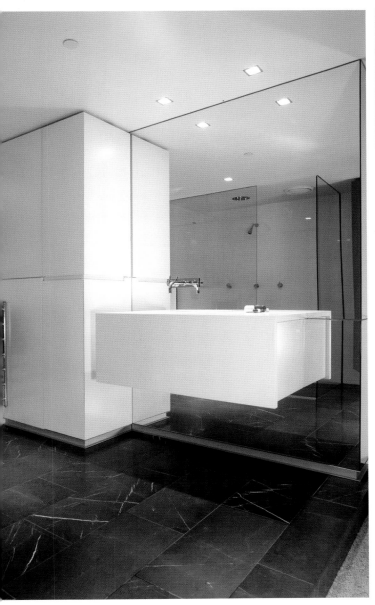
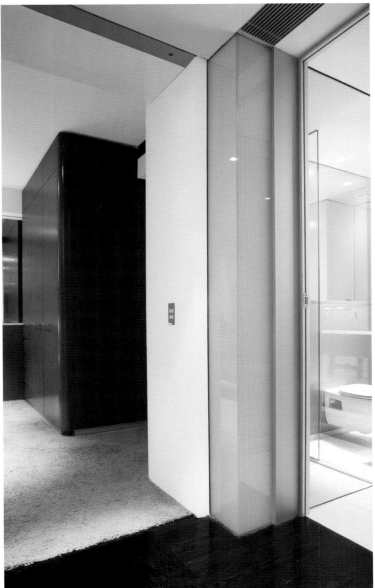

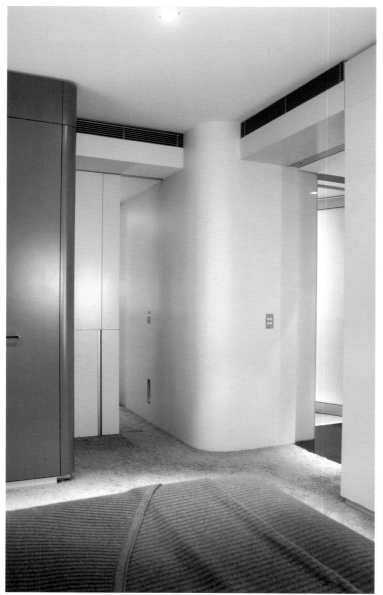
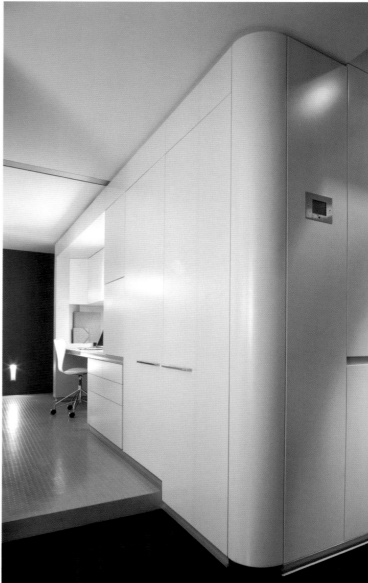

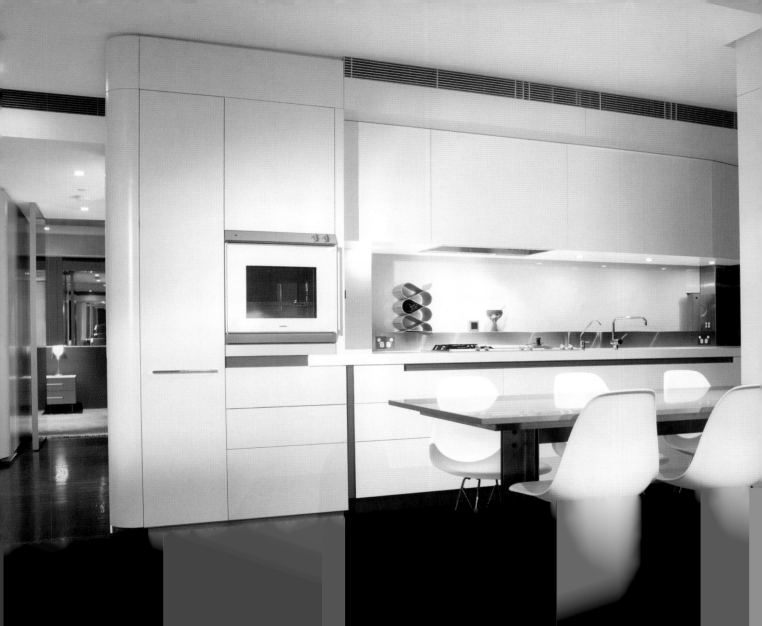

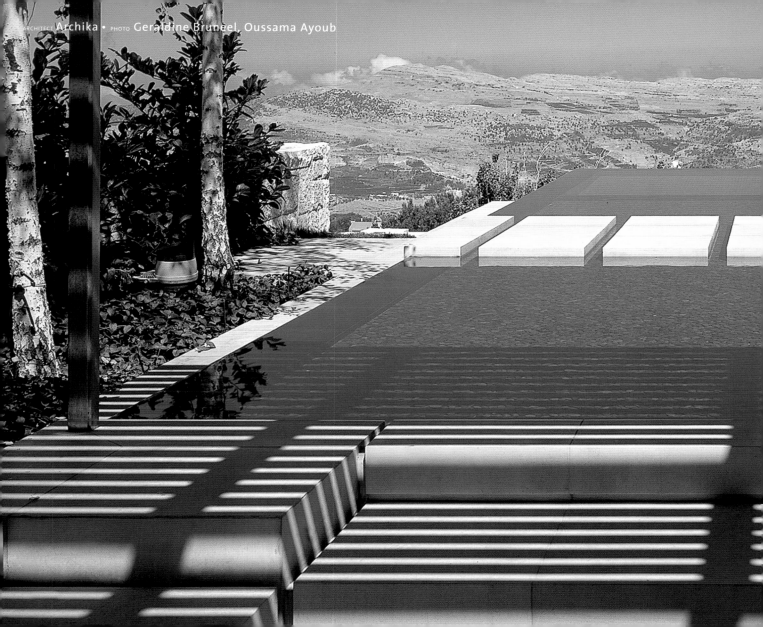

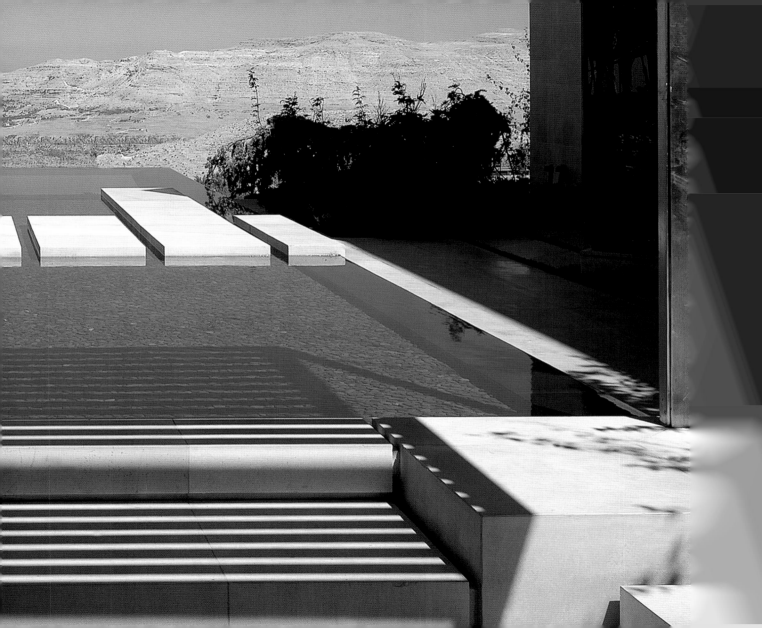

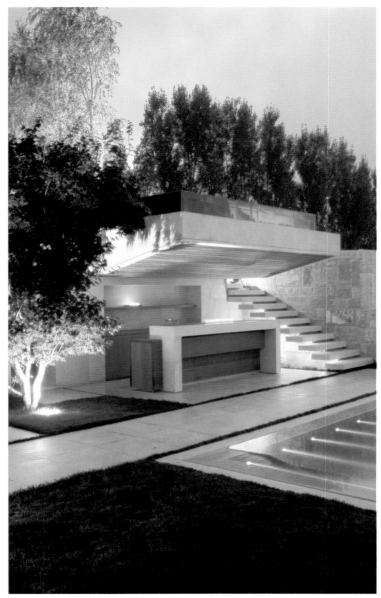
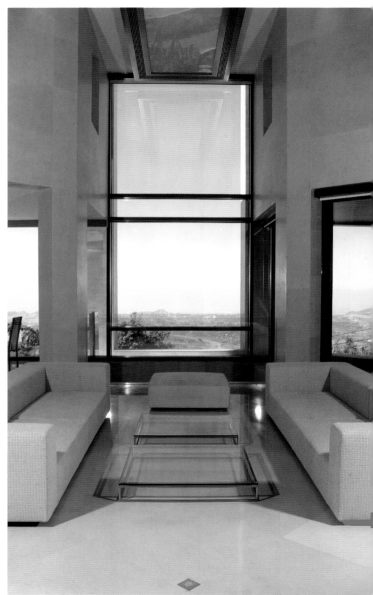

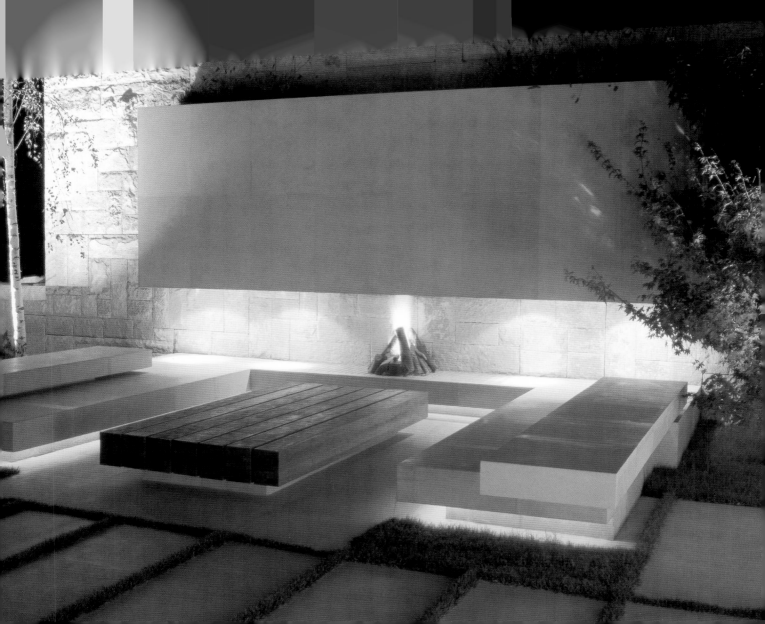

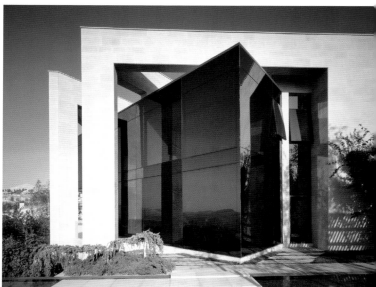
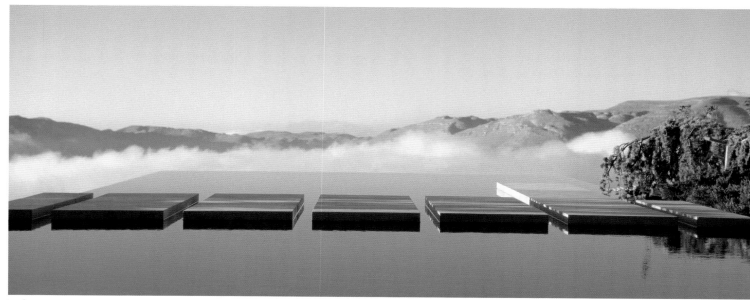

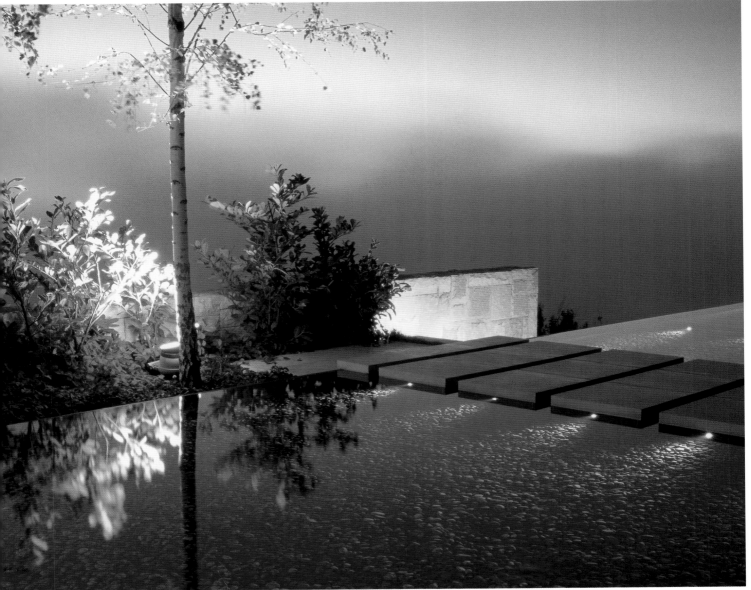

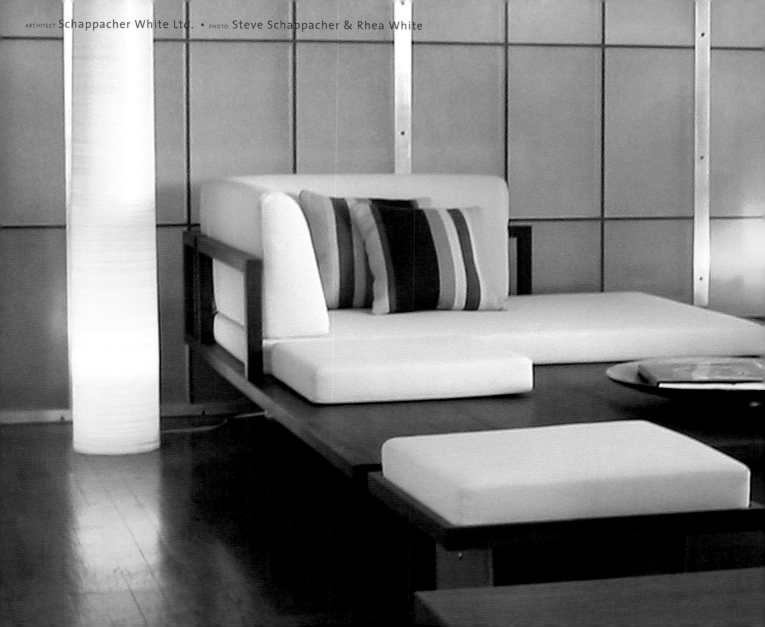

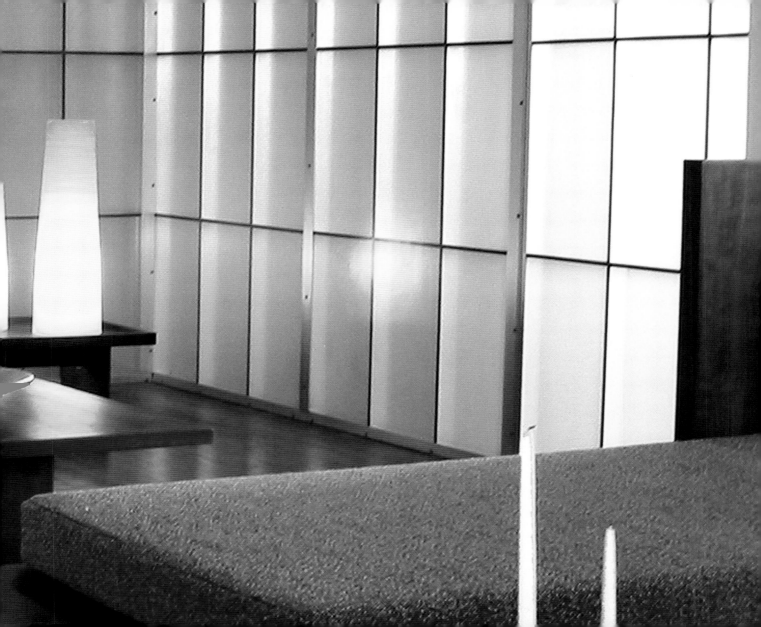

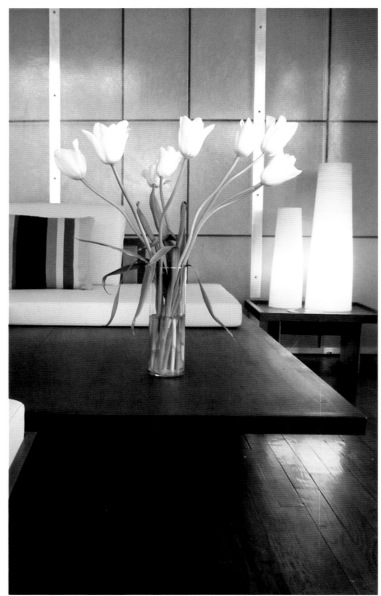
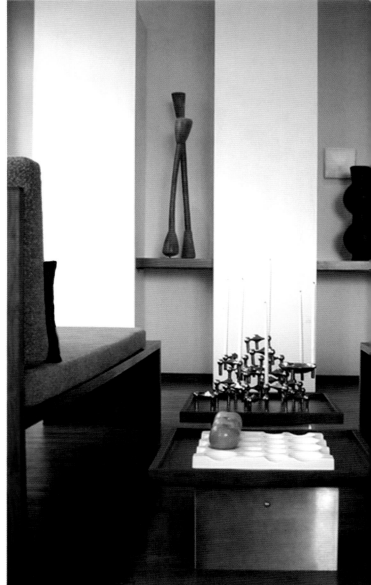

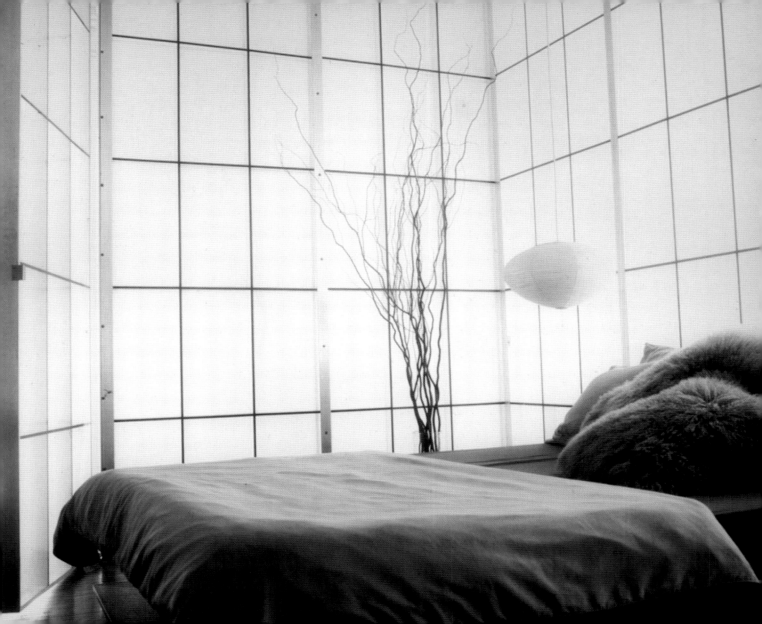

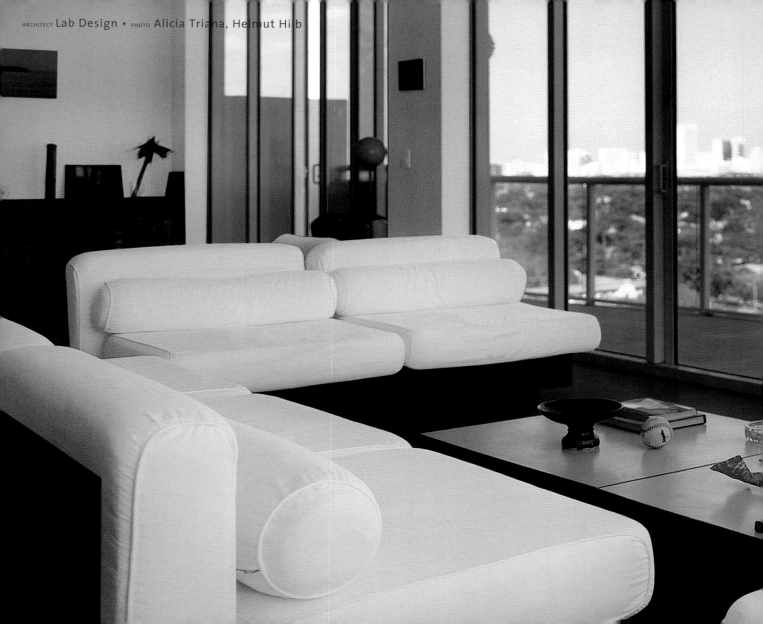

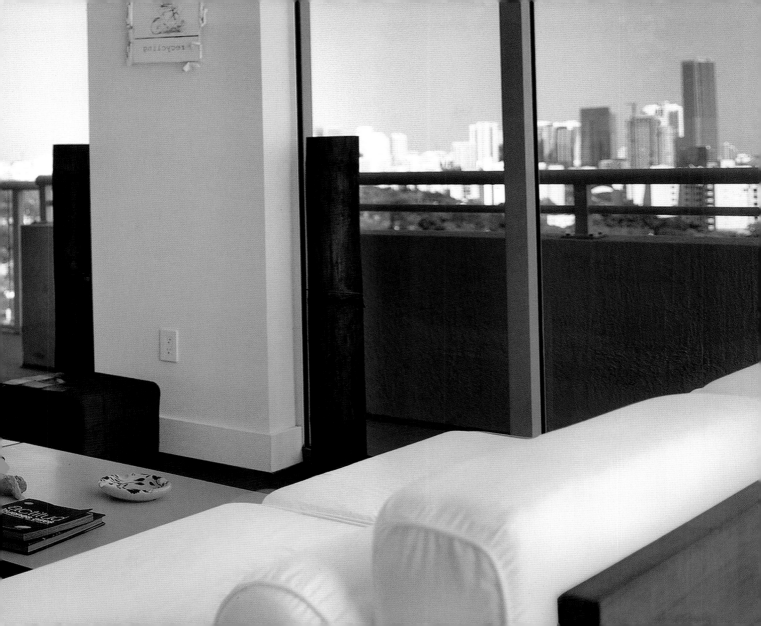

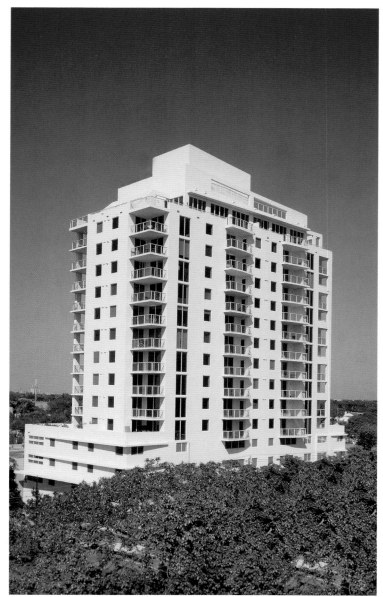

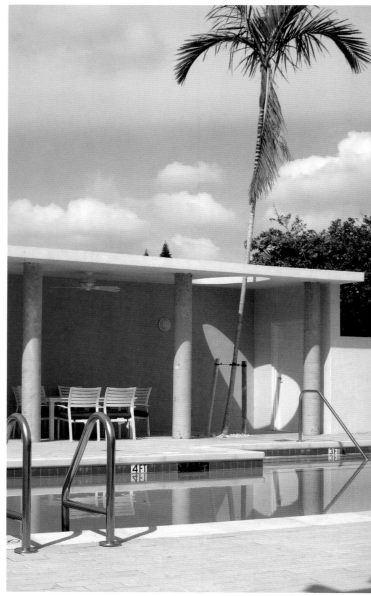

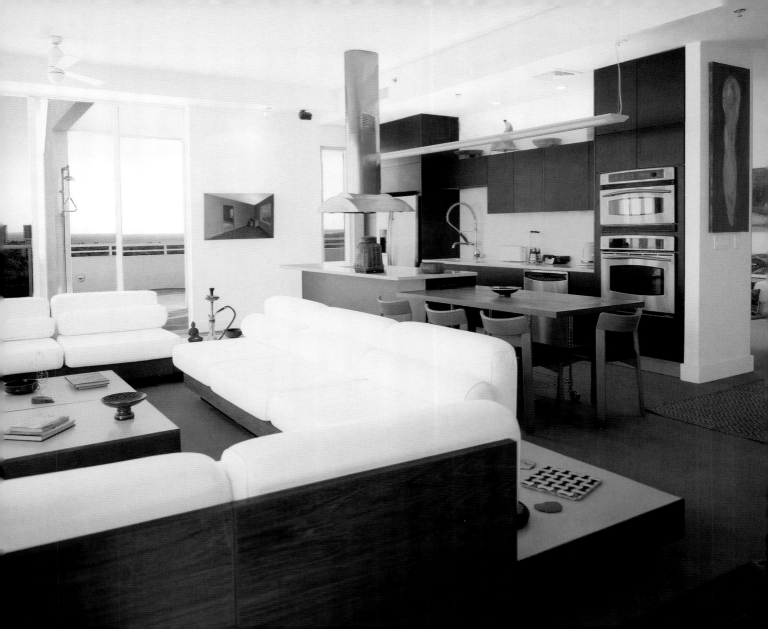

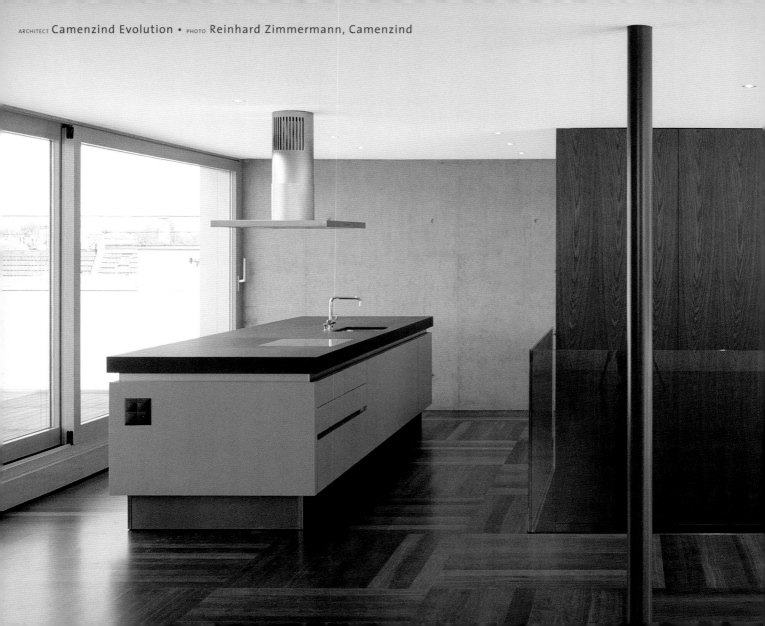

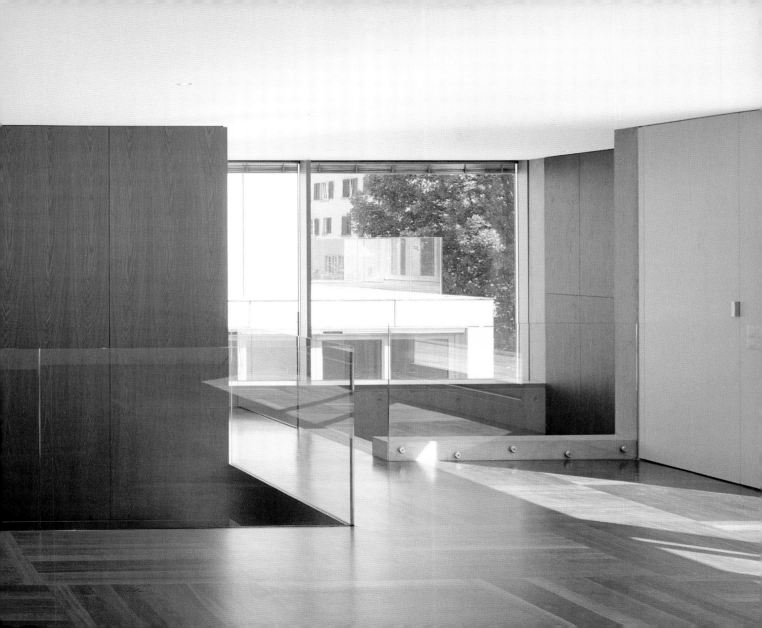

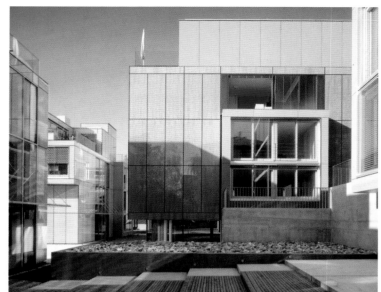
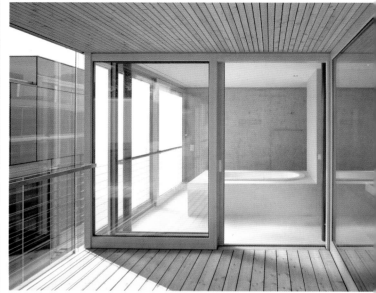
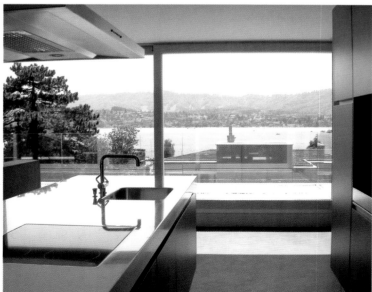
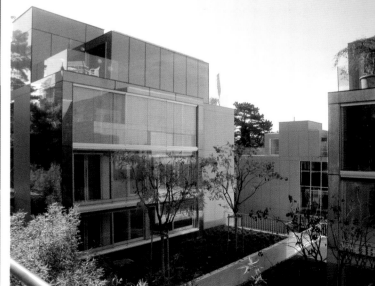

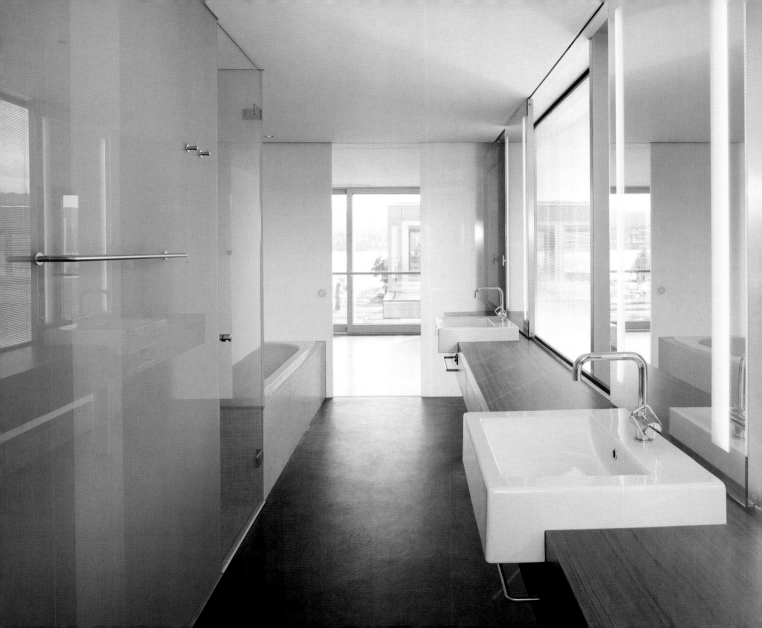

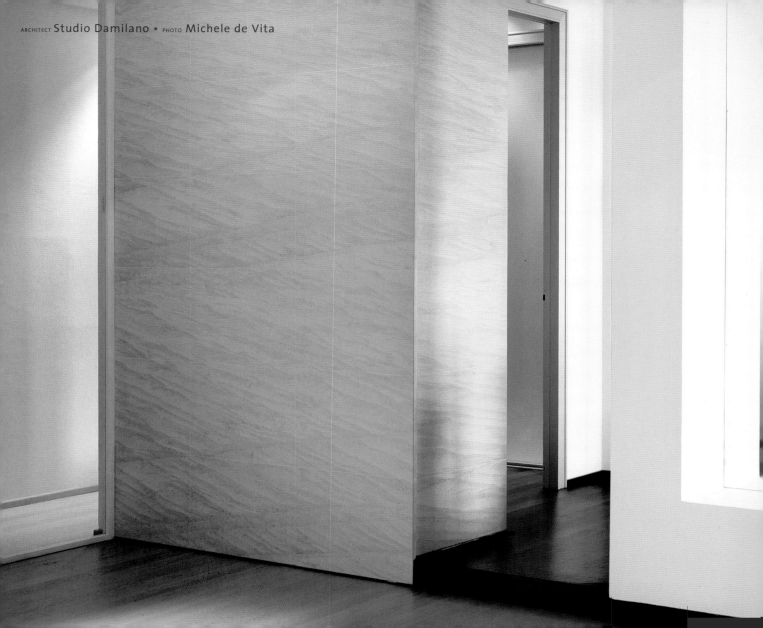

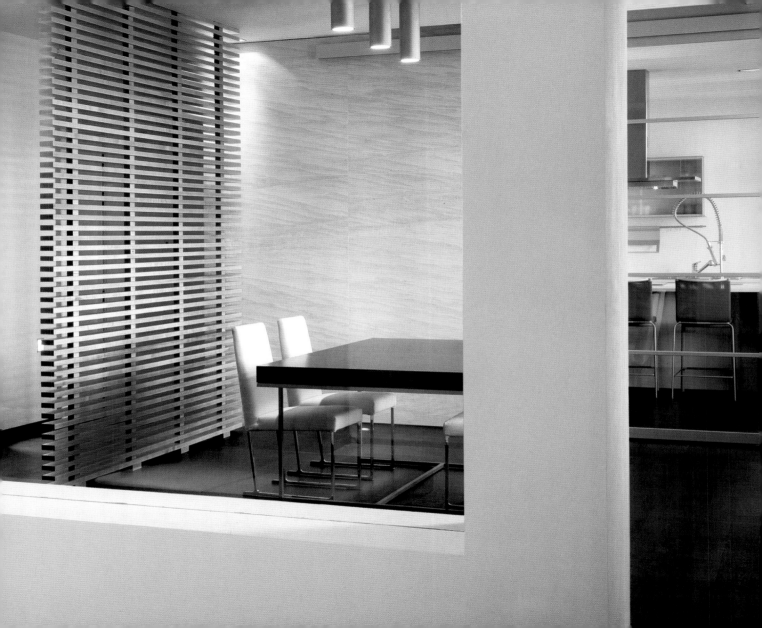

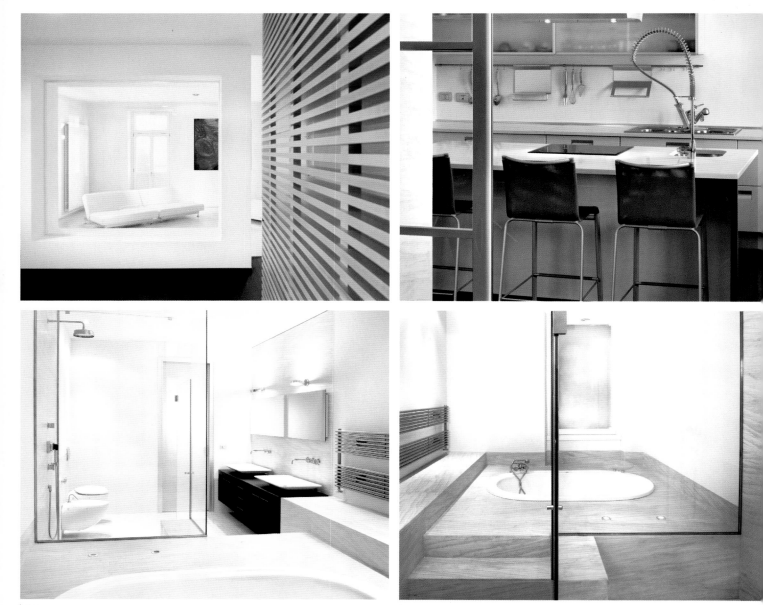

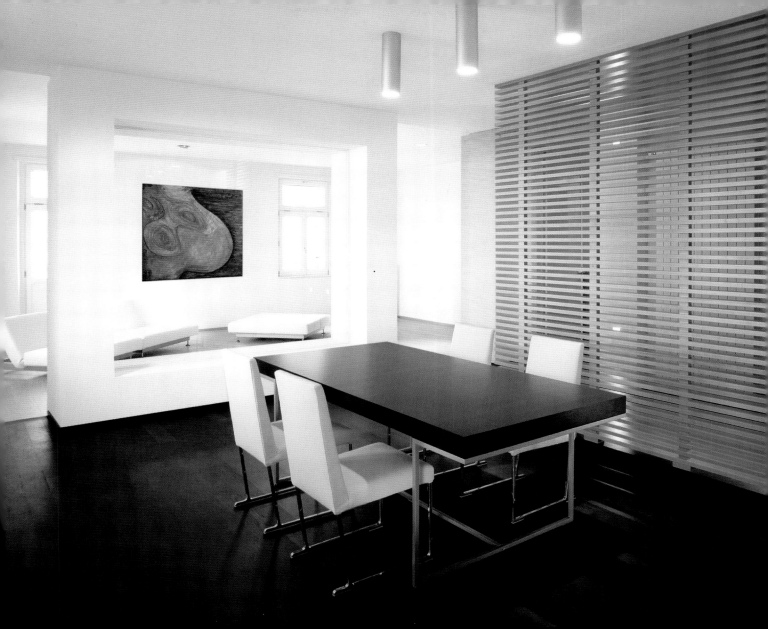

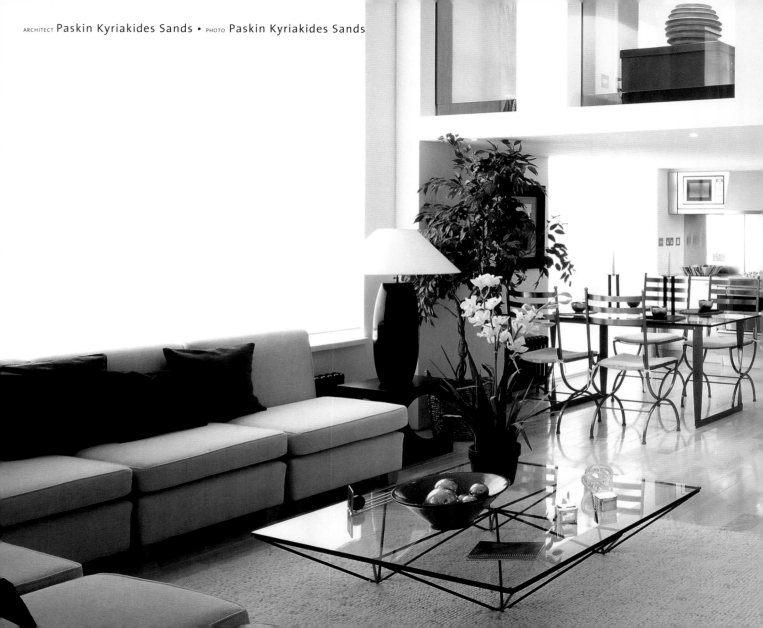

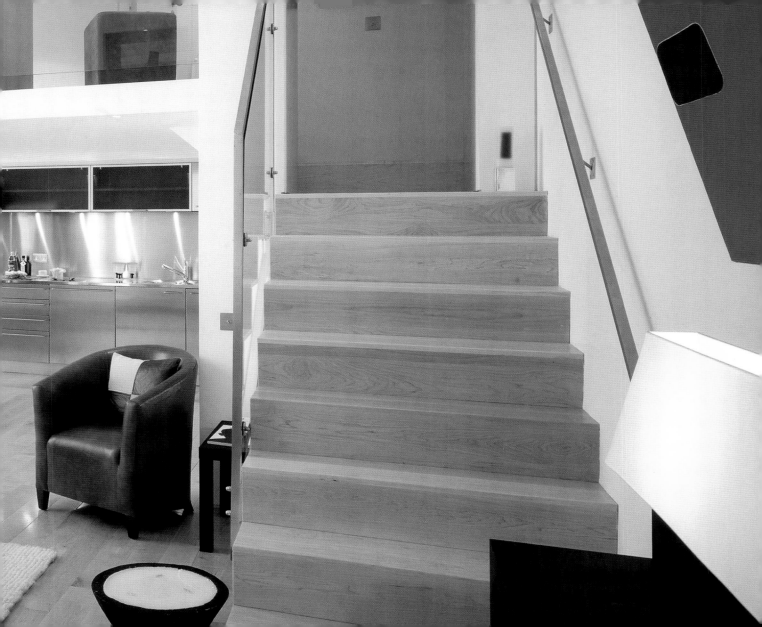

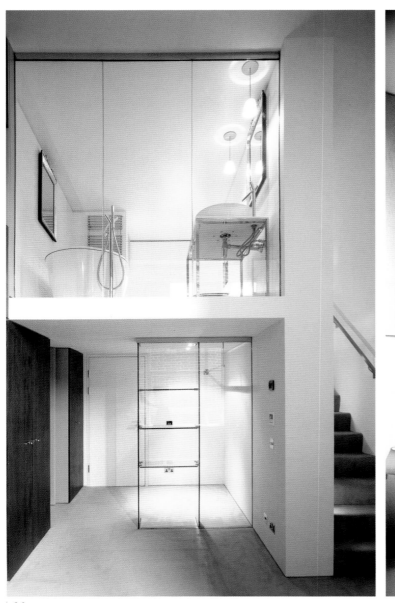
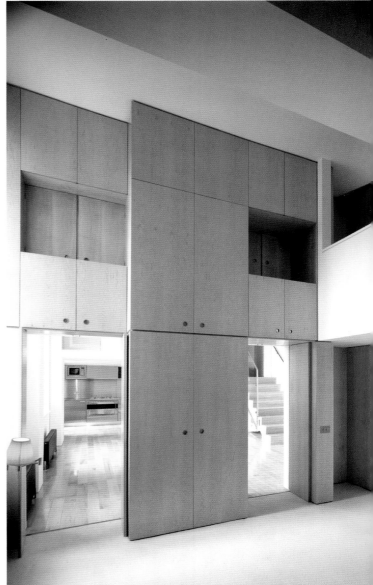

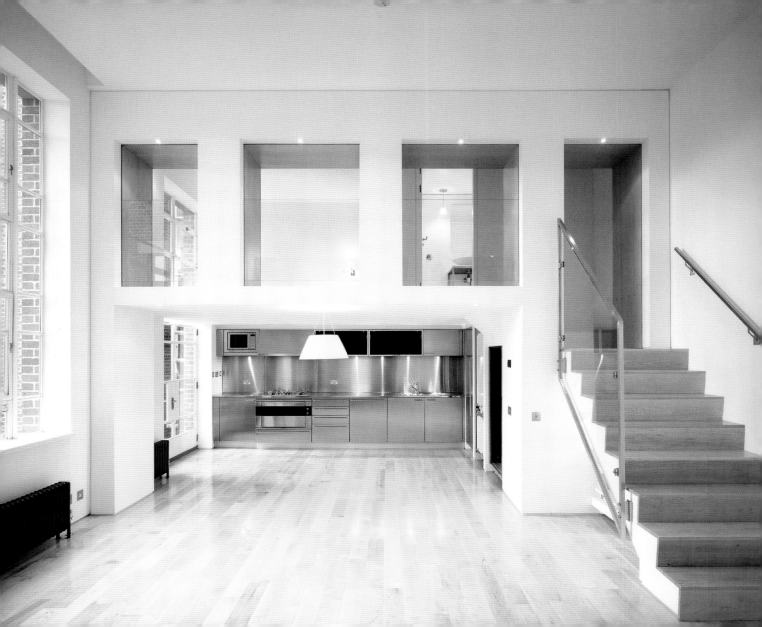

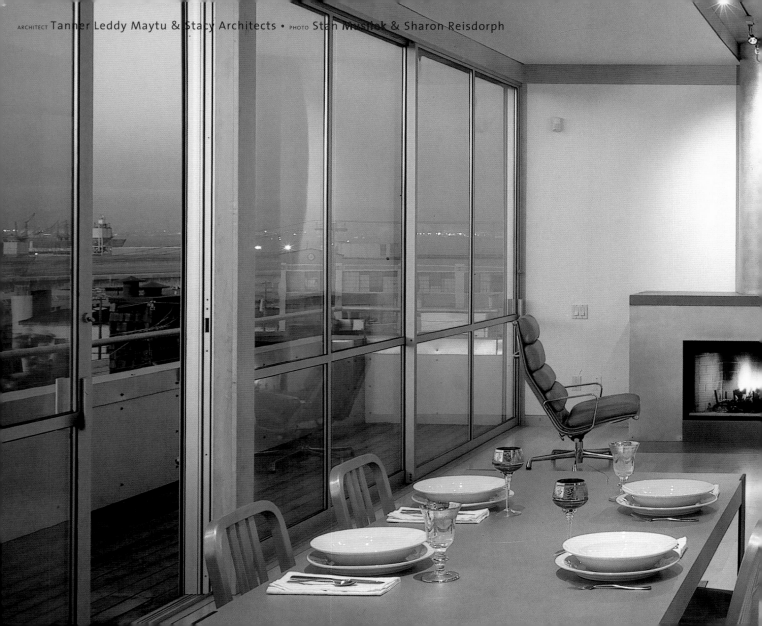

ARCHITECT Tanner Leddy Maytu & Stacy Architects • PHOTO Stan Musilek & Sharon Reisdorph

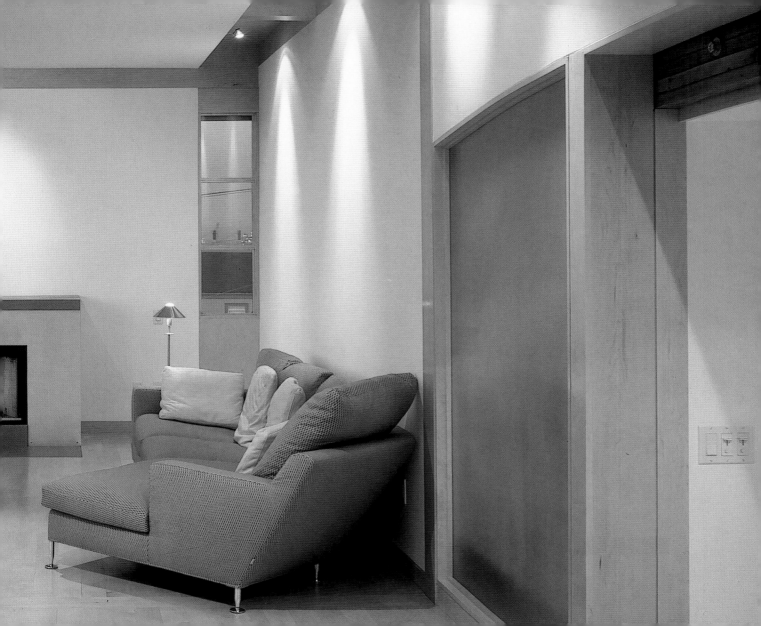

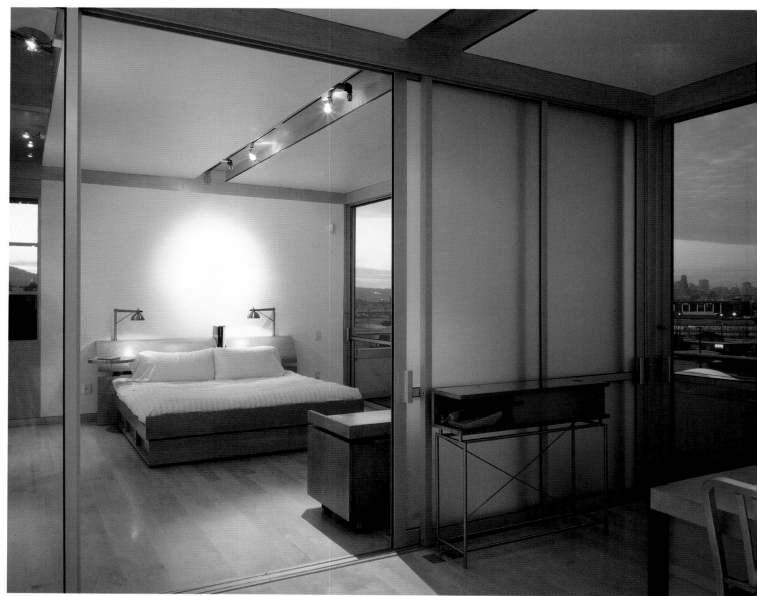

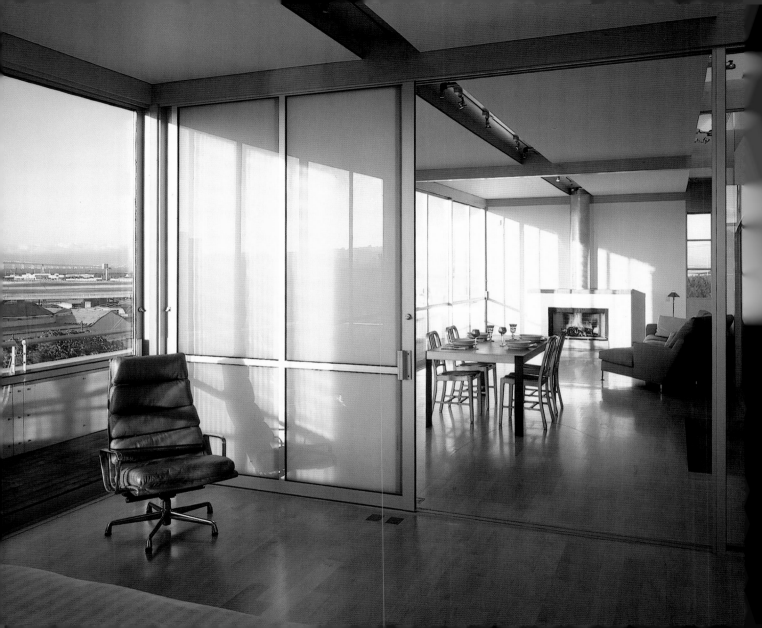

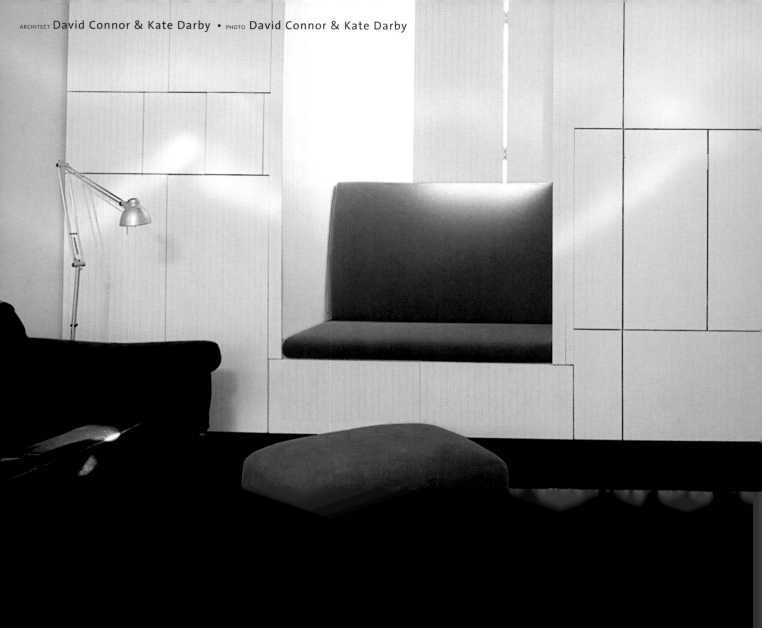

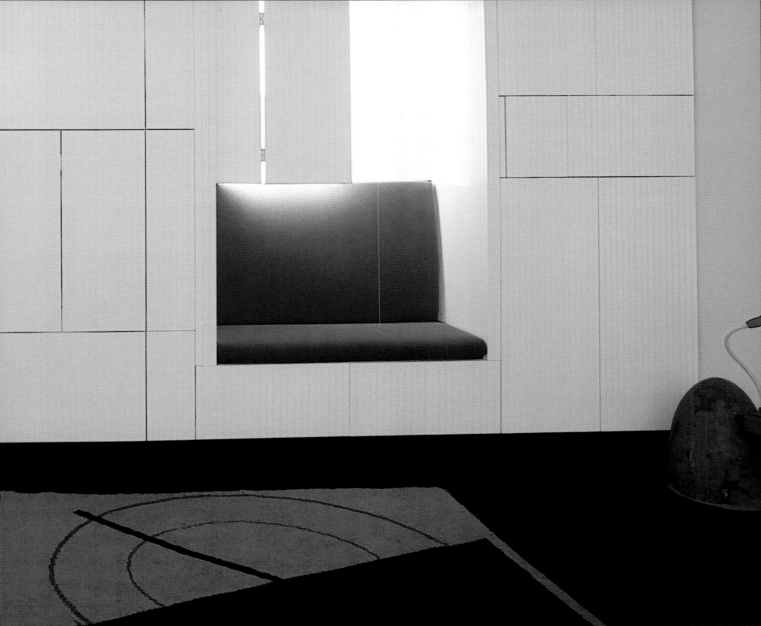

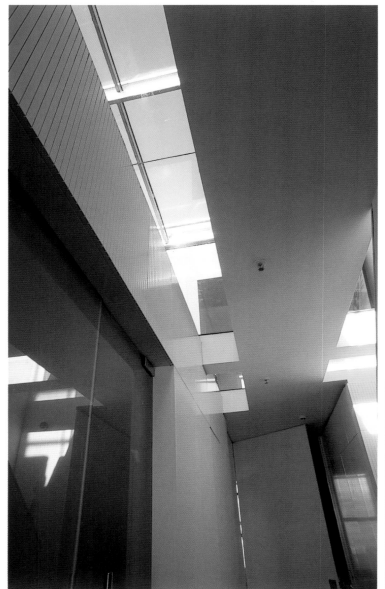
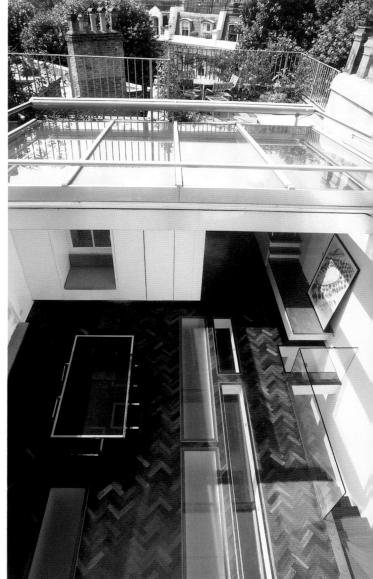

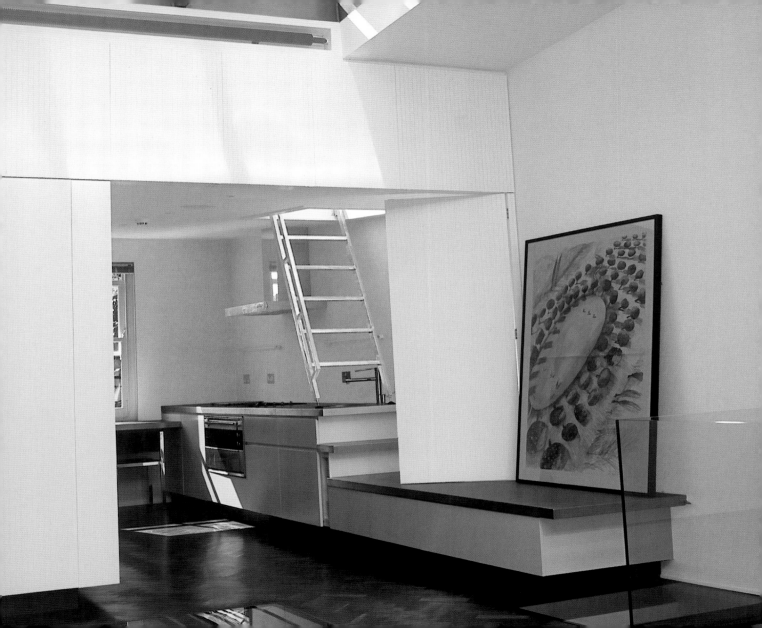

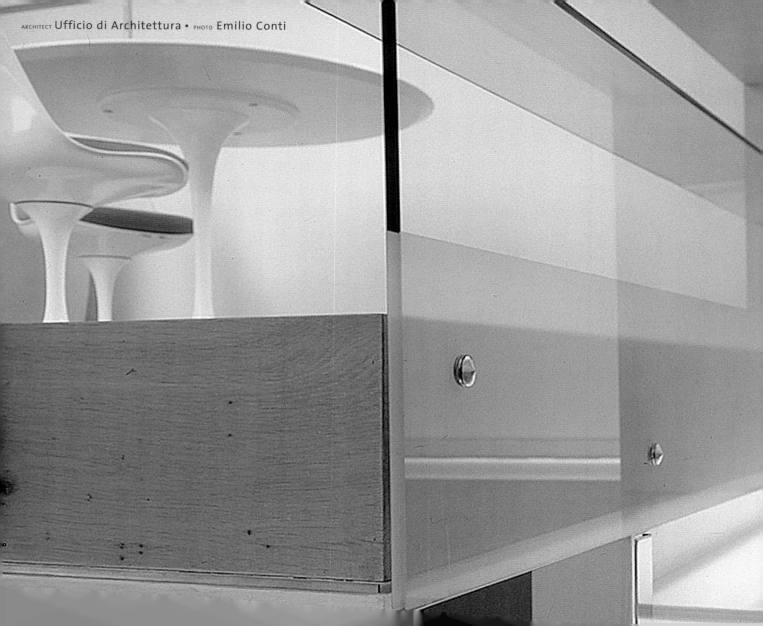

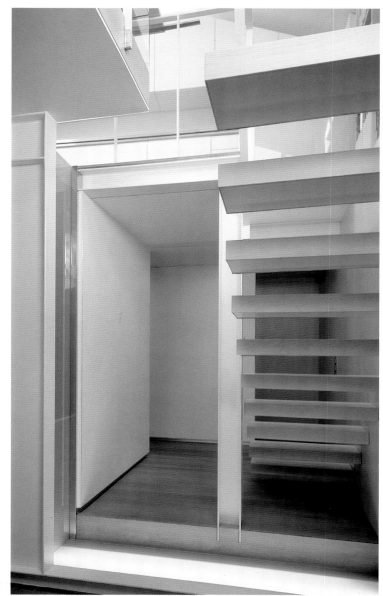
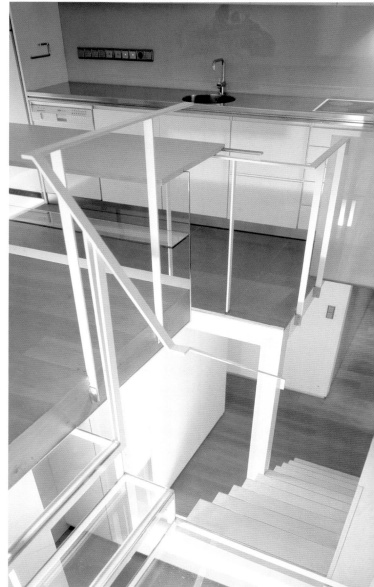

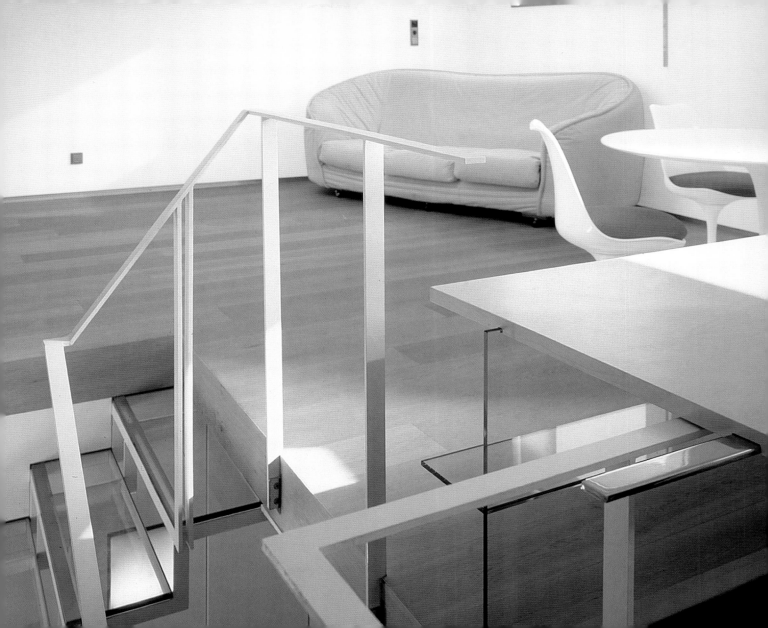

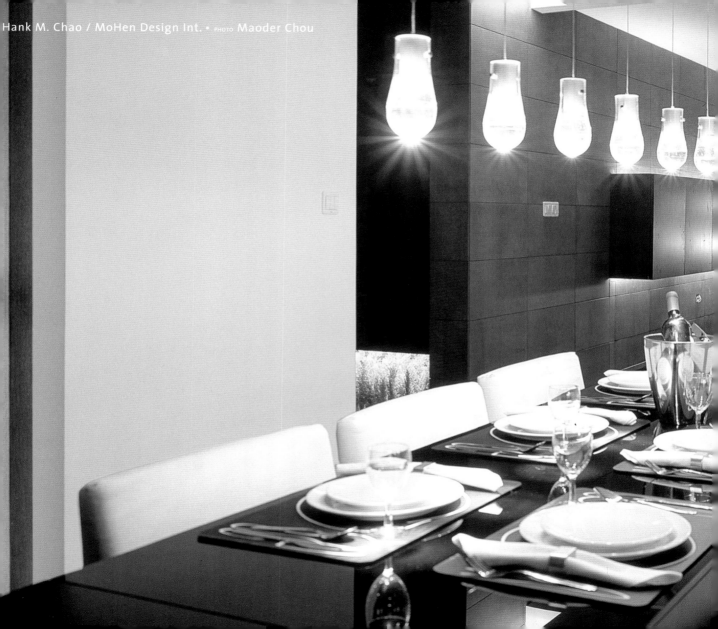

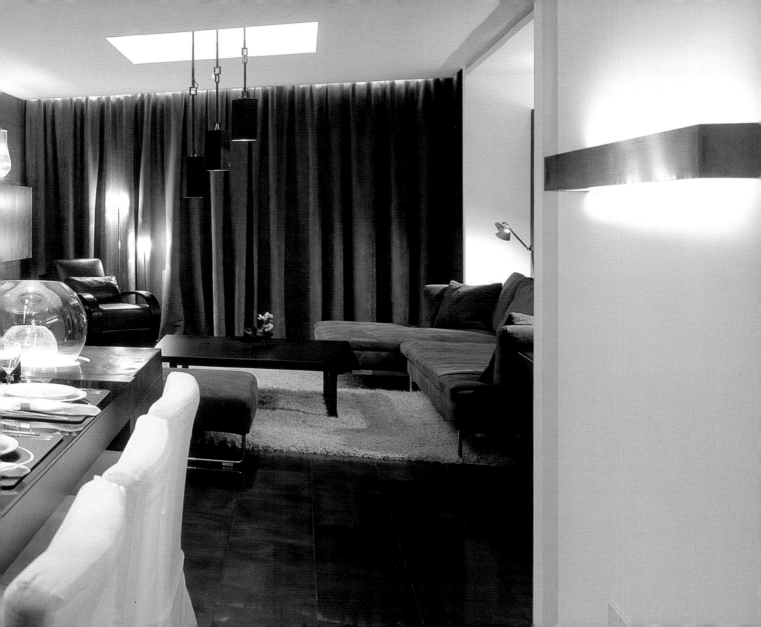

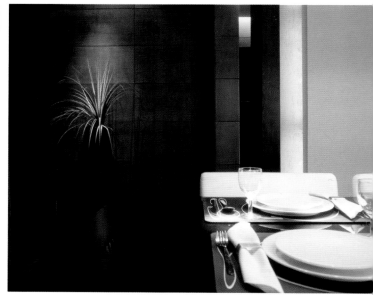
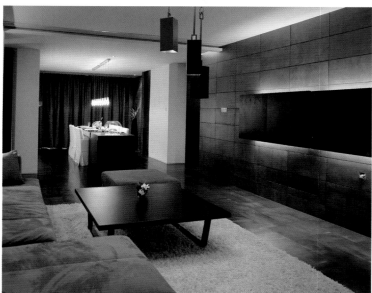

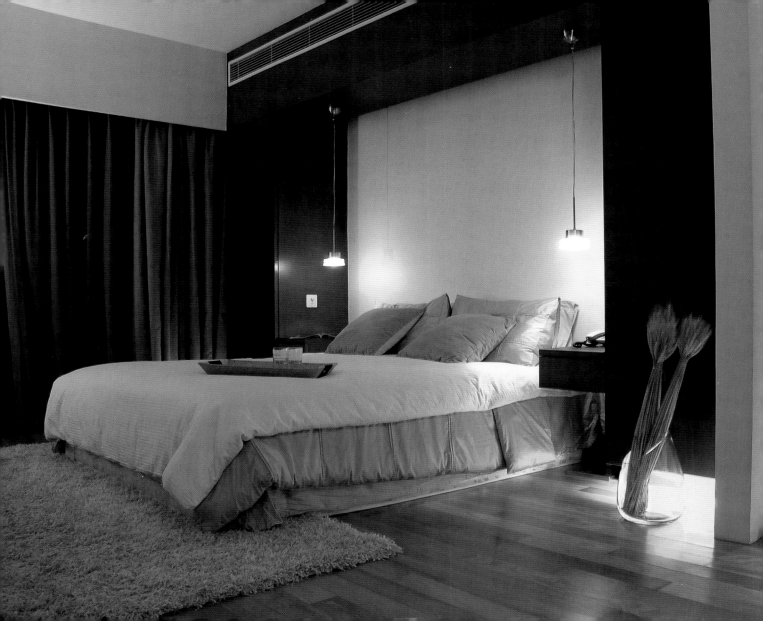

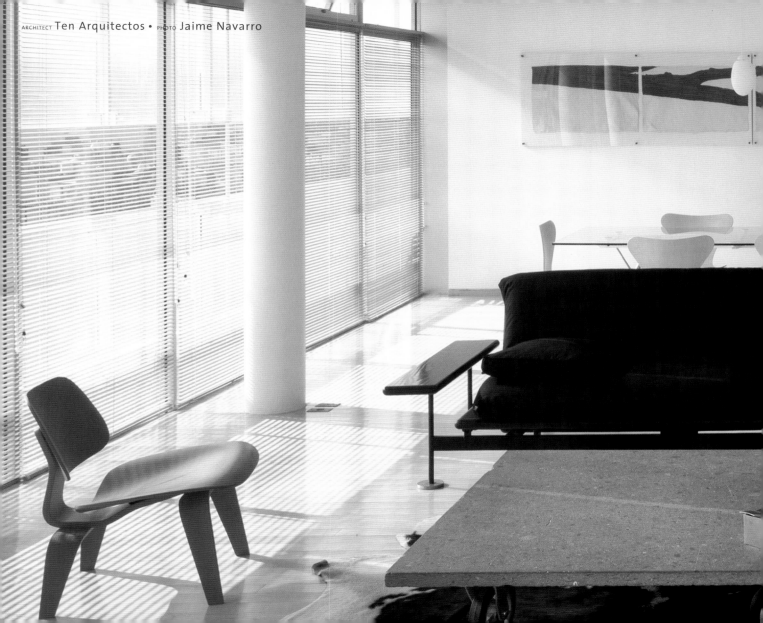

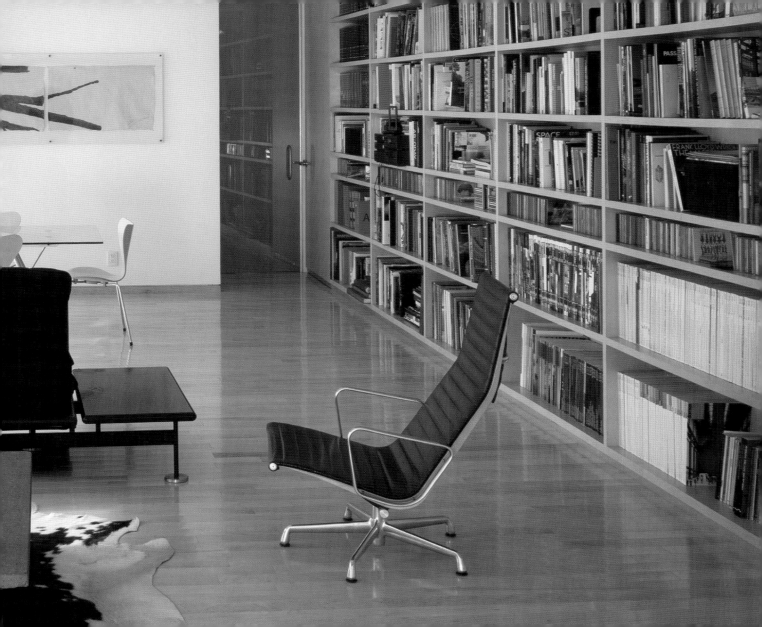

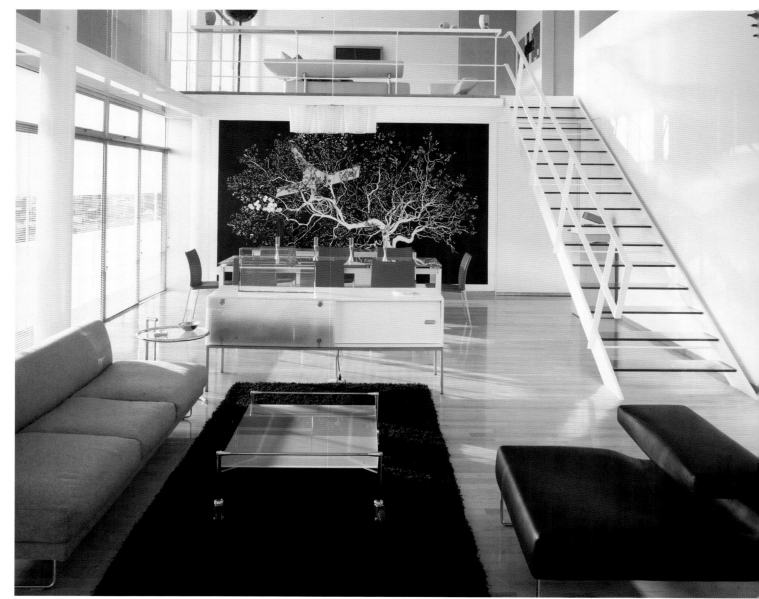

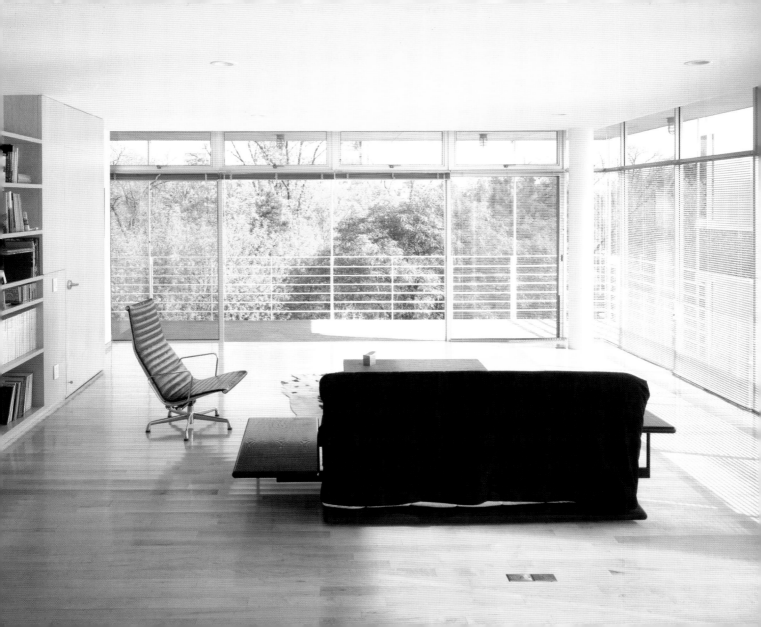

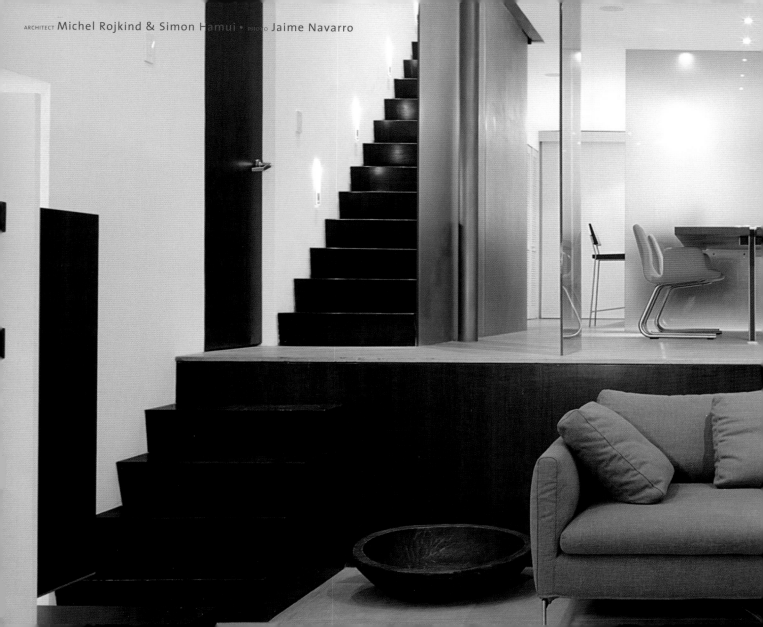

ARCHITECT Michel Rojkind & Simon Hamui • PHOTO Jaime Navarro

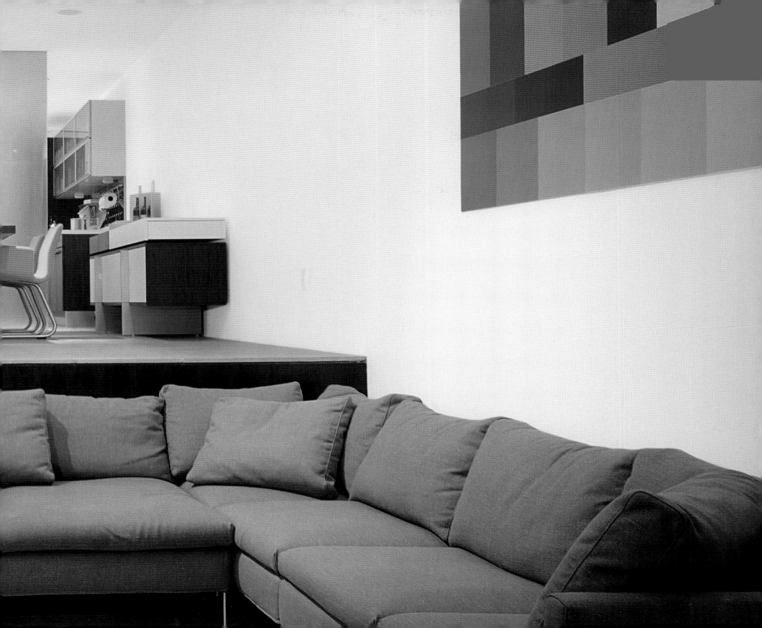

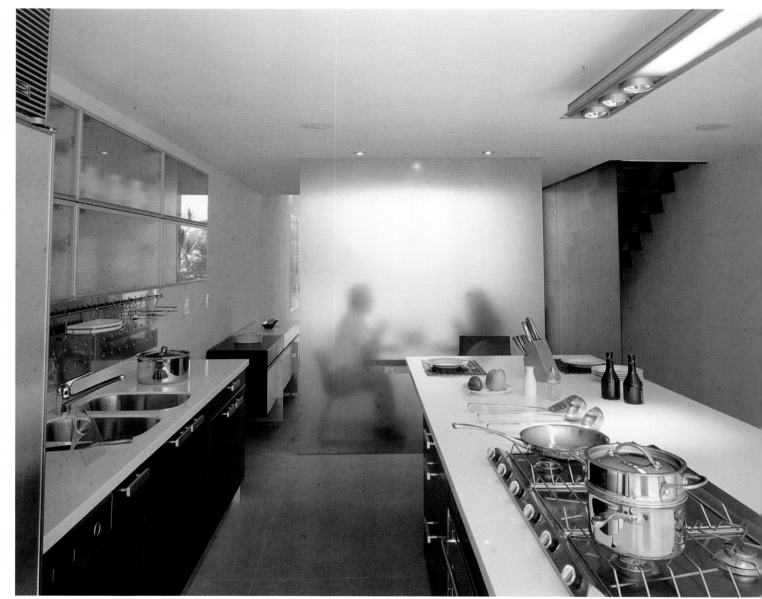

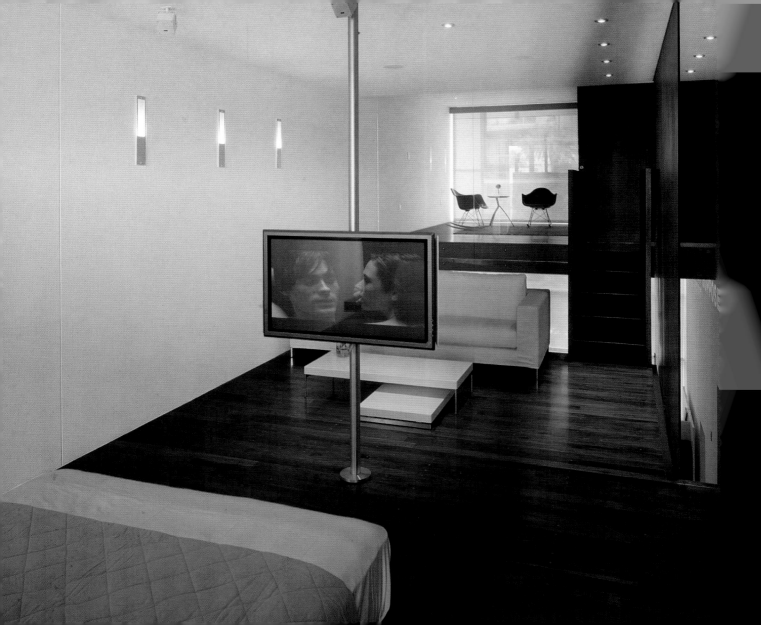

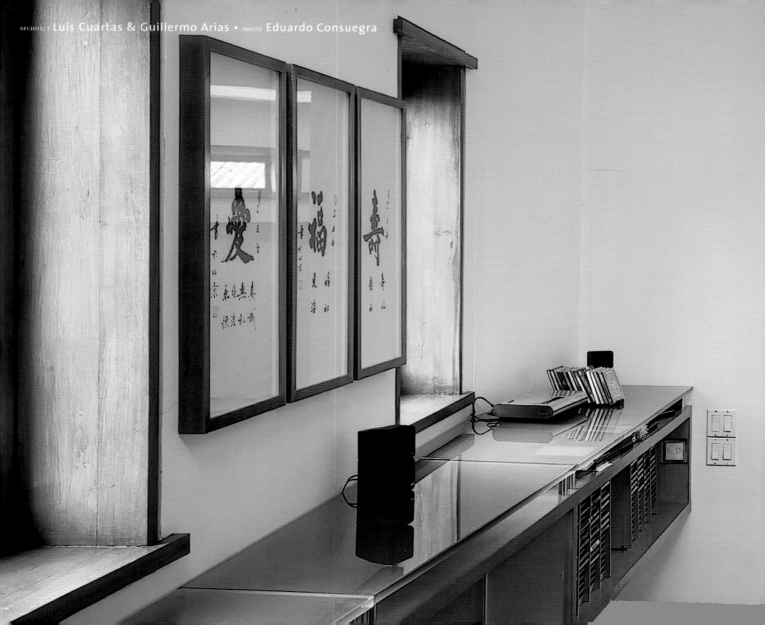

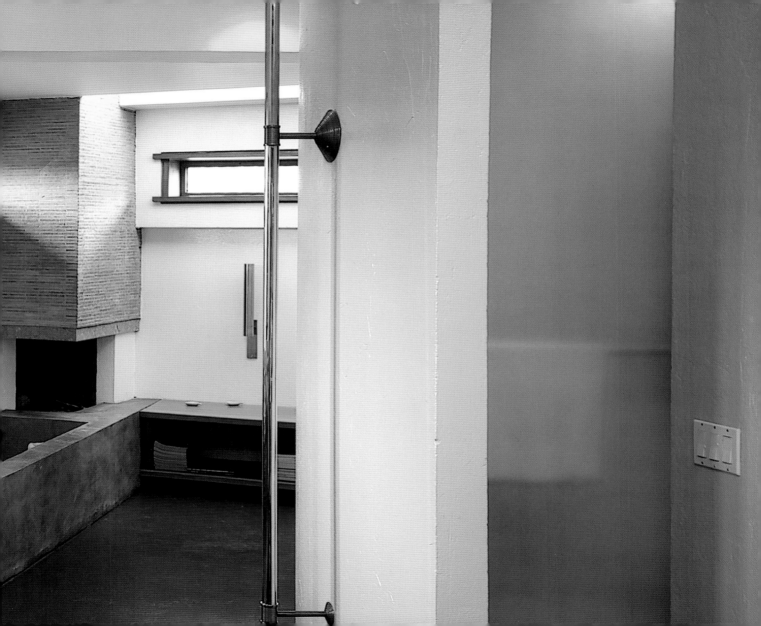

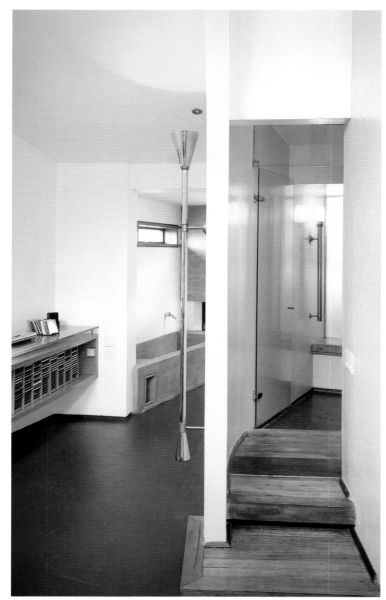
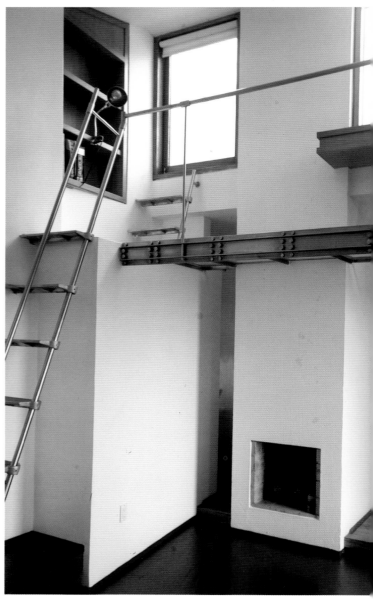

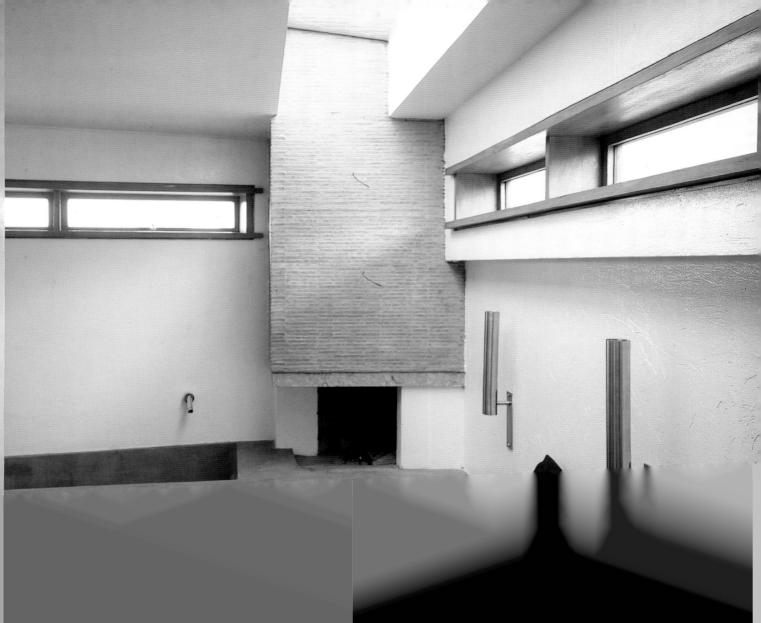

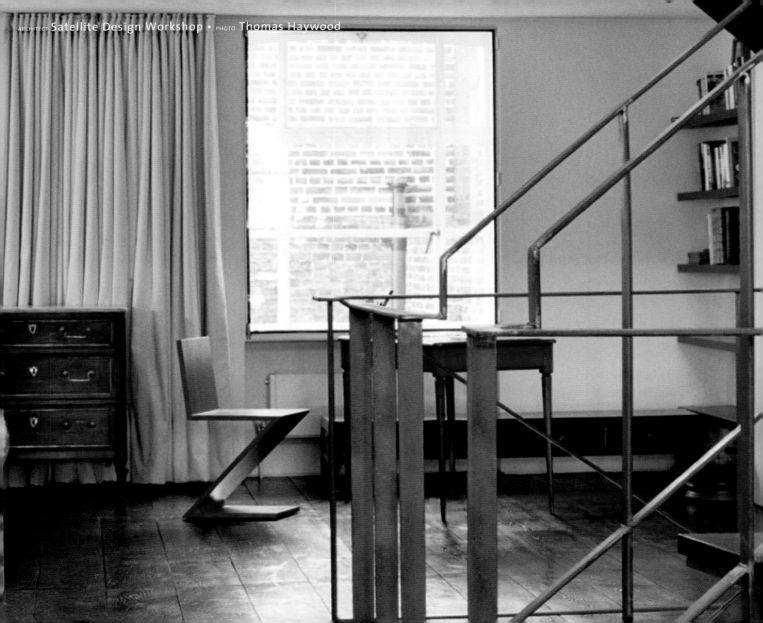

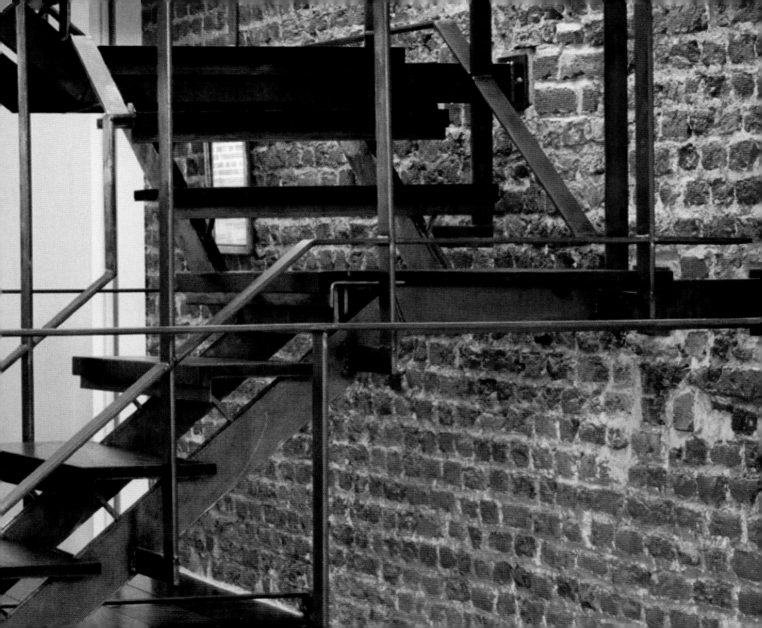

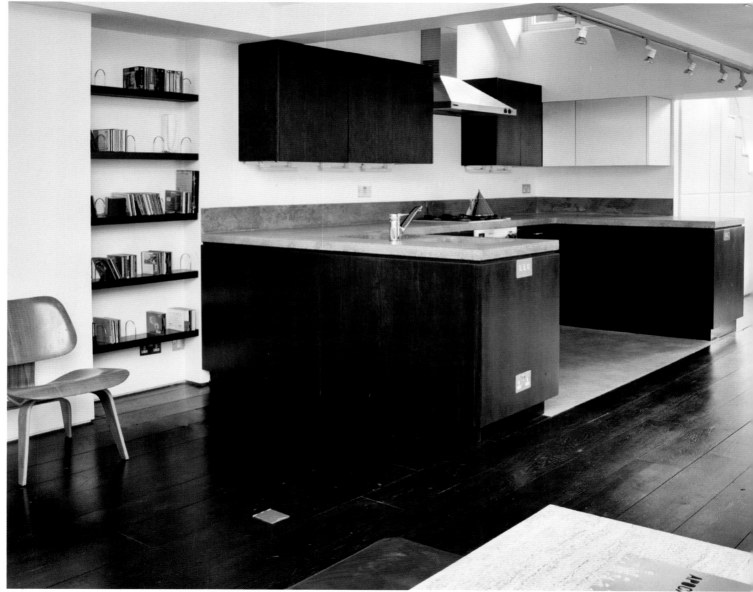

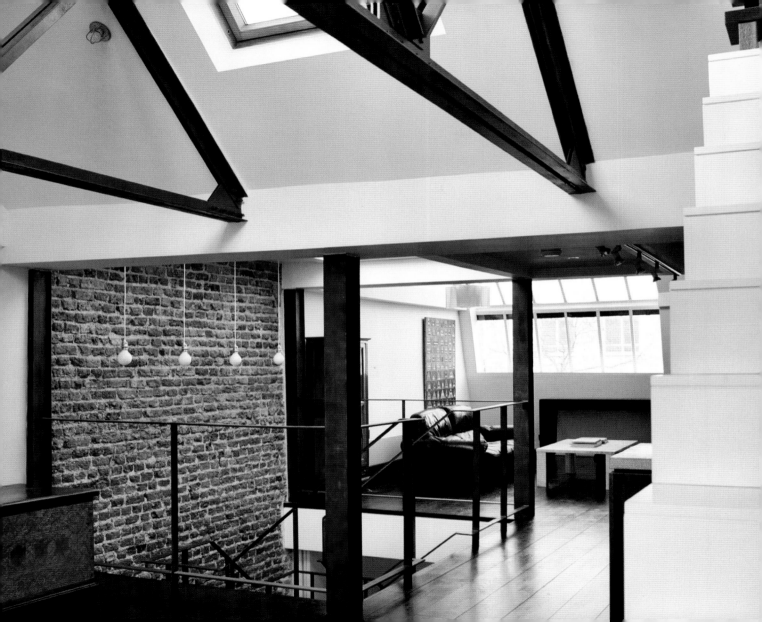

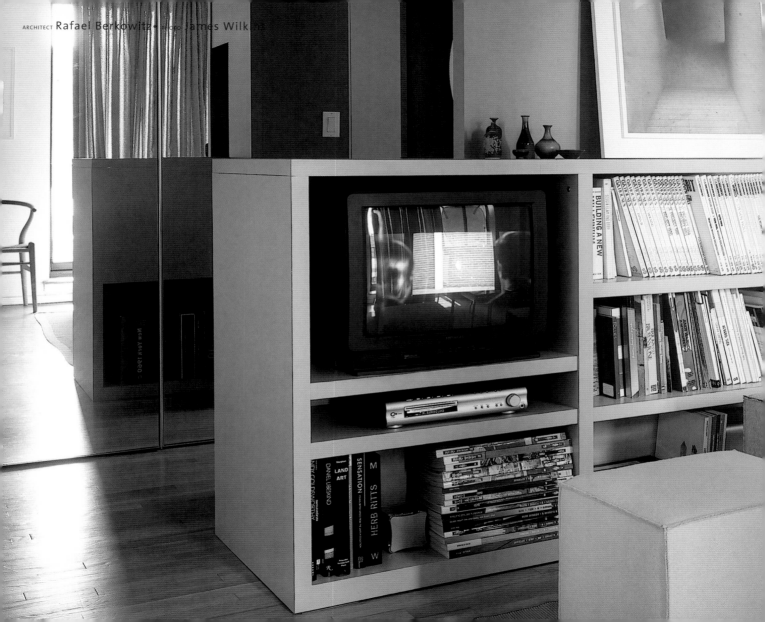

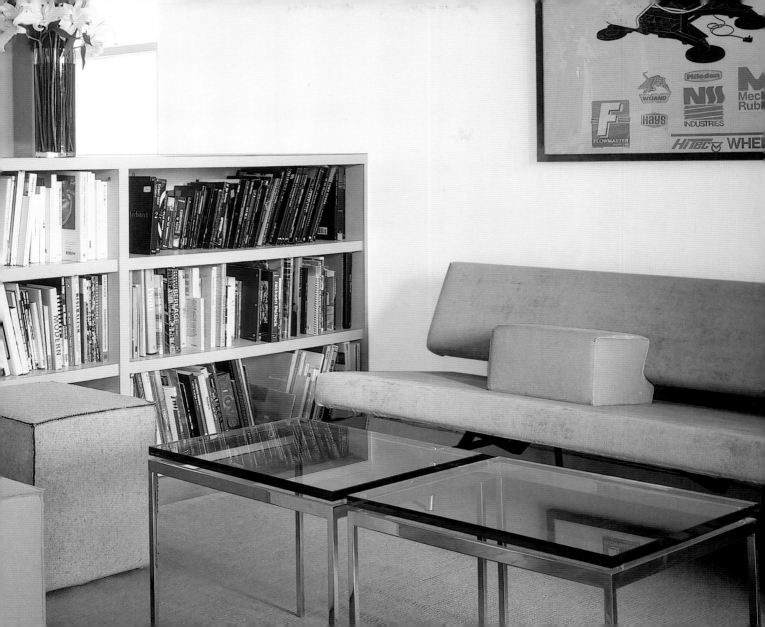

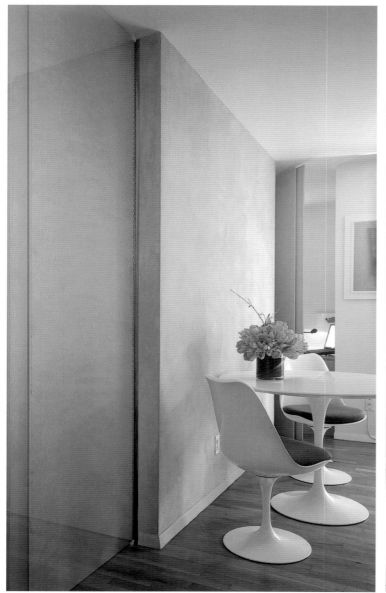
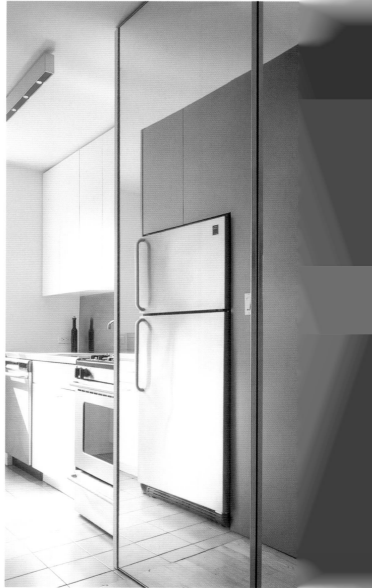

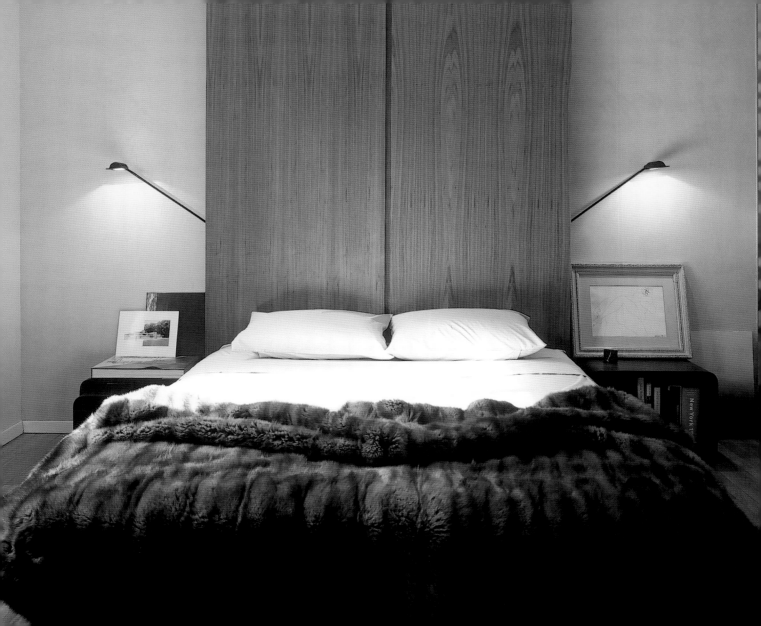

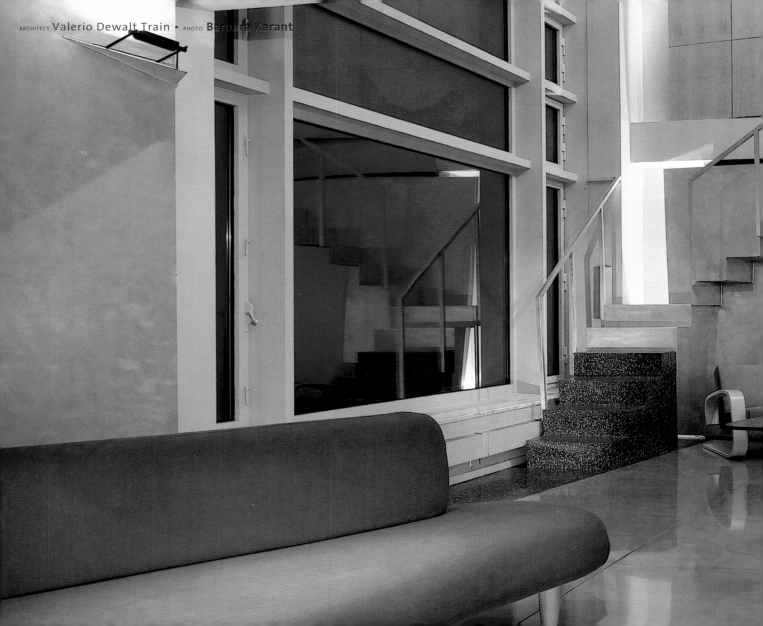

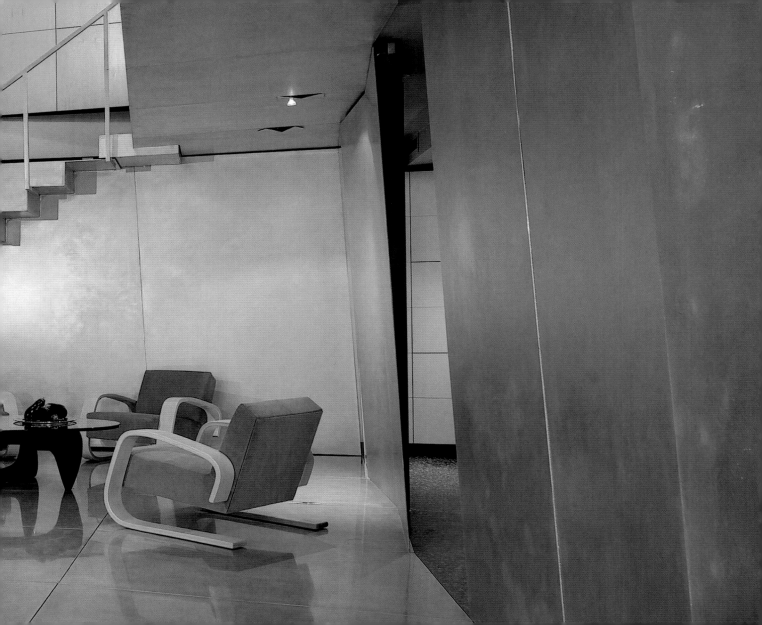

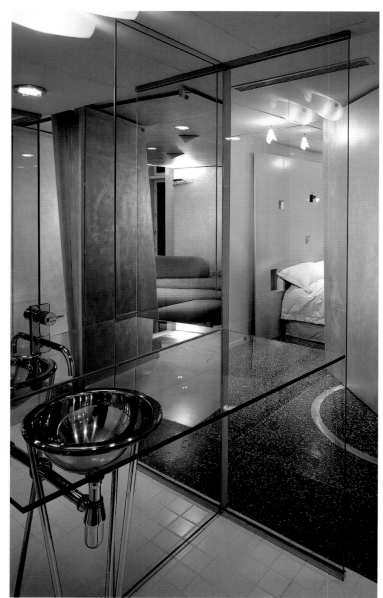
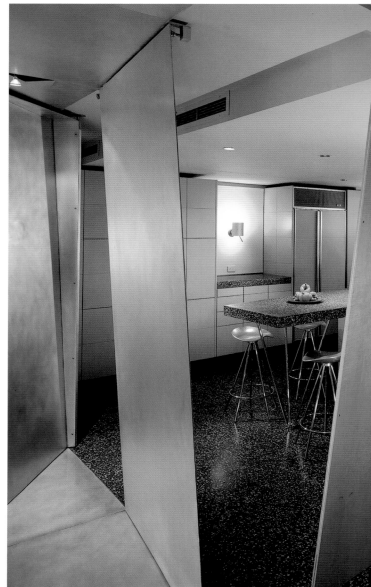

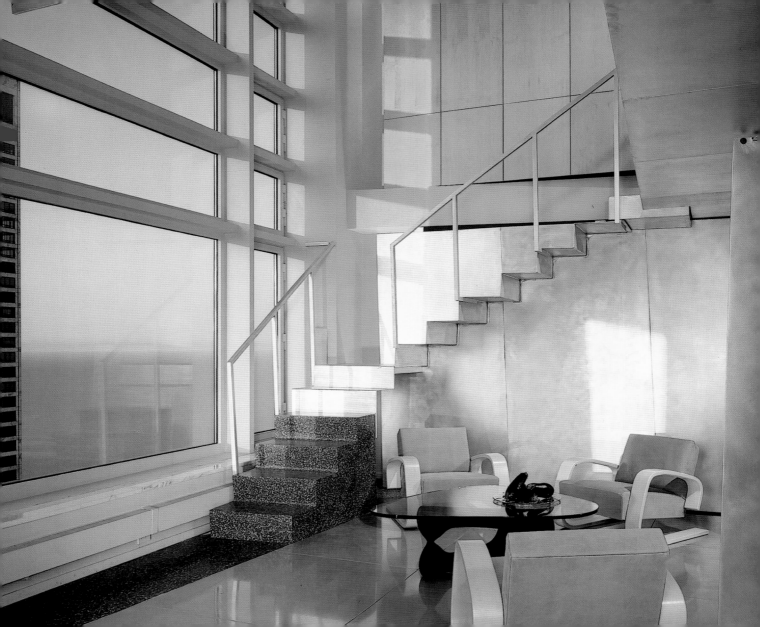

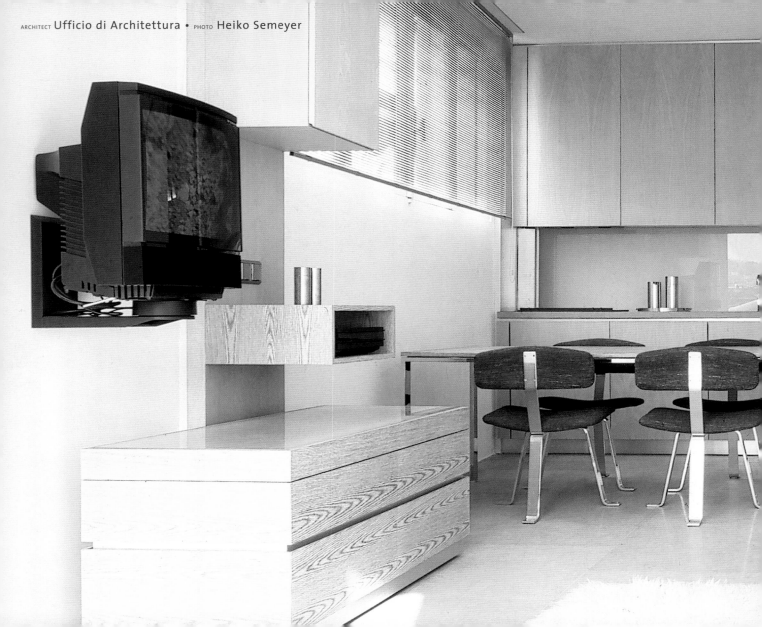

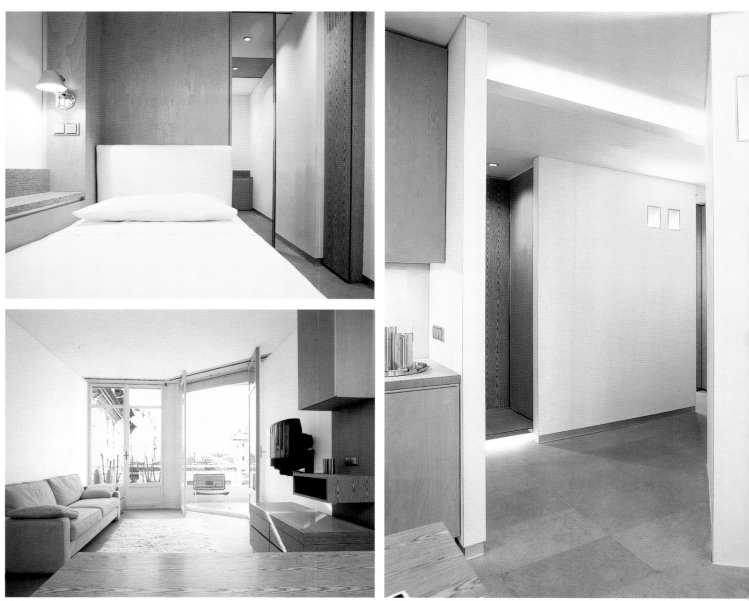

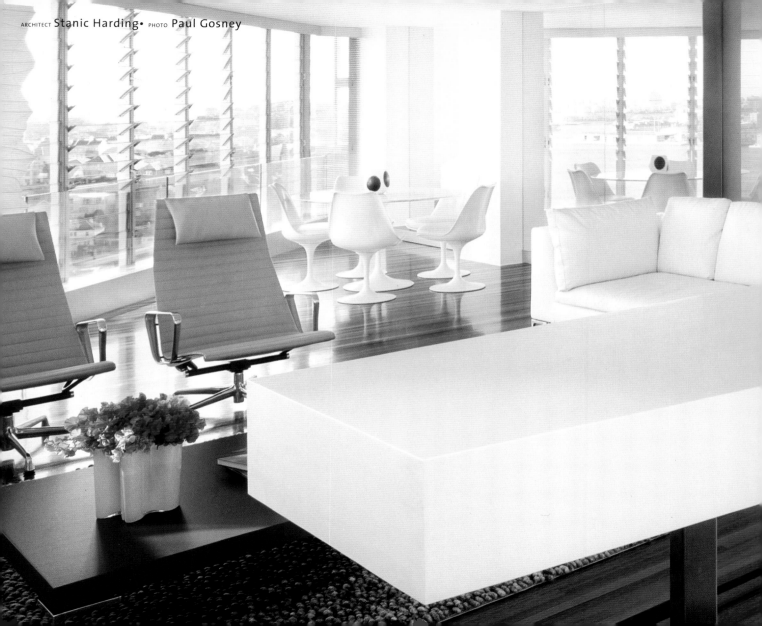

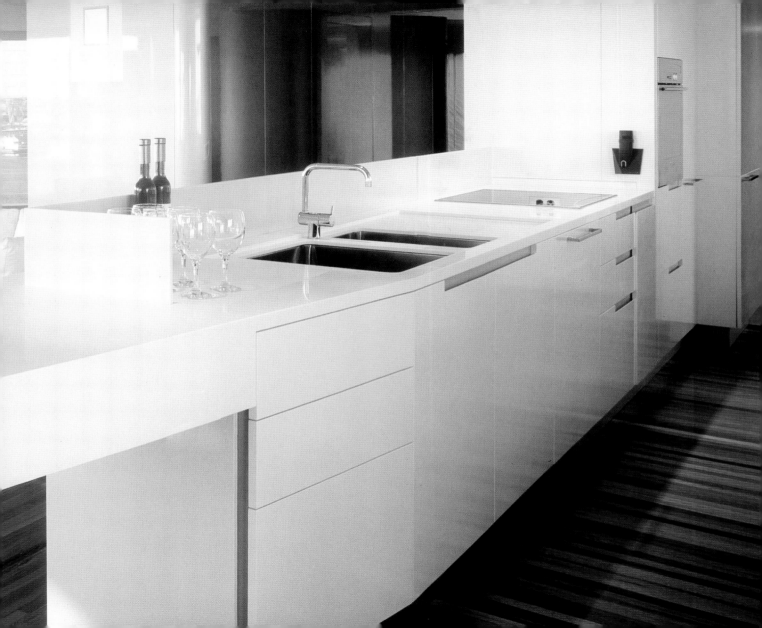

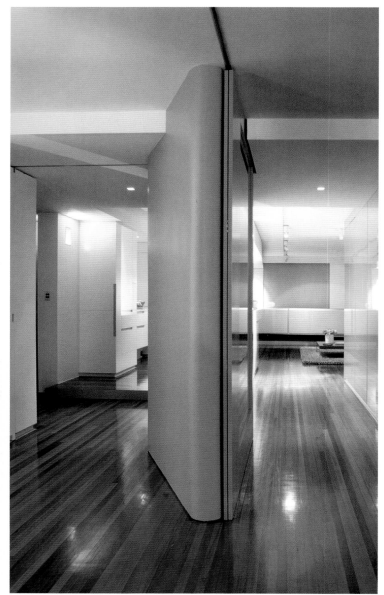
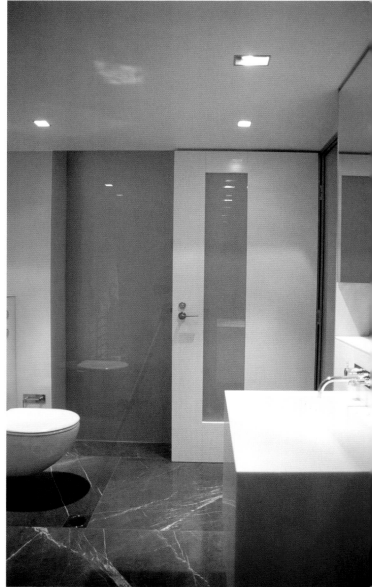

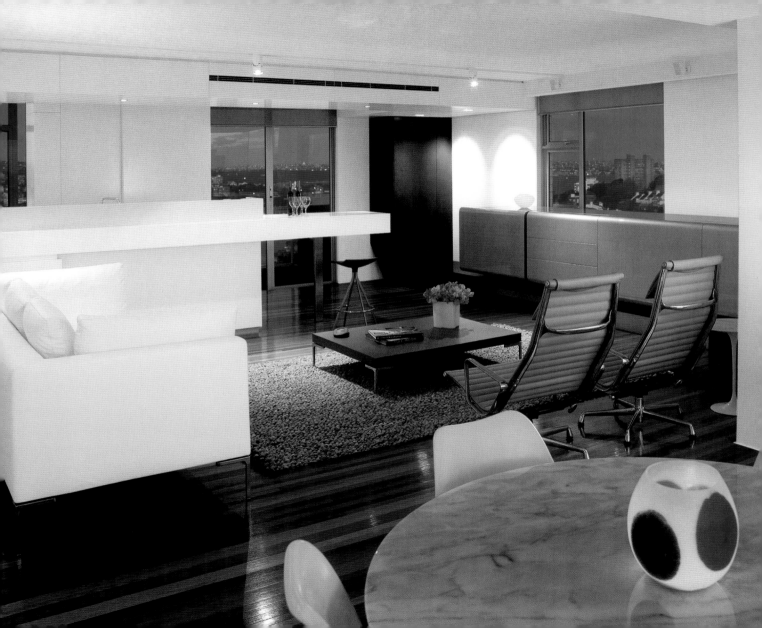

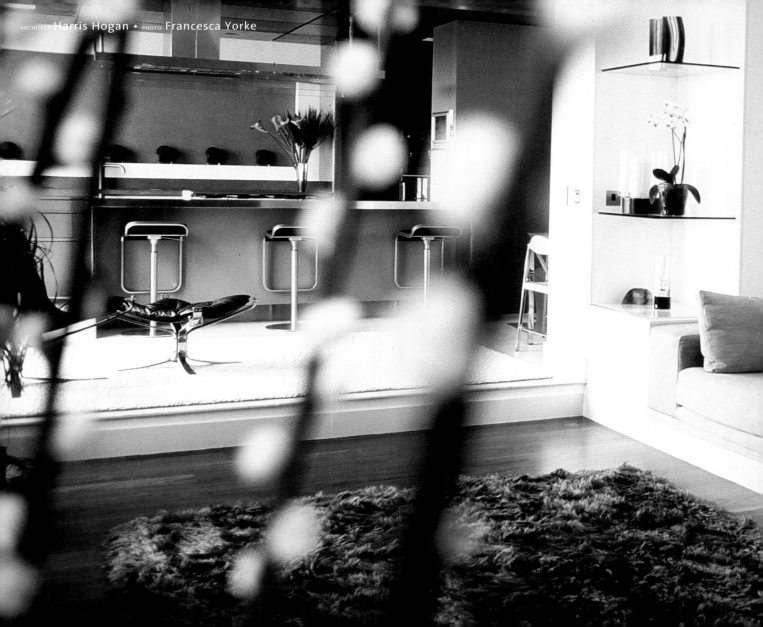

ARCHITECT Harris Hogan • PHOTO Francesca Yorke

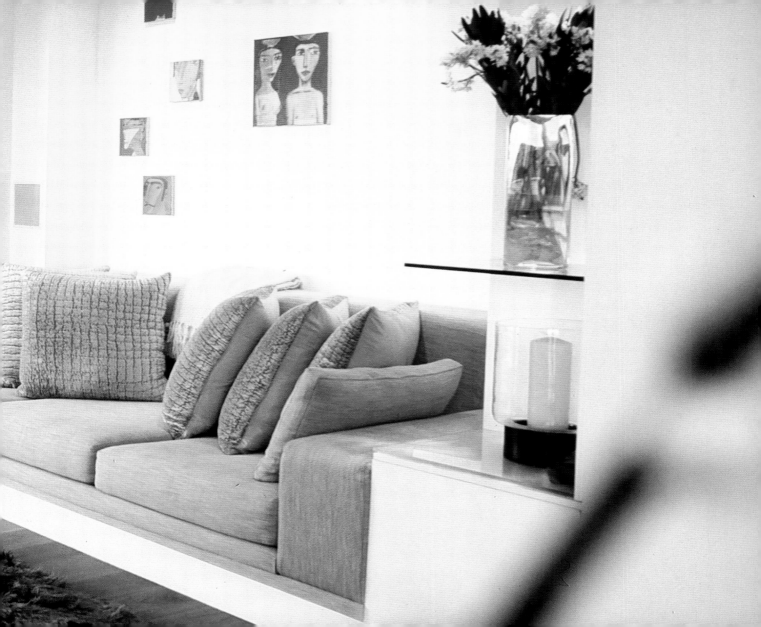

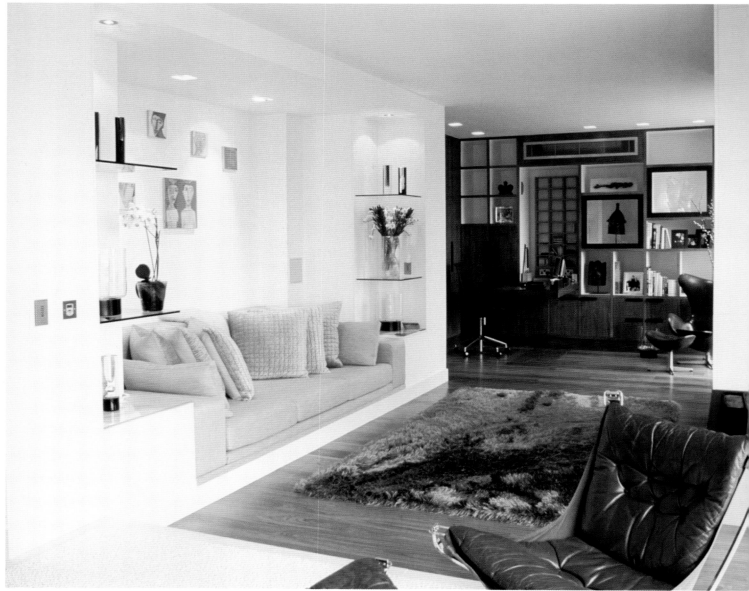

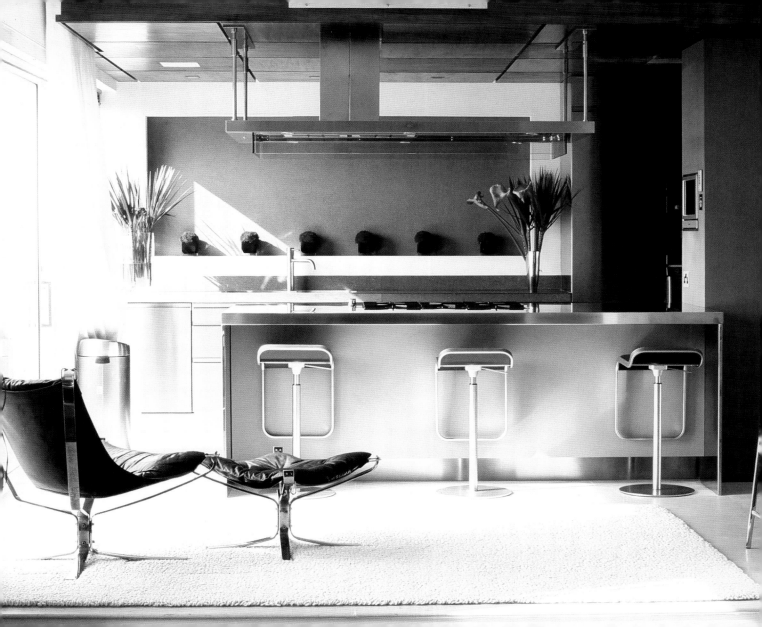

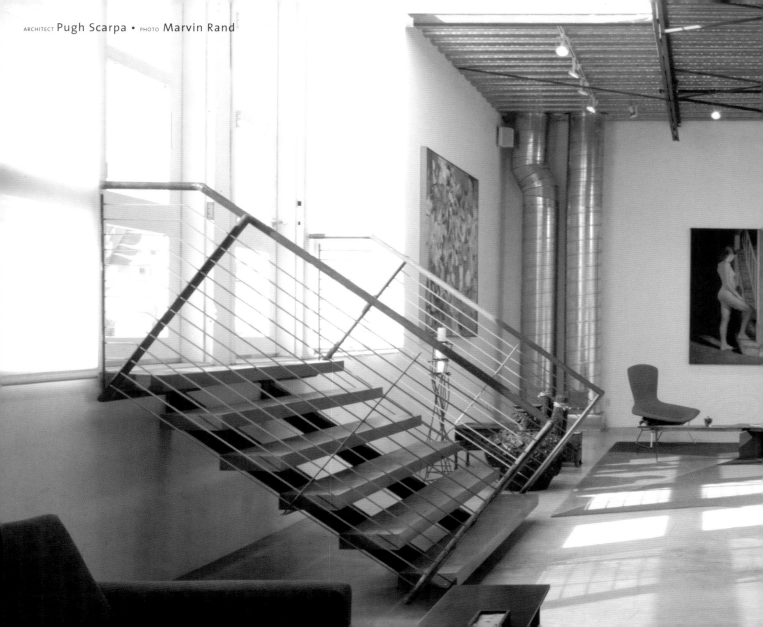

ARCHITECT Pugh Scarpa • PHOTO Marvin Rand

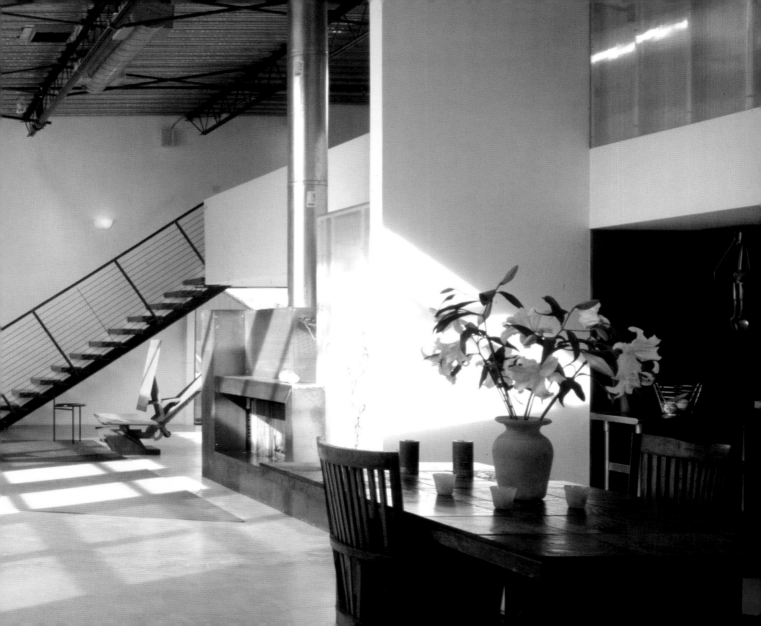

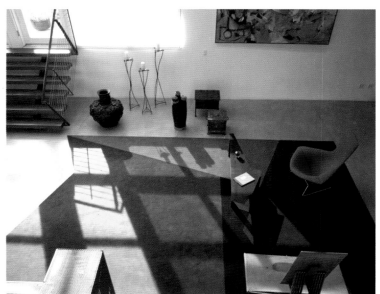
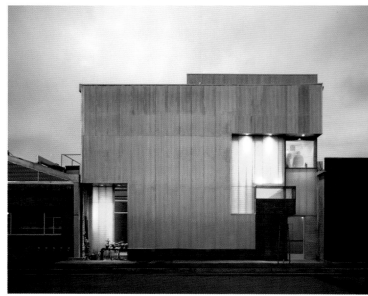
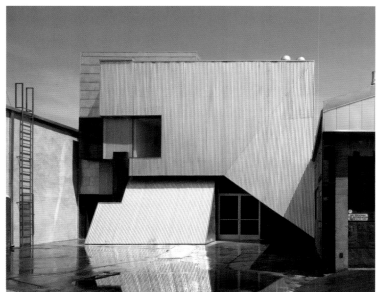
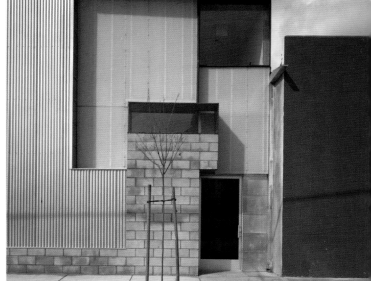

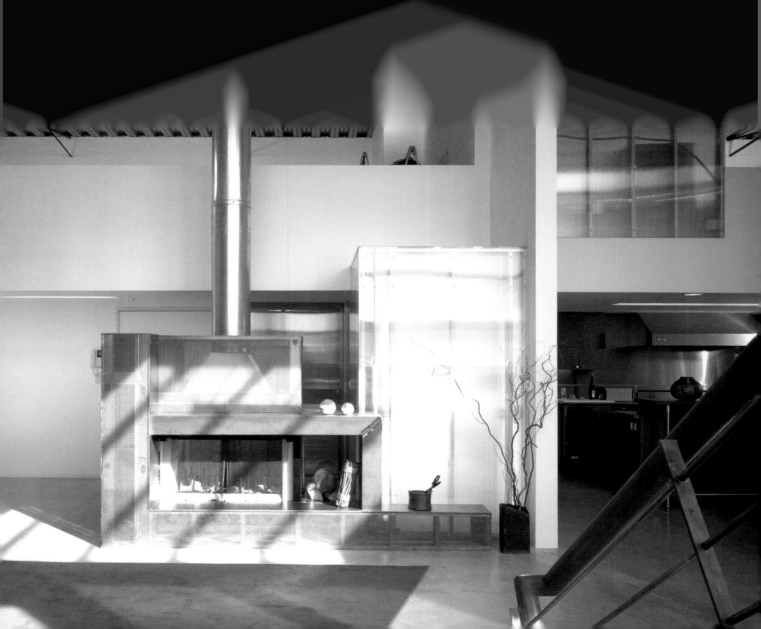

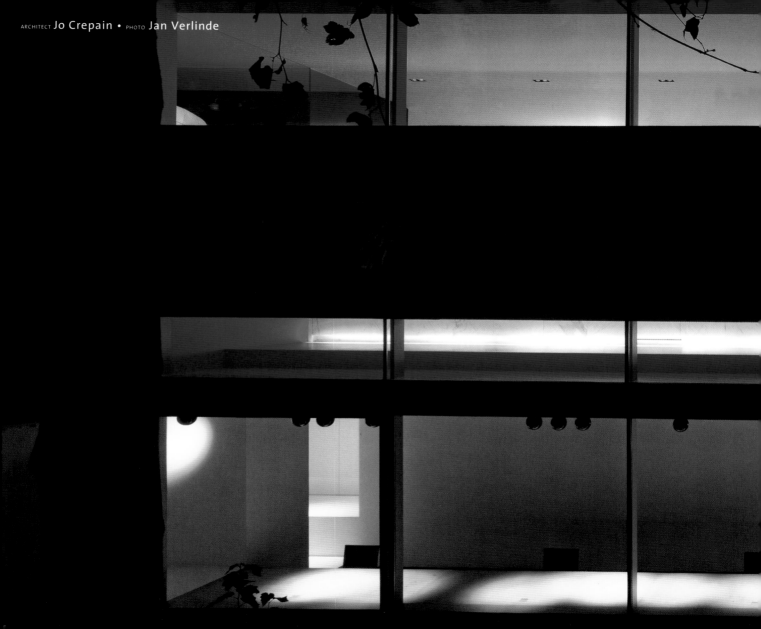

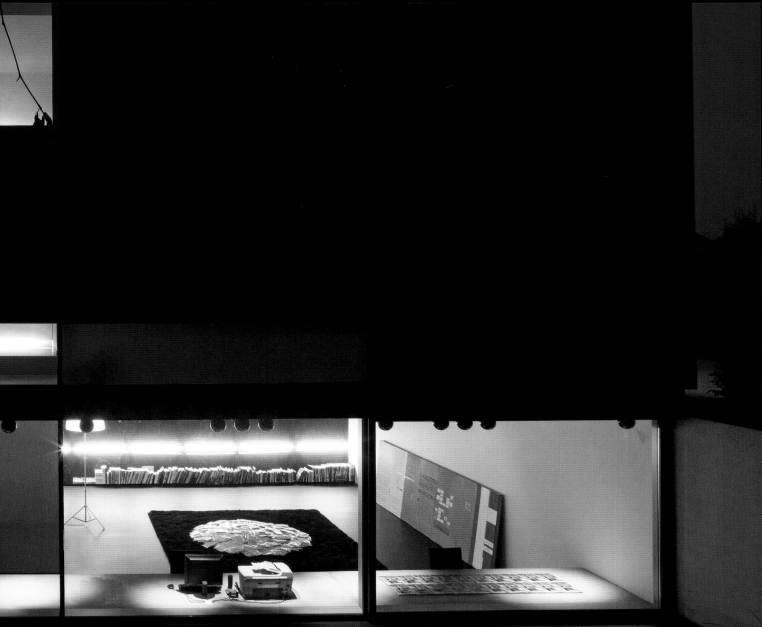

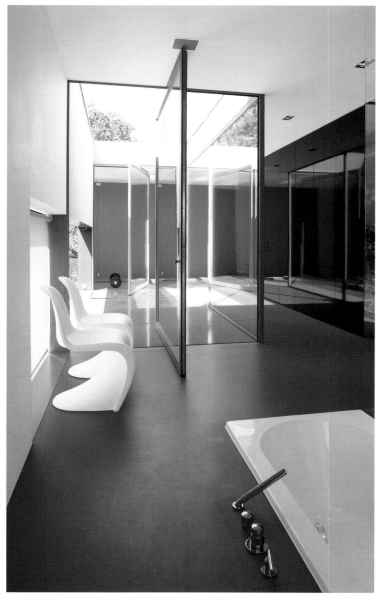

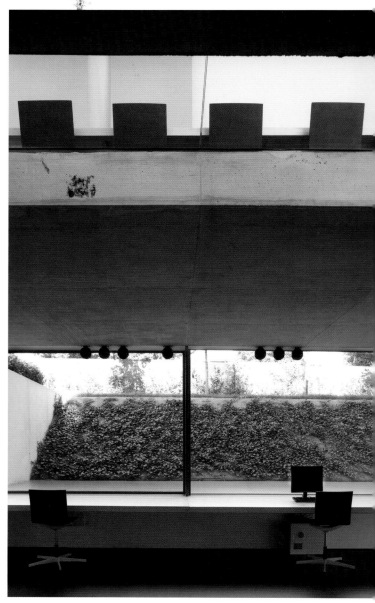

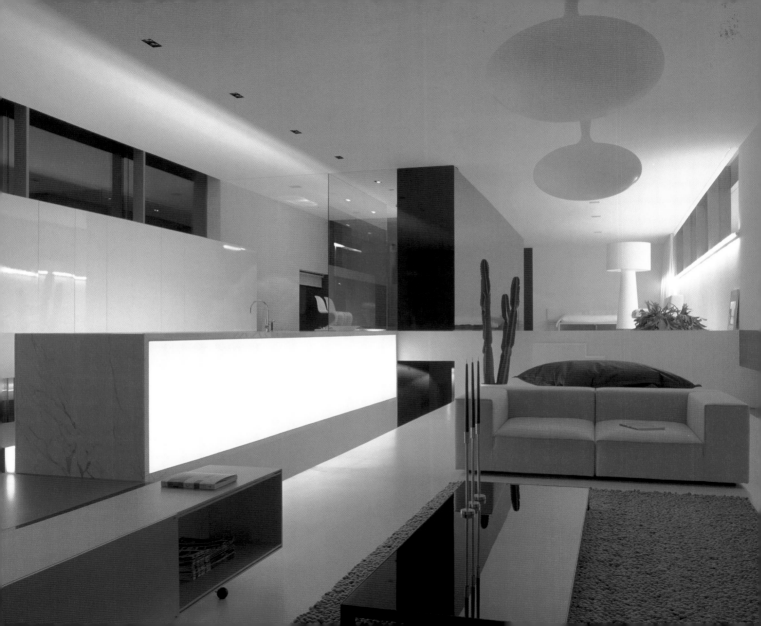

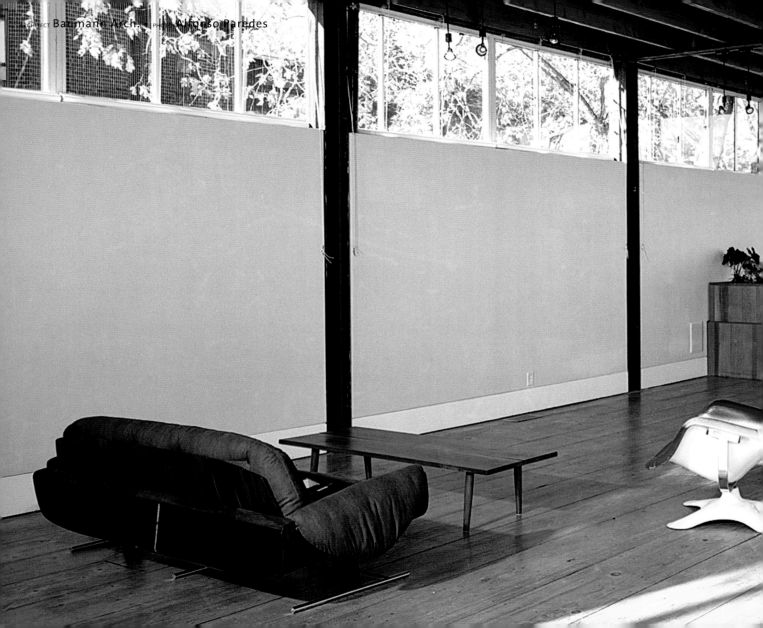
ARCHITECT Baumann Arch. PHOTO Alfonso Paredes

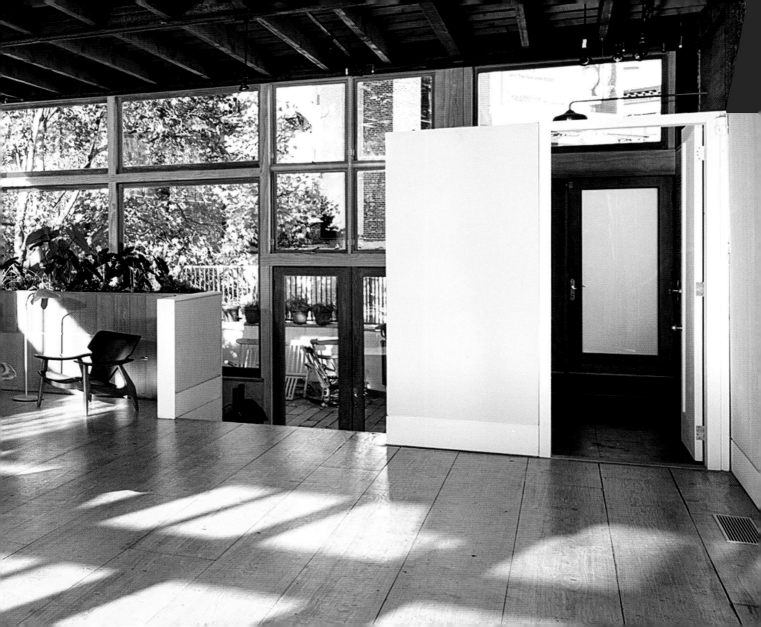

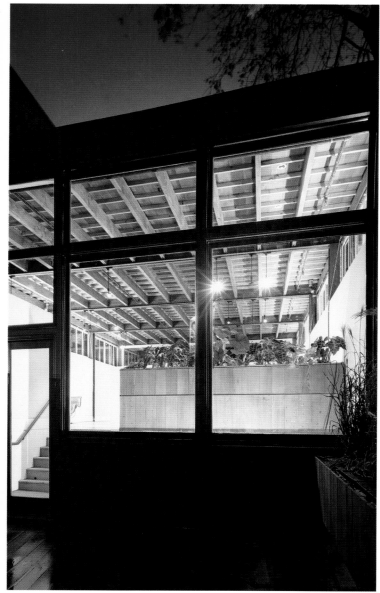

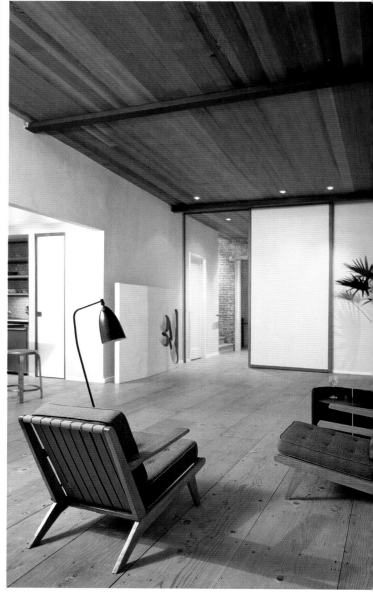

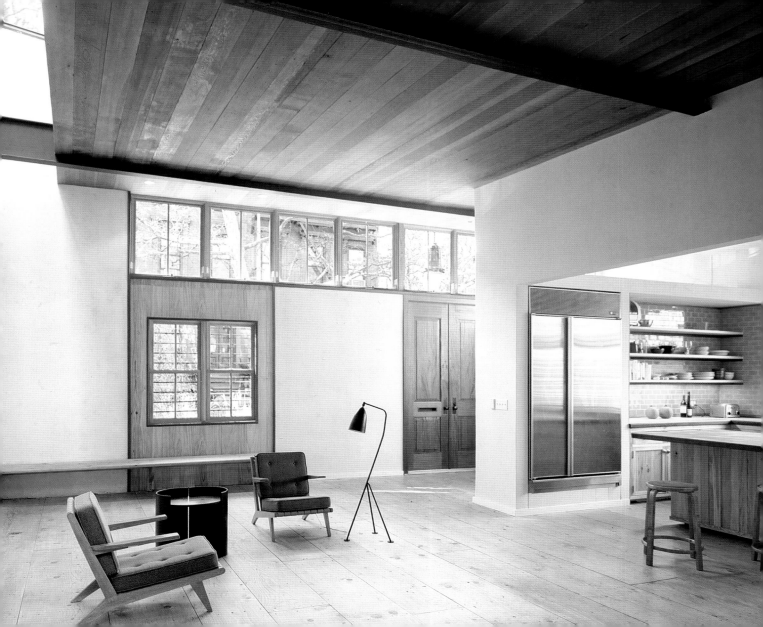

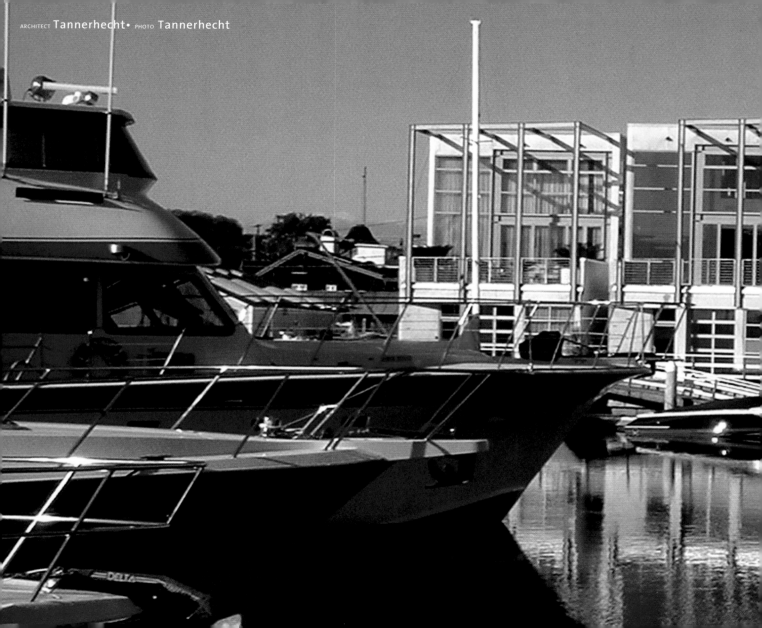

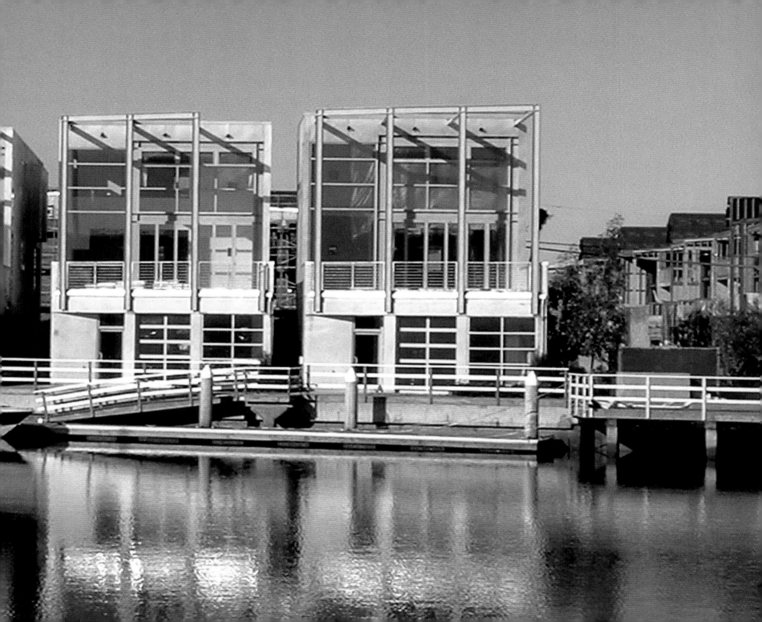

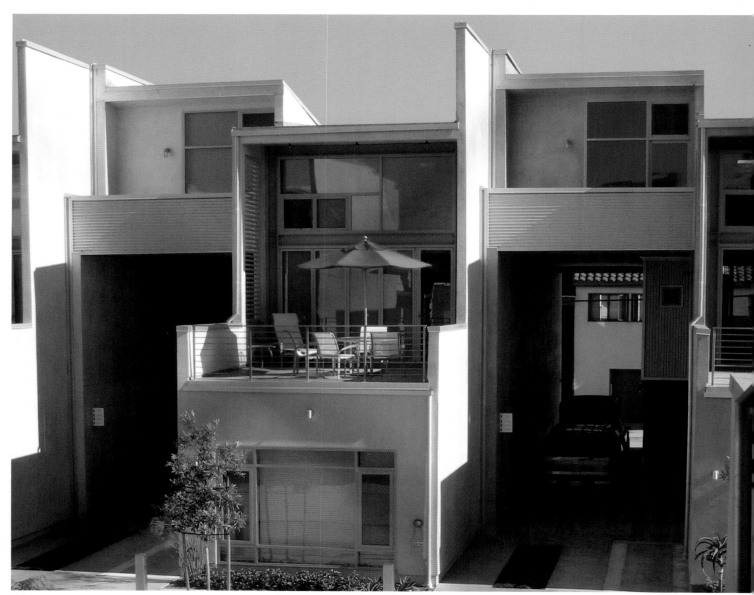

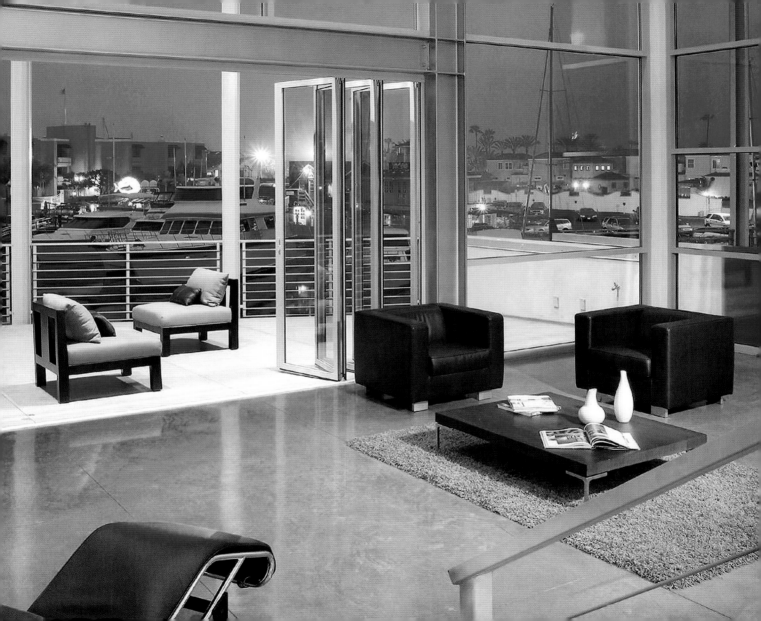

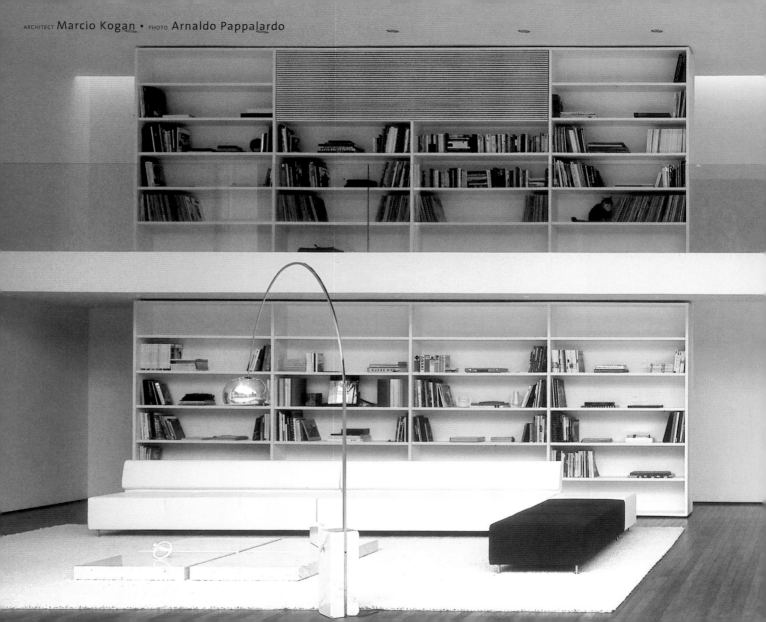

ARCHITECT Marcio Kogan • PHOTO Arnaldo Pappalardo

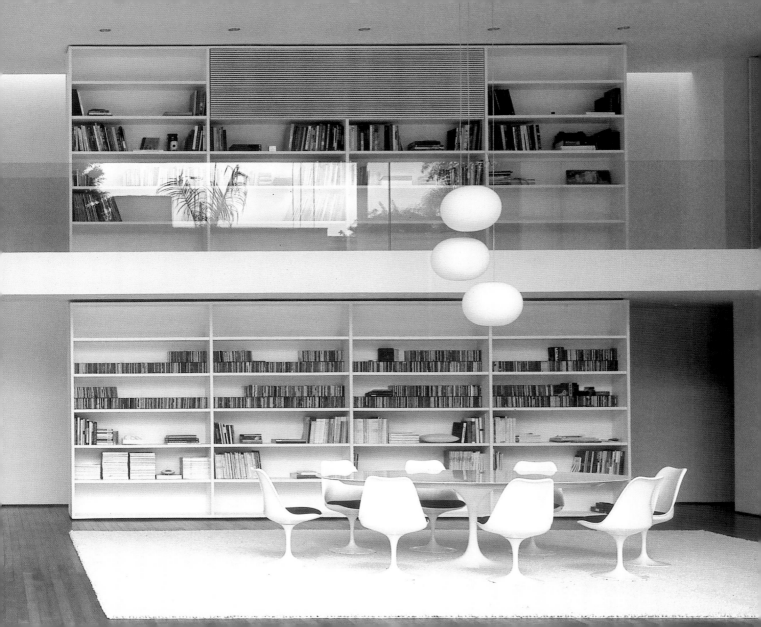

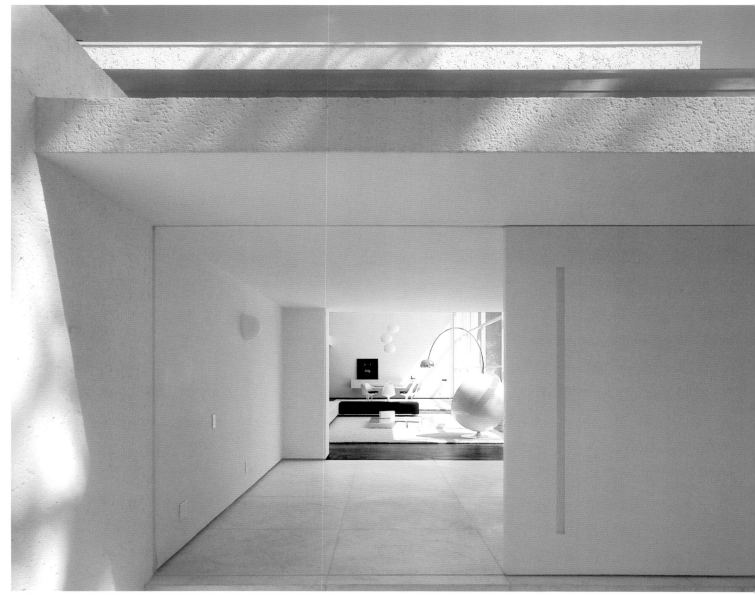

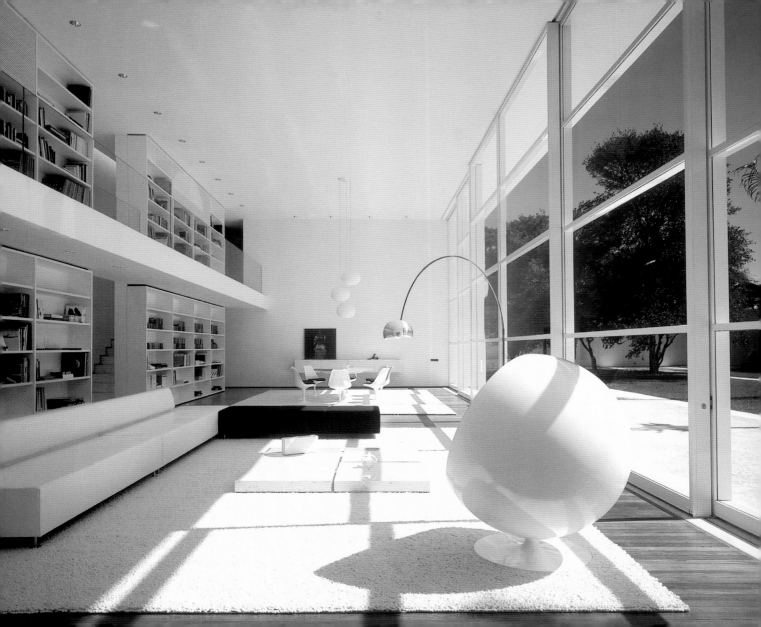

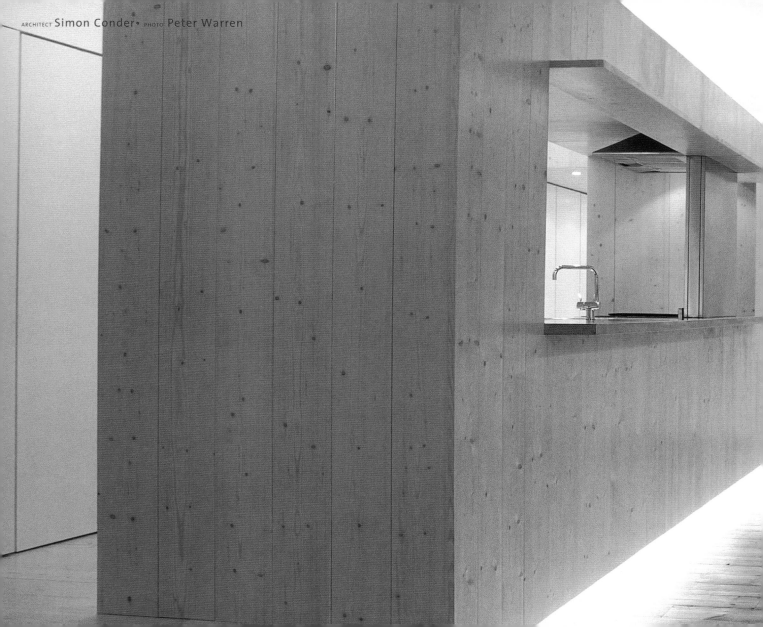

ARCHITECT Simon Conder • PHOTO Peter Warren

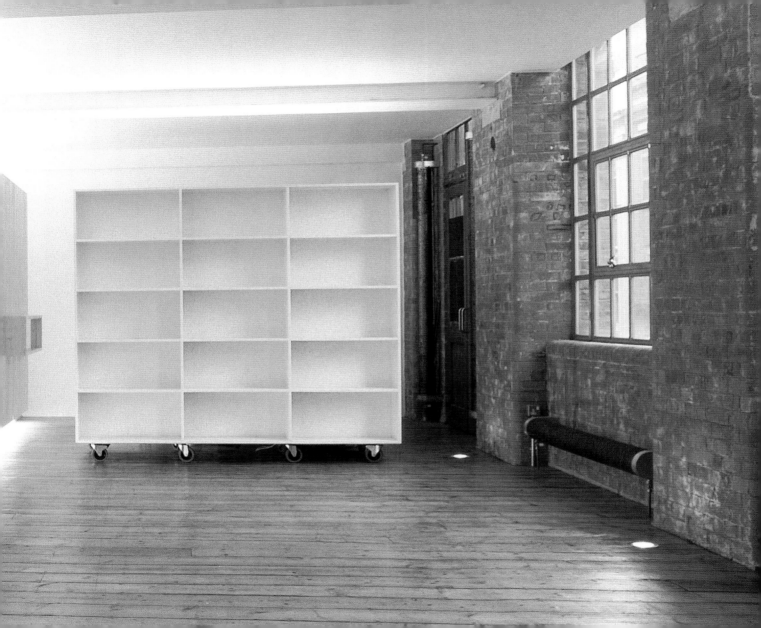

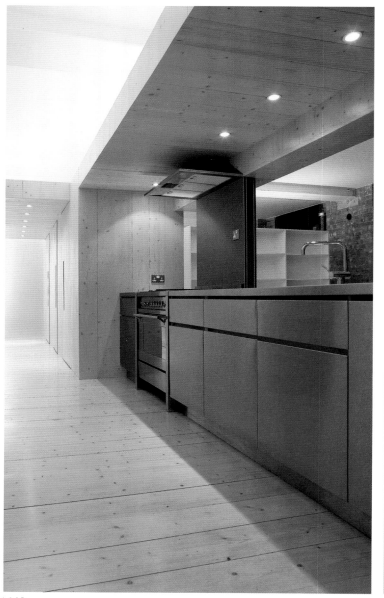
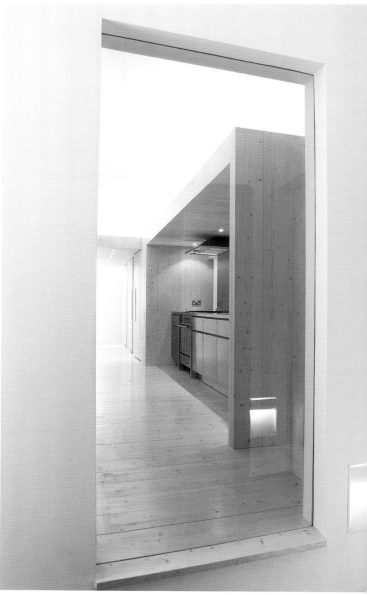

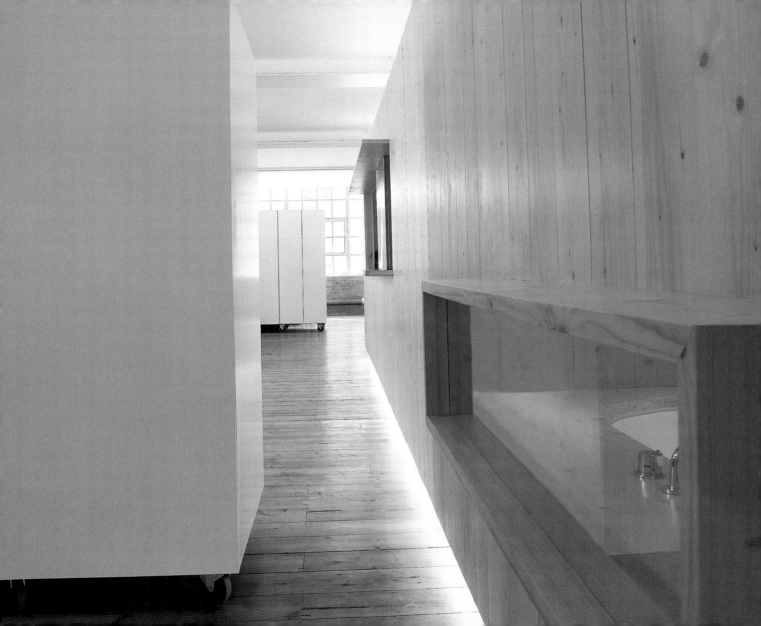

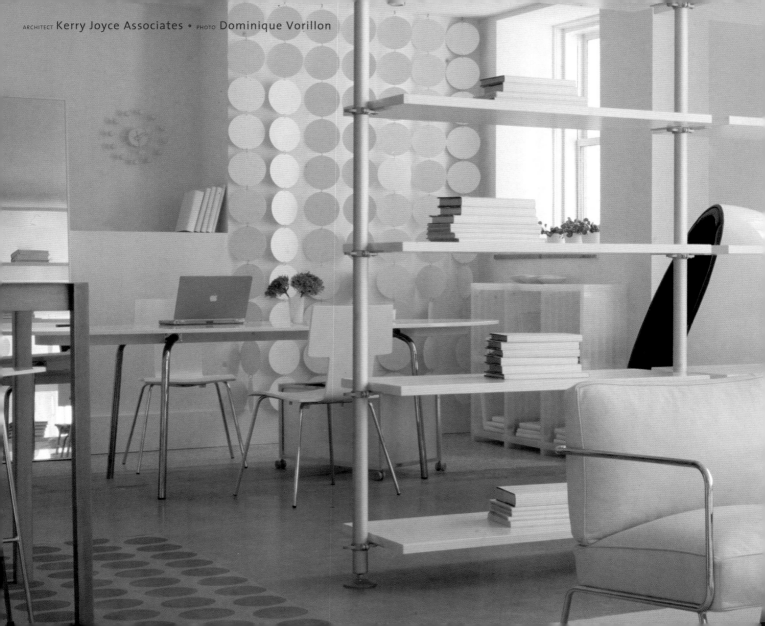

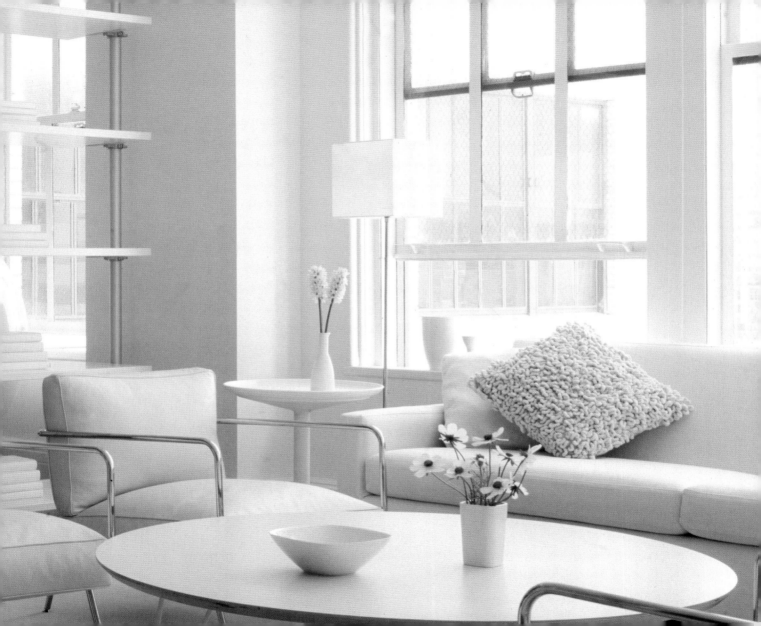

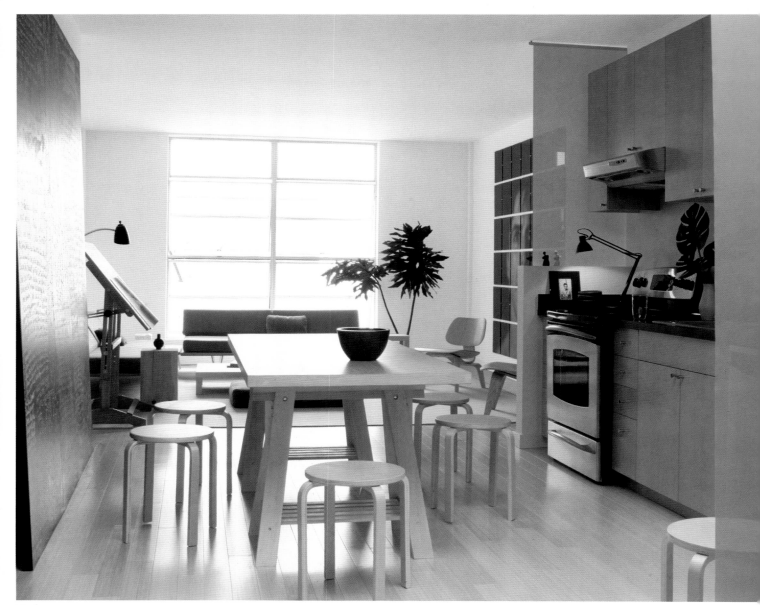

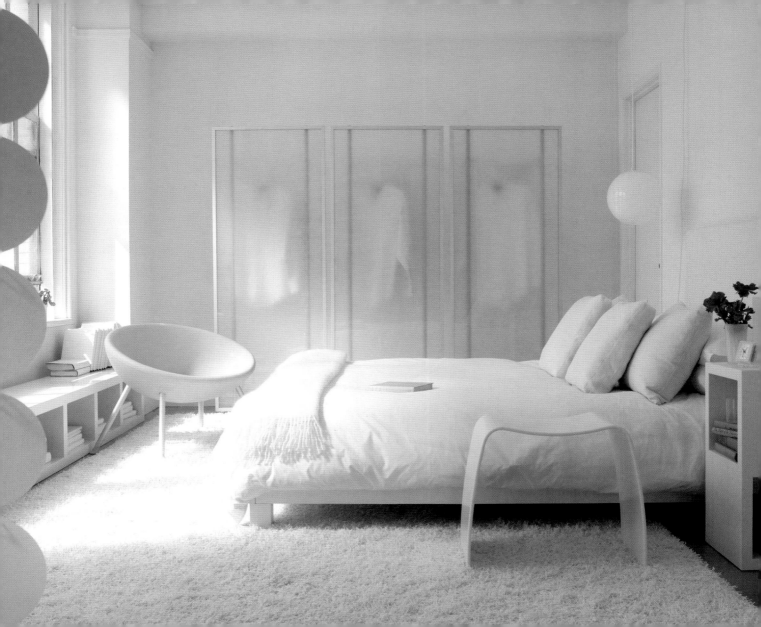

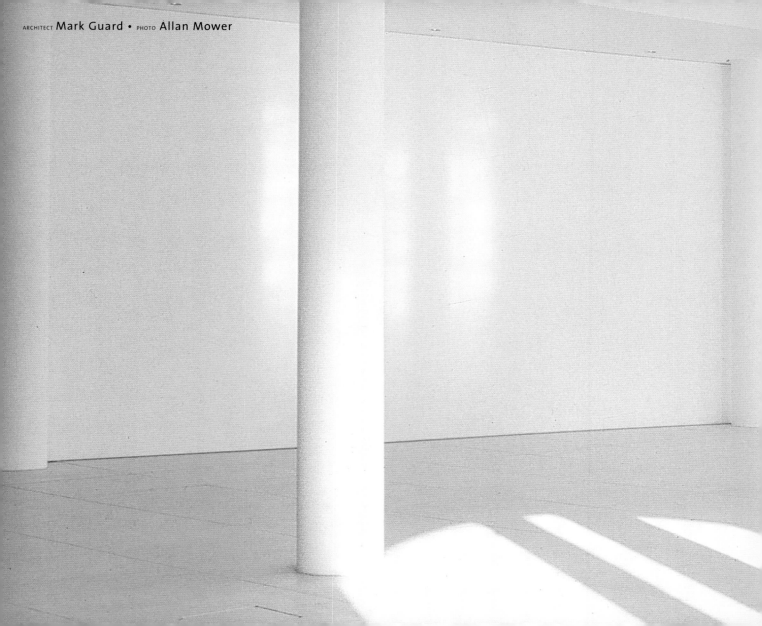

ARCHITECT Mark Guard • PHOTO Allan Mower

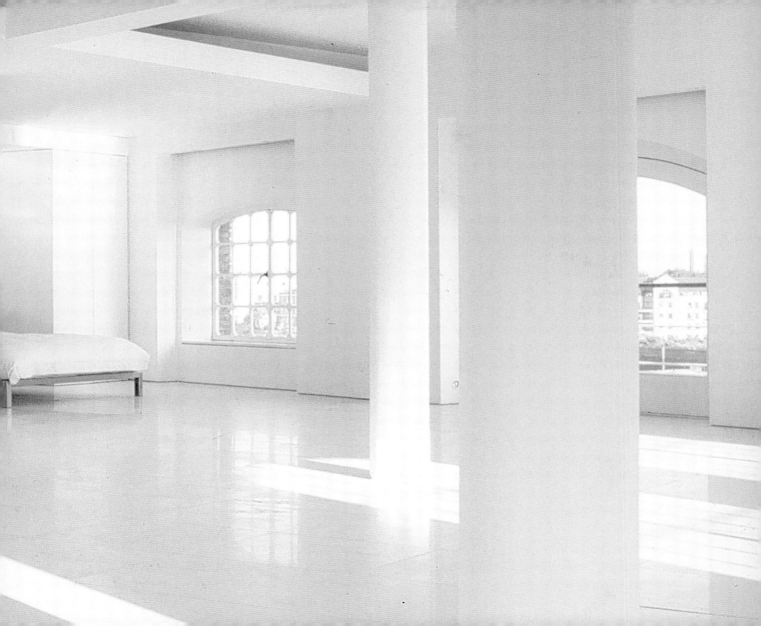

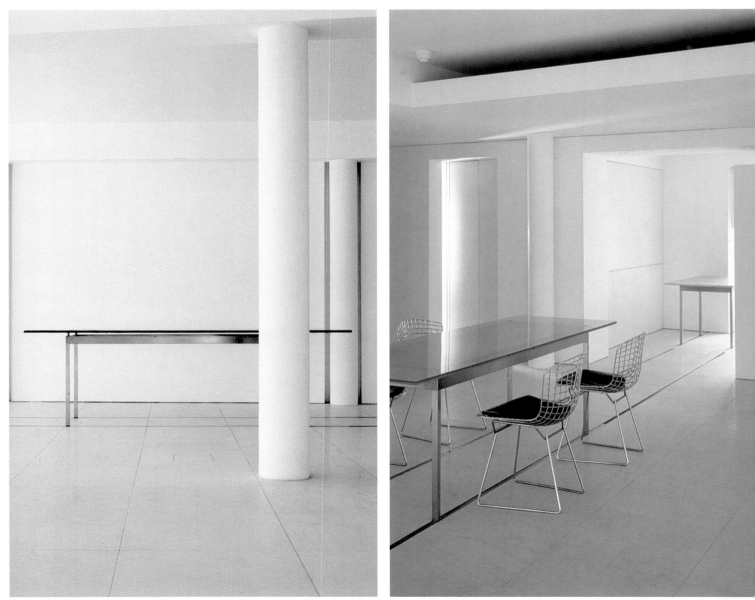

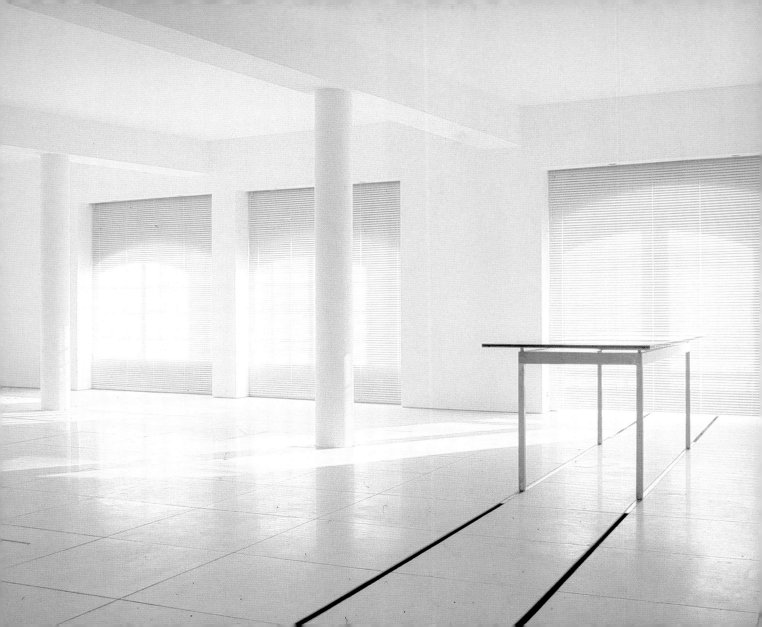

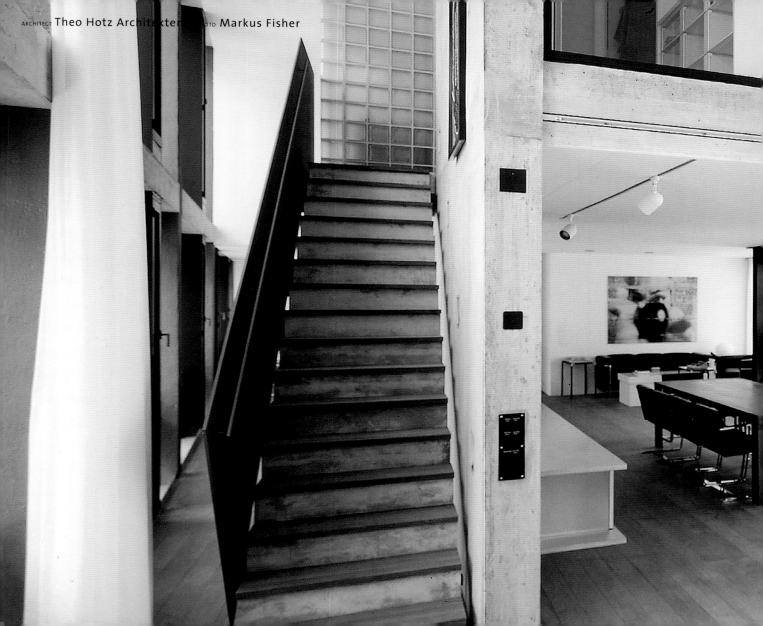

ARCHITECT Theo Hotz Architexten PHOTO Markus Fisher

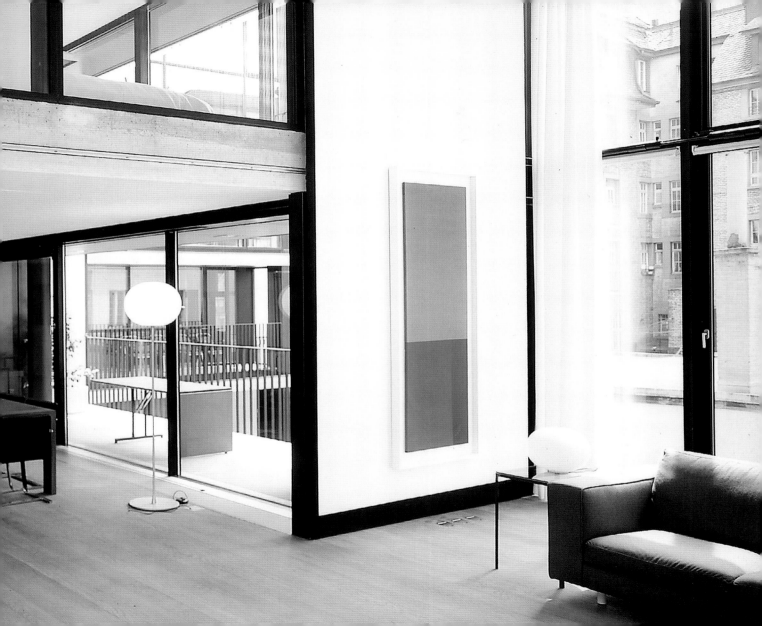

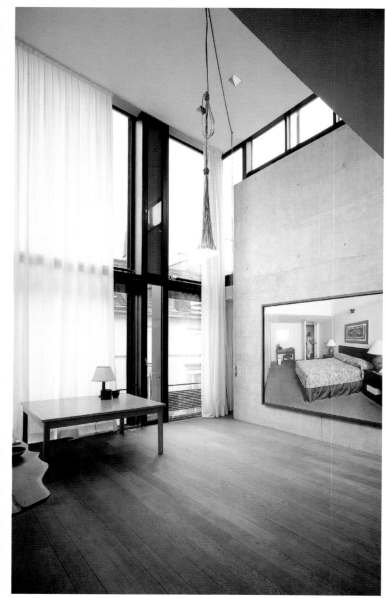
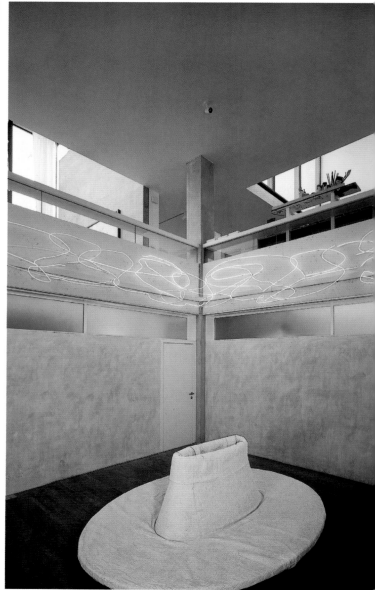

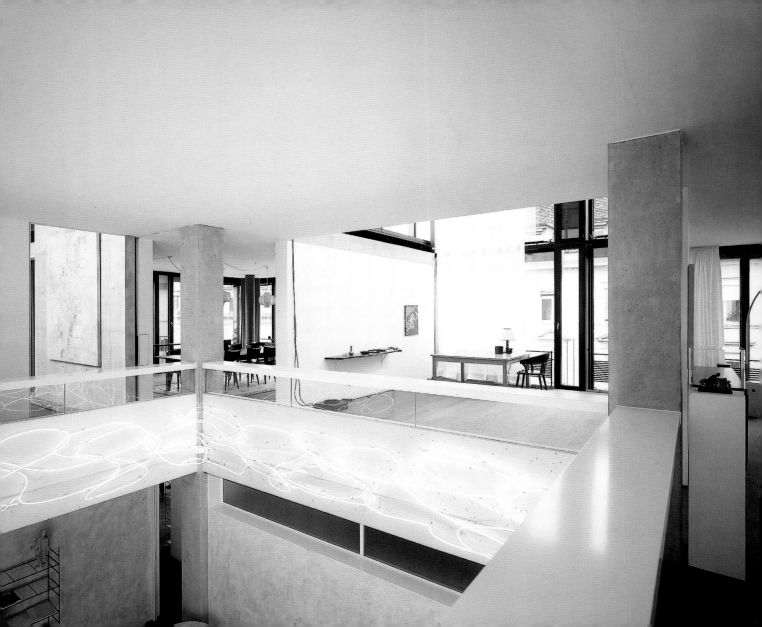

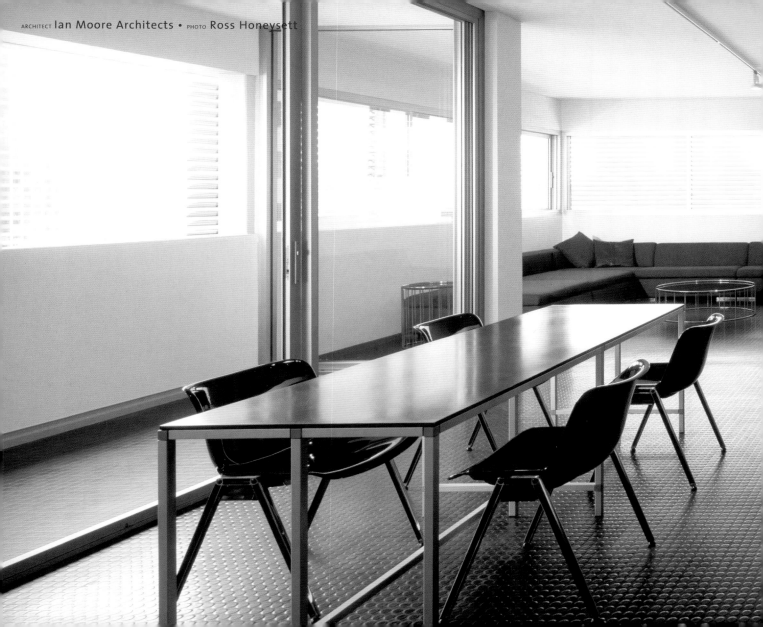

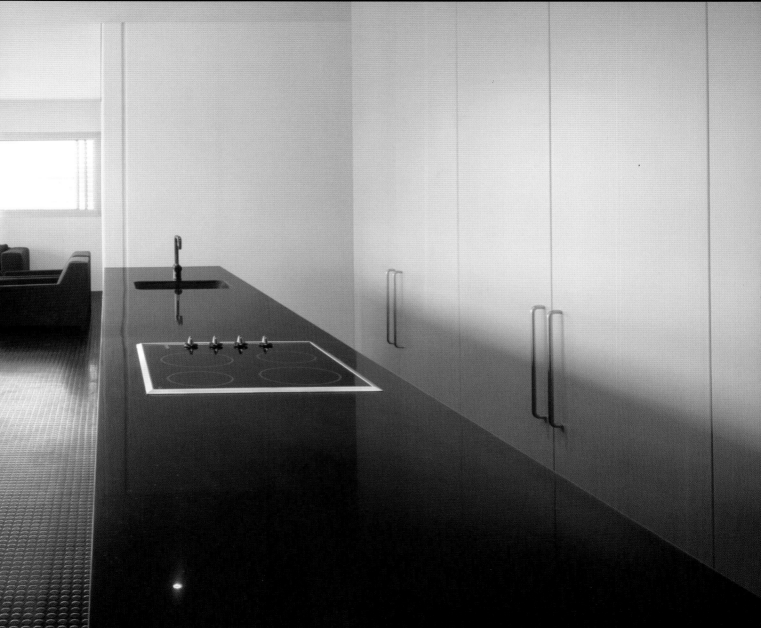

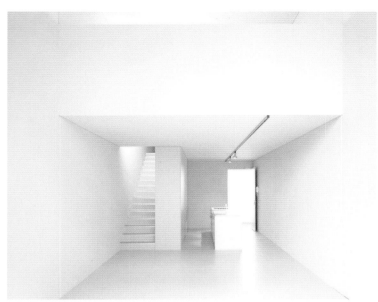
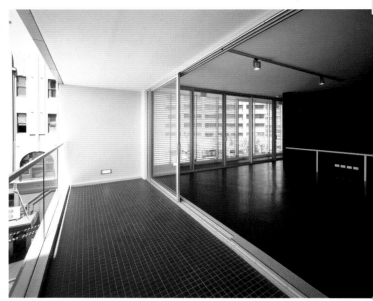
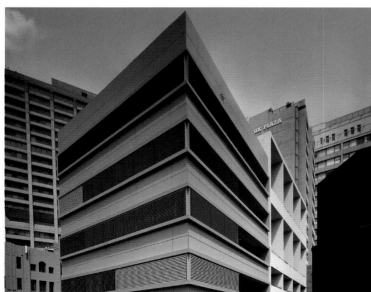
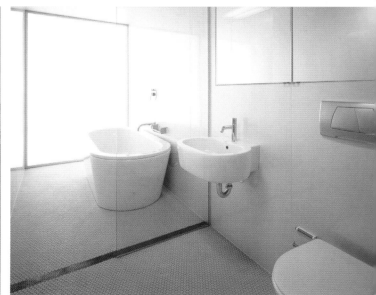

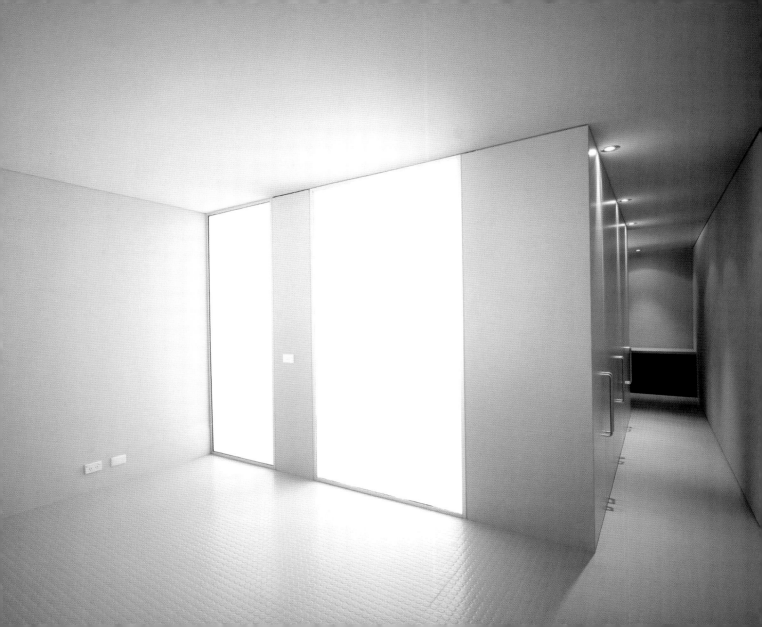

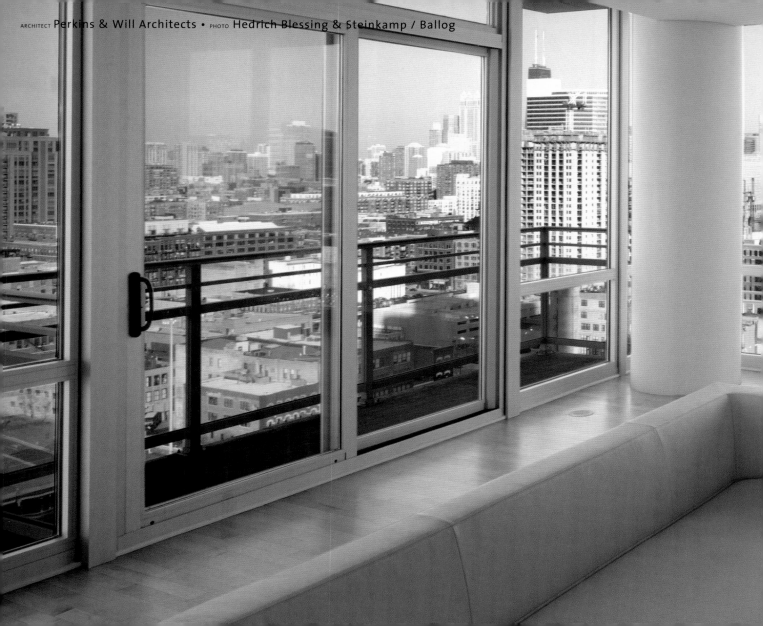

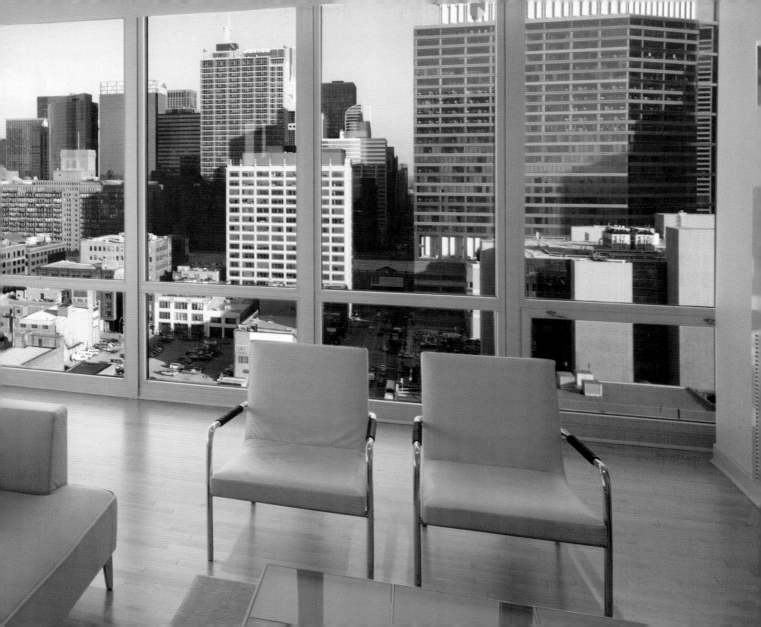

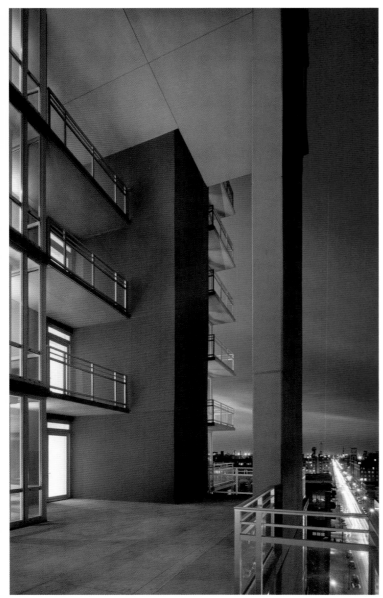
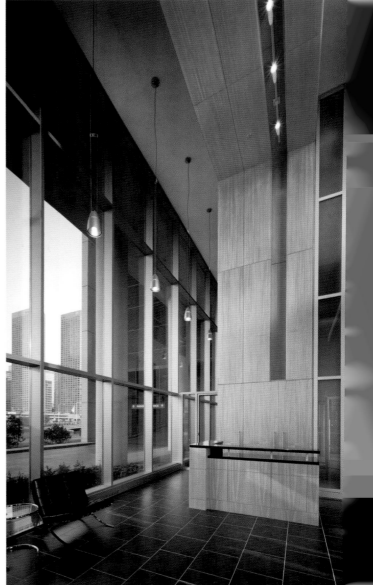

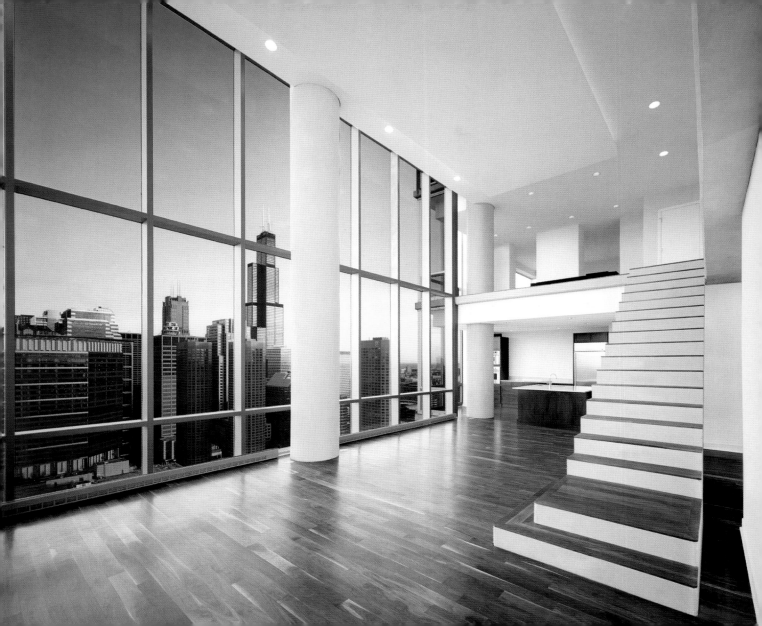

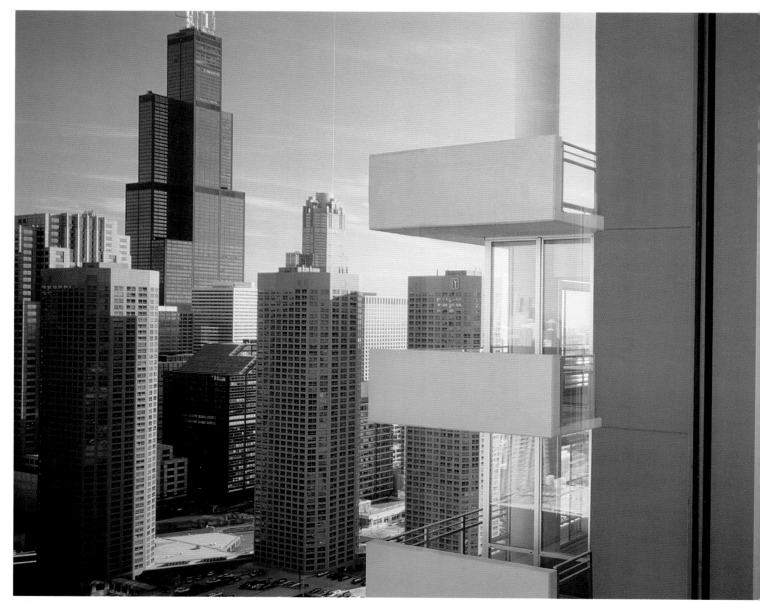

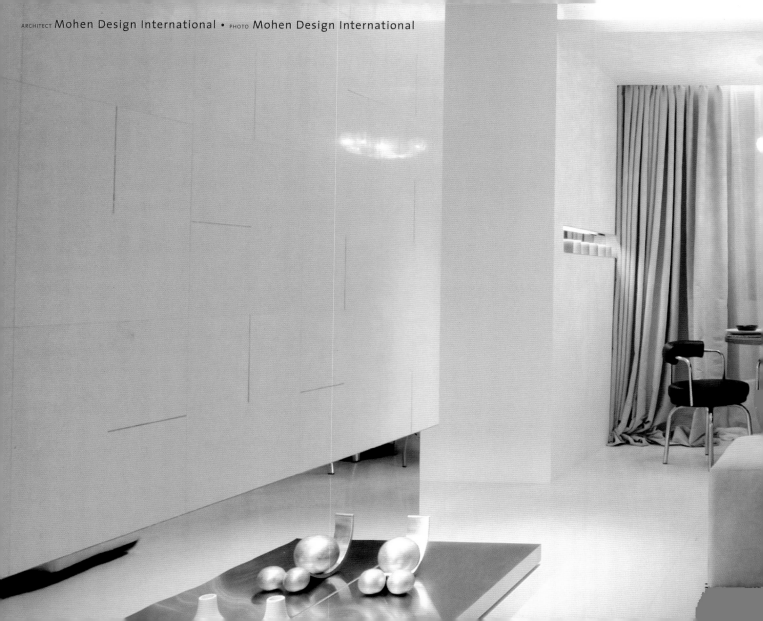

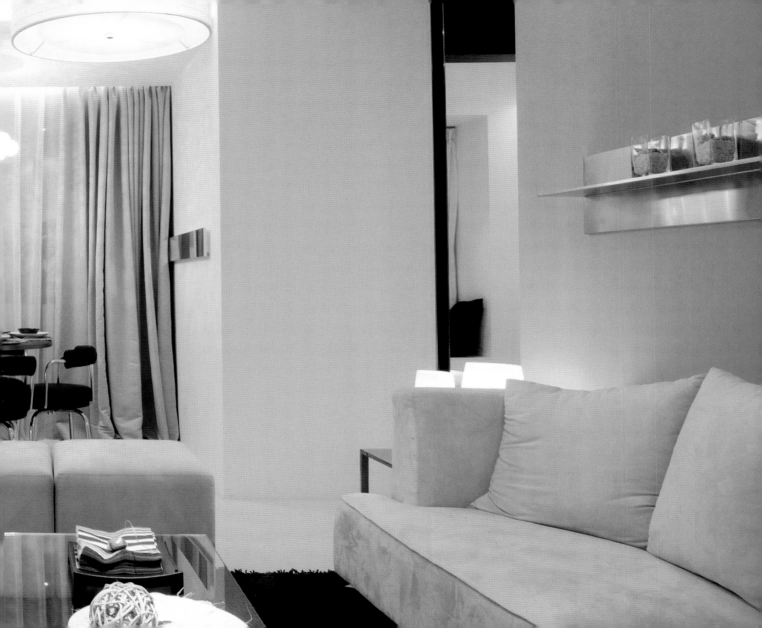

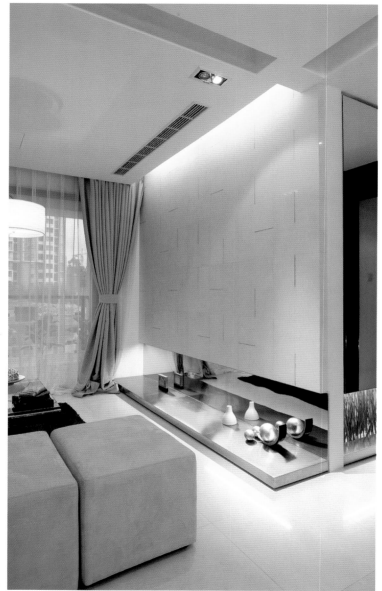
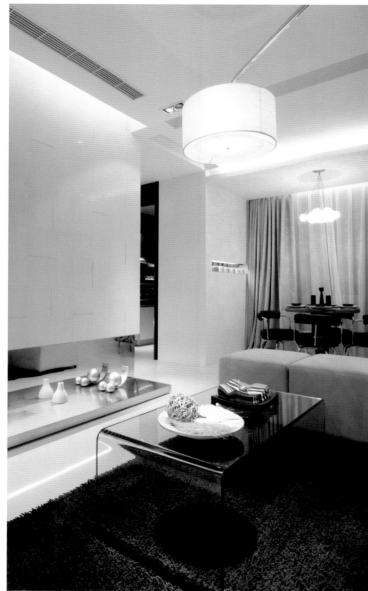

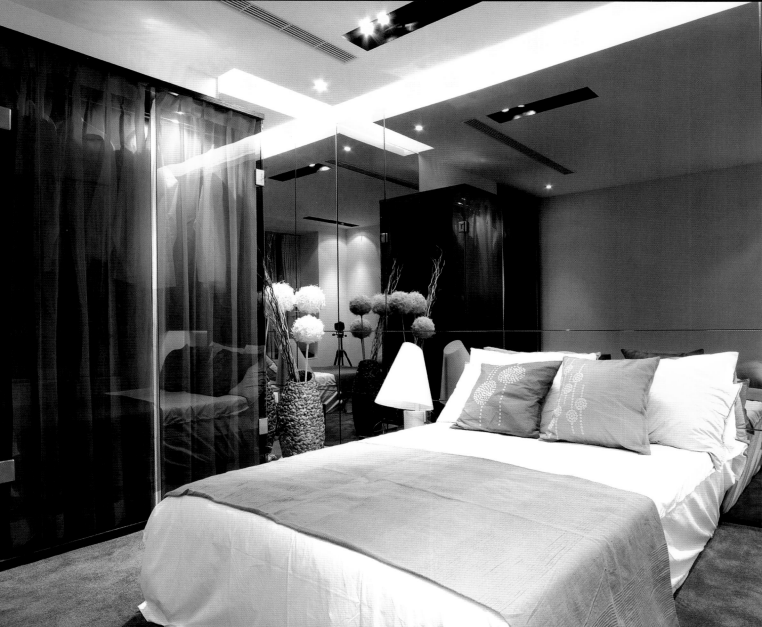

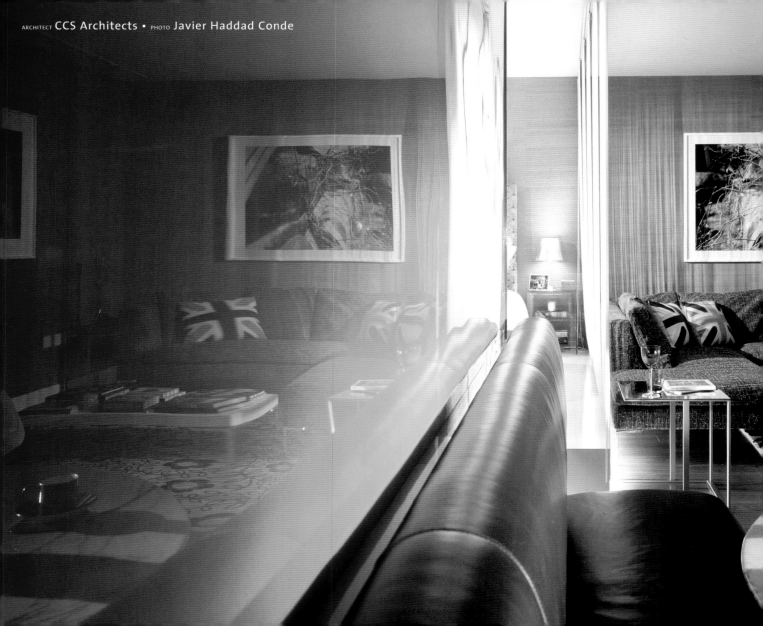

ARCHITECT **CCS Architects** • PHOTO **Javier Haddad Conde**

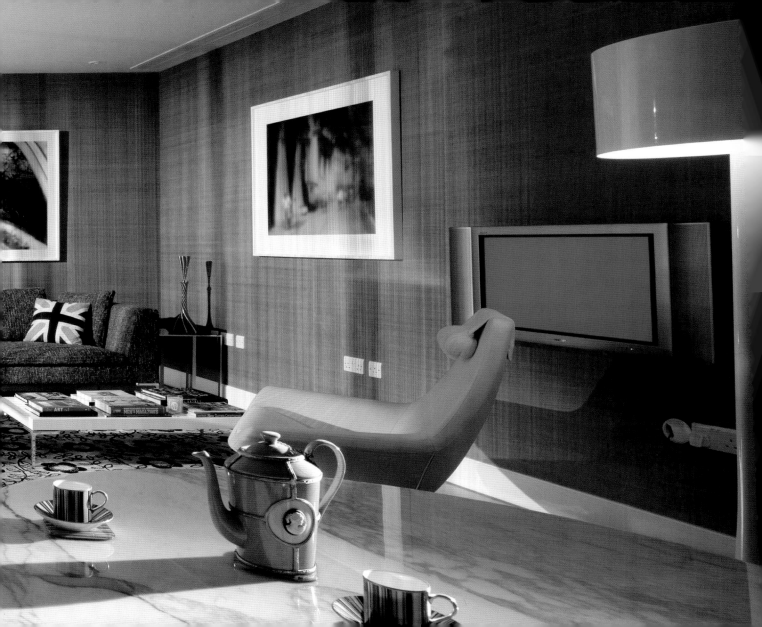

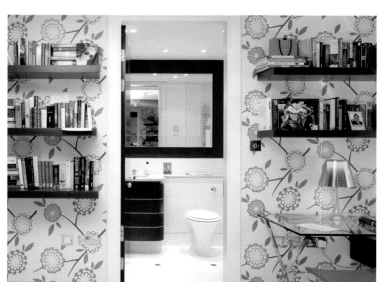
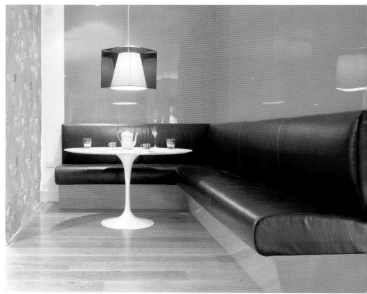
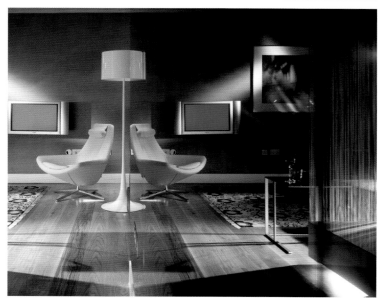
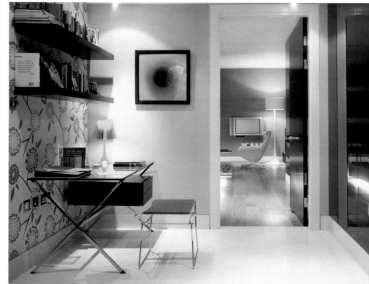

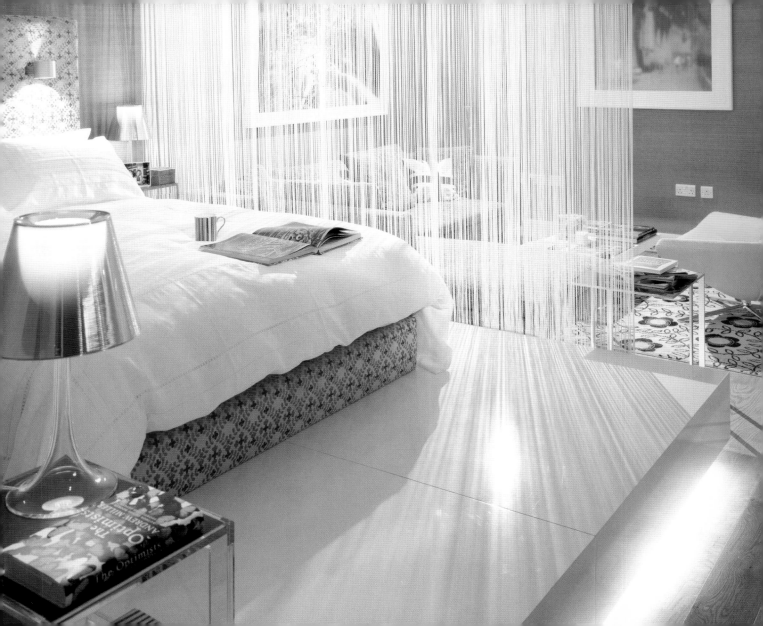

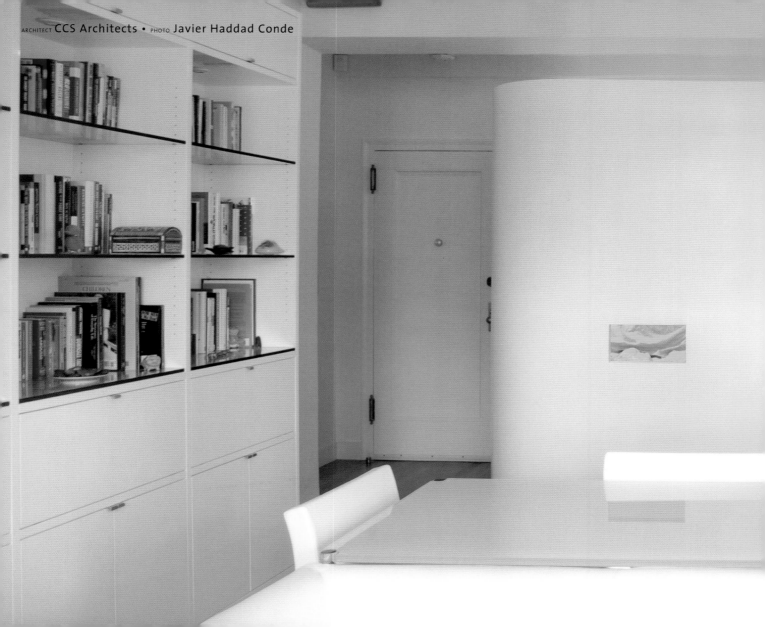

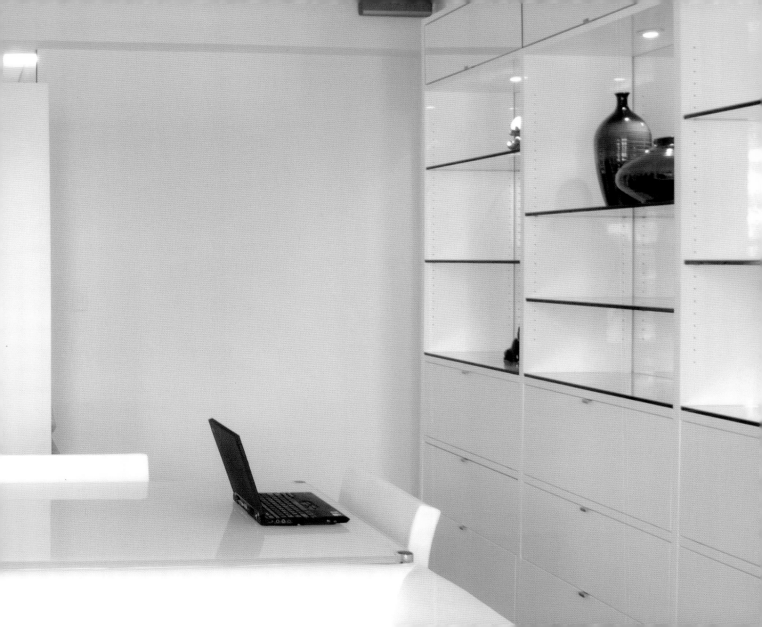

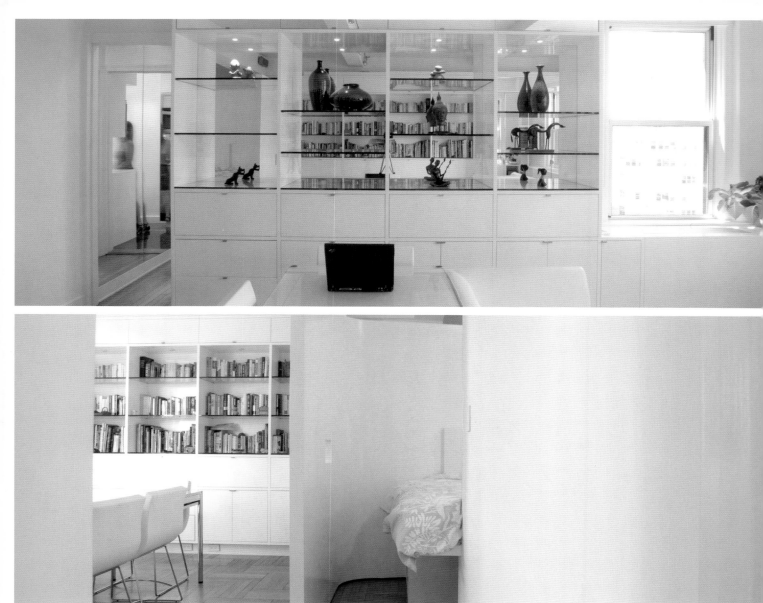

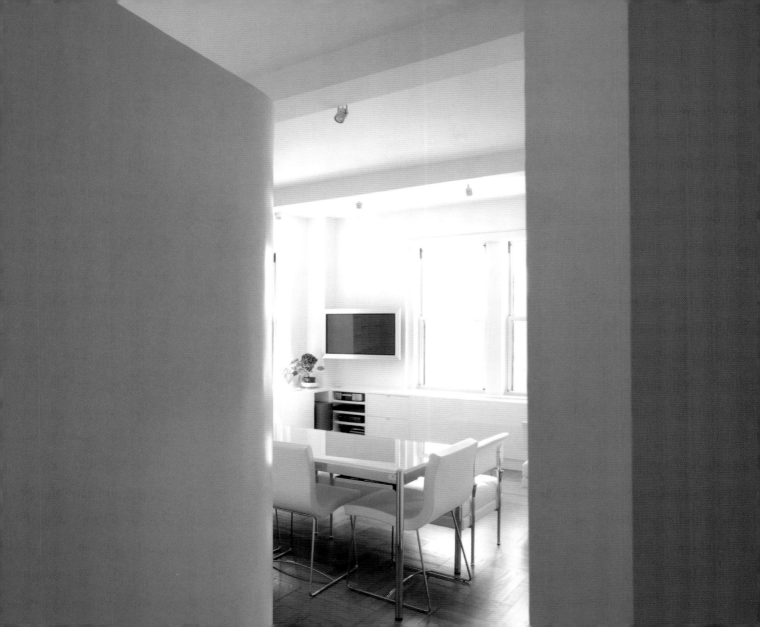

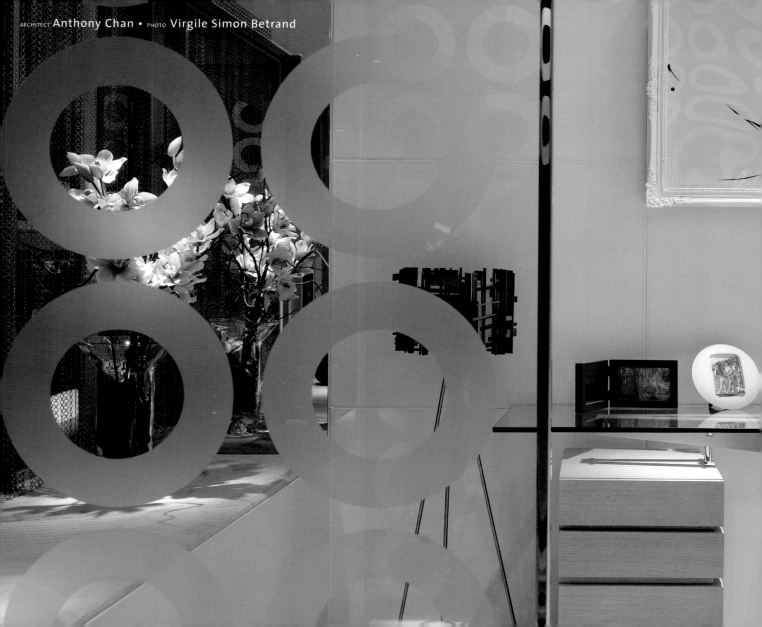

ARCHITECT Anthony Chan • PHOTO Virgile Simon Betrand

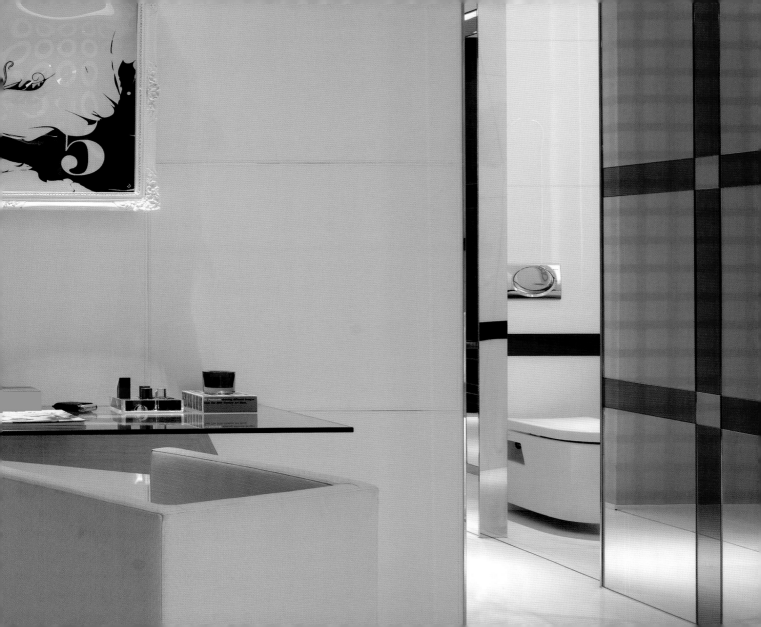

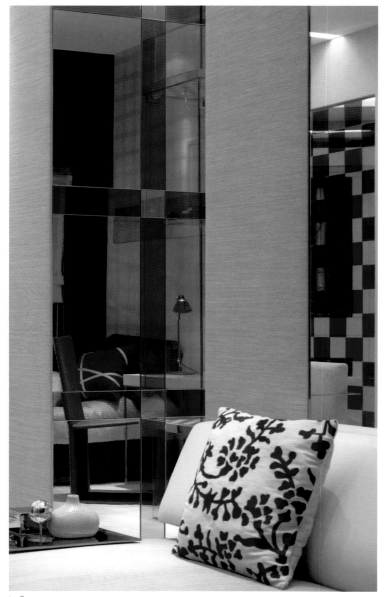
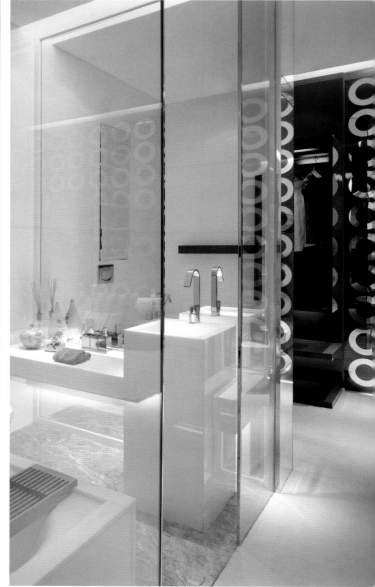

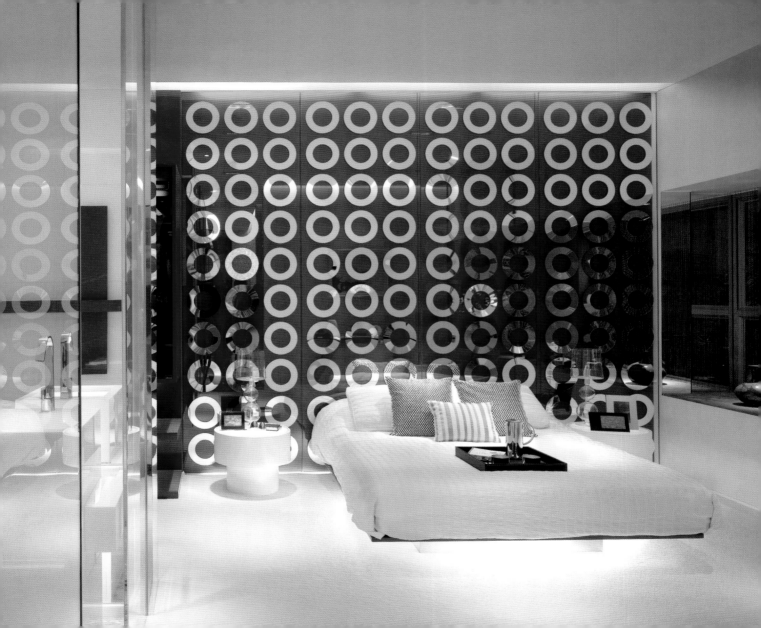

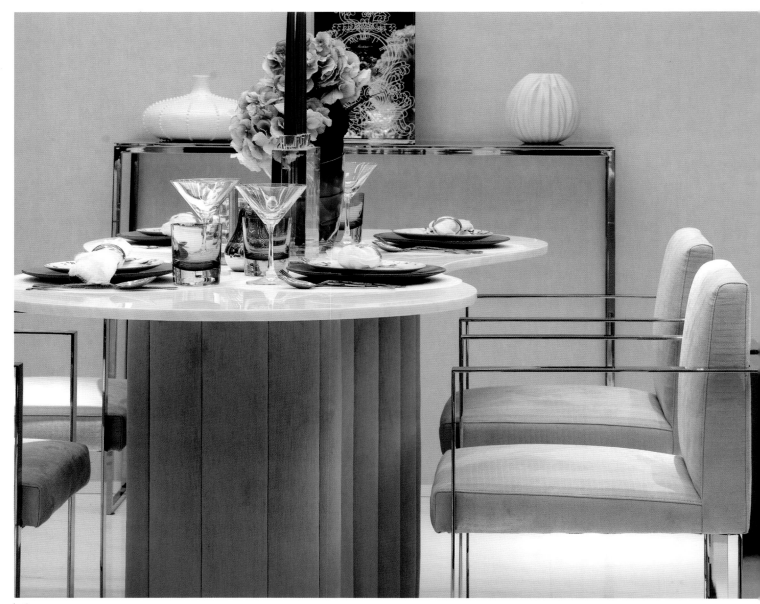

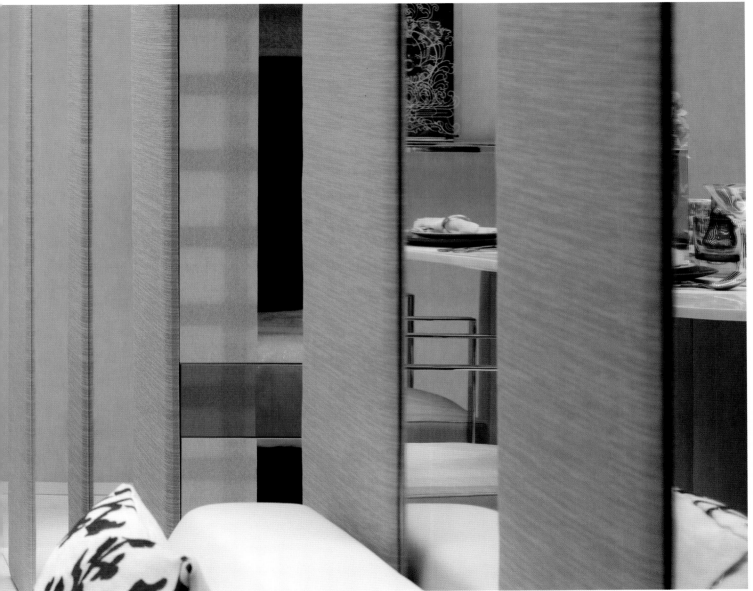

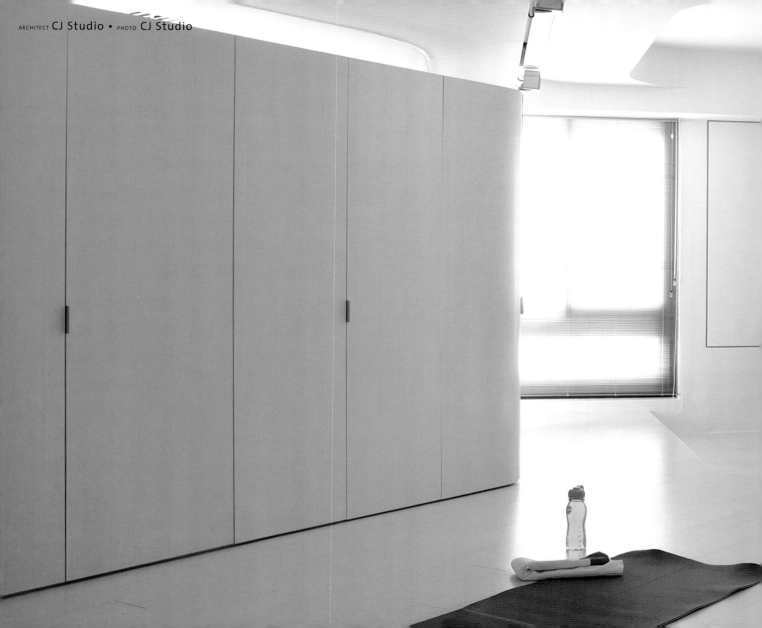

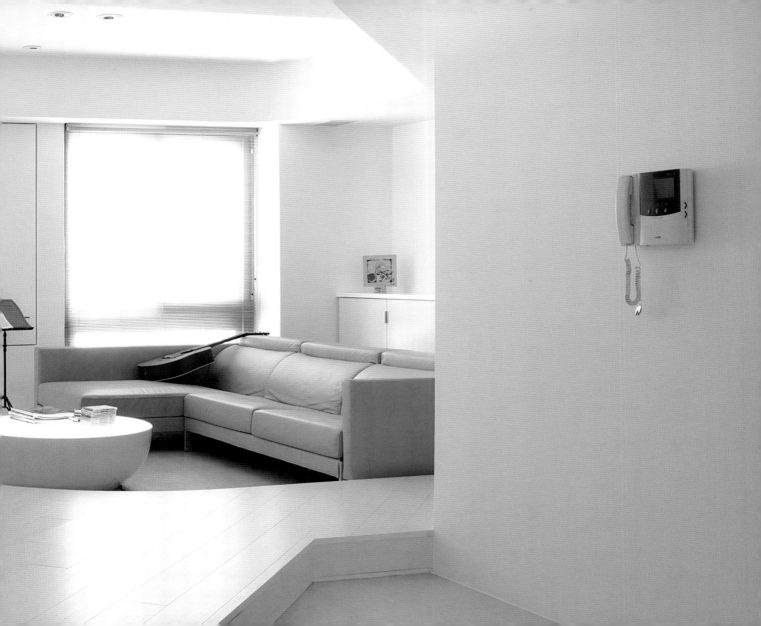

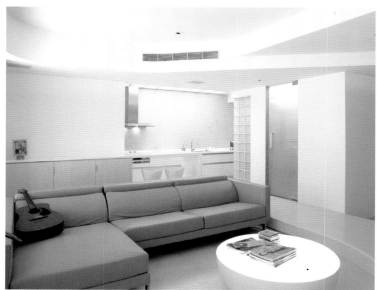
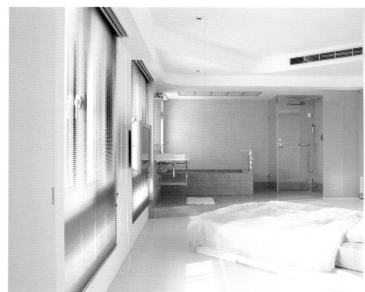
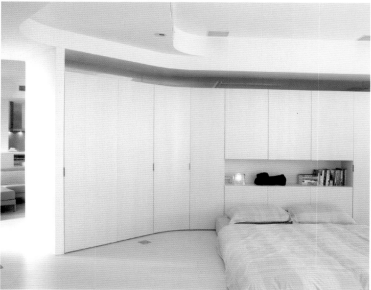
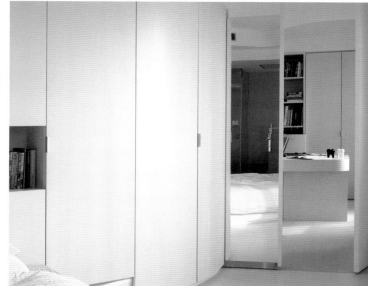

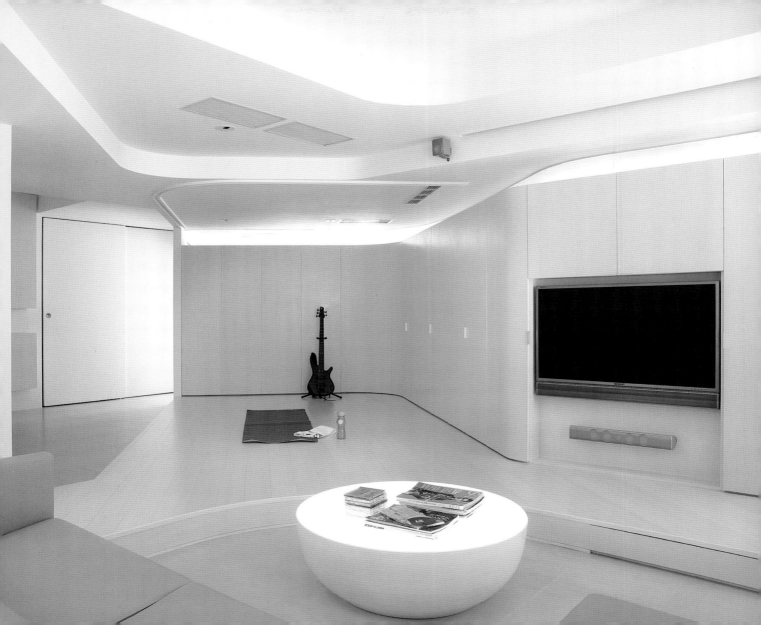

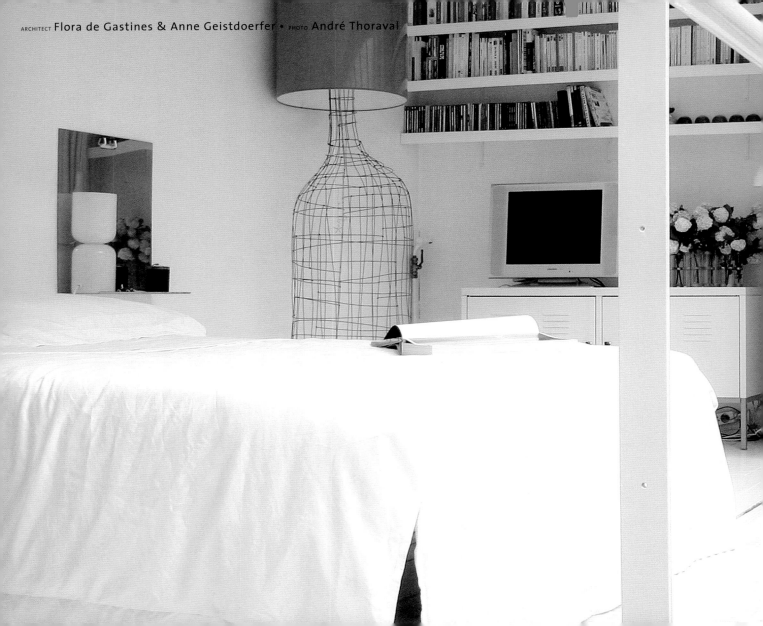

ARCHITECT **Flora de Gastines & Anne Geistdoerfer** • PHOTO **André Thoraval**

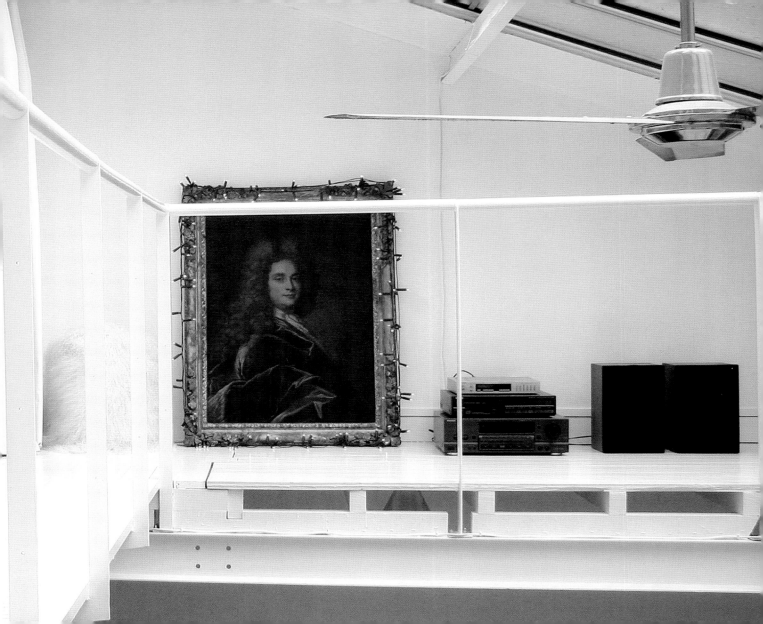

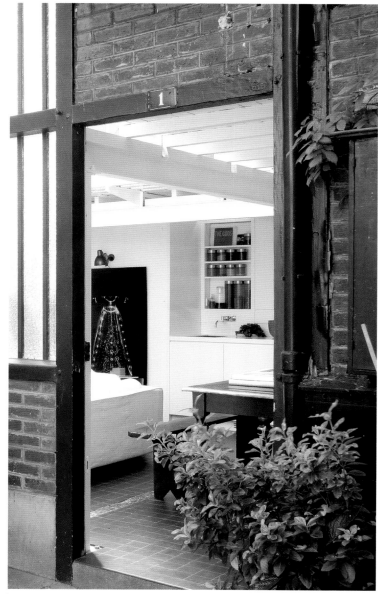
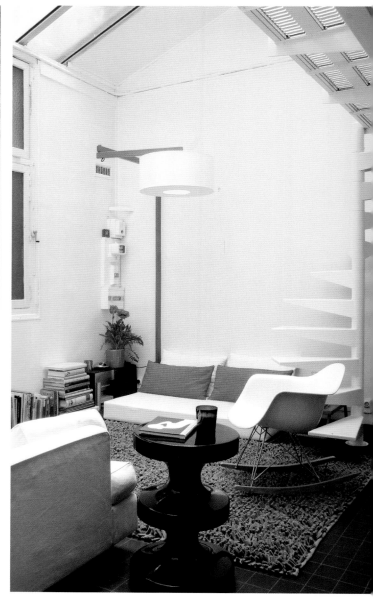

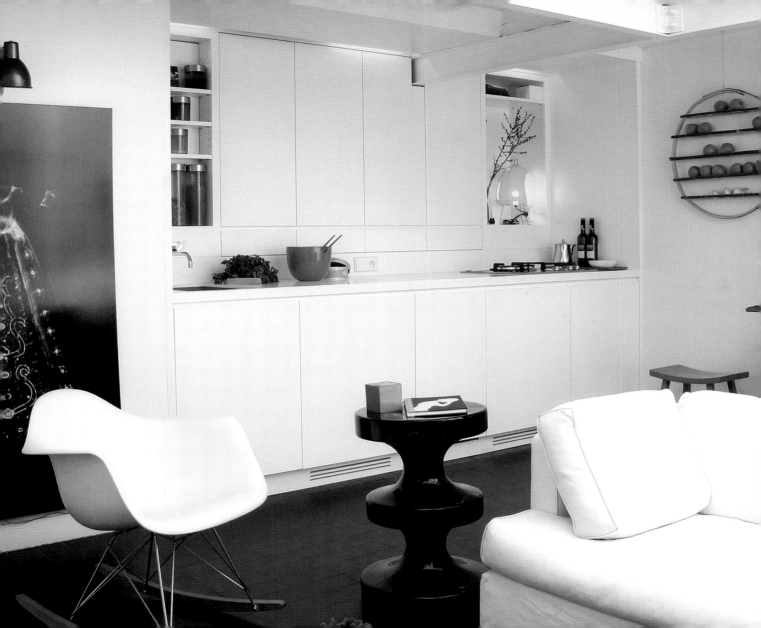

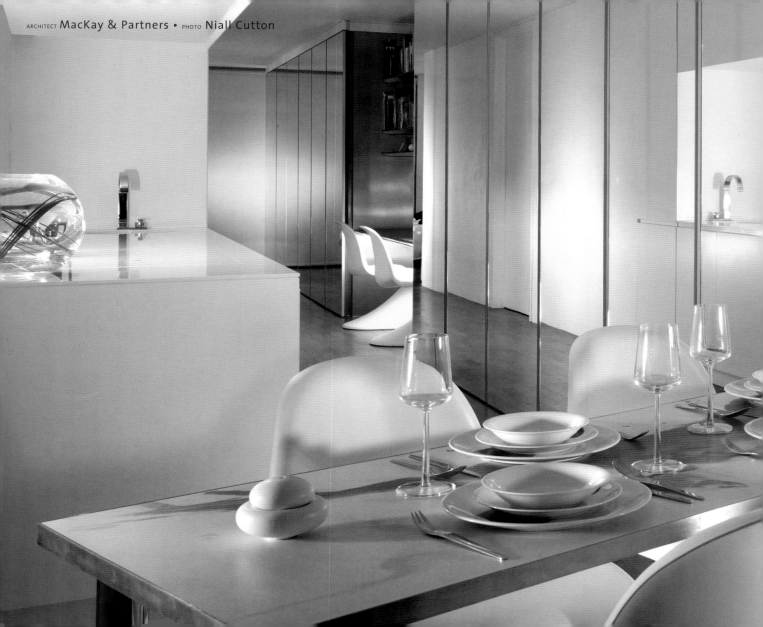

ARCHITECT MacKay & Partners • PHOTO Niall Cutton

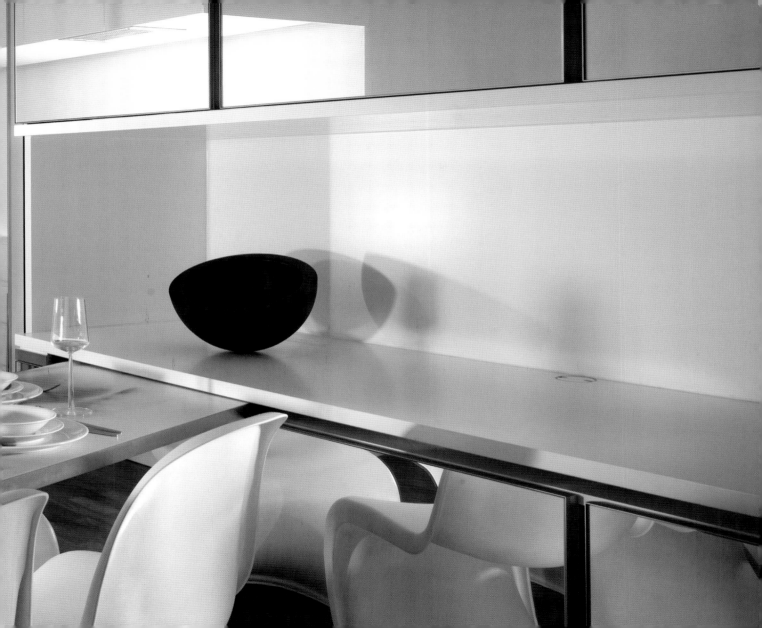

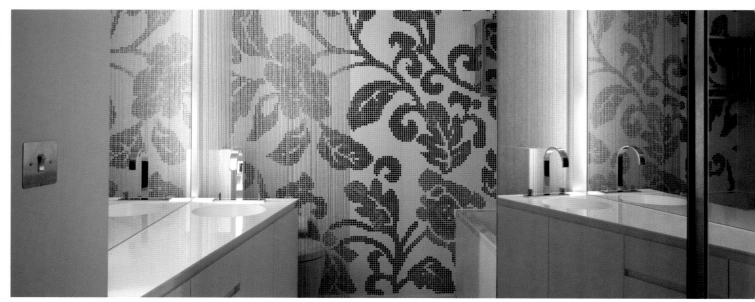

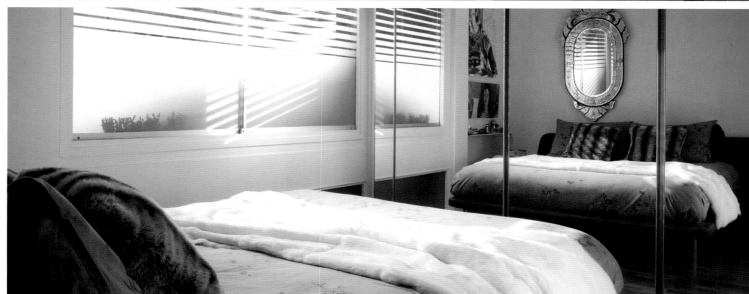

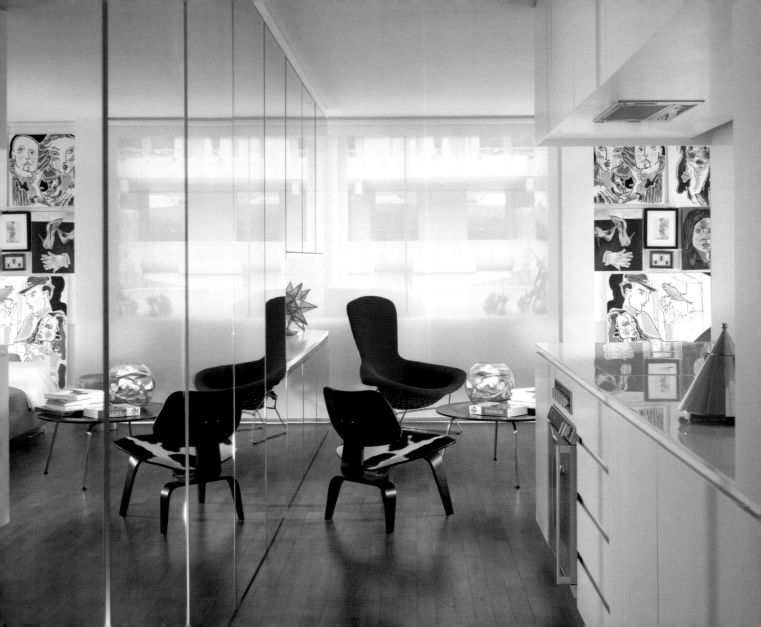

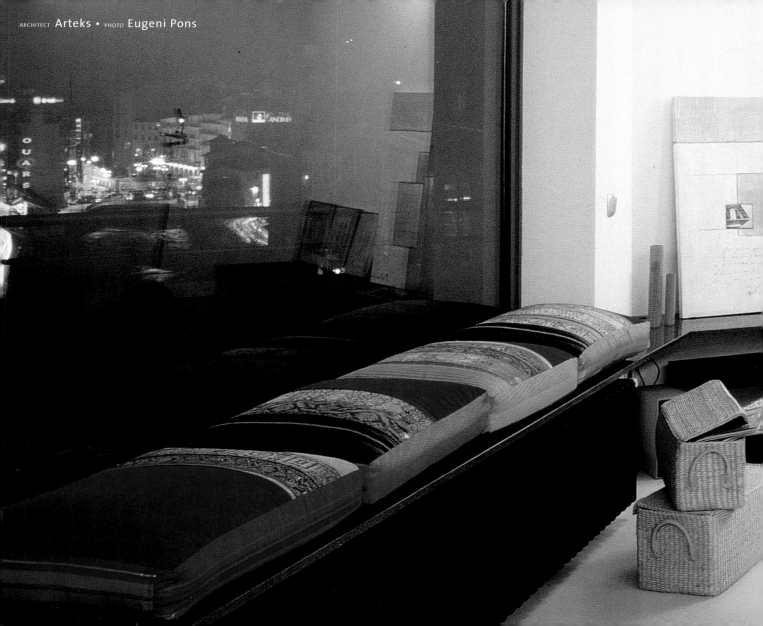

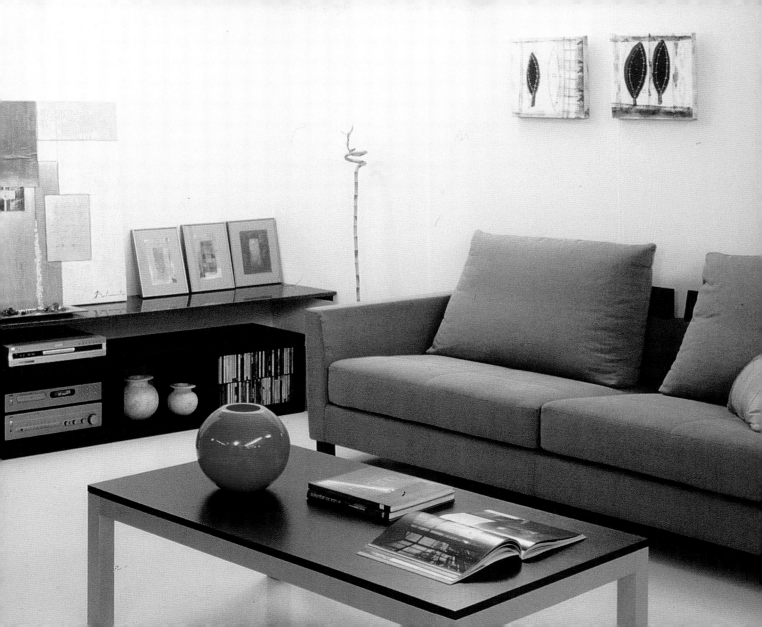

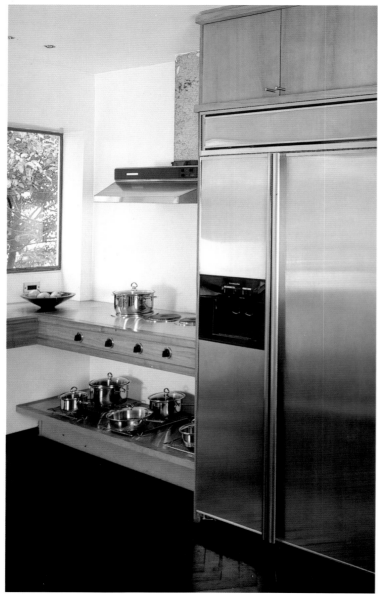
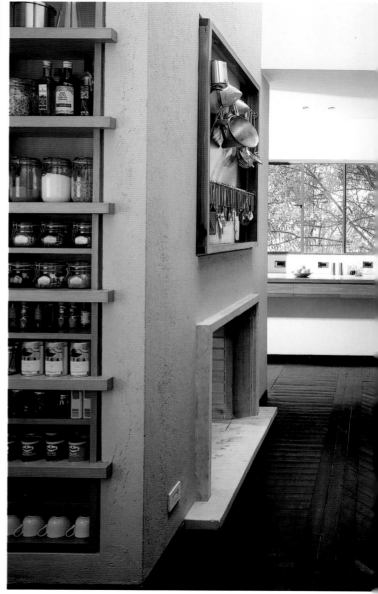

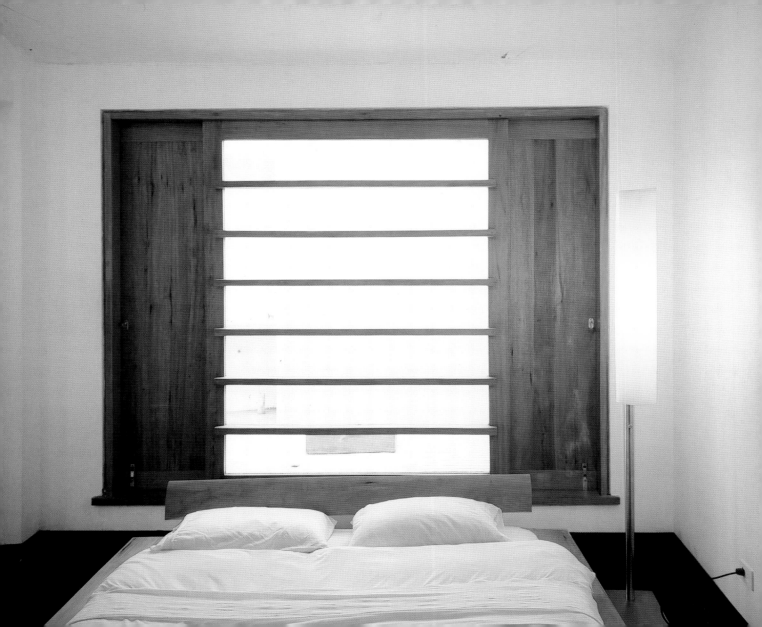

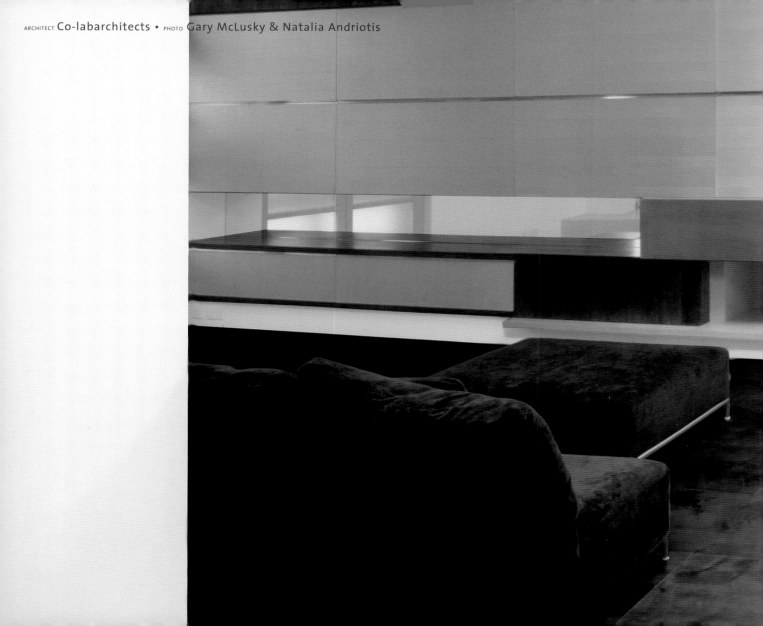

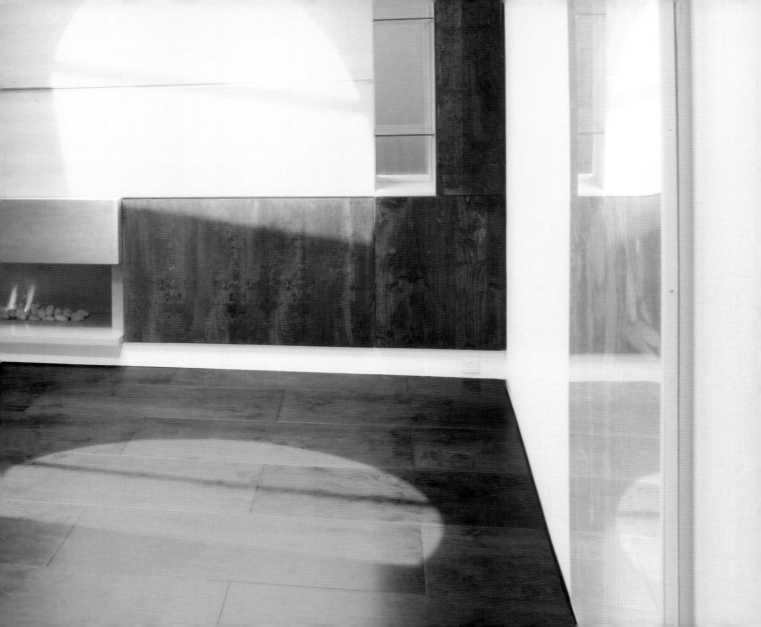

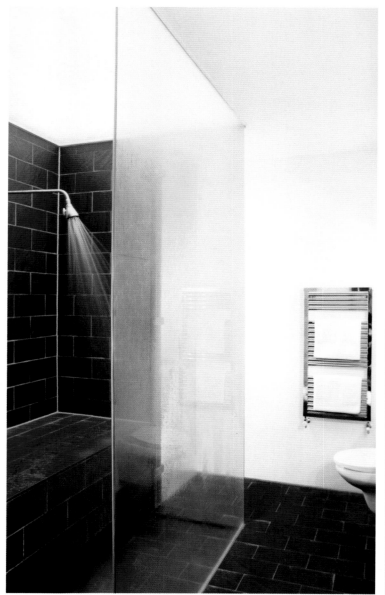
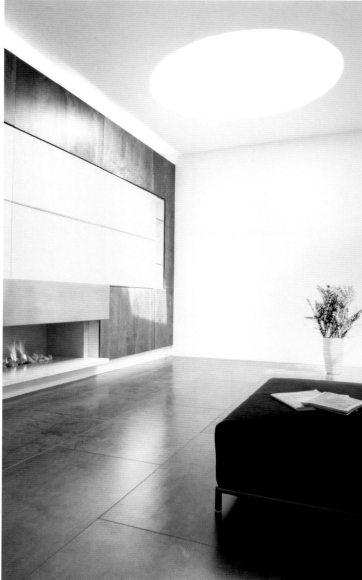

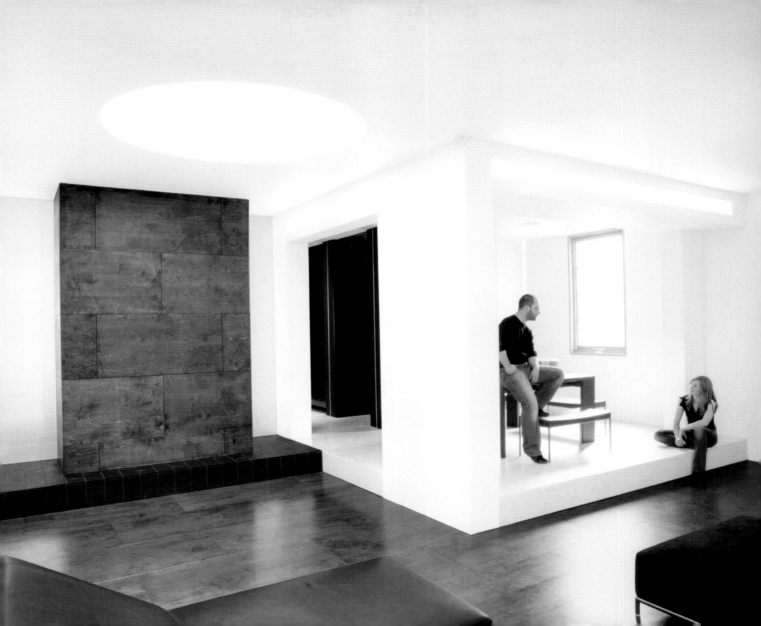

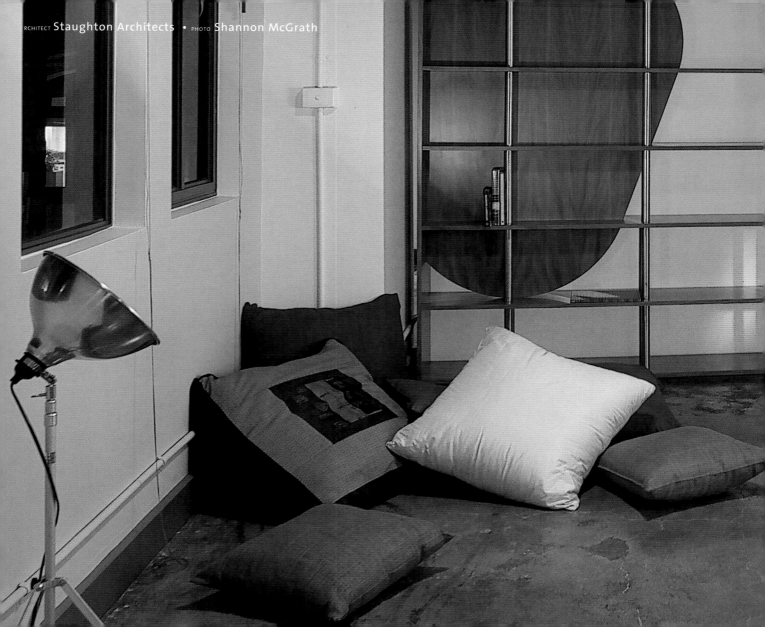

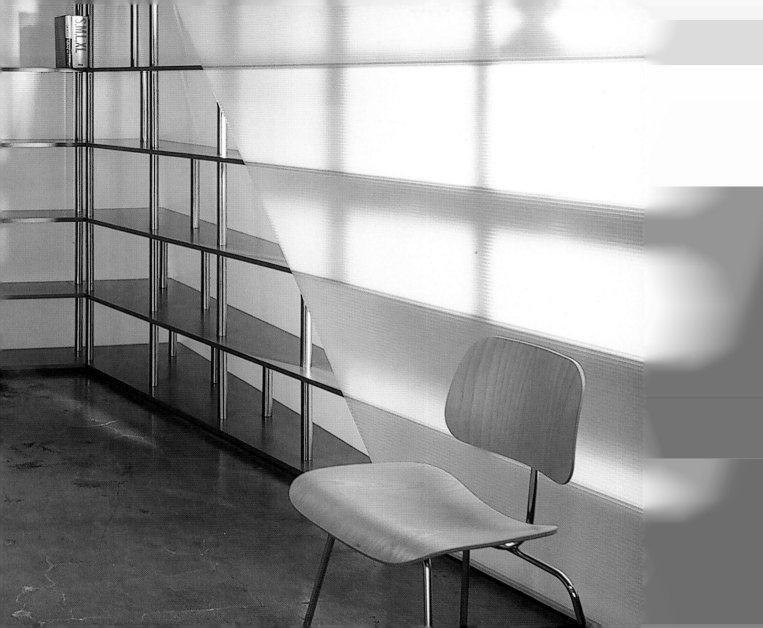

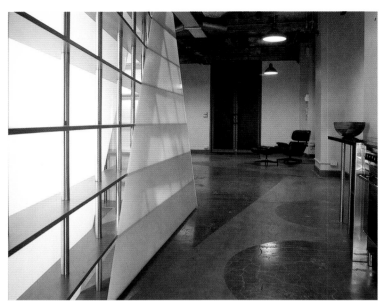

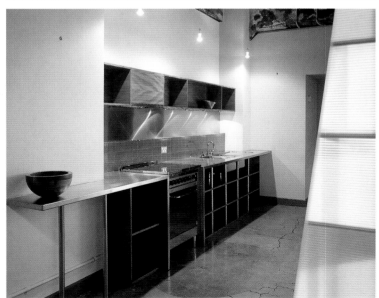
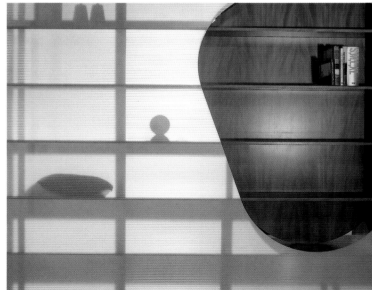

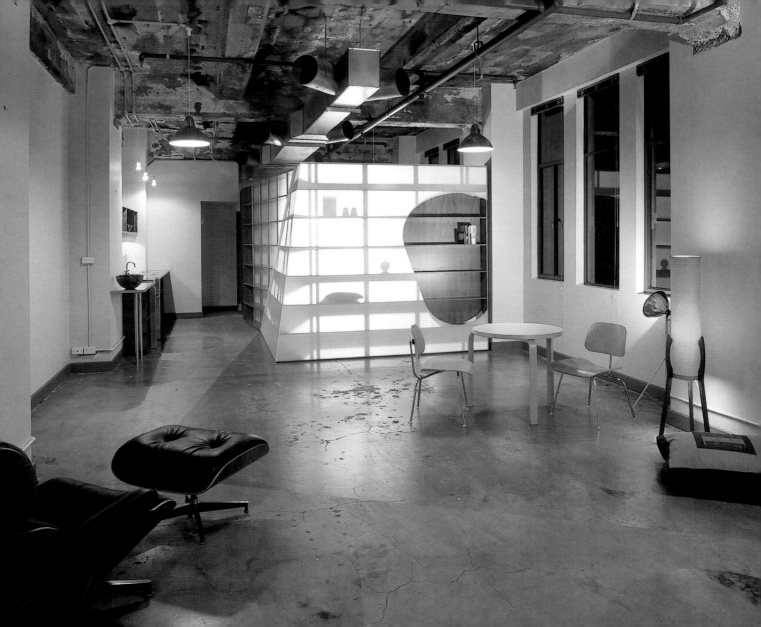

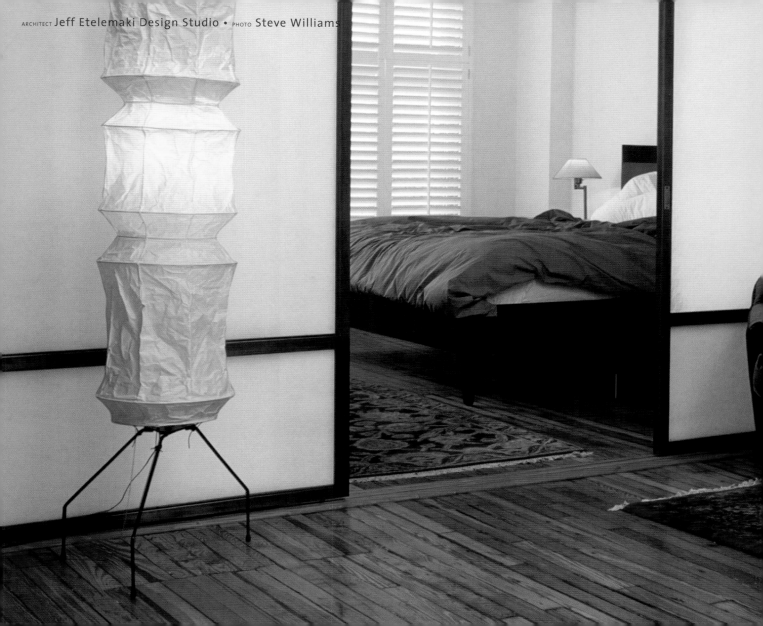

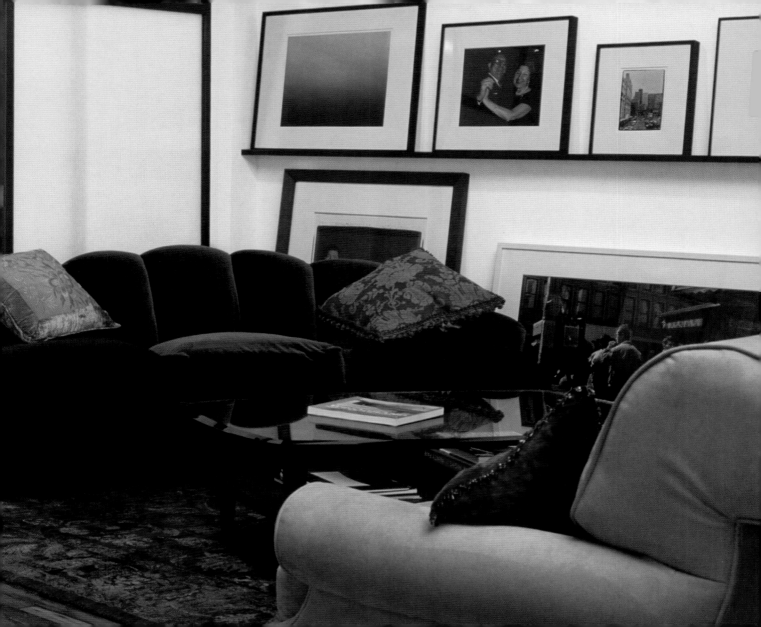

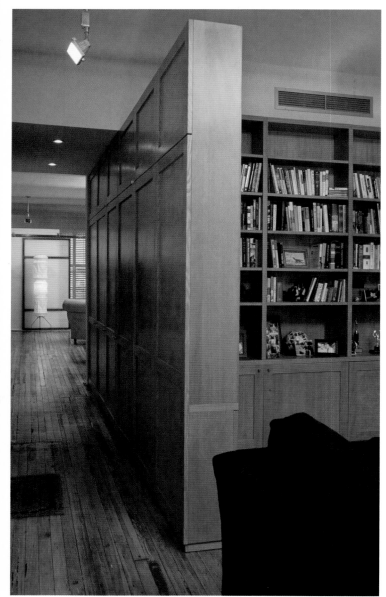
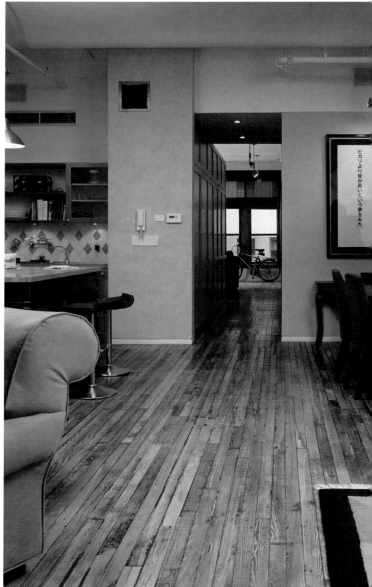

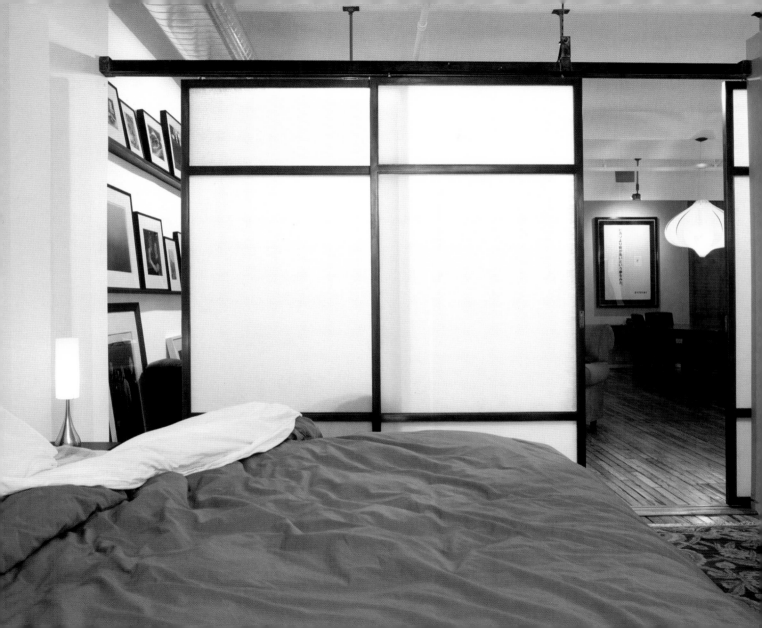

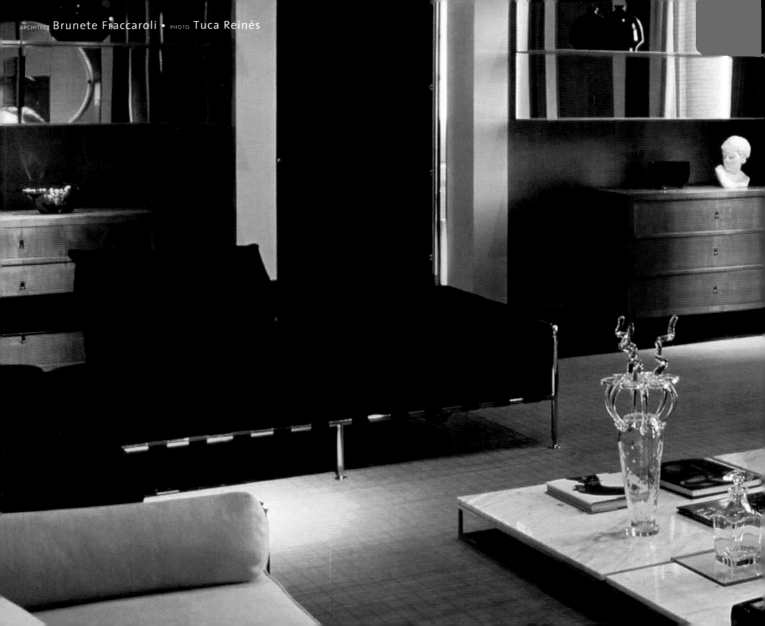

ARCHITECT Brunete Fraccaroli • PHOTO Tuca Reinés

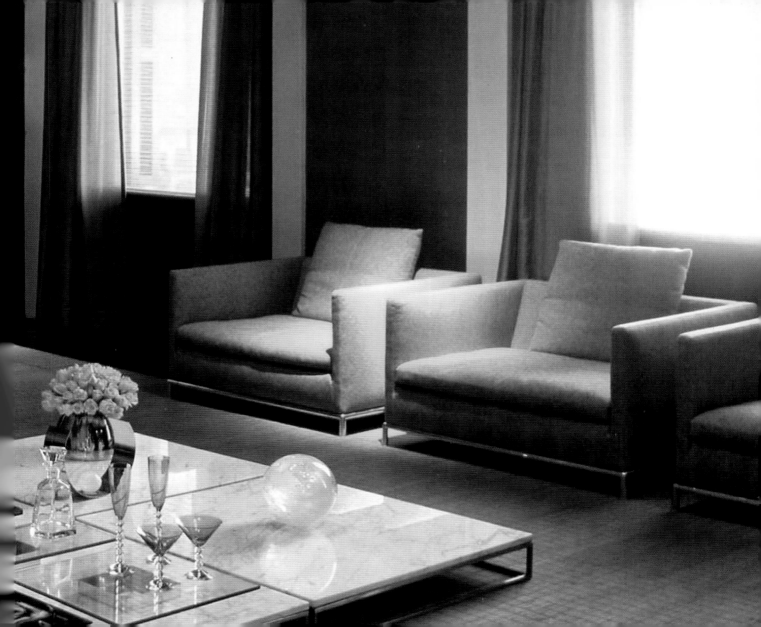

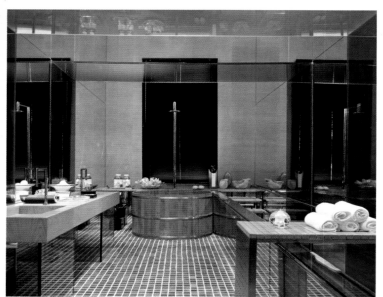
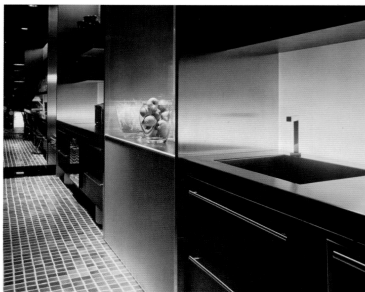
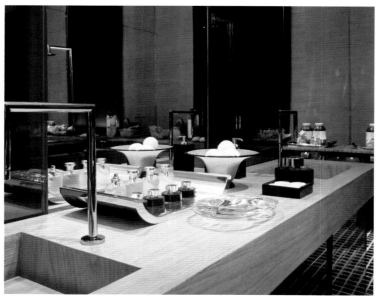
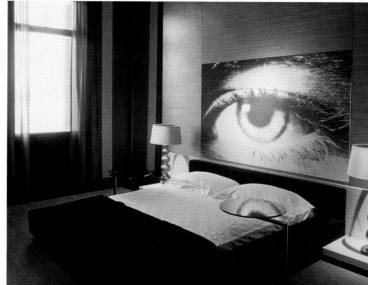

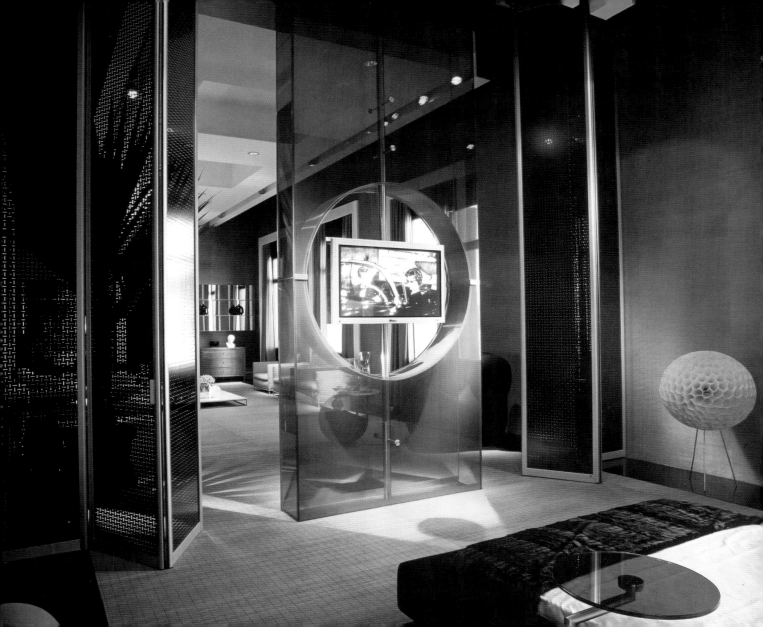

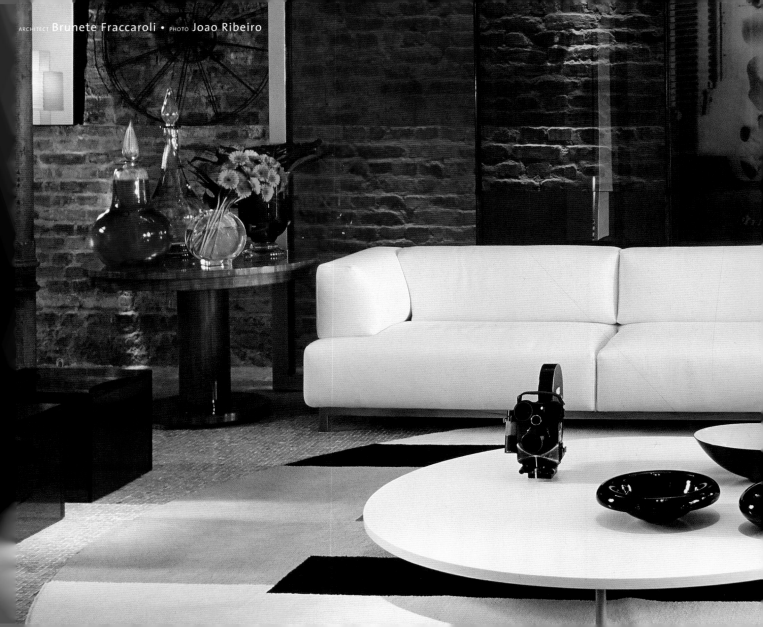

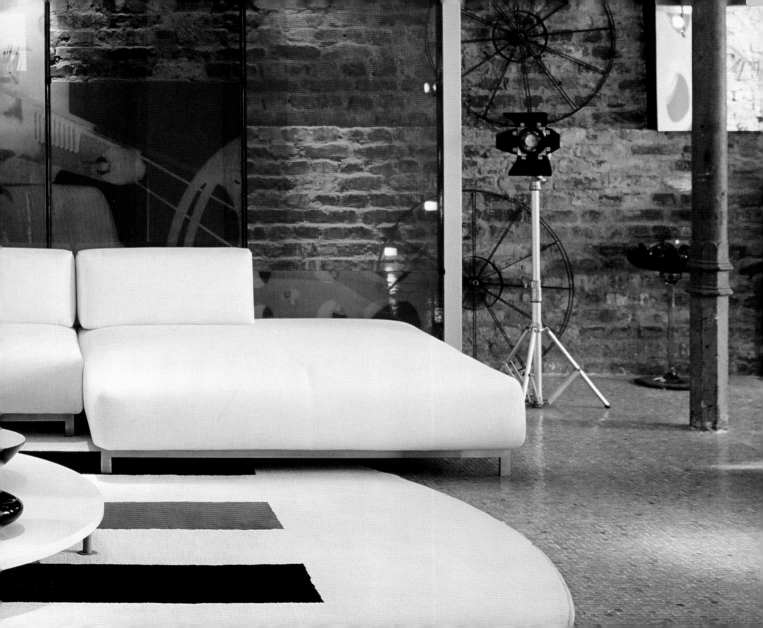

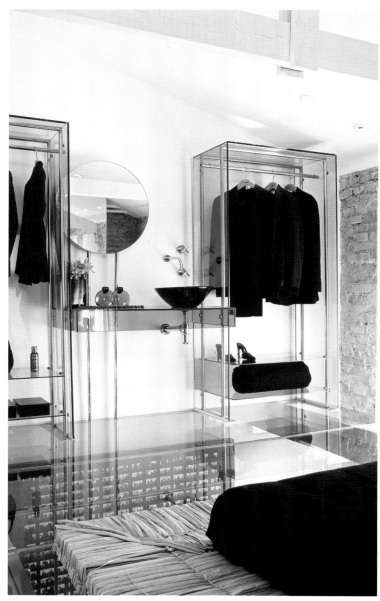
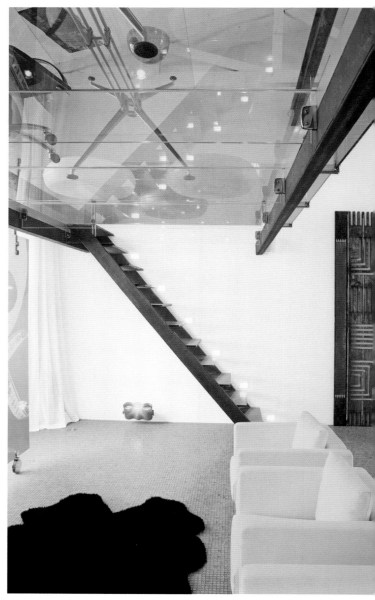

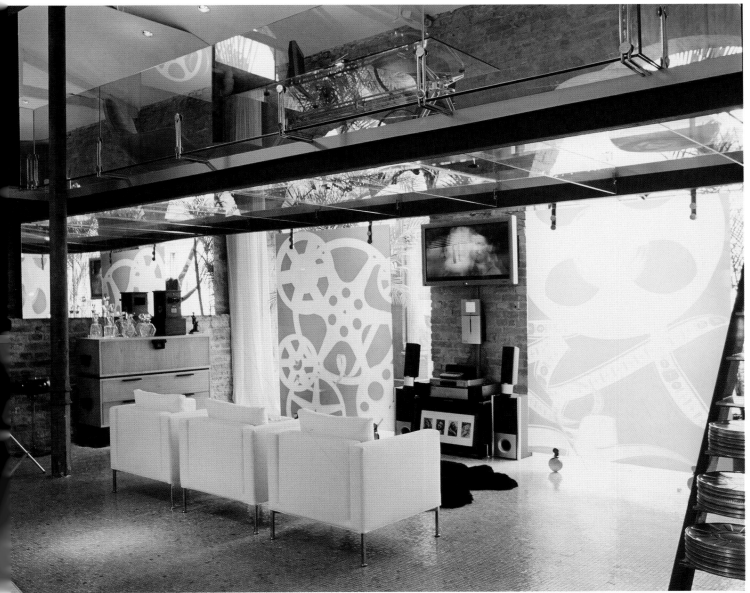

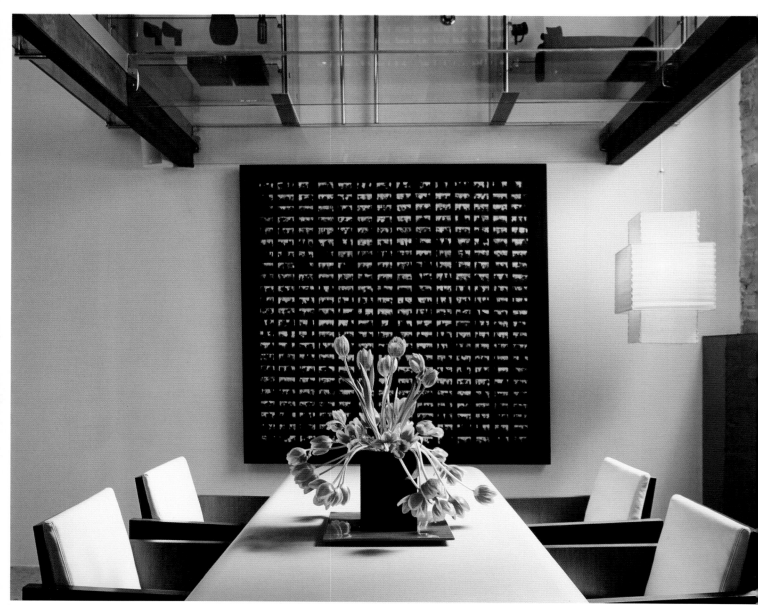

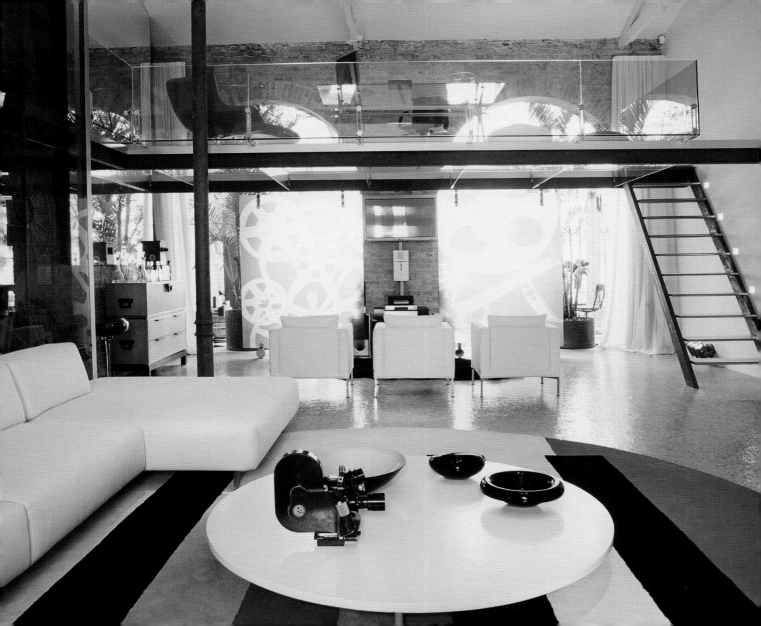

ARCHITECT Avi Laiser & Amir Scharz • PHOTO Miri Davidovitch

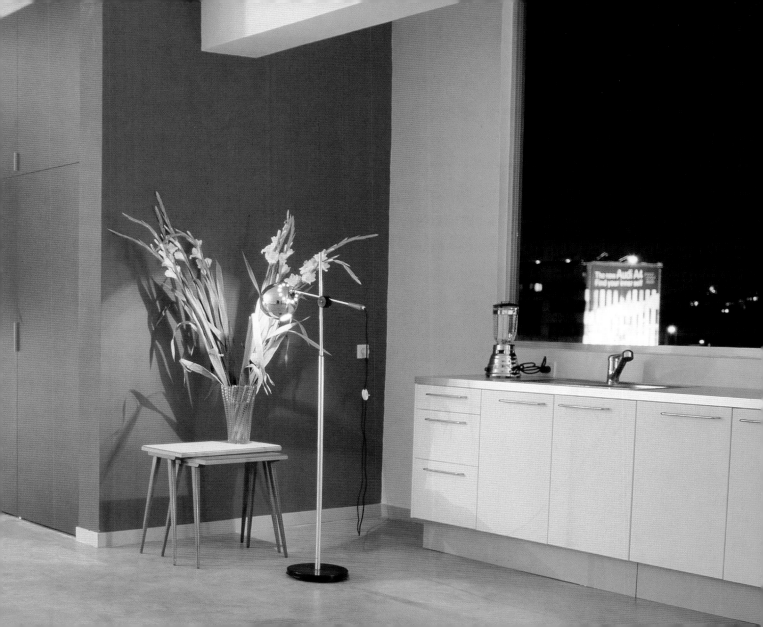

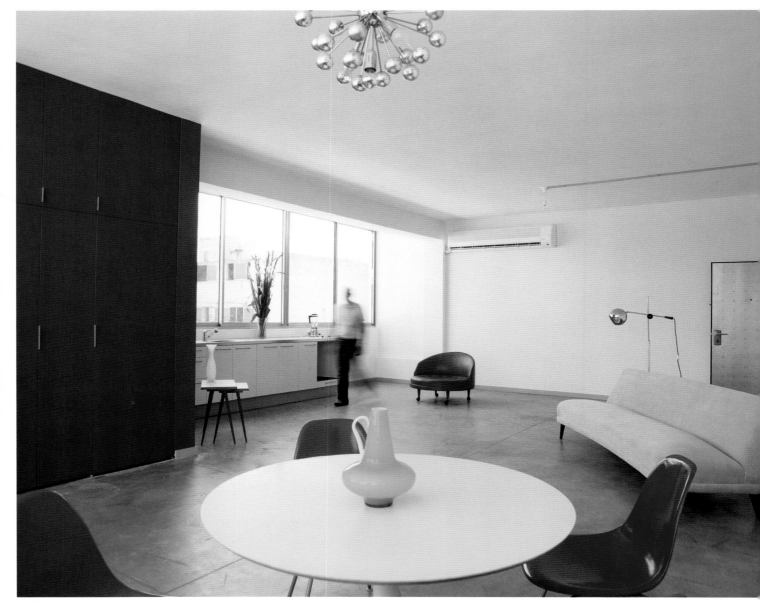

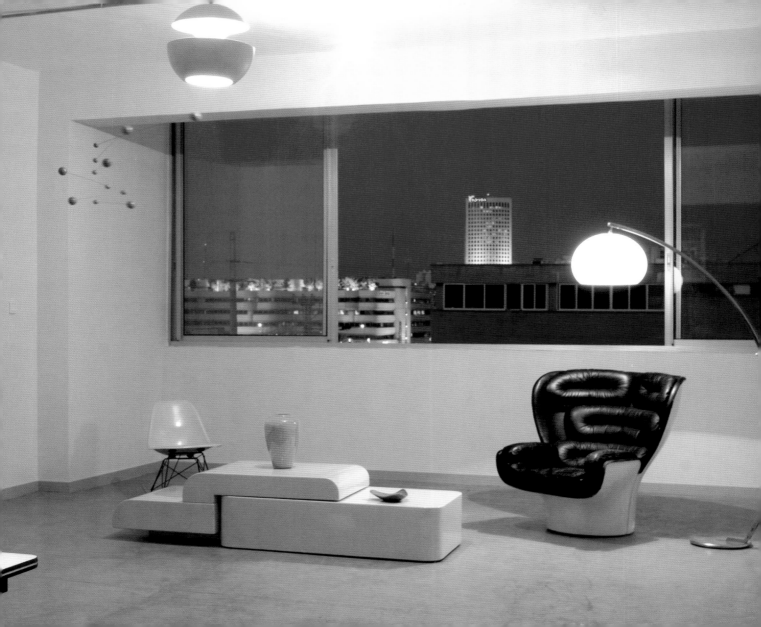

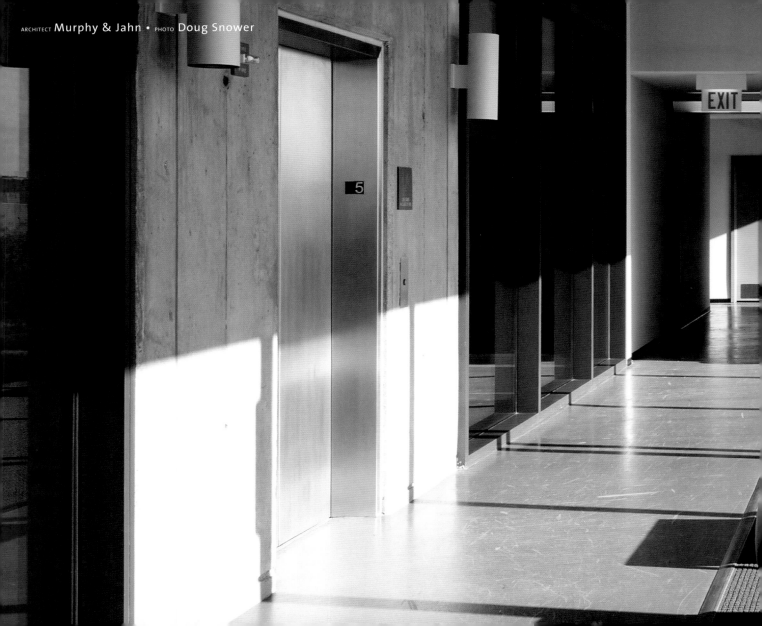

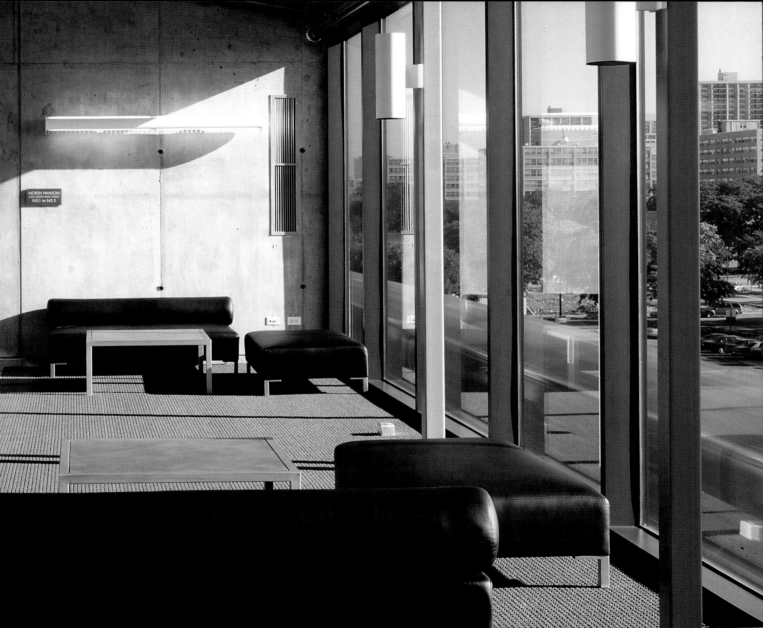

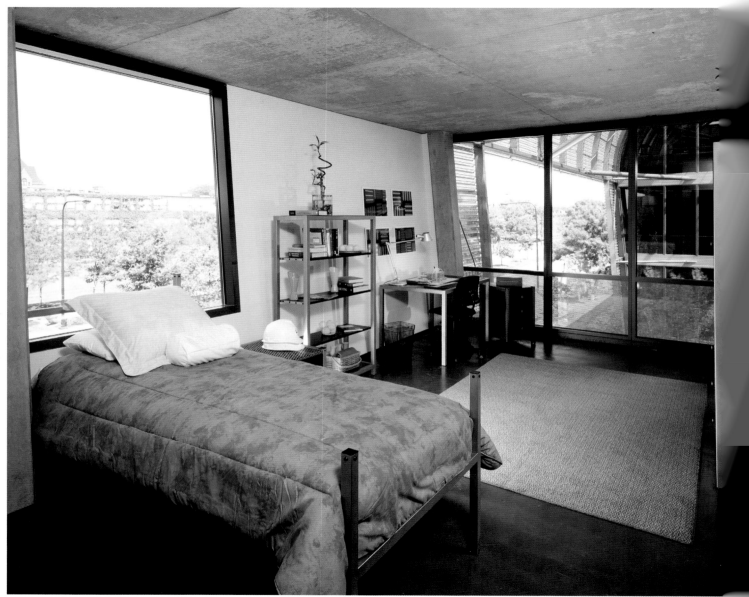

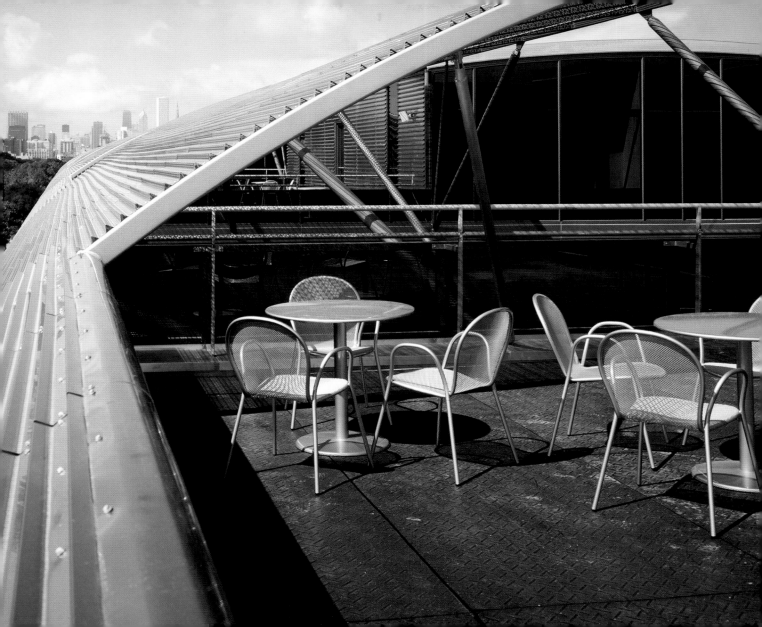

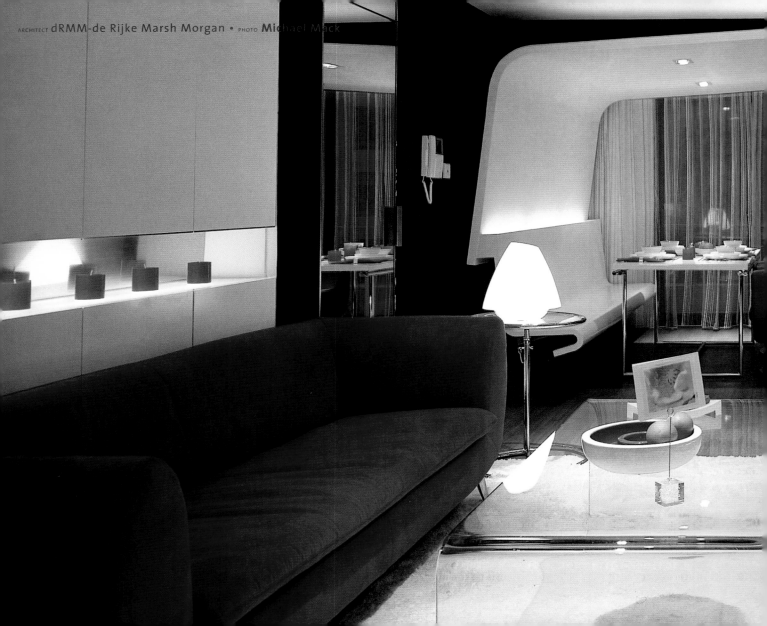

ARCHITECT dRMM-de Rijke Marsh Morgan • PHOTO Michael Mack

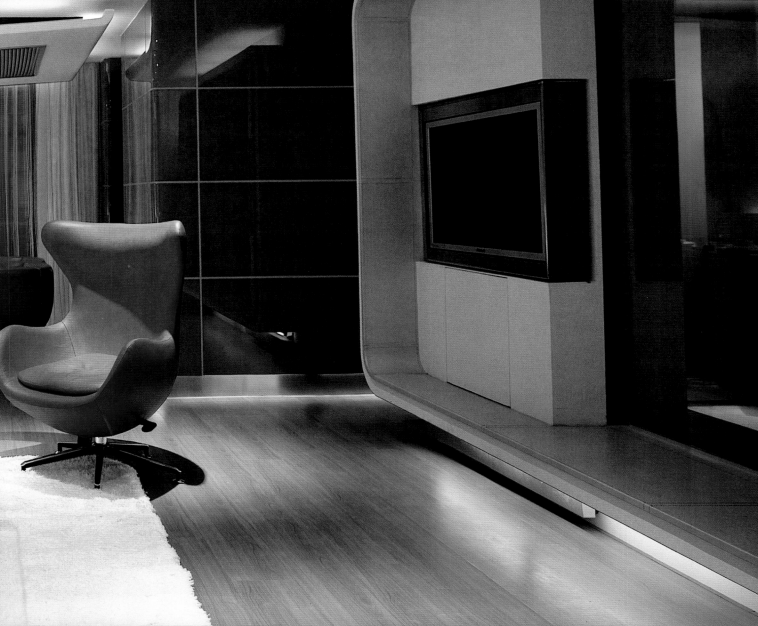

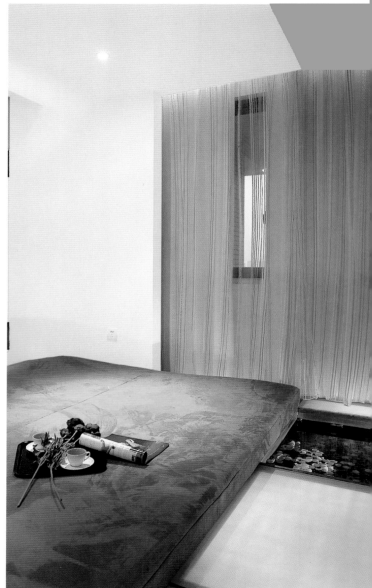

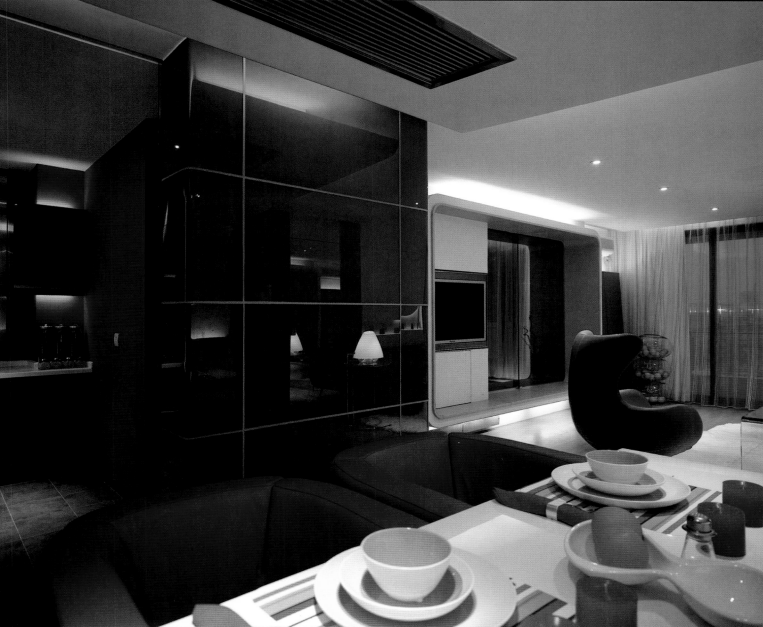

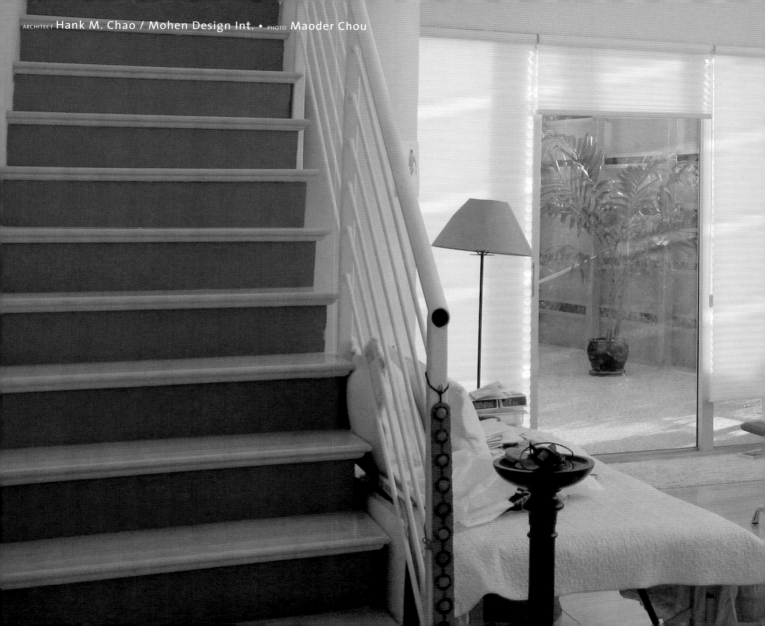

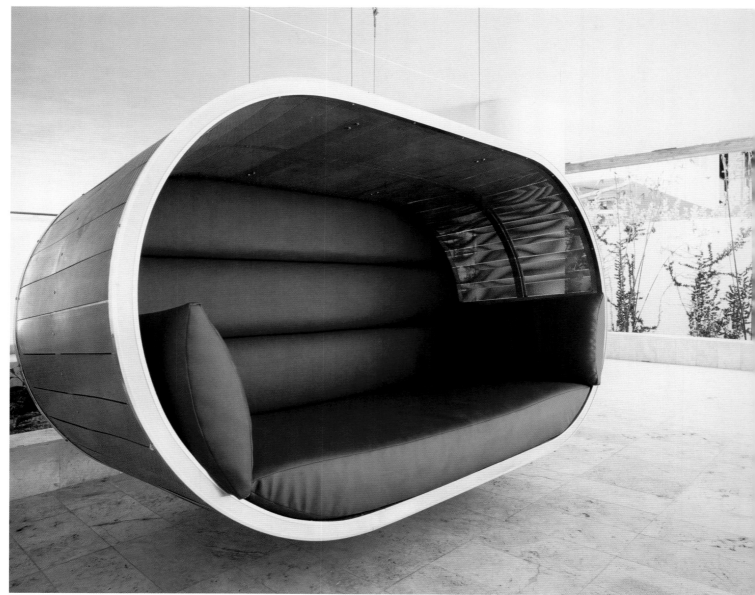

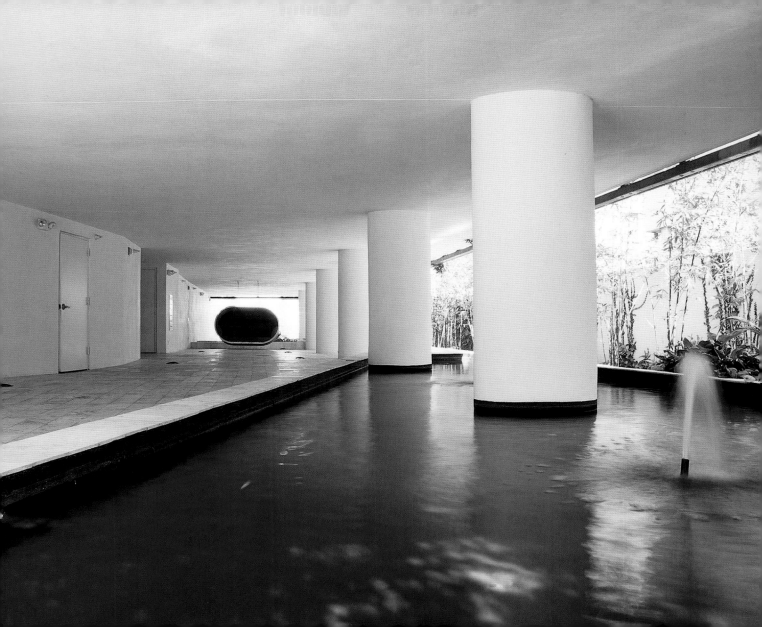

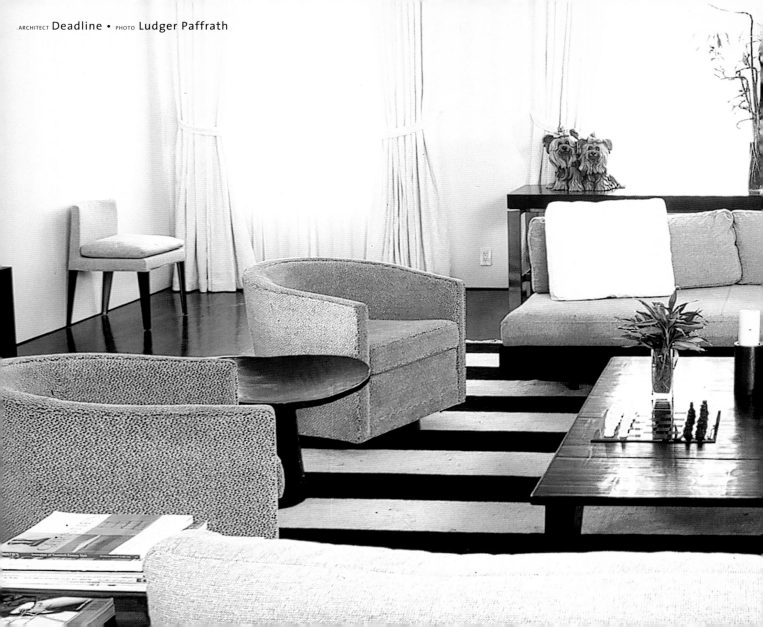

.ARCHITECT Deadline • PHOTO Ludger Paffrath

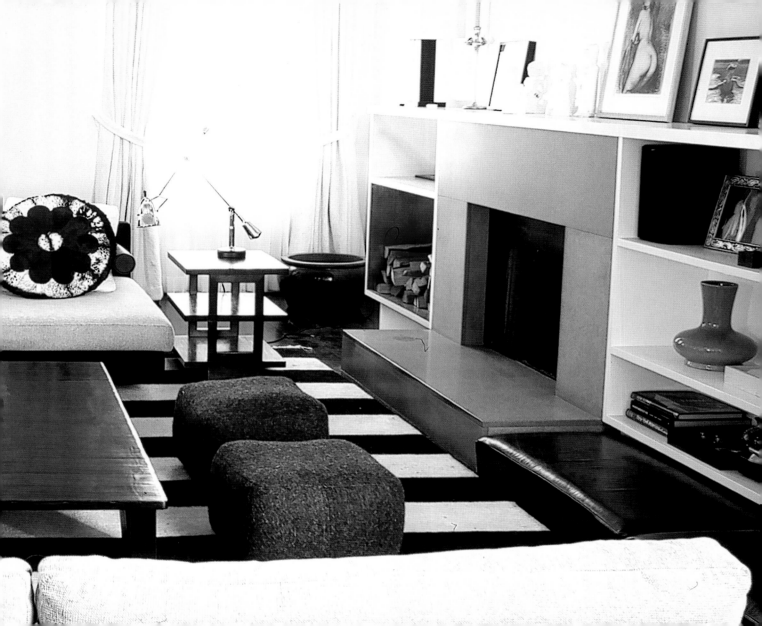

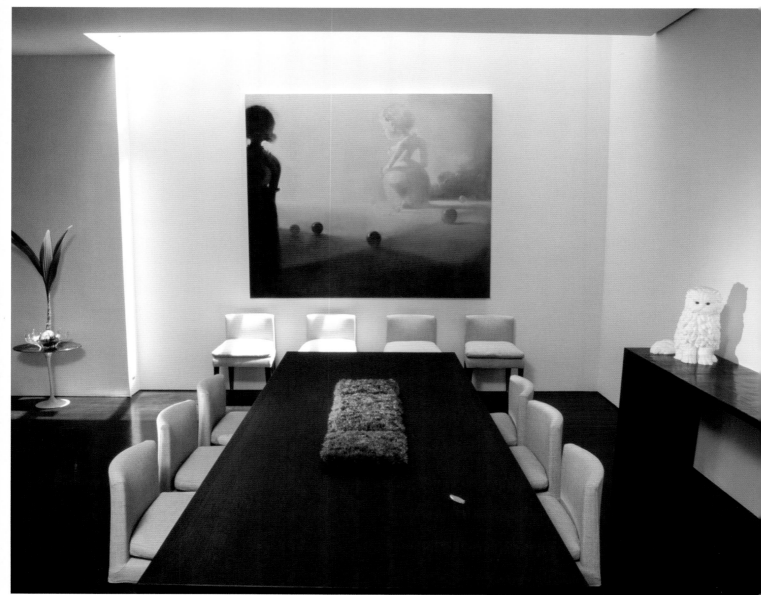

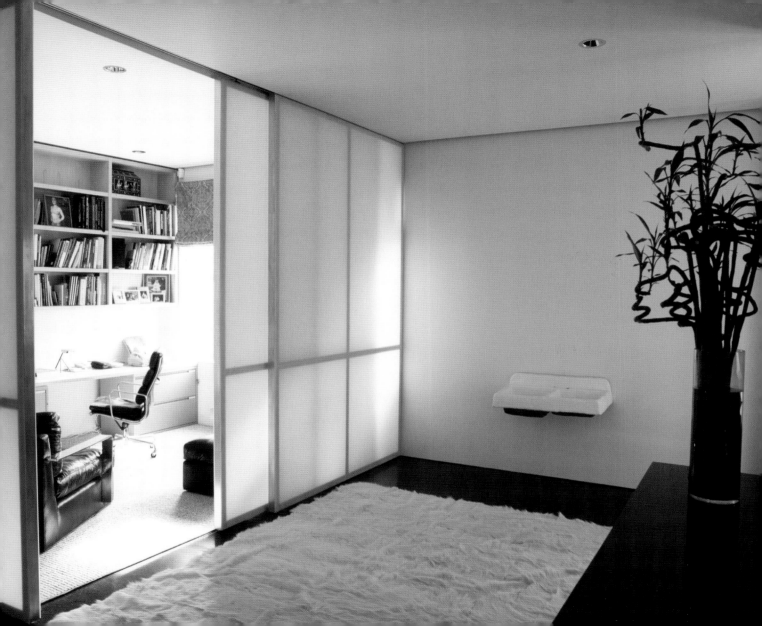

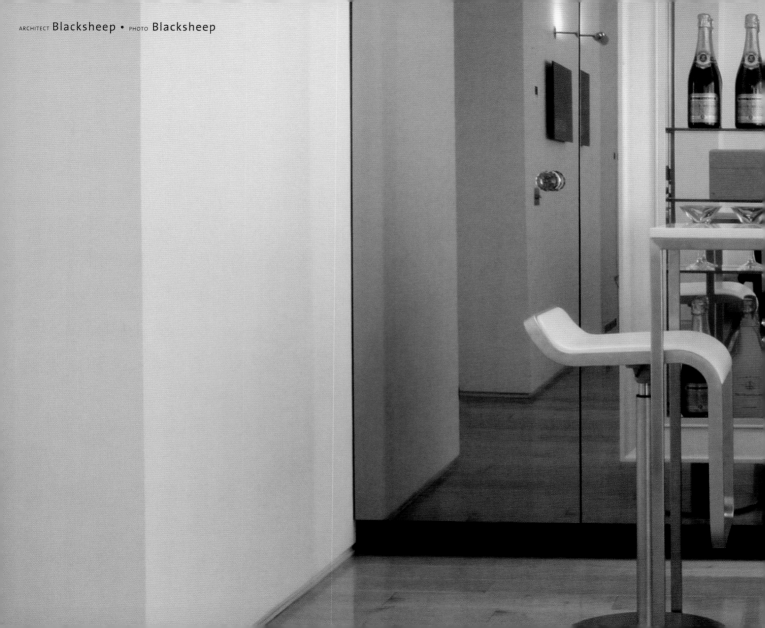

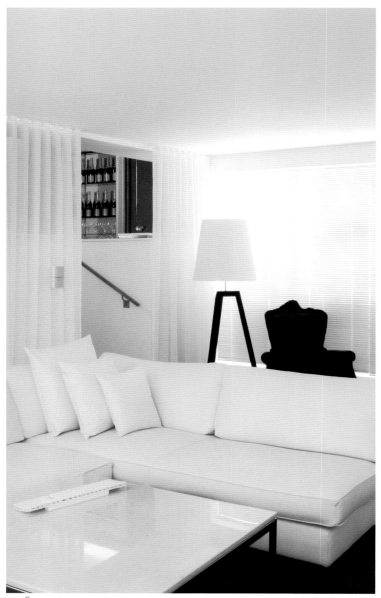
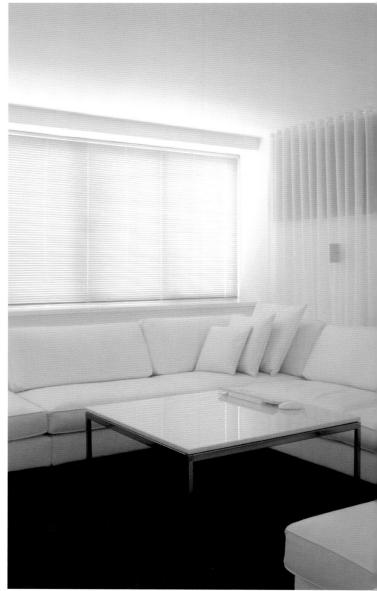

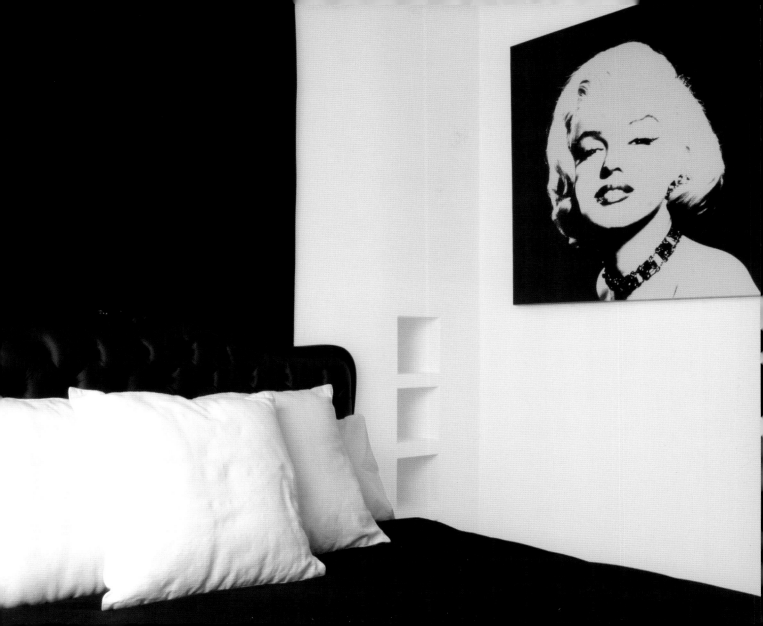

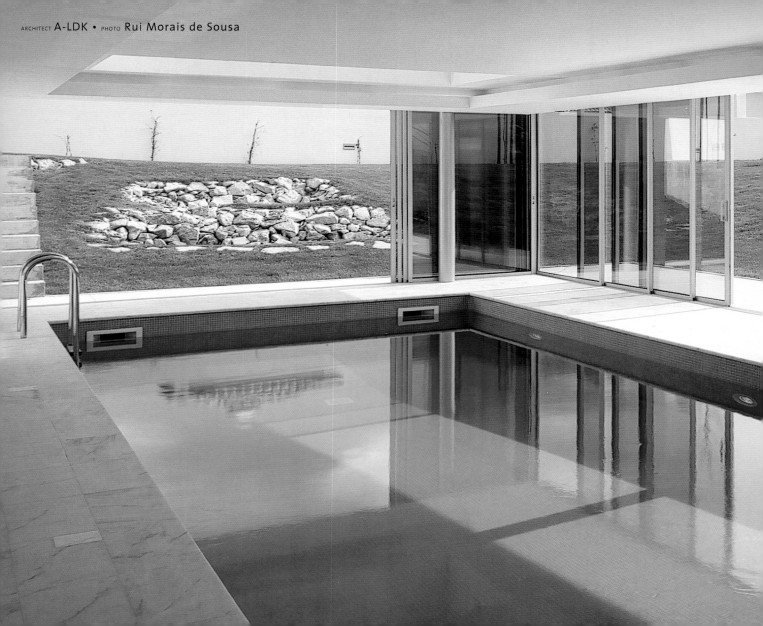

ARCHITECT A-LDK • PHOTO Rui Morais de Sousa

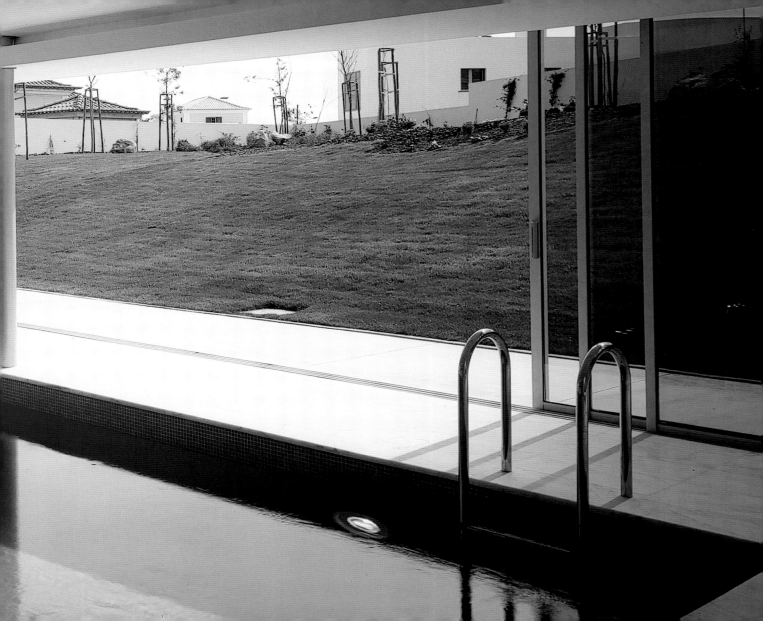

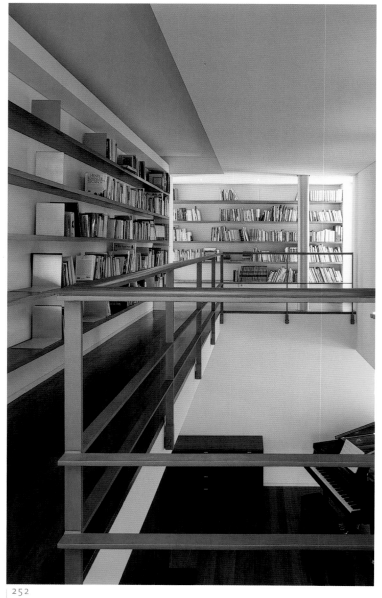
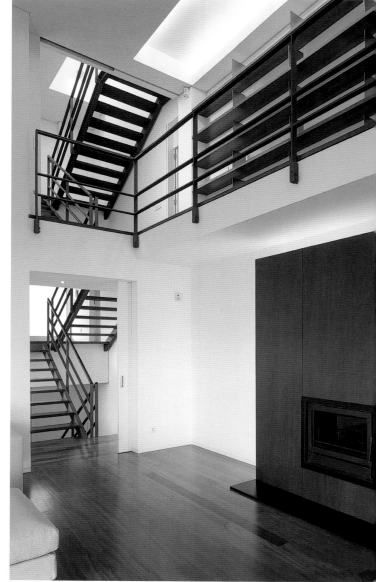

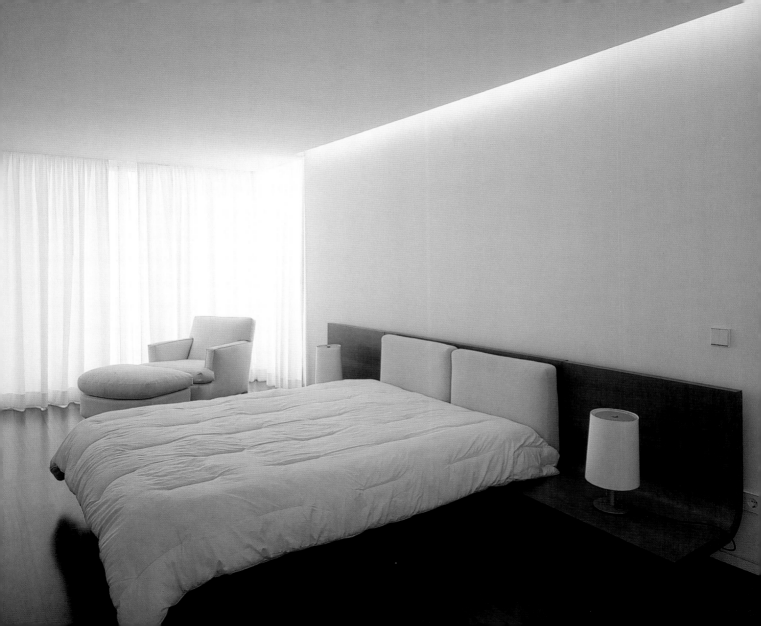

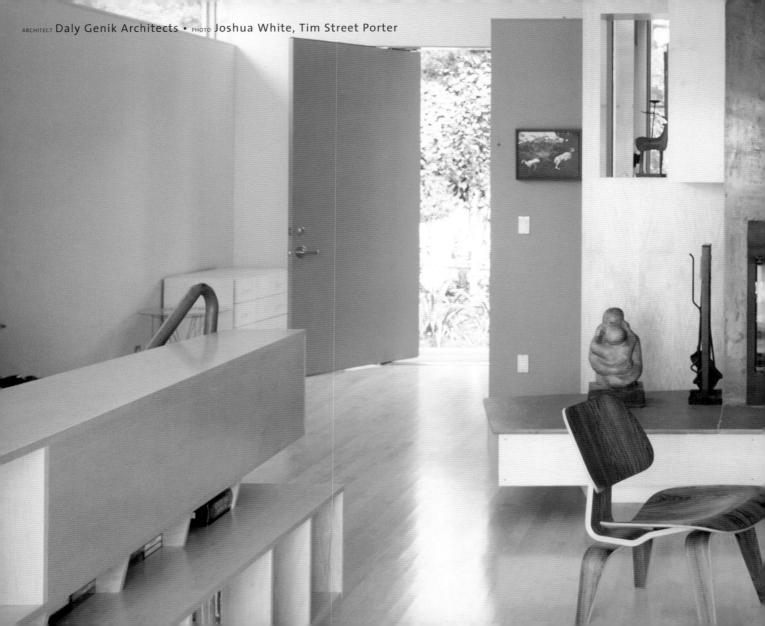

ARCHITECT Daly Genik Architects • PHOTO Joshua White, Tim Street Porter

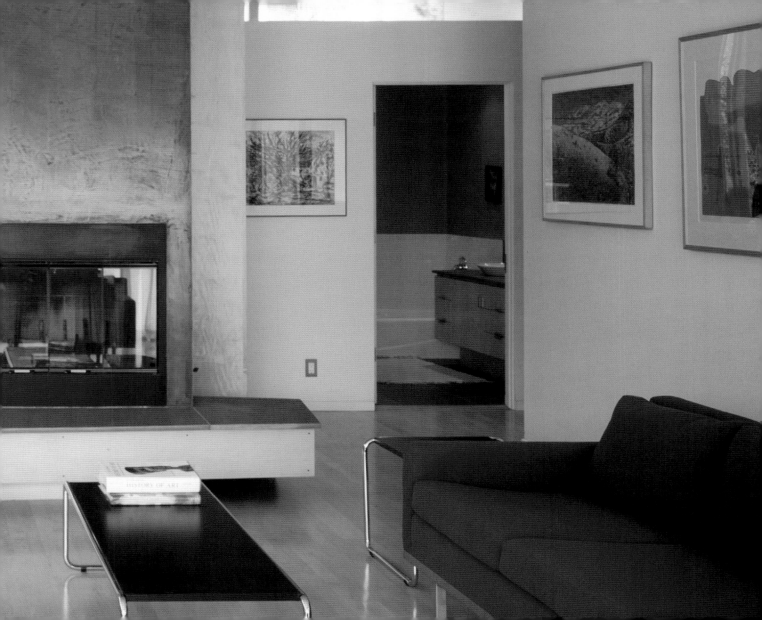

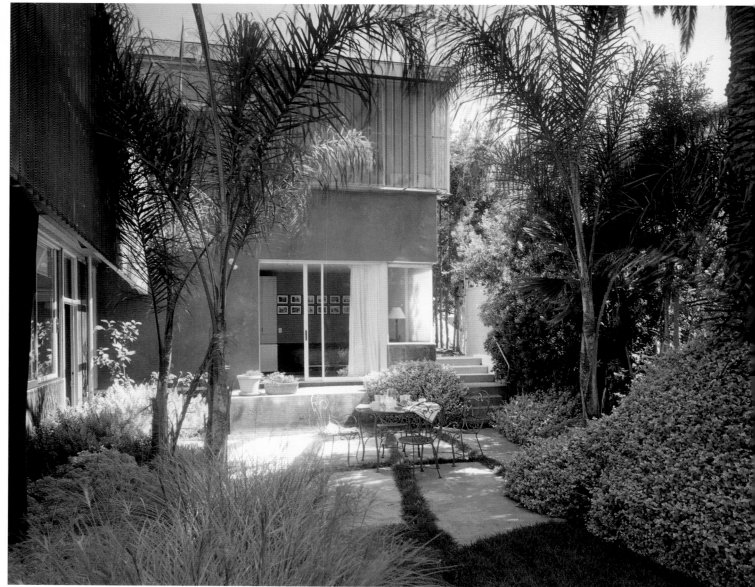

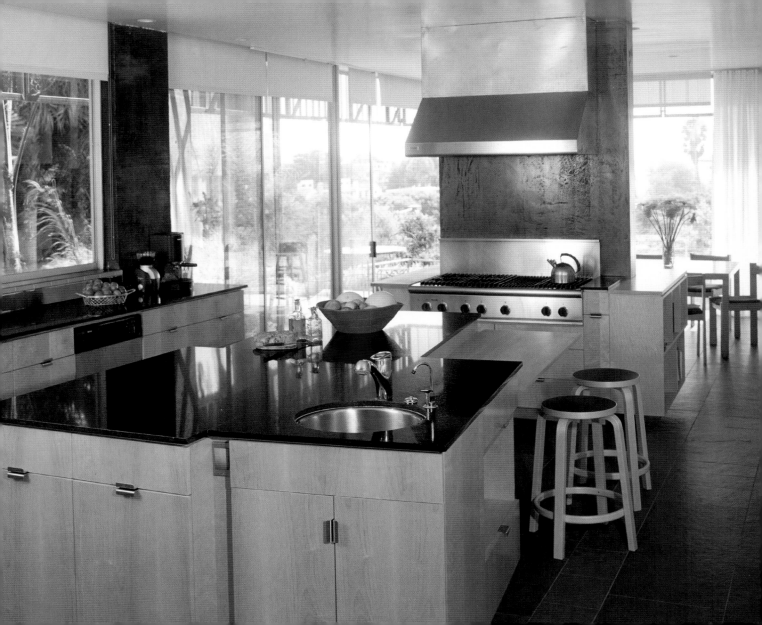

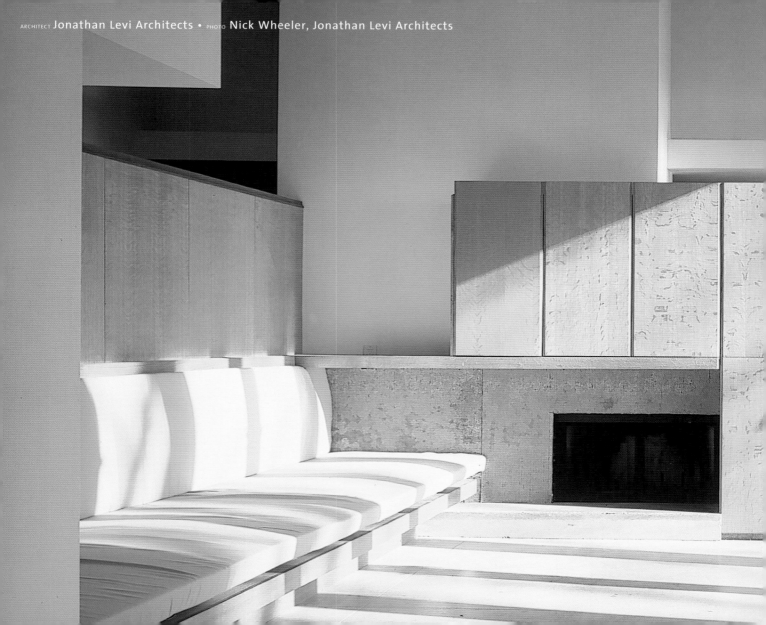

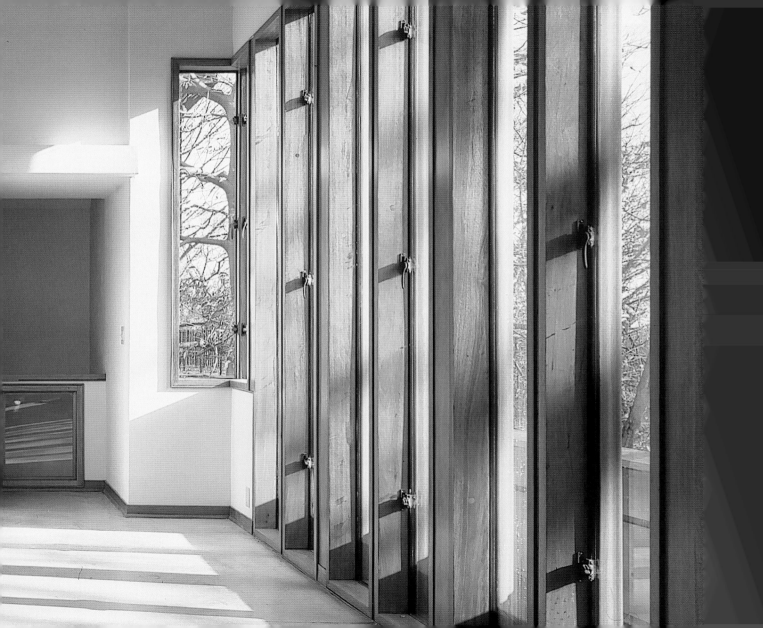

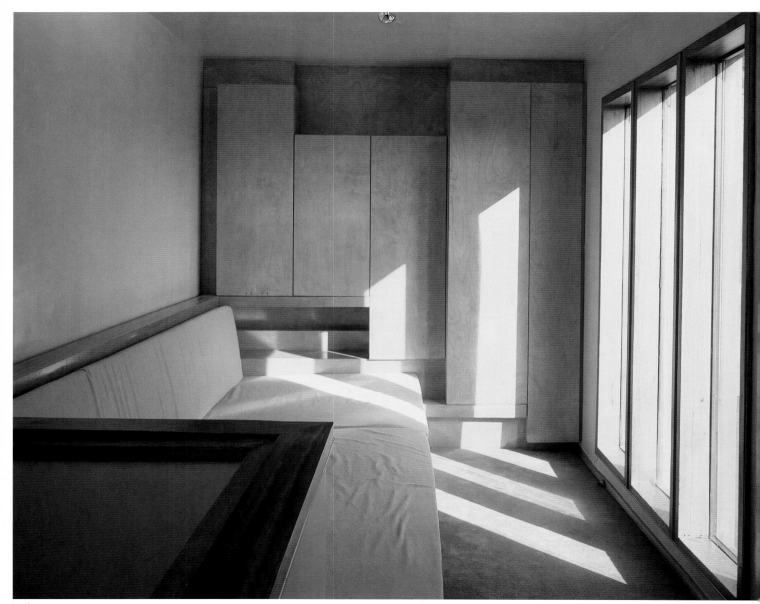

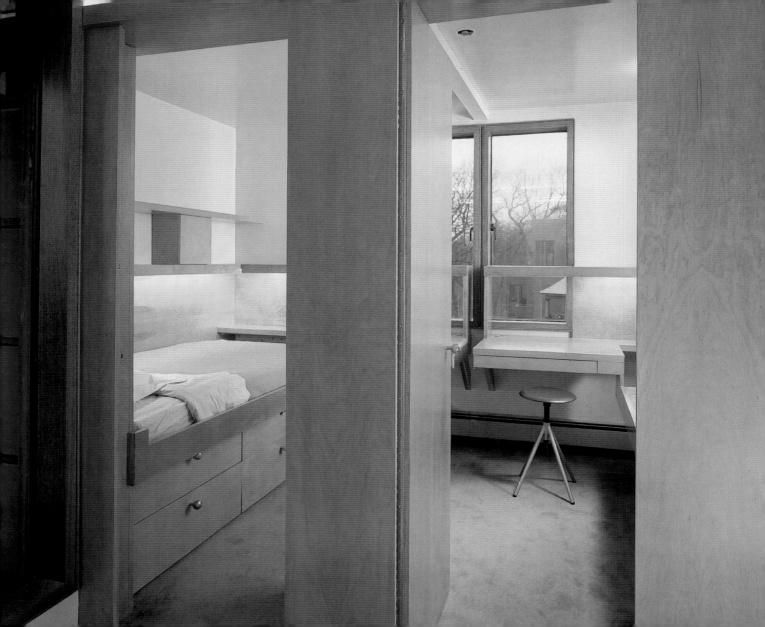

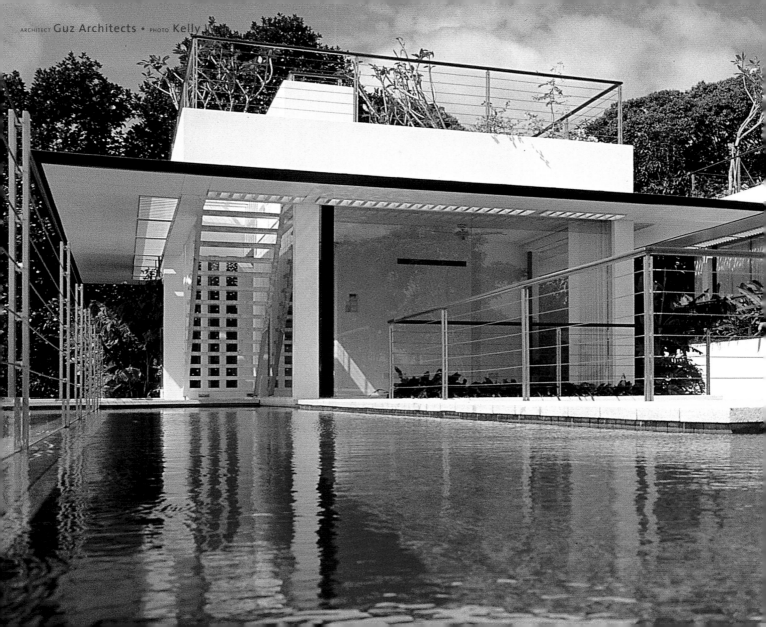

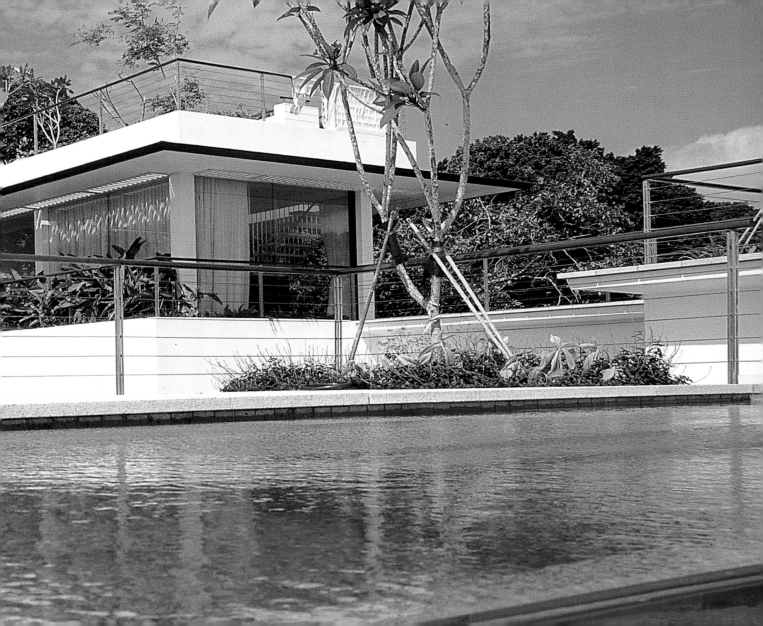

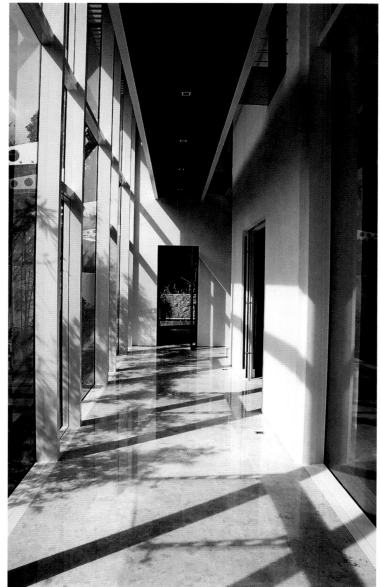
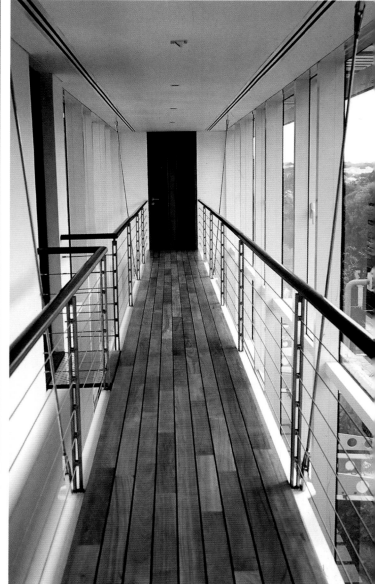

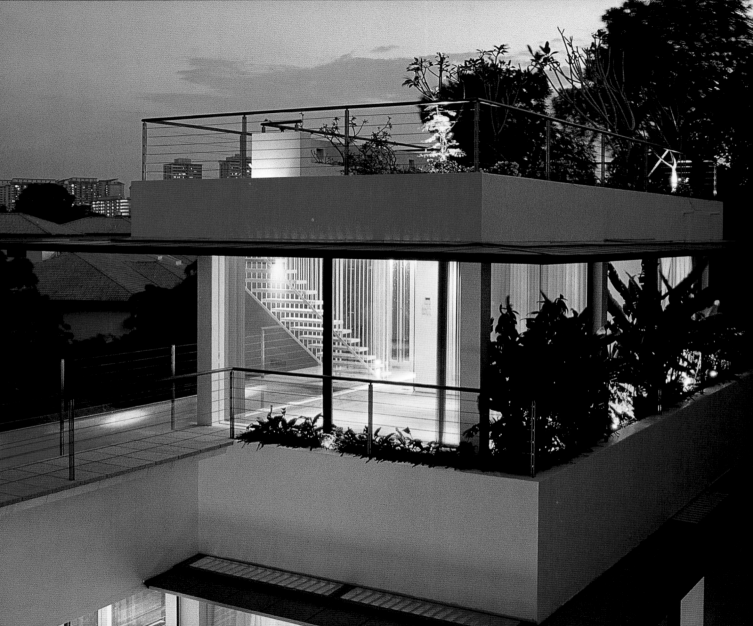

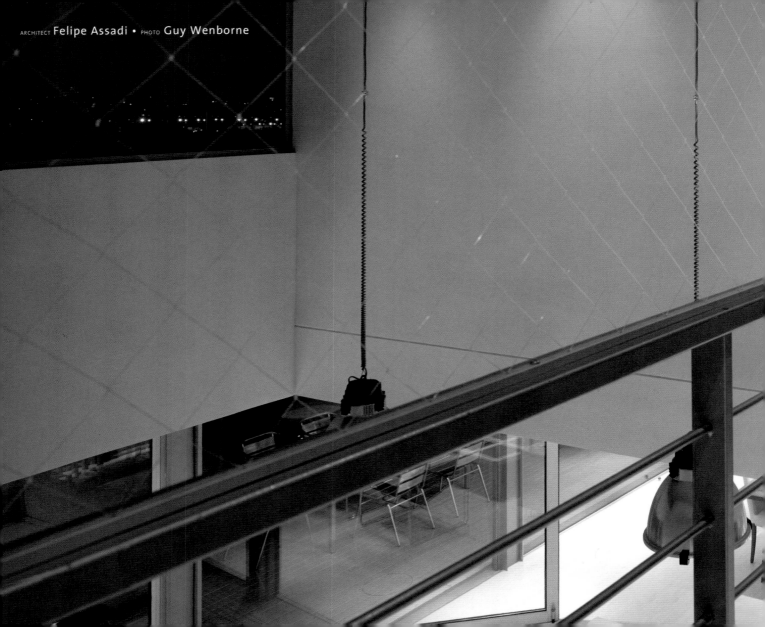

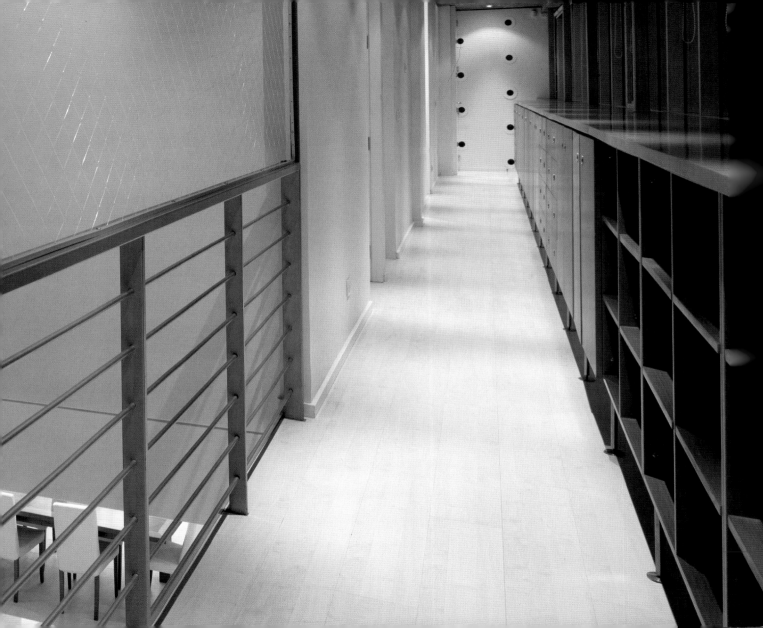

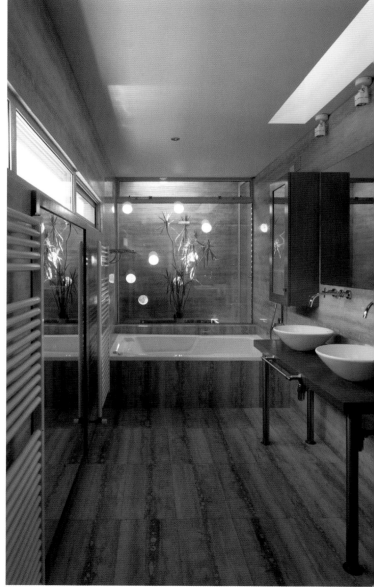

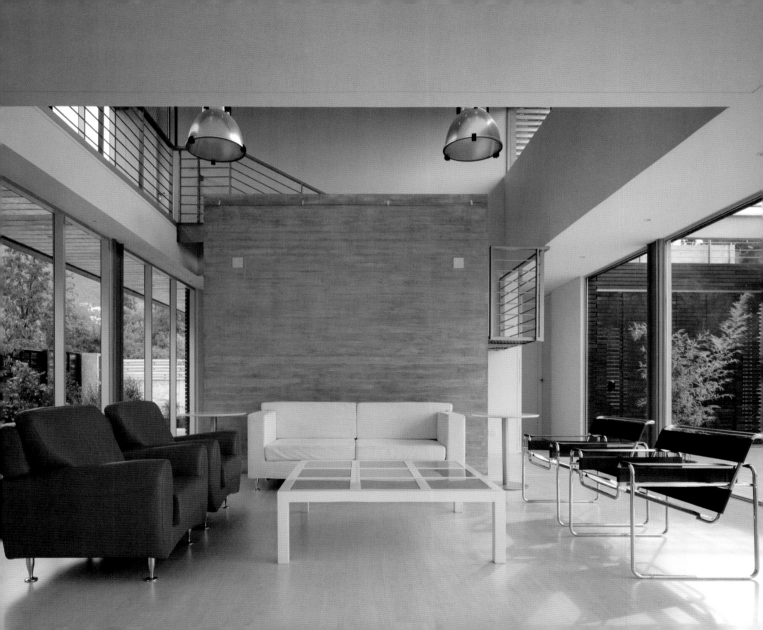

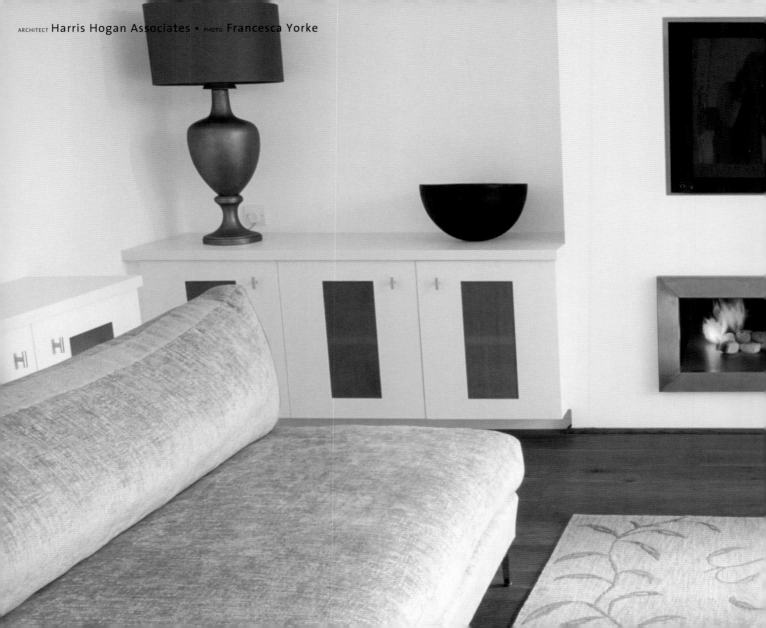

ARCHITECT **Harris Hogan Associates** • PHOTO **Francesca Yorke**

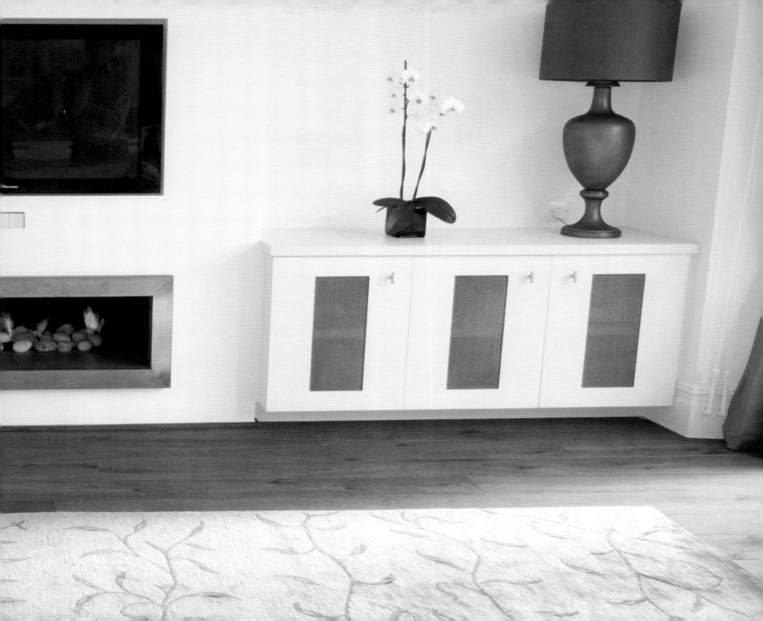

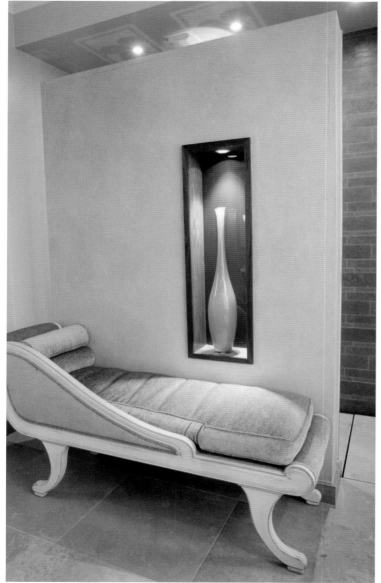
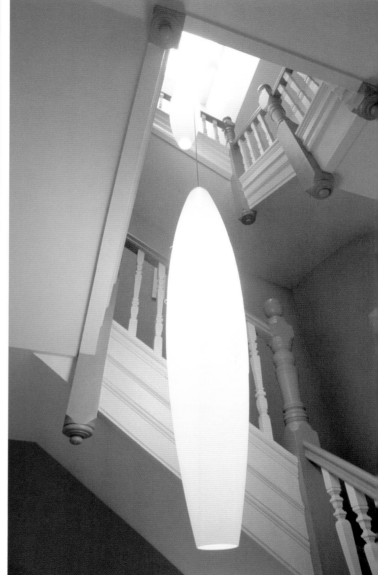

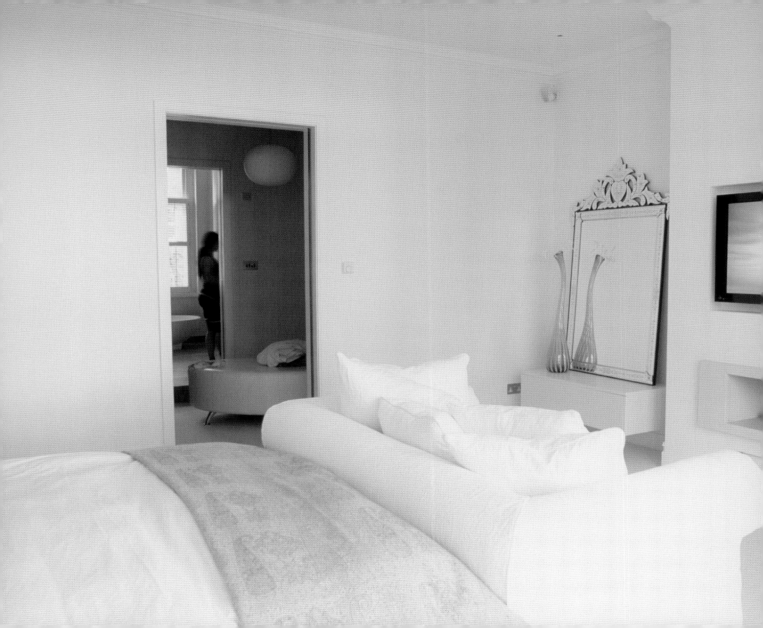

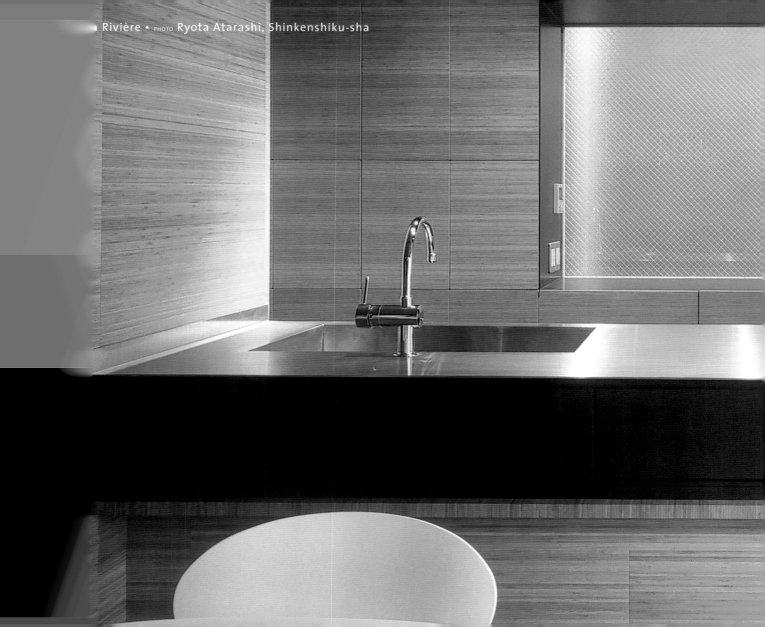

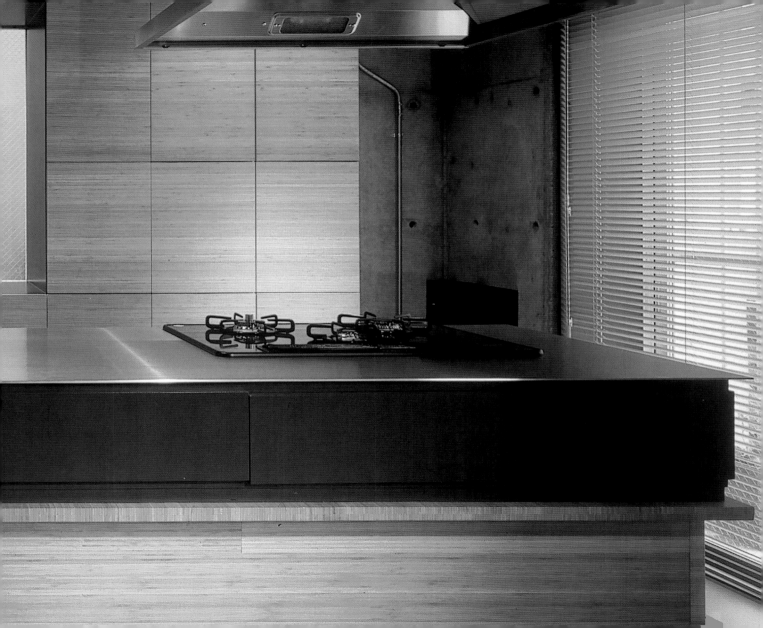

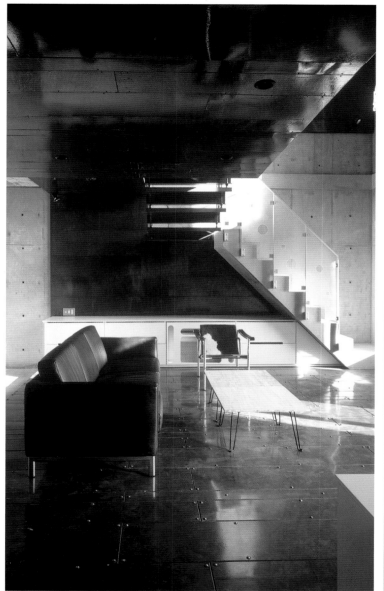
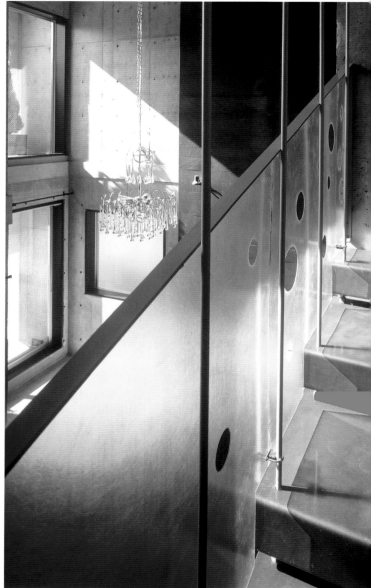

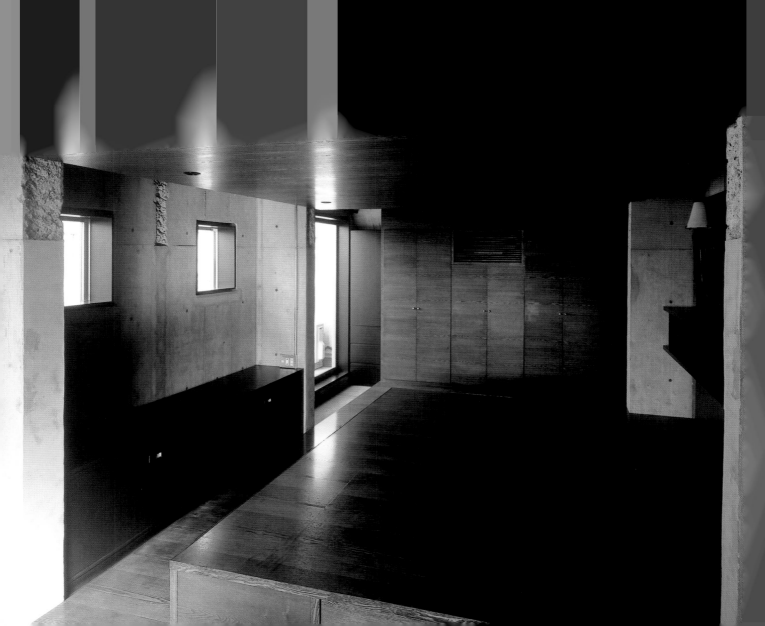

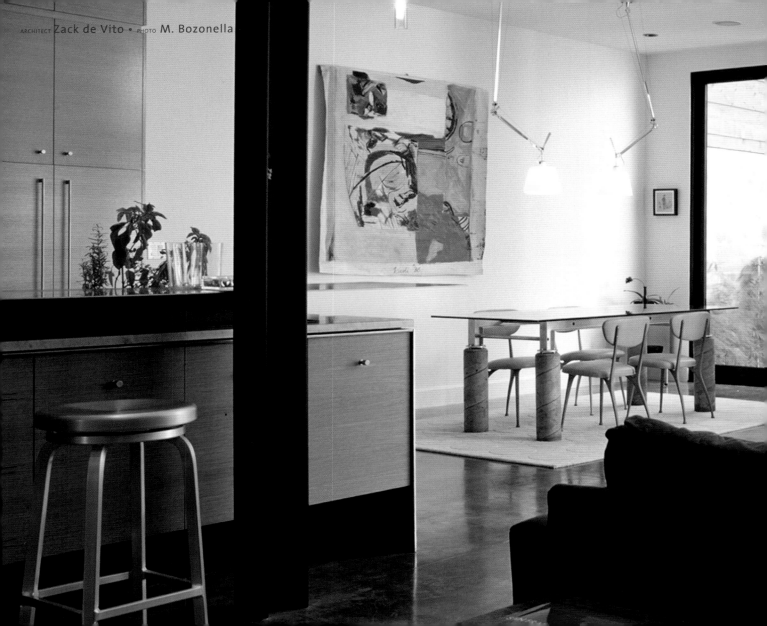

ARCHITECT Zack de Vito • PHOTO M. Bozonella

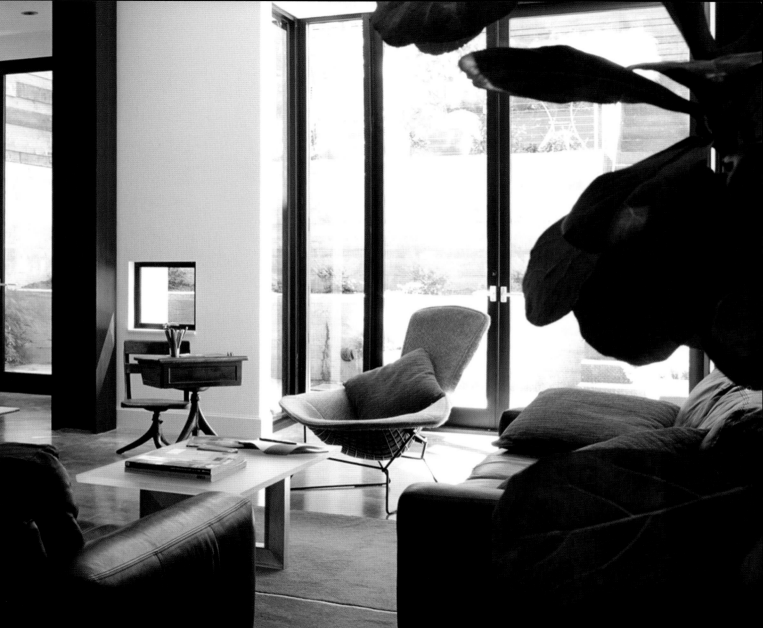

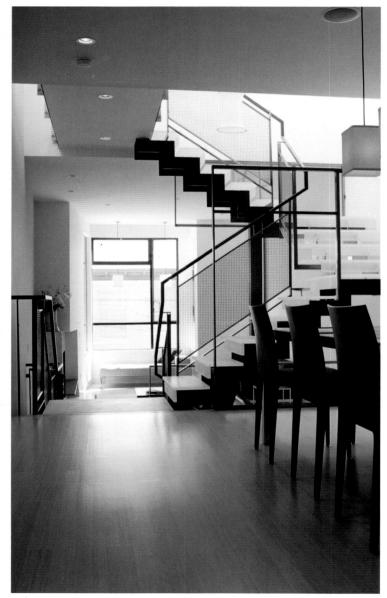
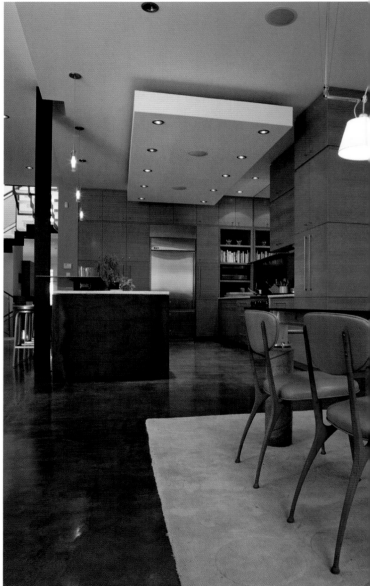

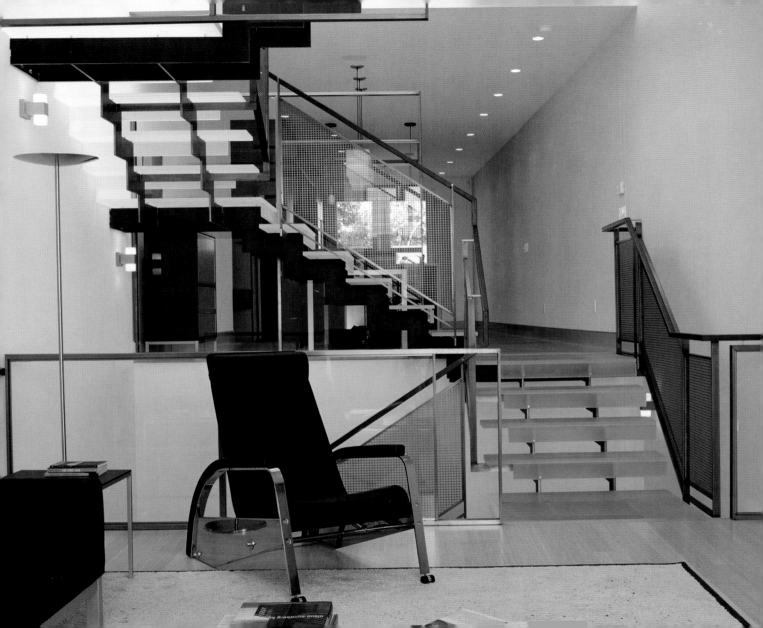

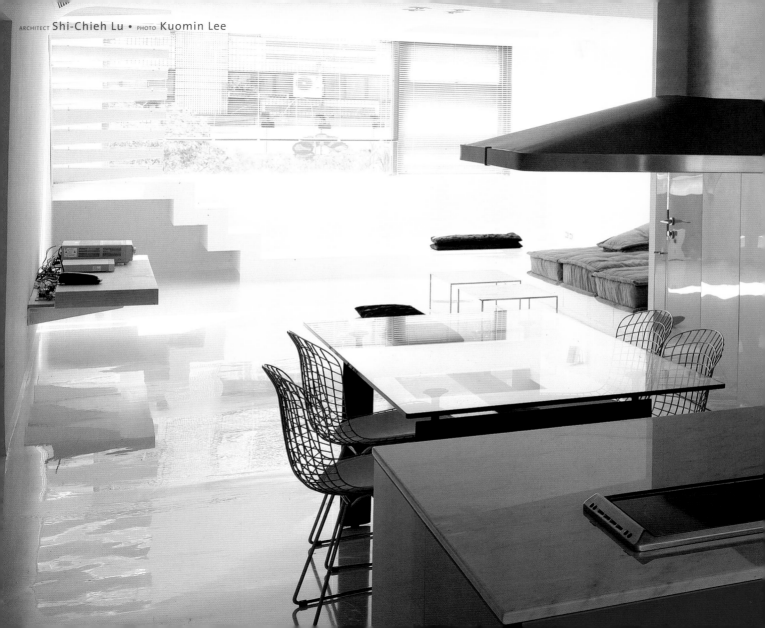

ARCHITECT Shi-Chieh Lu • PHOTO Kuomin Lee

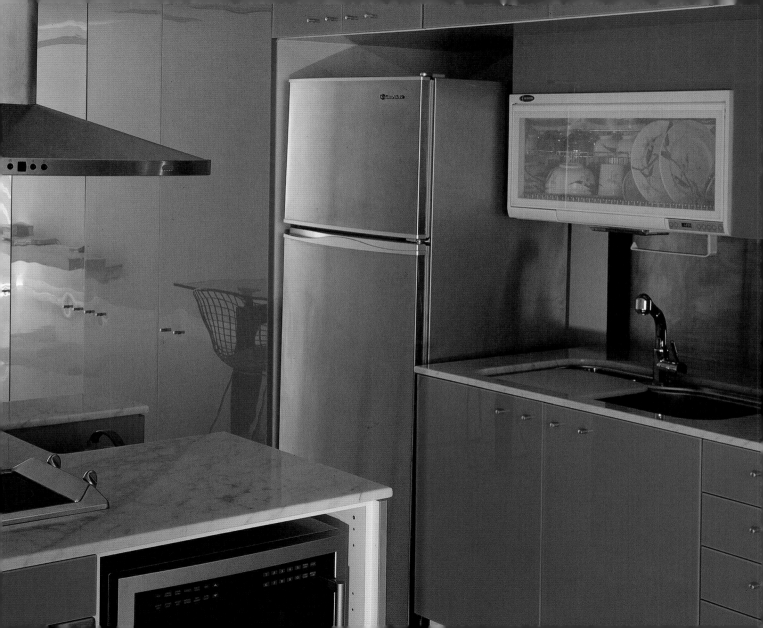

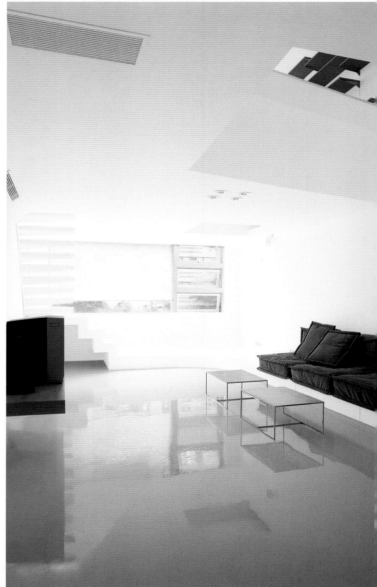

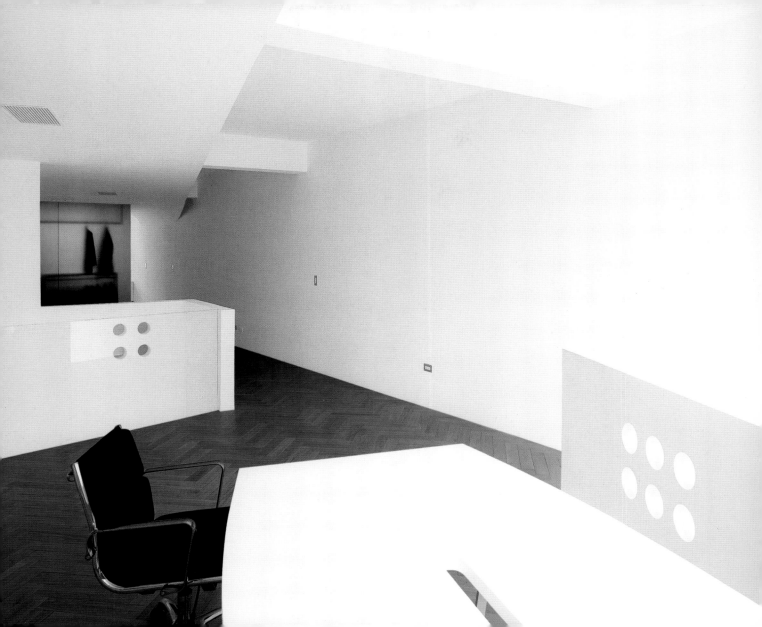

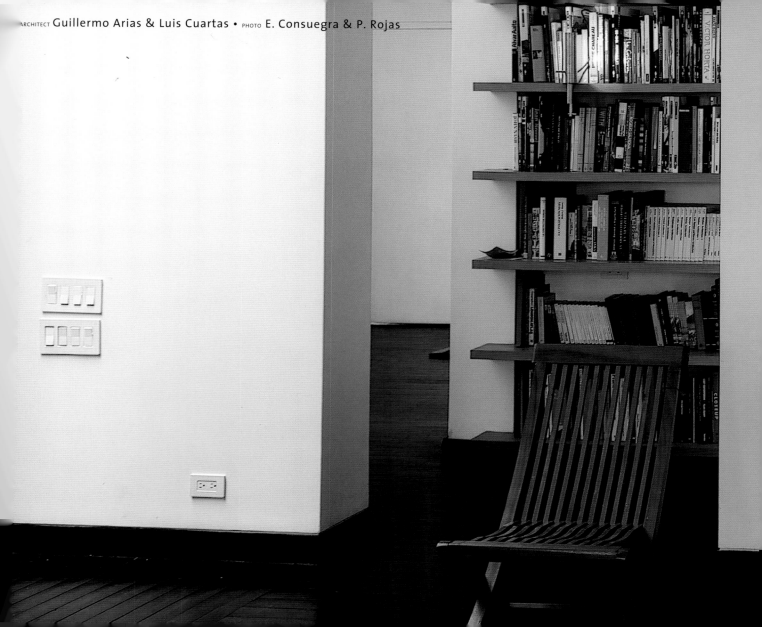

ARCHITECT Guillermo Arias & Luis Cuartas • PHOTO E. Consuegra & P. Rojas

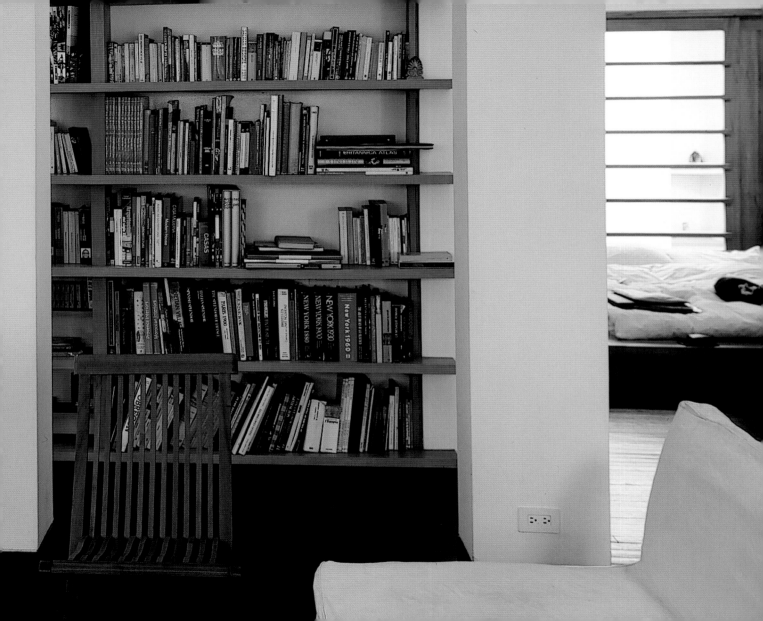

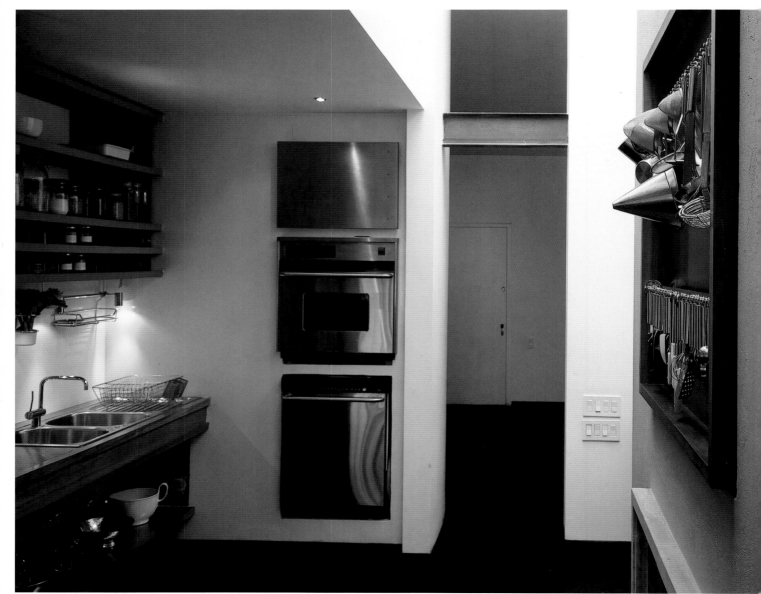

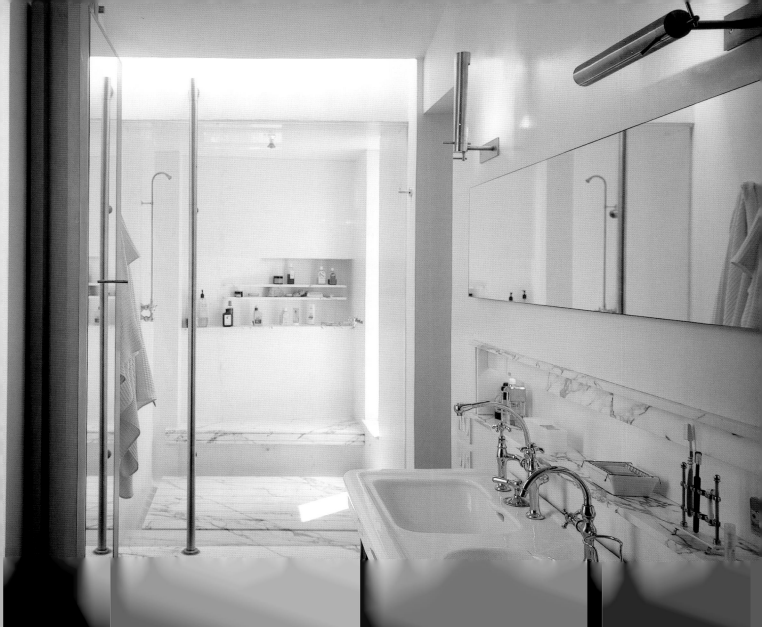

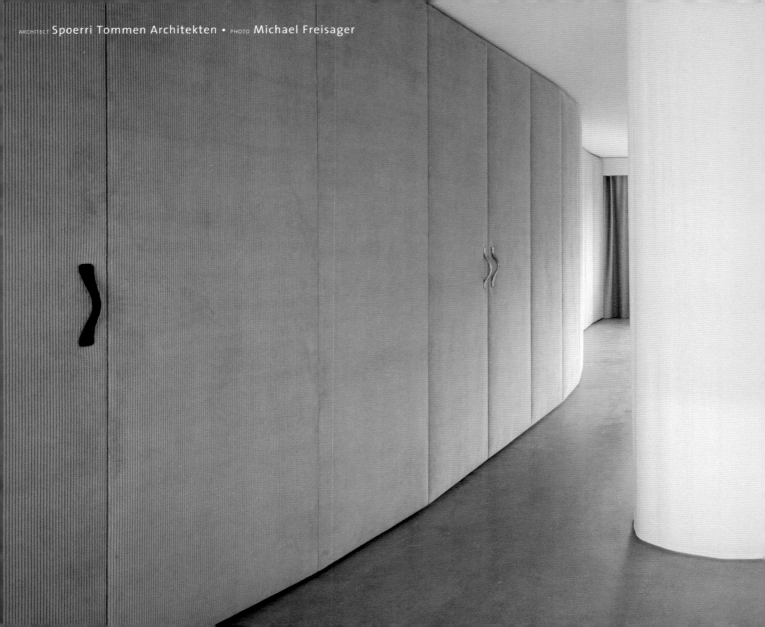

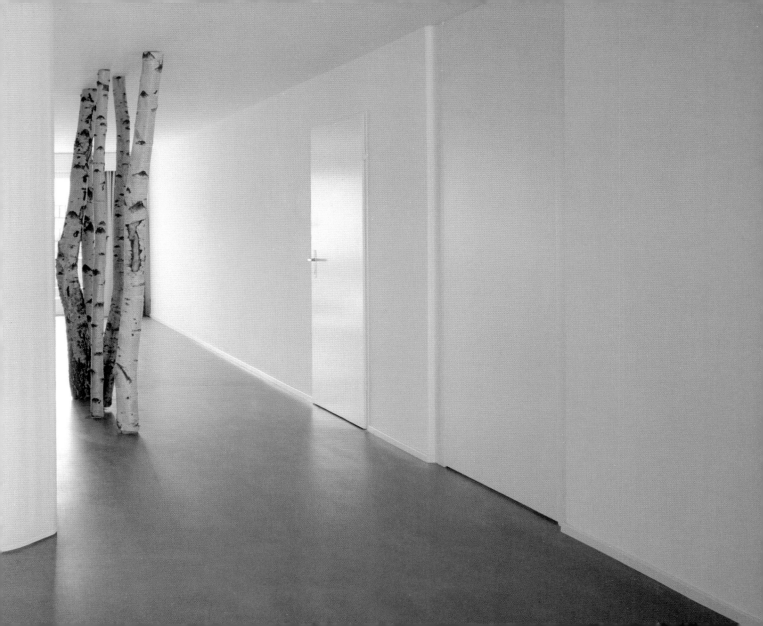

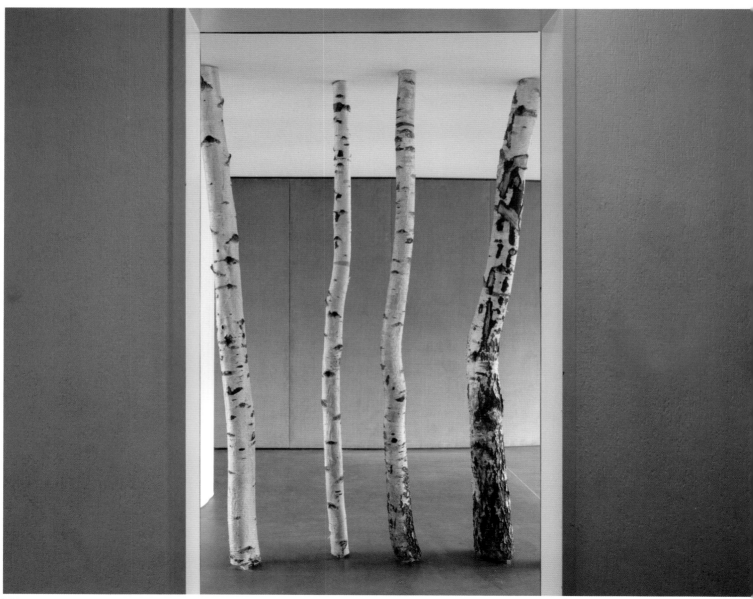

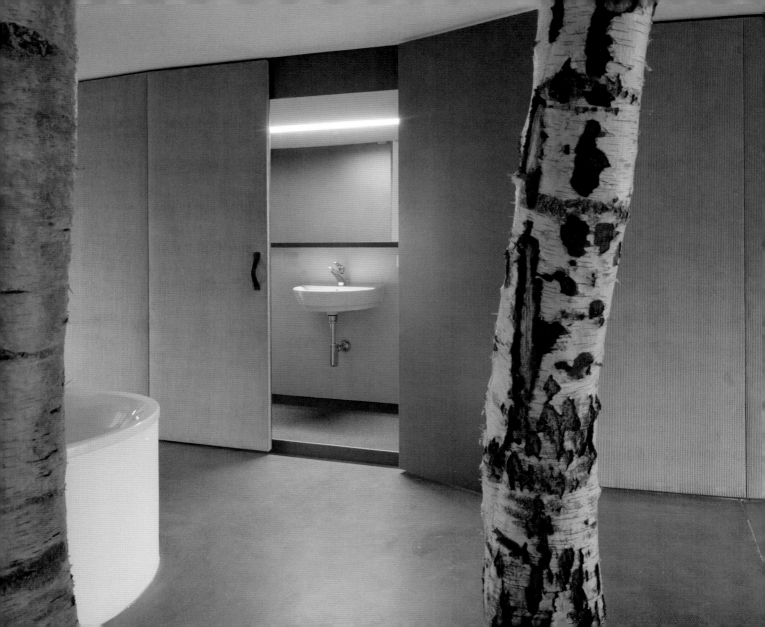

ARCHITECT Joshua R. Coggeshall / Cog Work Shop • PHOTO Deborah Bird, Cog Work Shop

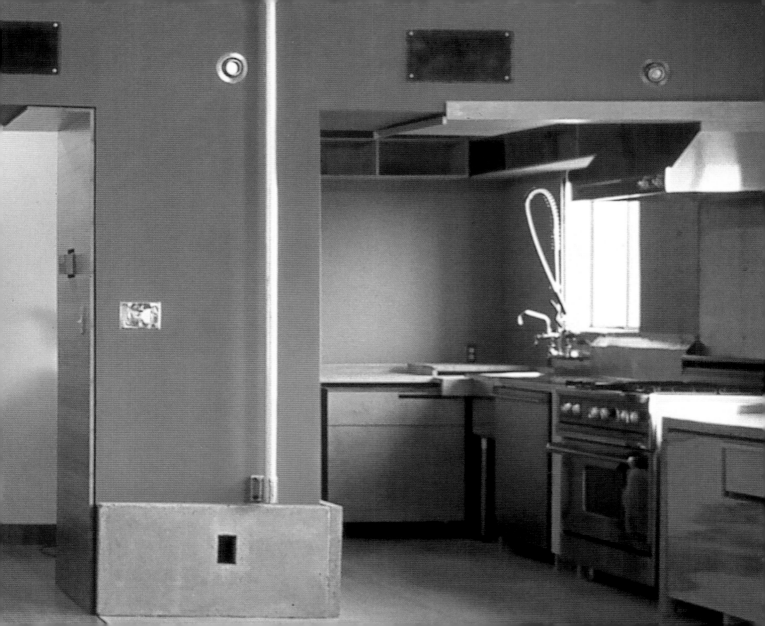

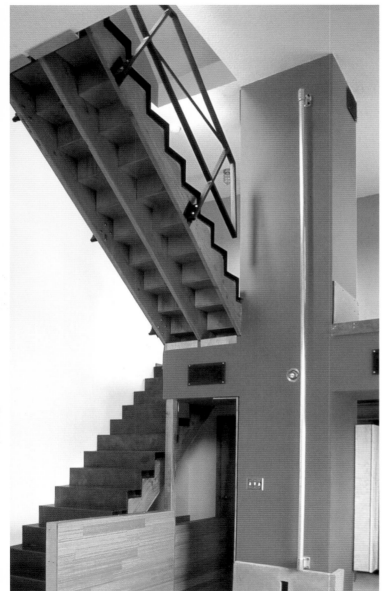
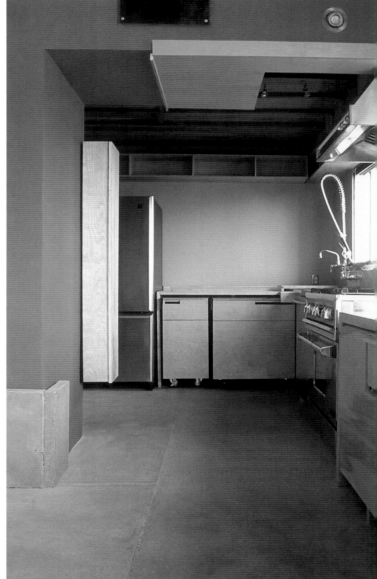

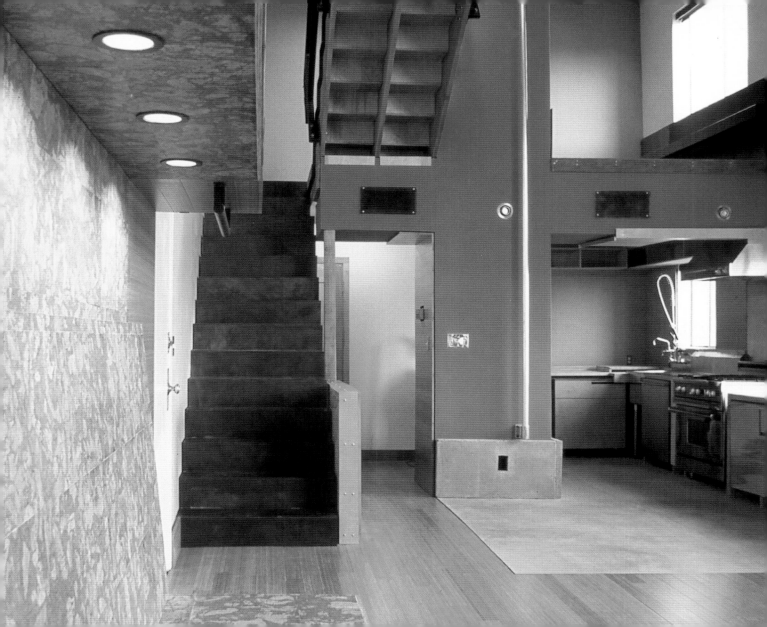

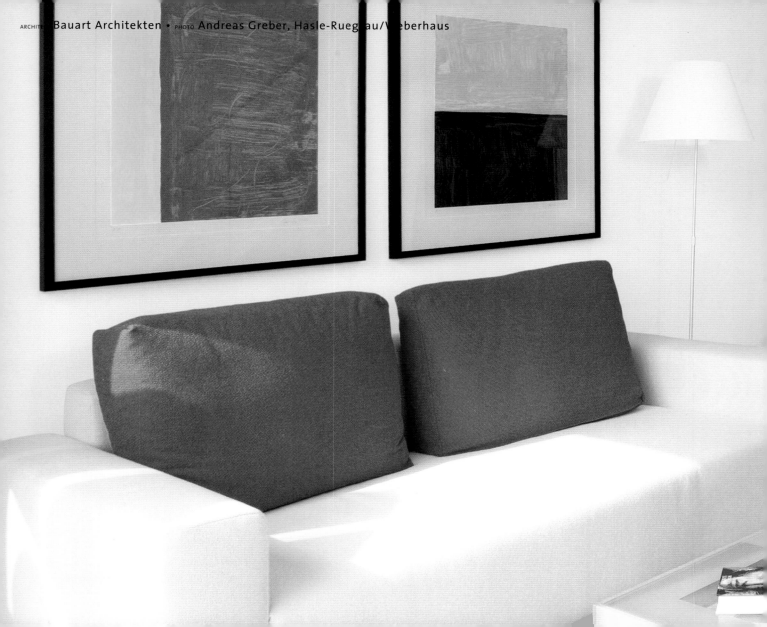

ARCHITECT Bauart Architekten • PHOTO Andreas Greber, Hasle-Rüegsau/Weberhaus

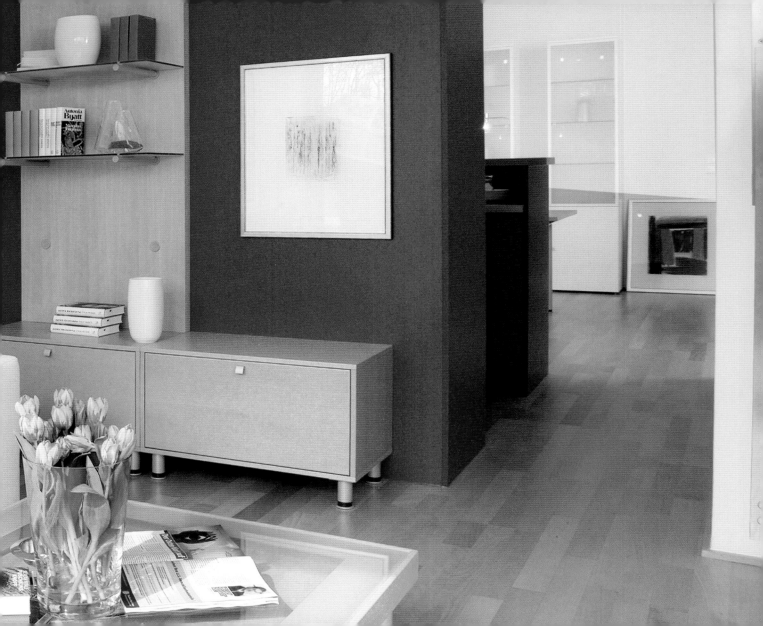

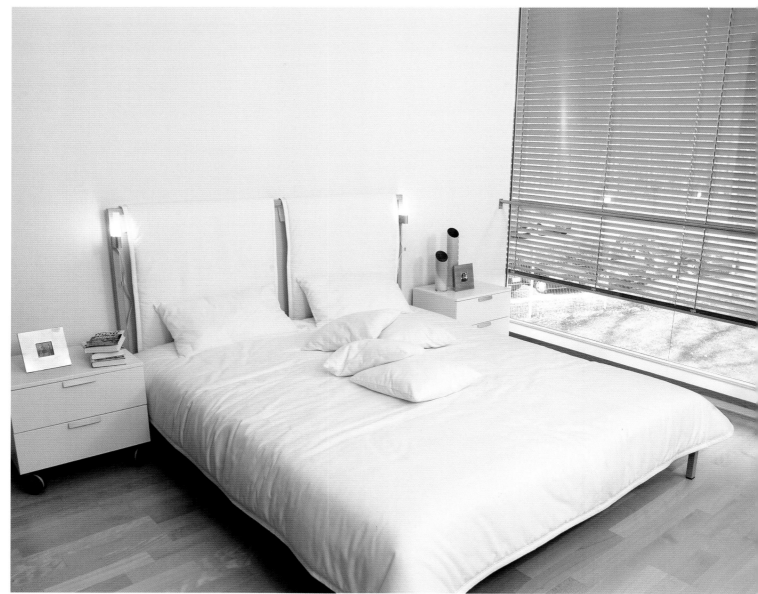

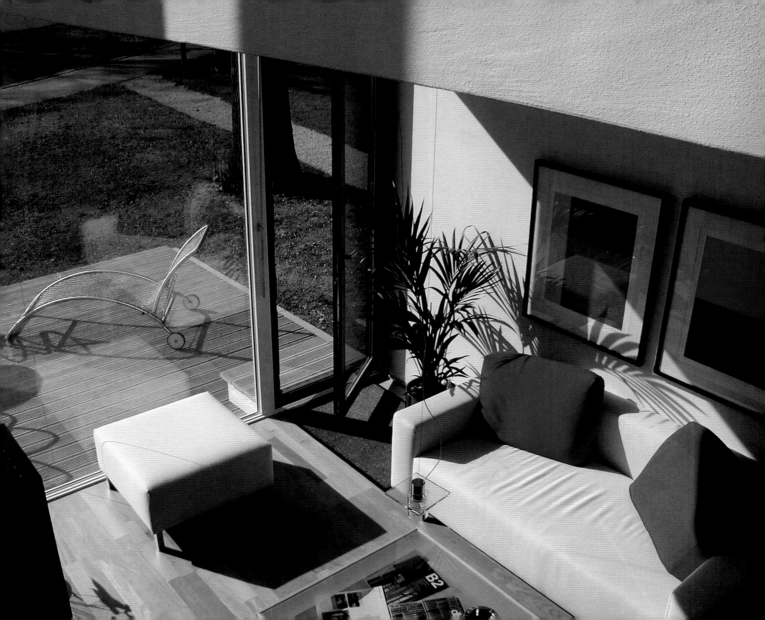

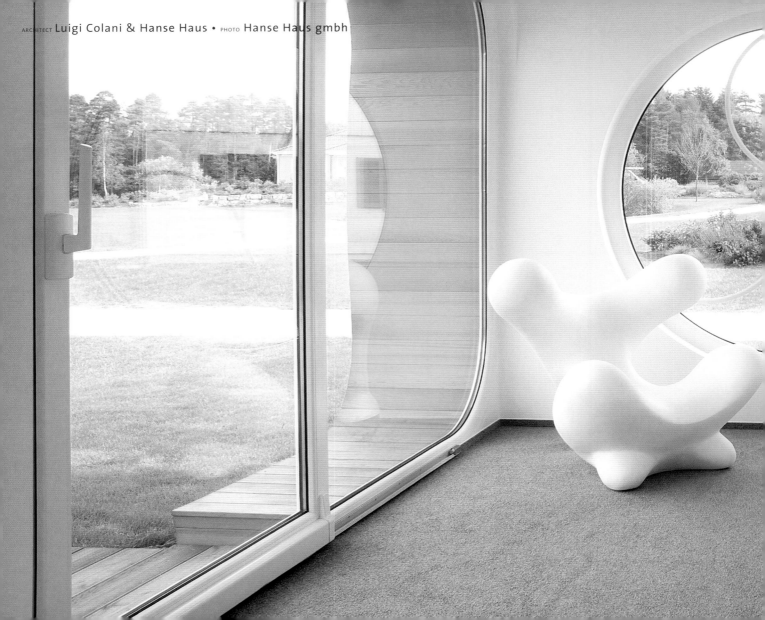

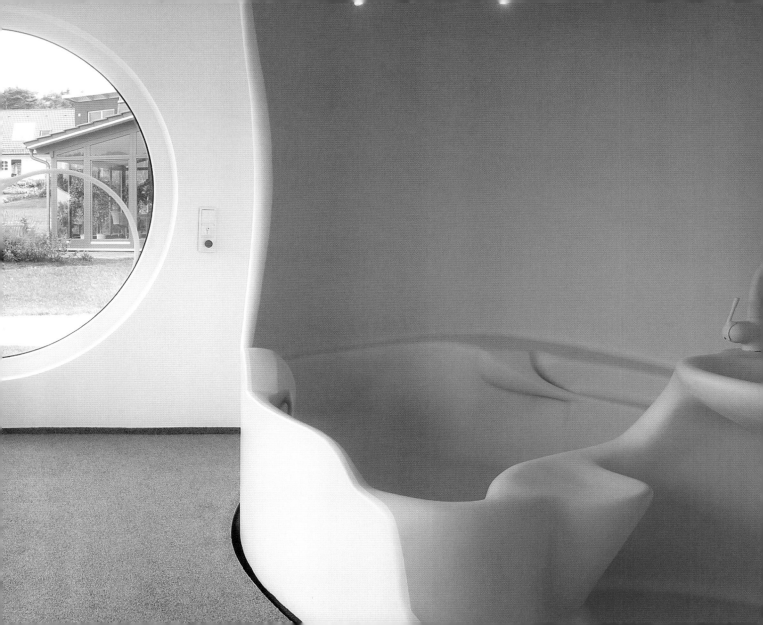

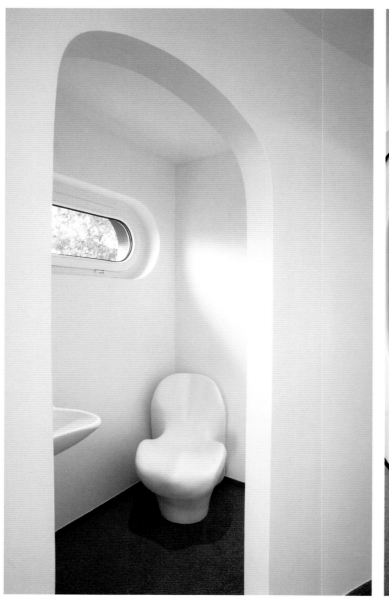
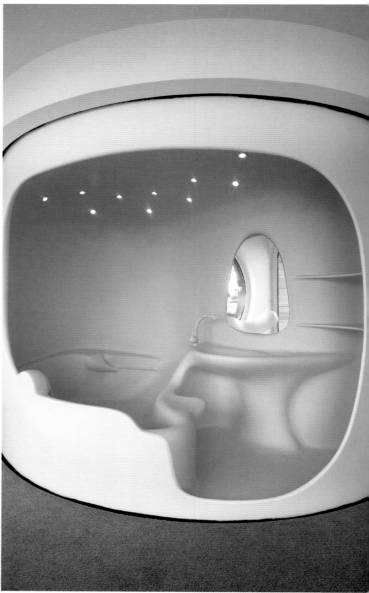

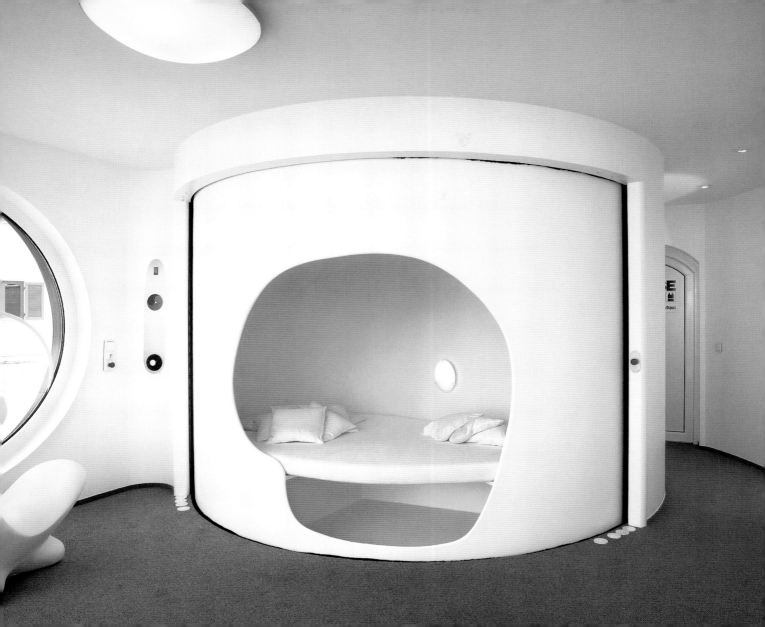

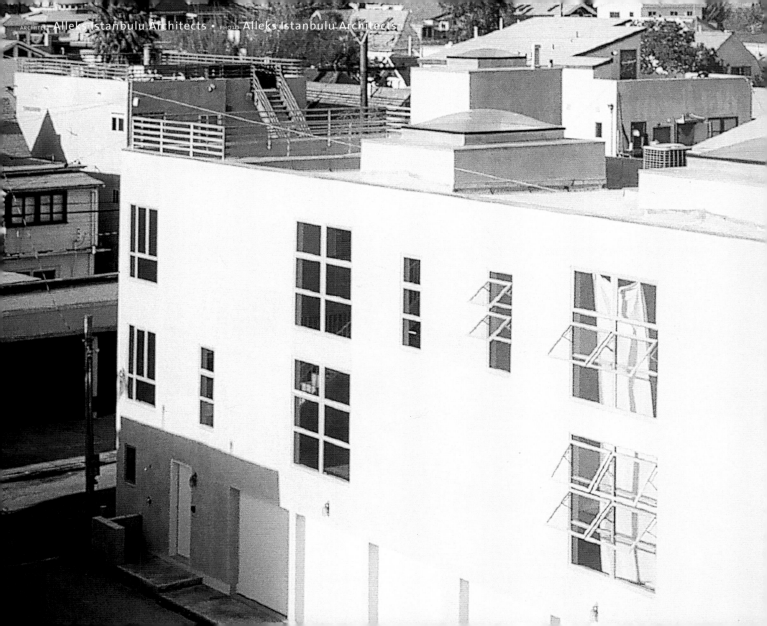

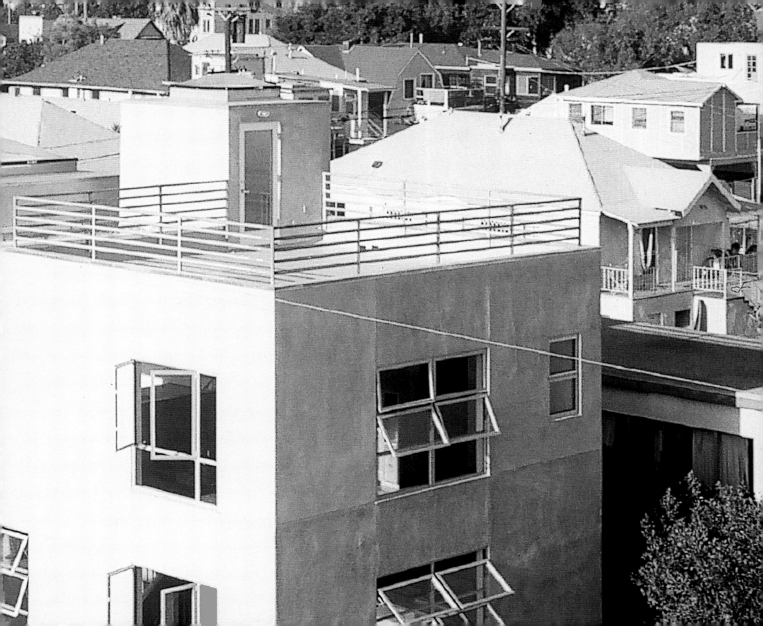

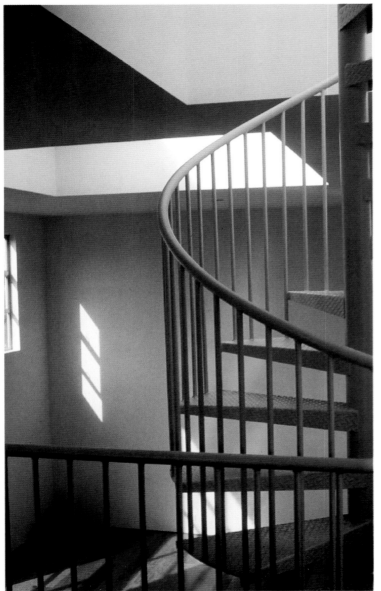
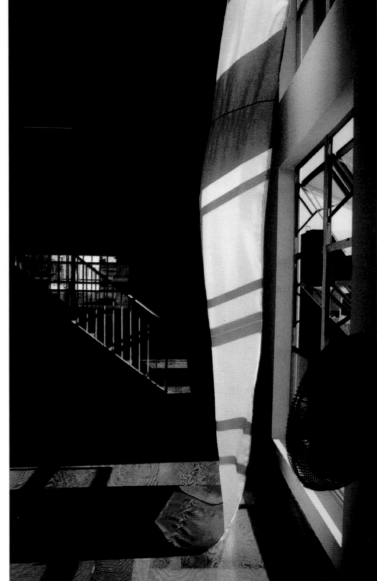

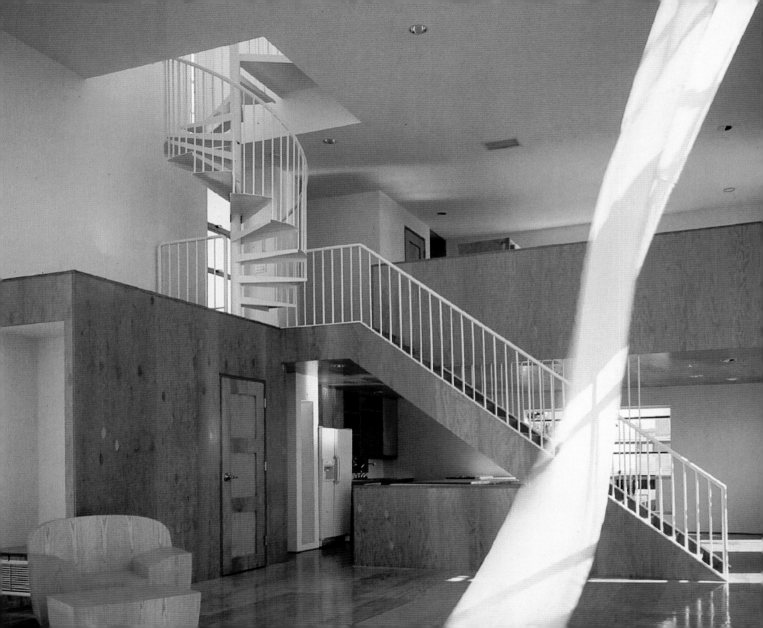

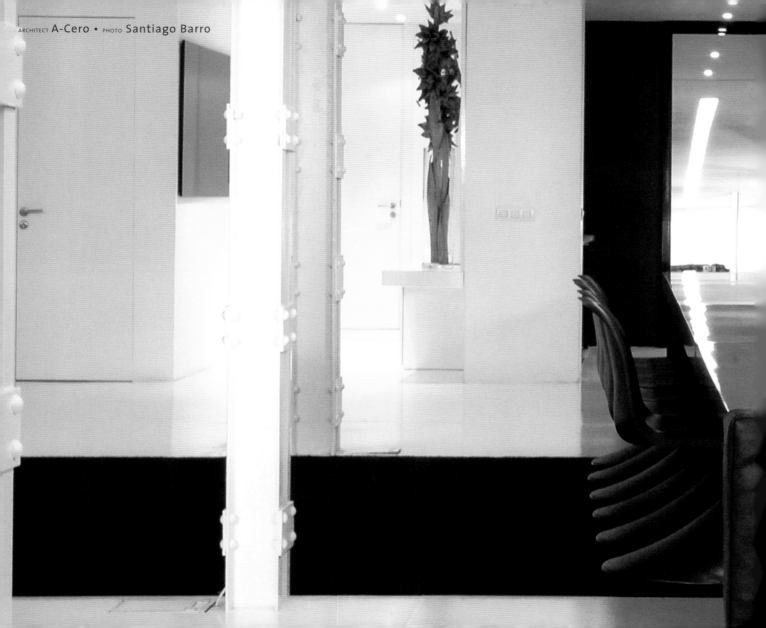

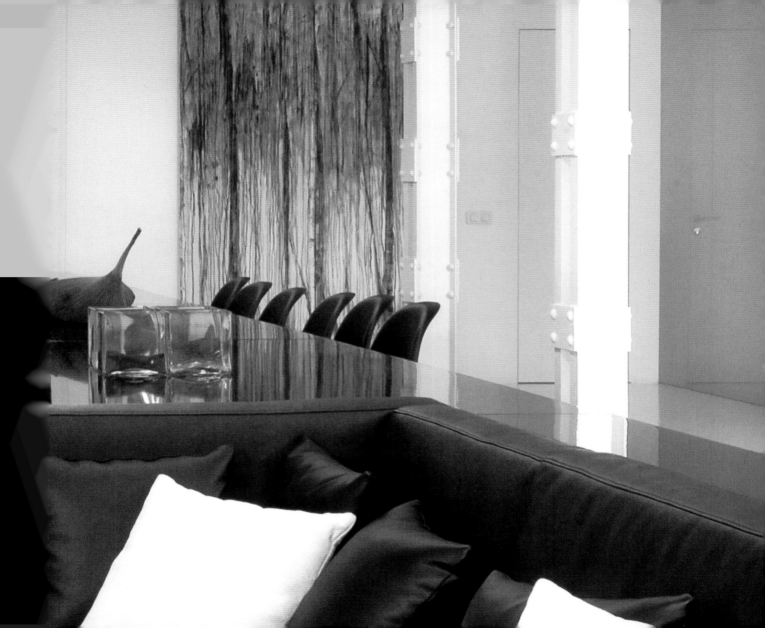

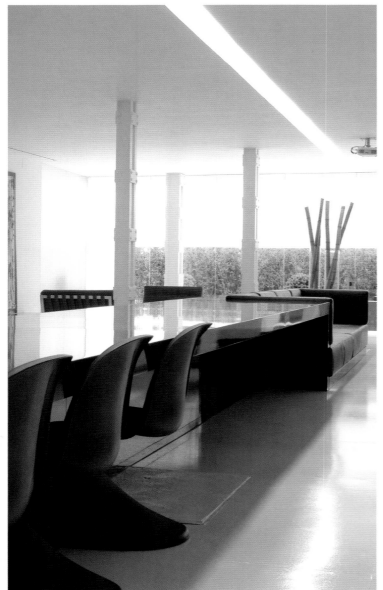
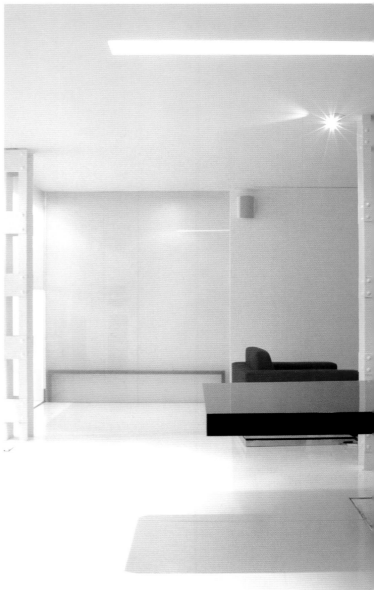

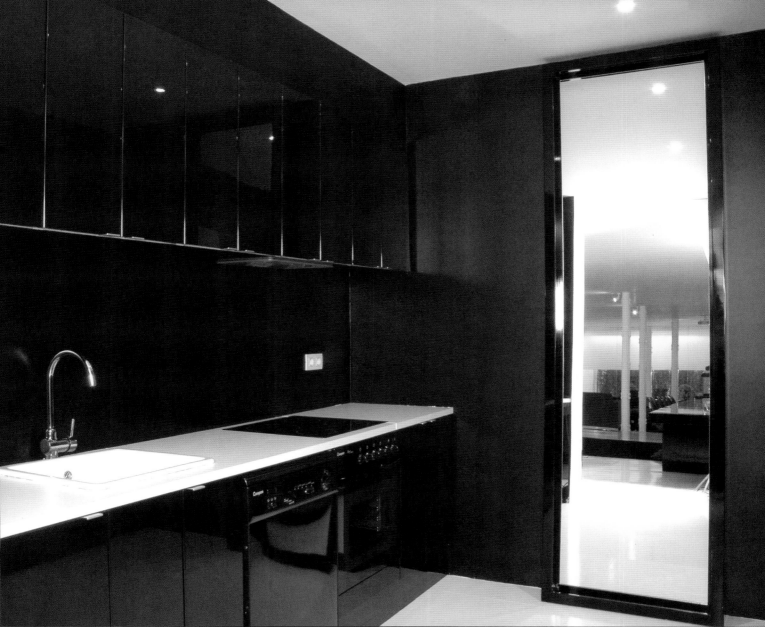

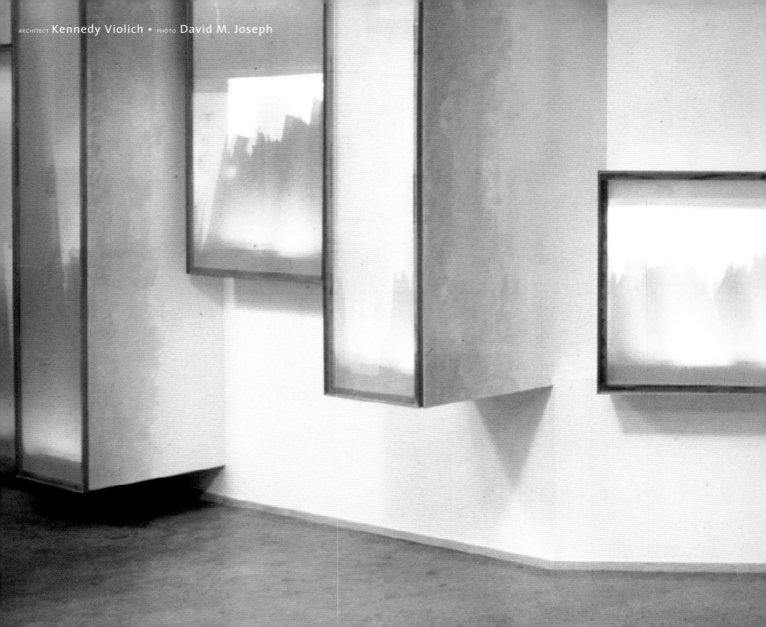

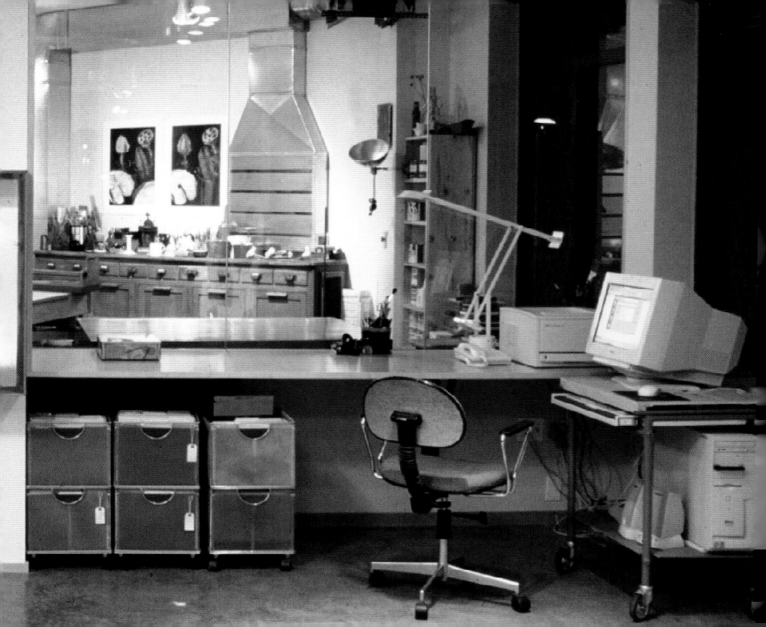

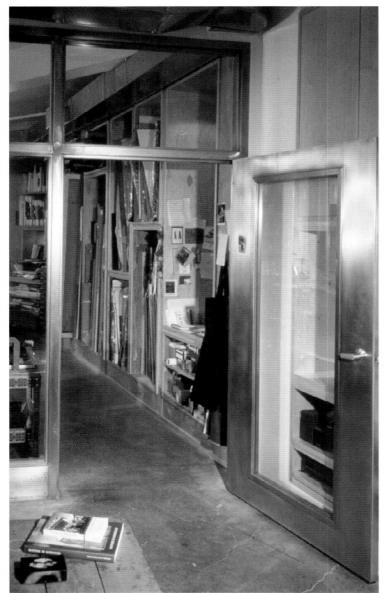
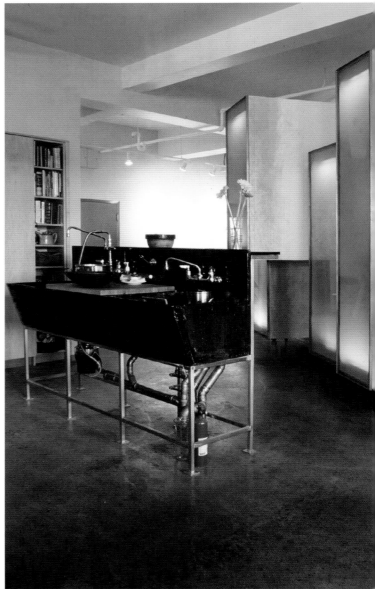

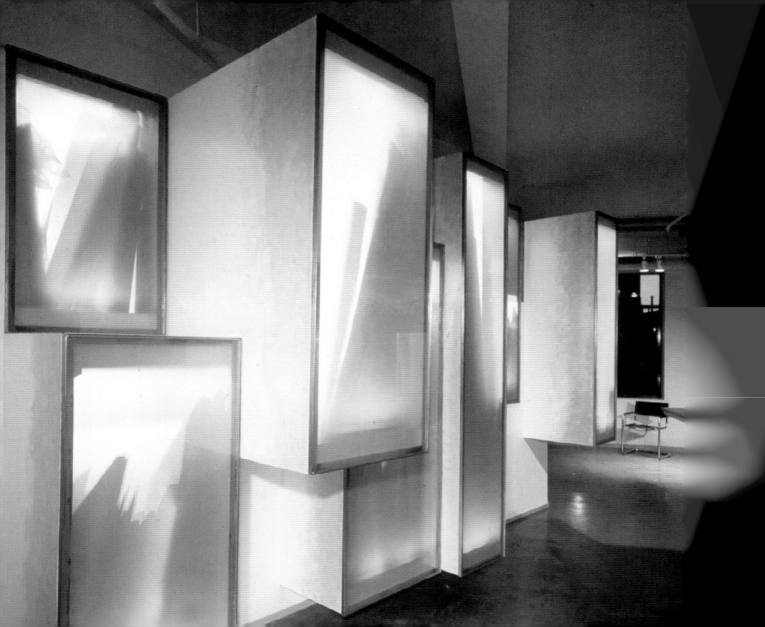

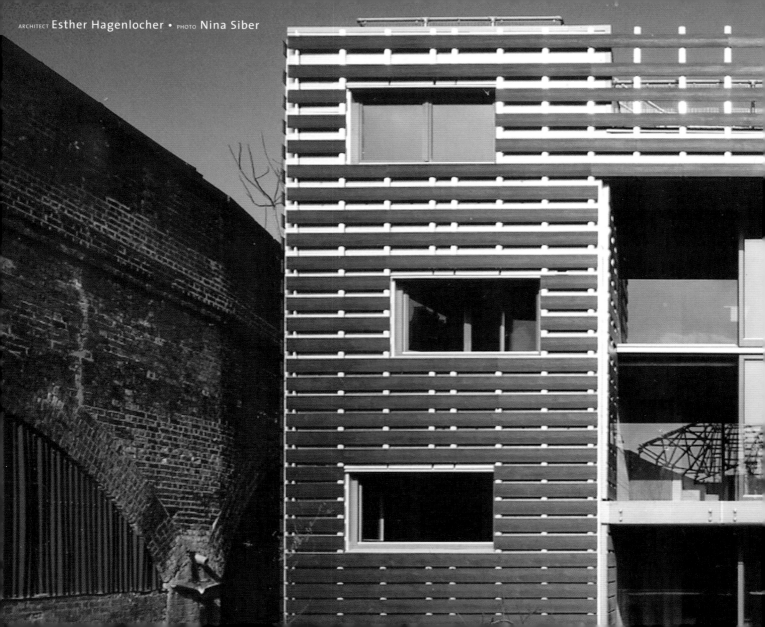

ARCHITECT Esther Hagenlocher • PHOTO Nina Siber

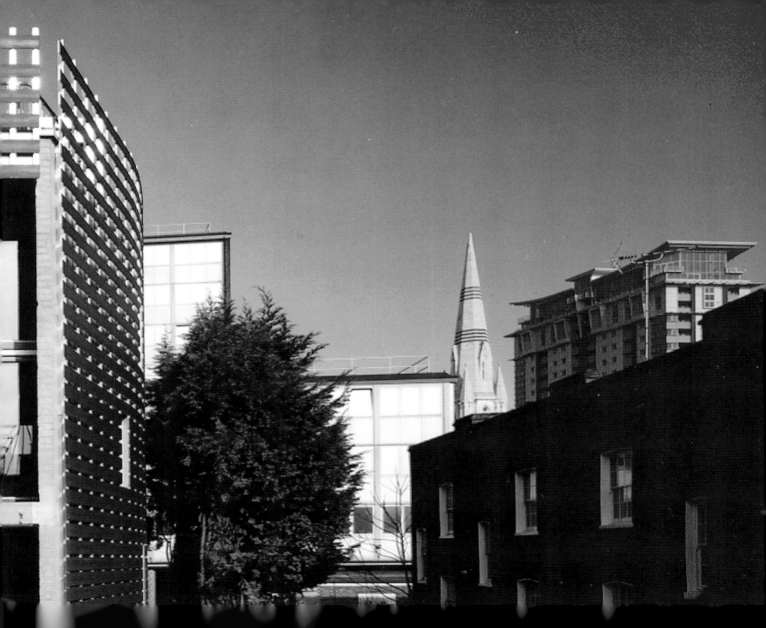

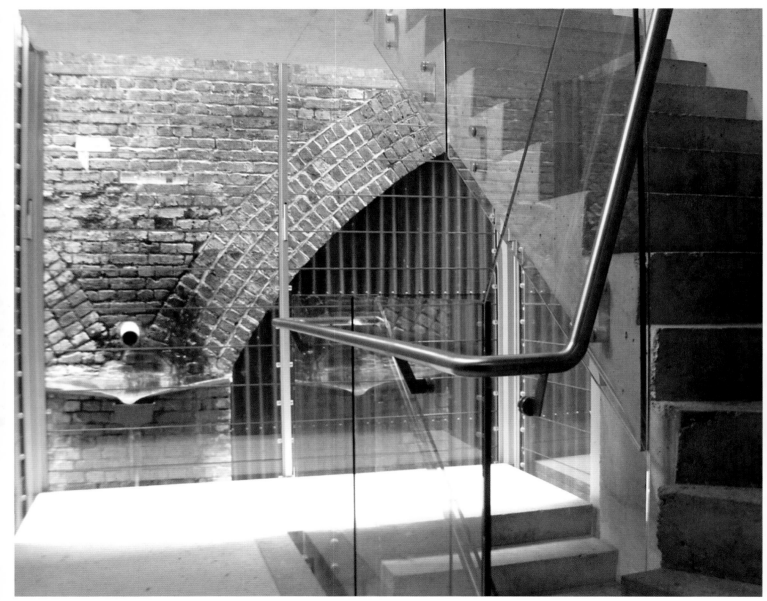

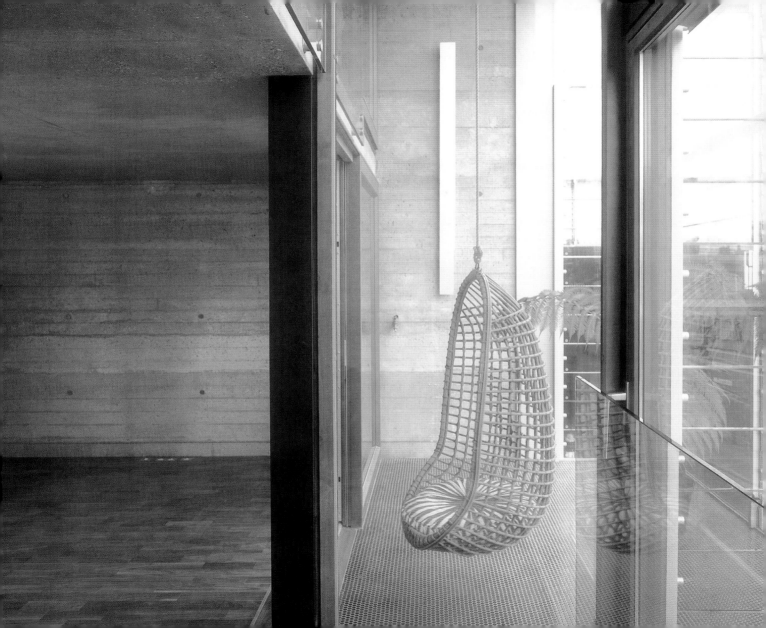

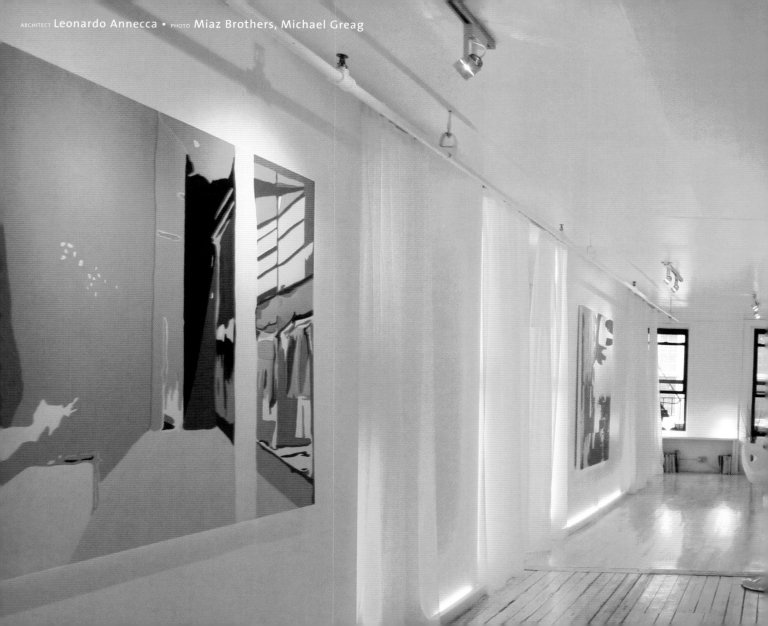

ARCHITECT Leonardo Annecca • PHOTO Miaz Brothers, Michael Greag

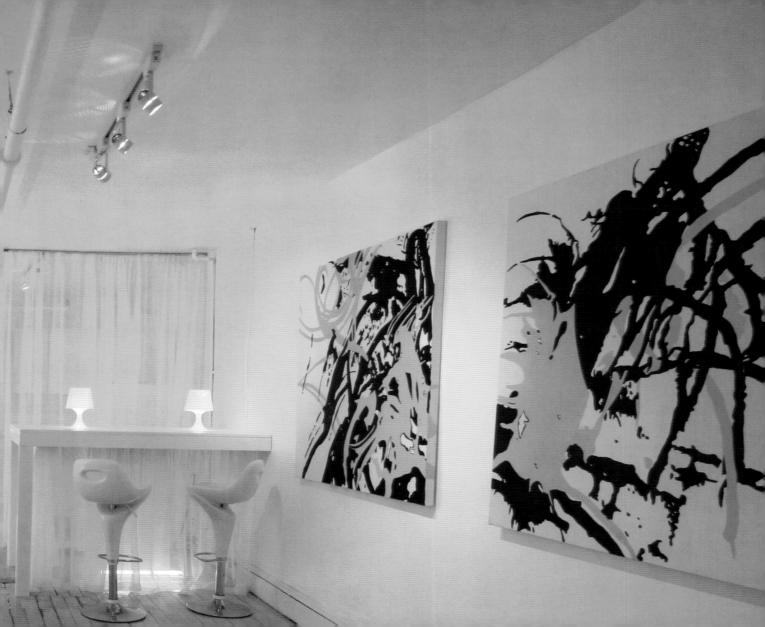

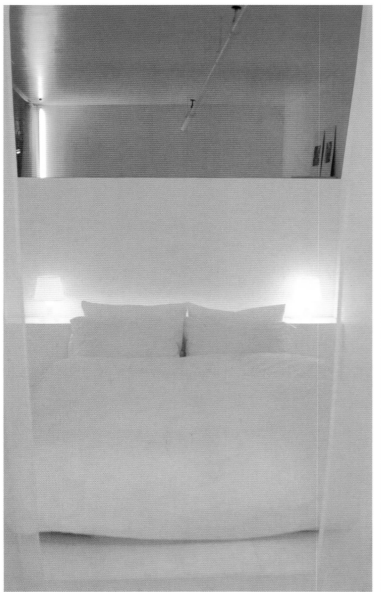
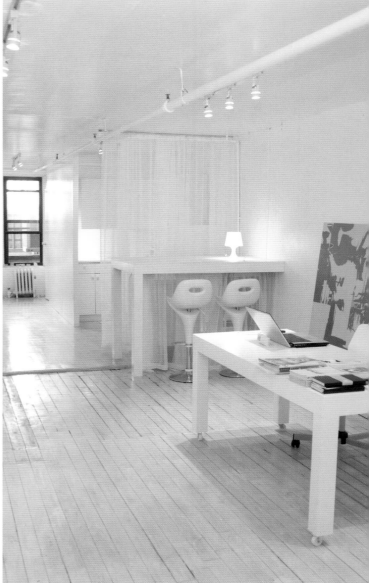

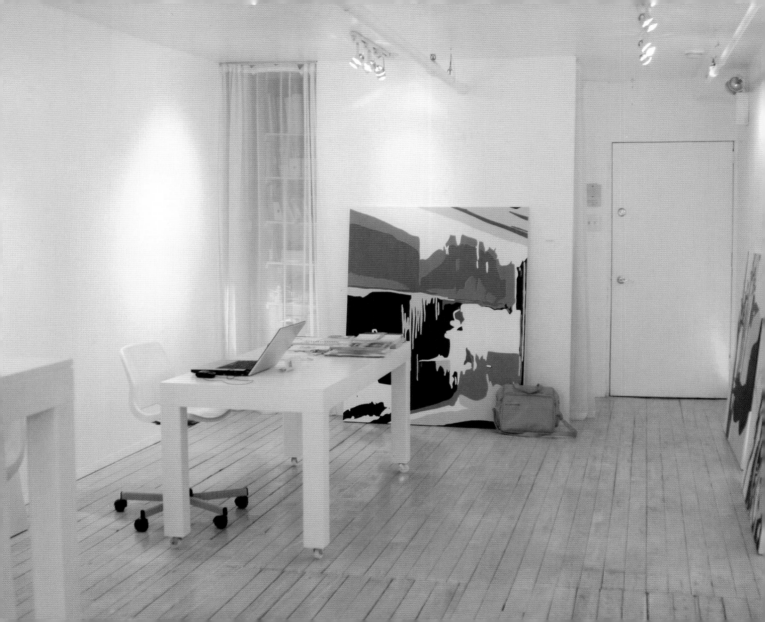

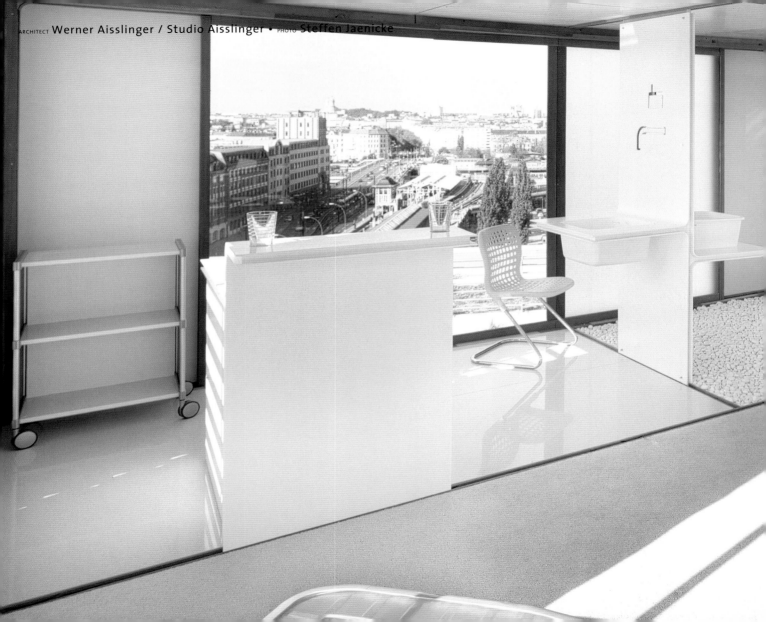

ARCHITECT Werner Aisslinger / Studio Aisslinger • PHOTO Steffen Jaenicke

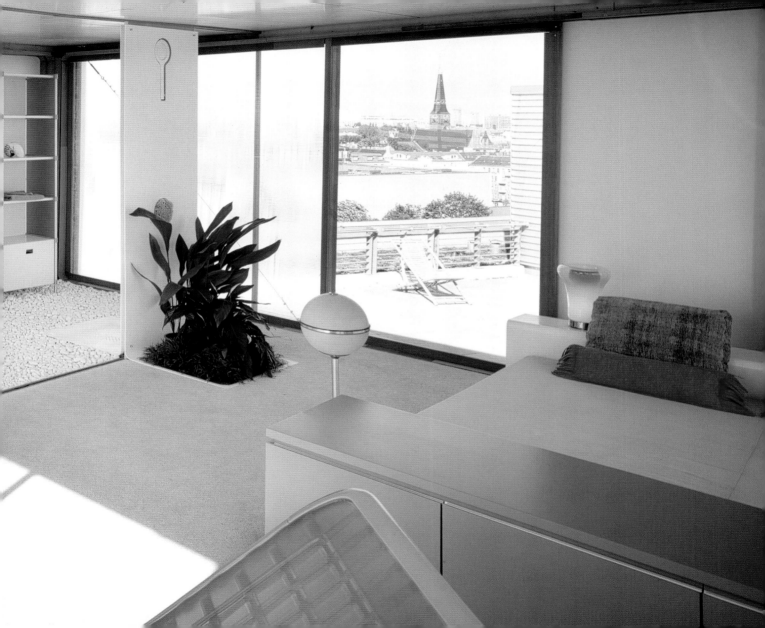

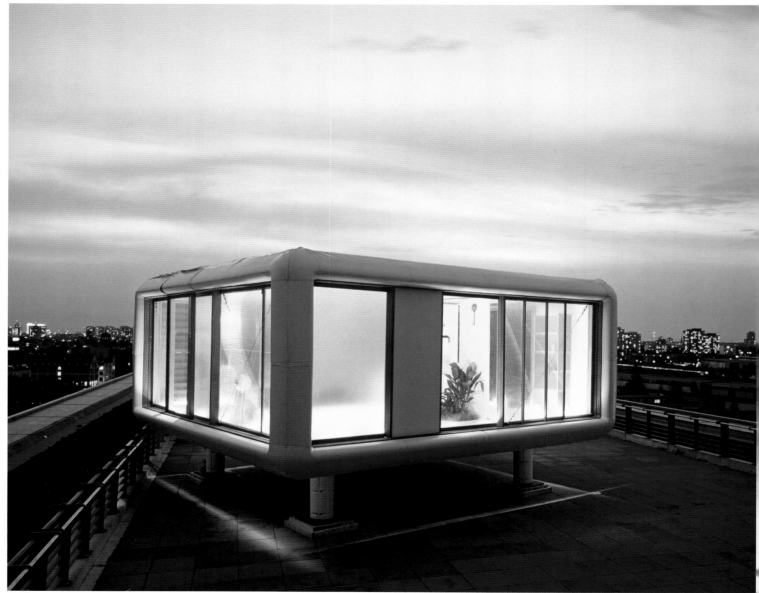

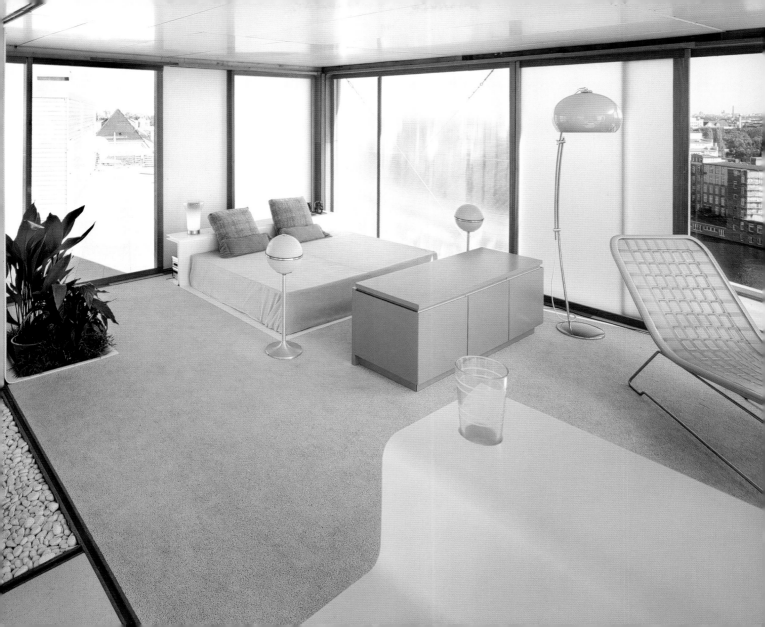

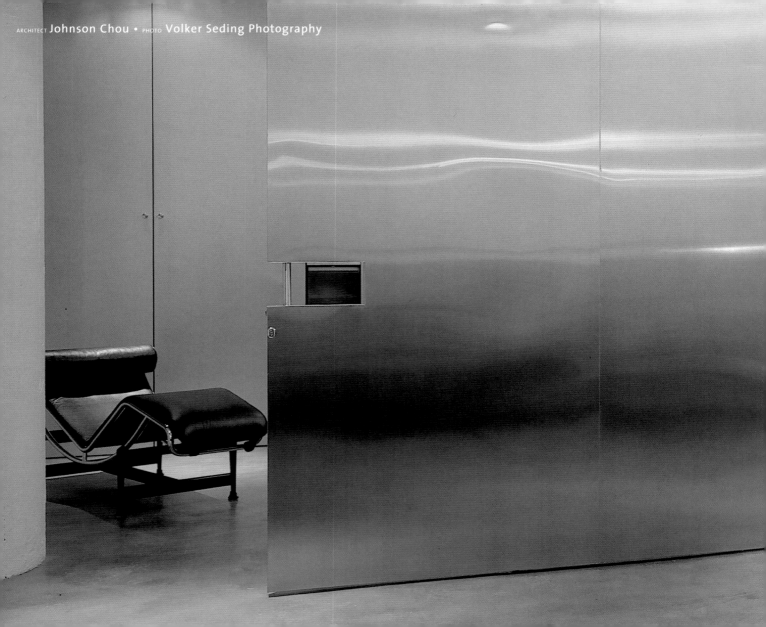

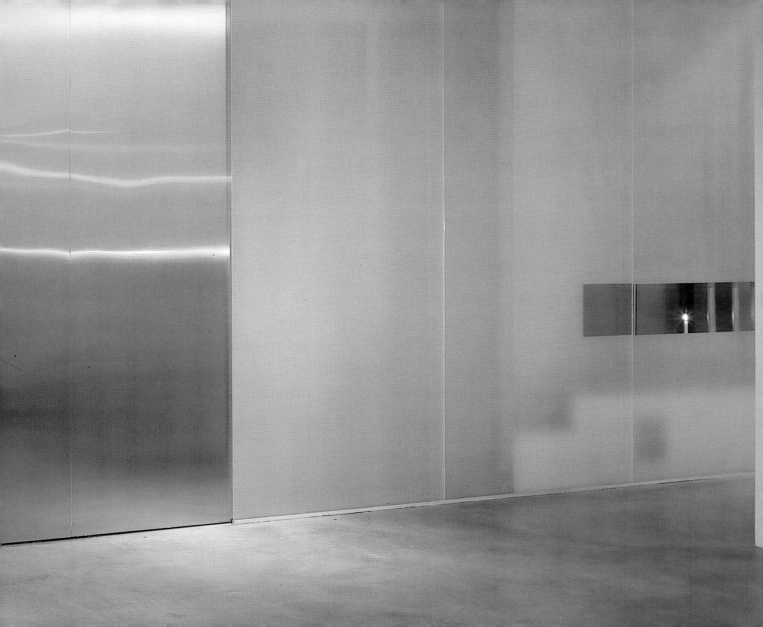

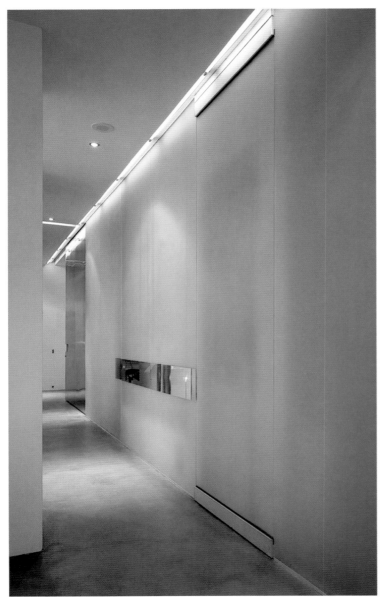
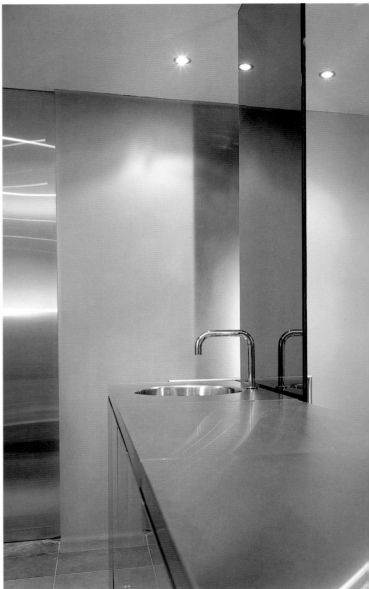

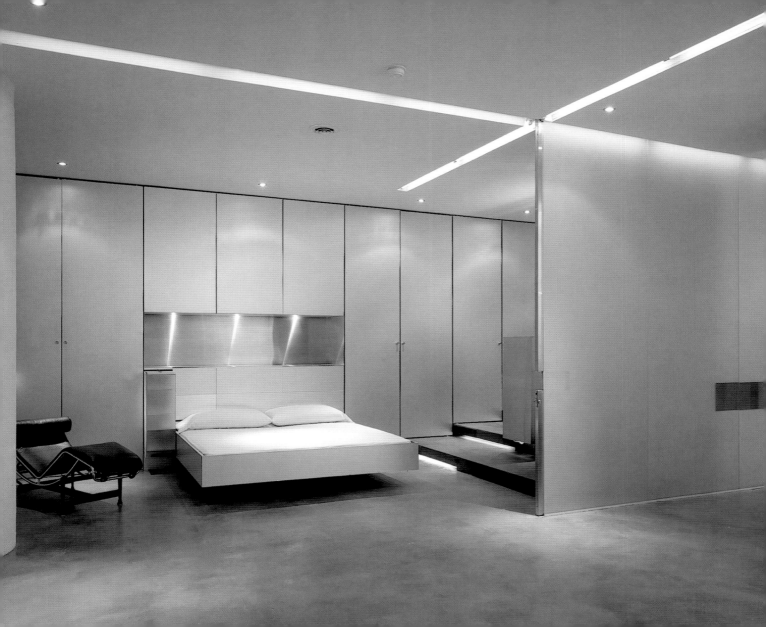

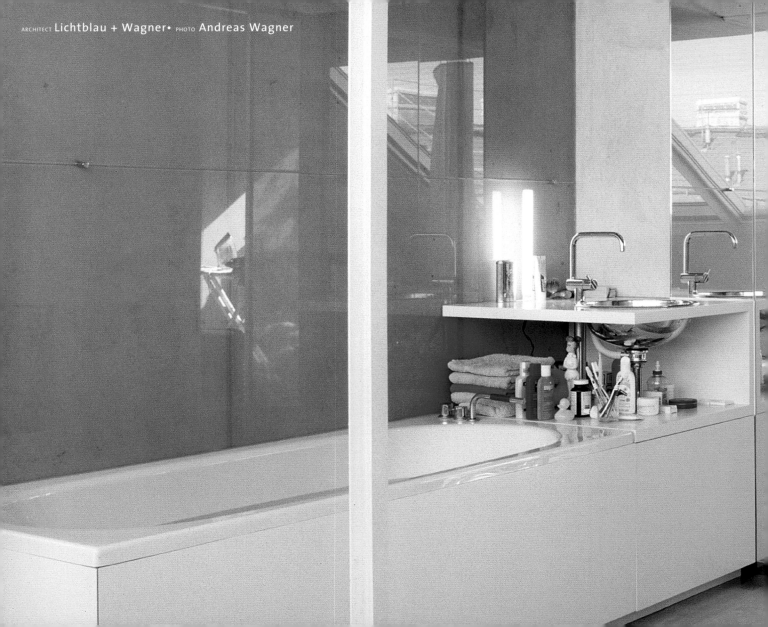

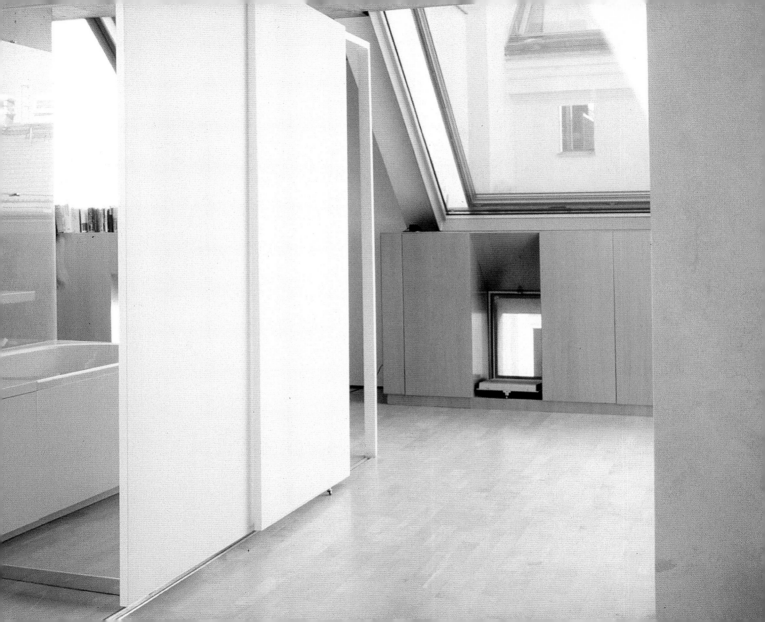

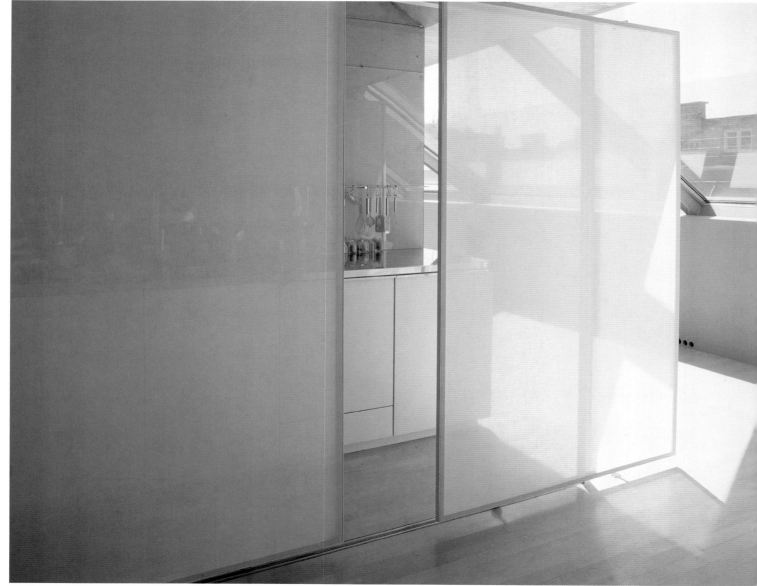

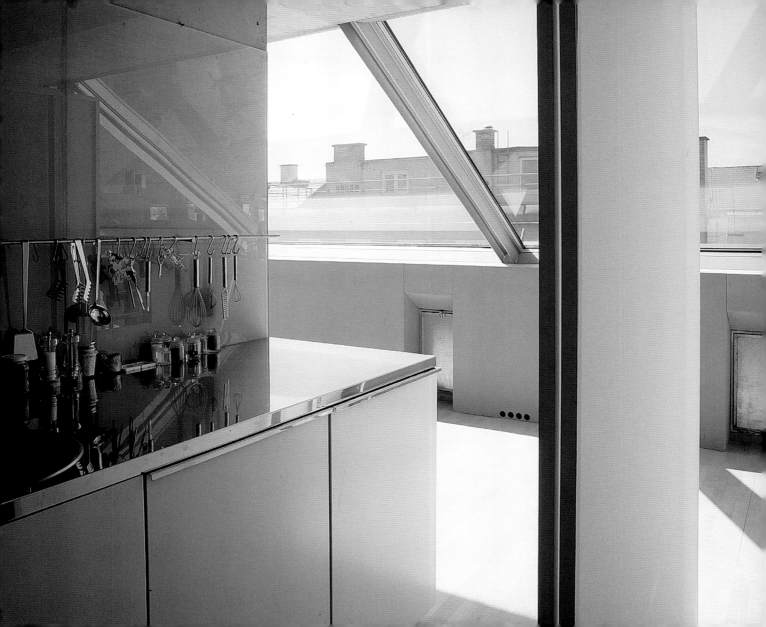

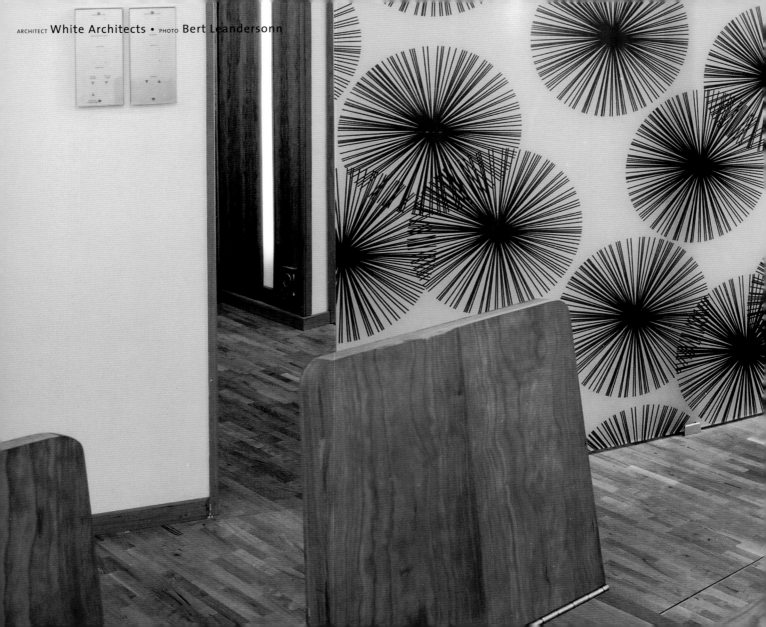

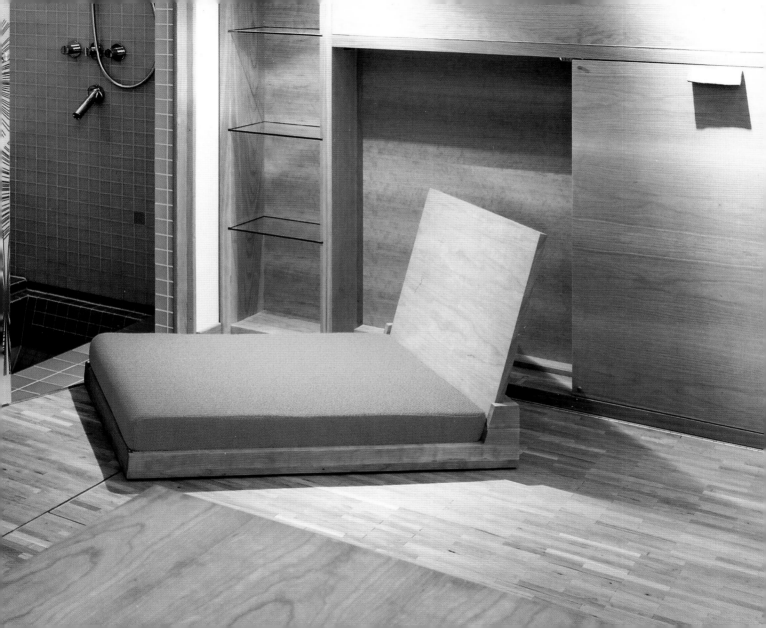

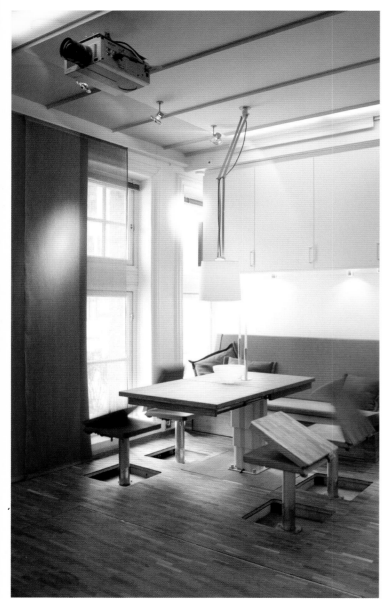
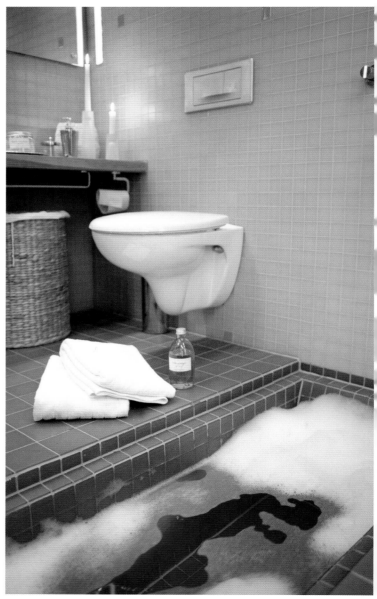

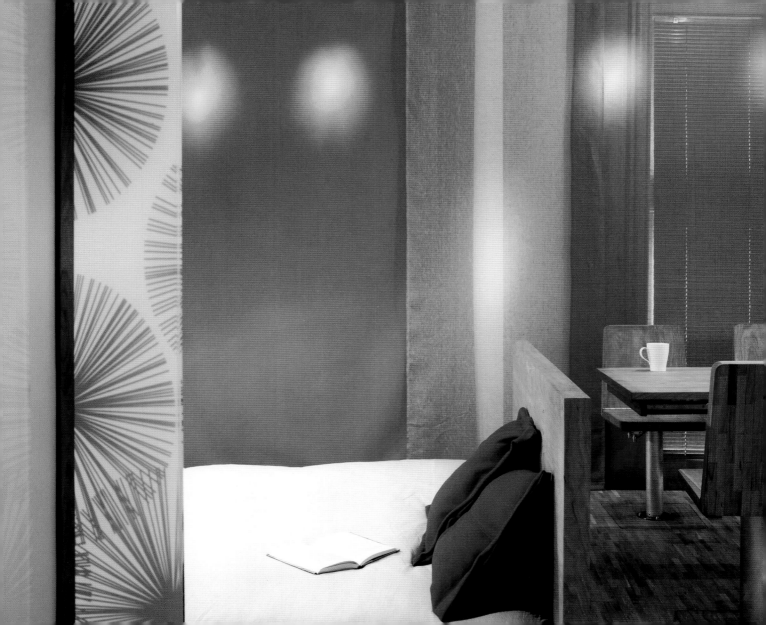

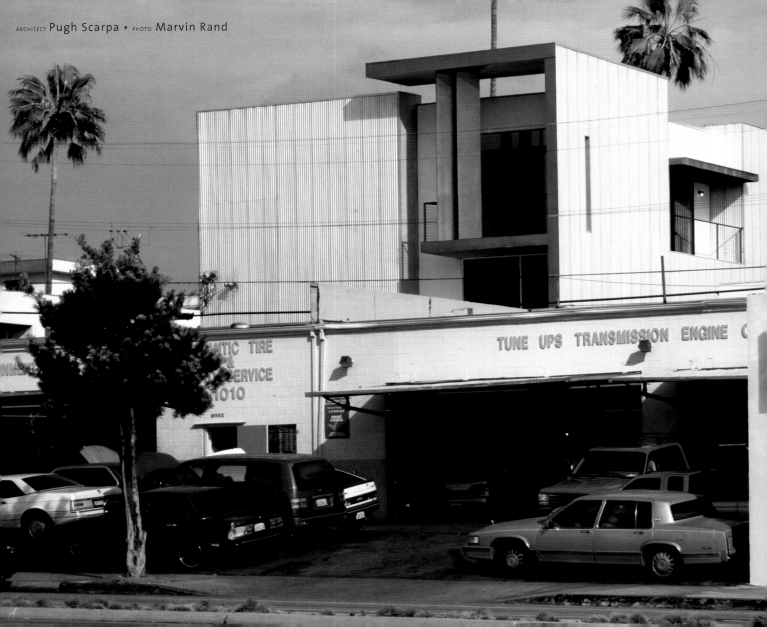

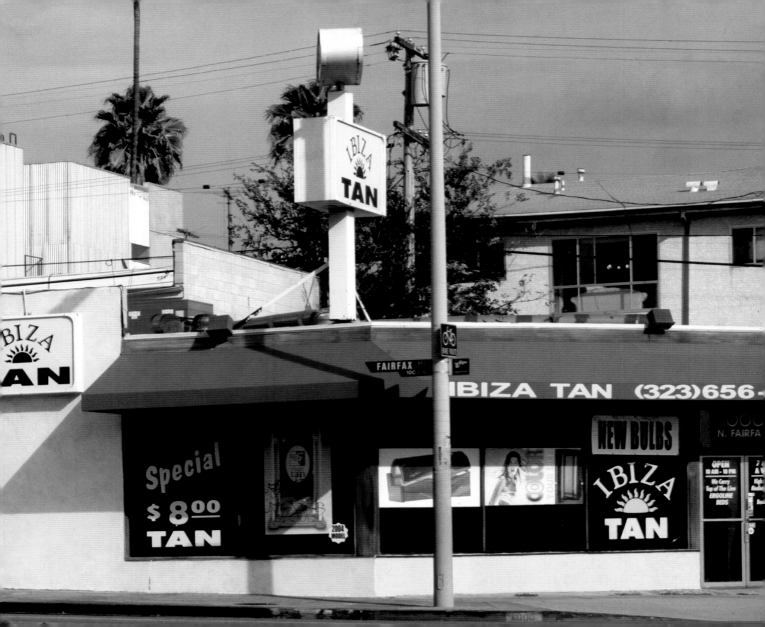

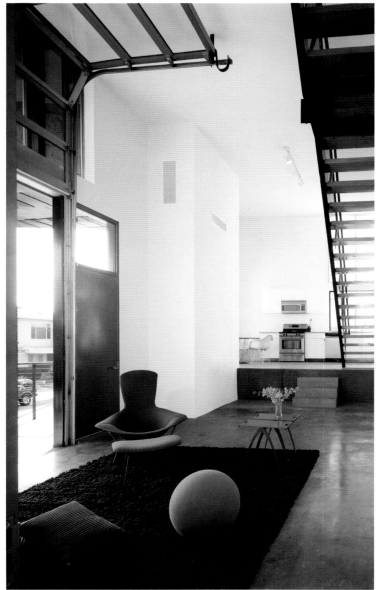
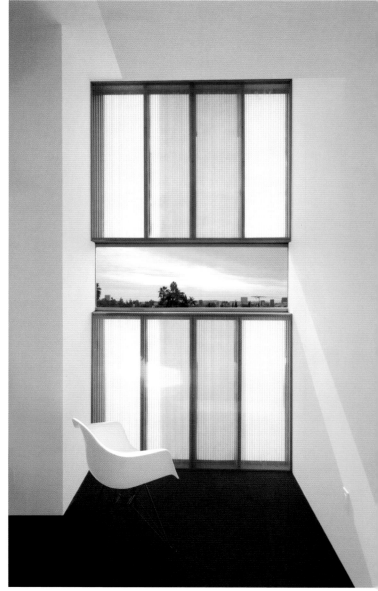

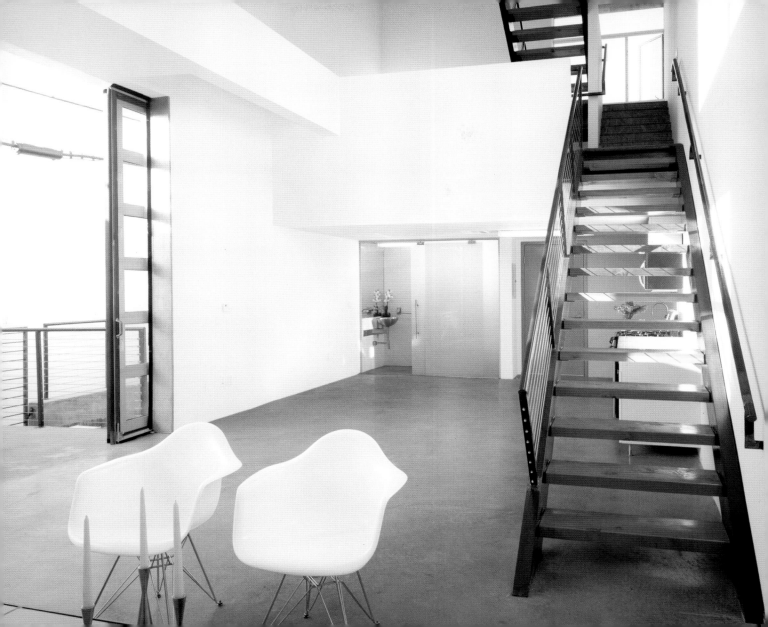

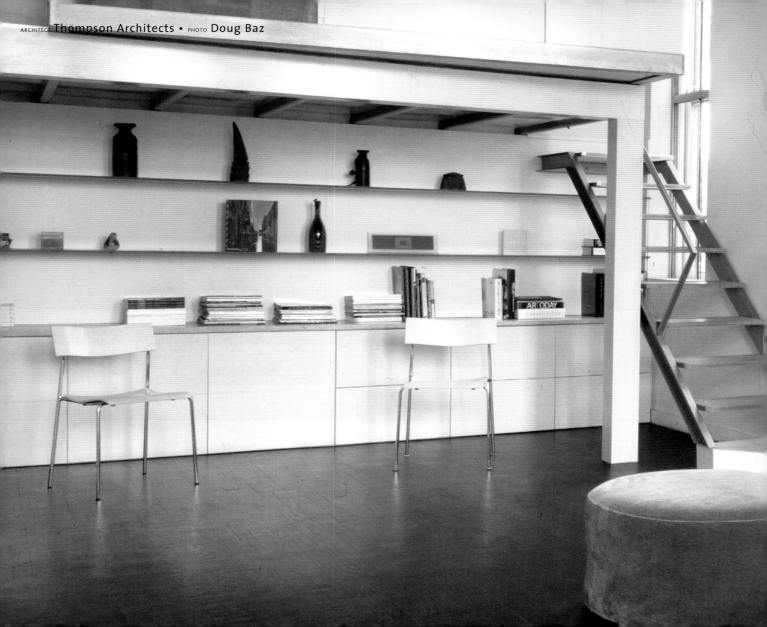

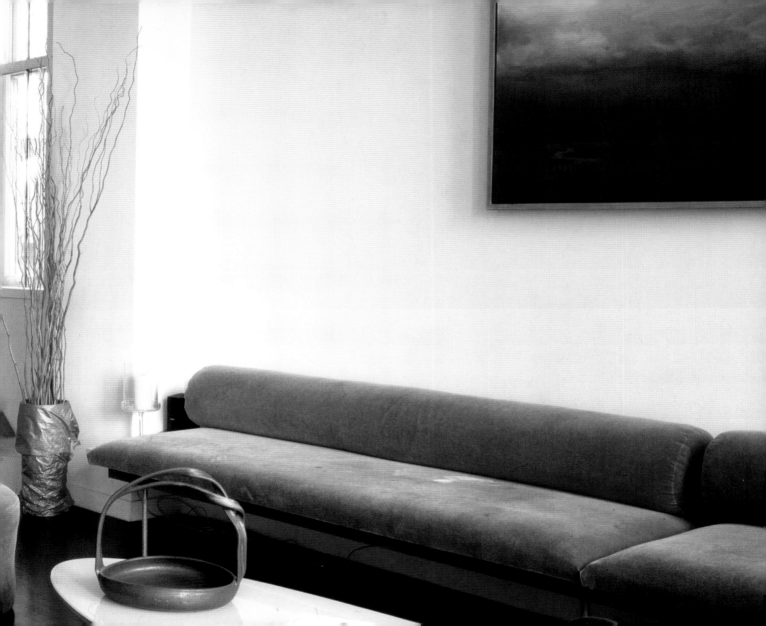

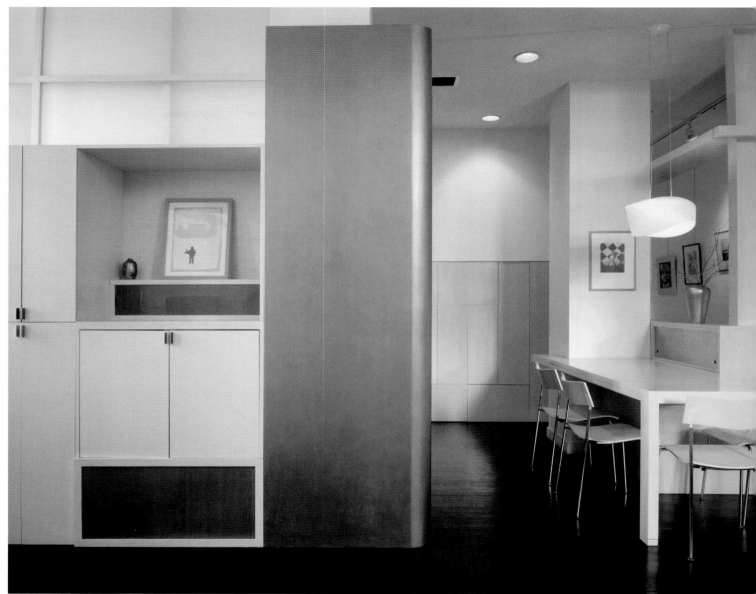

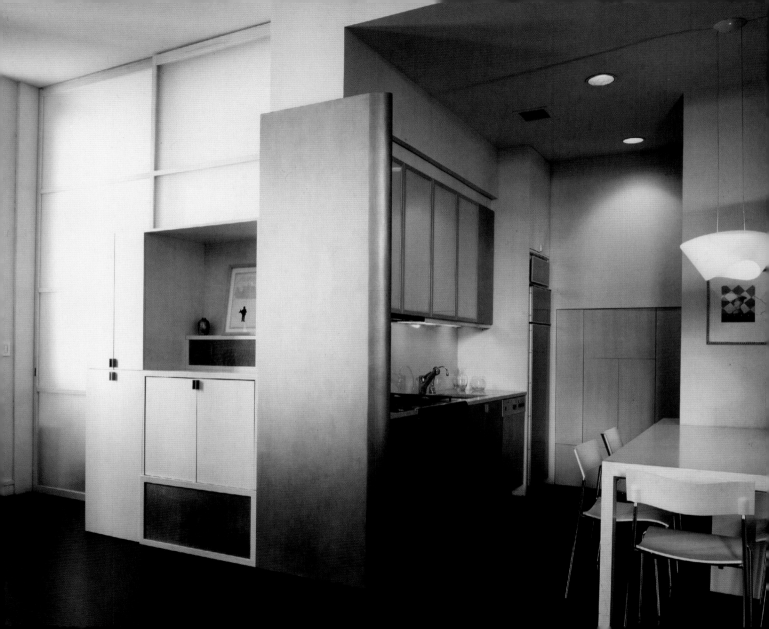

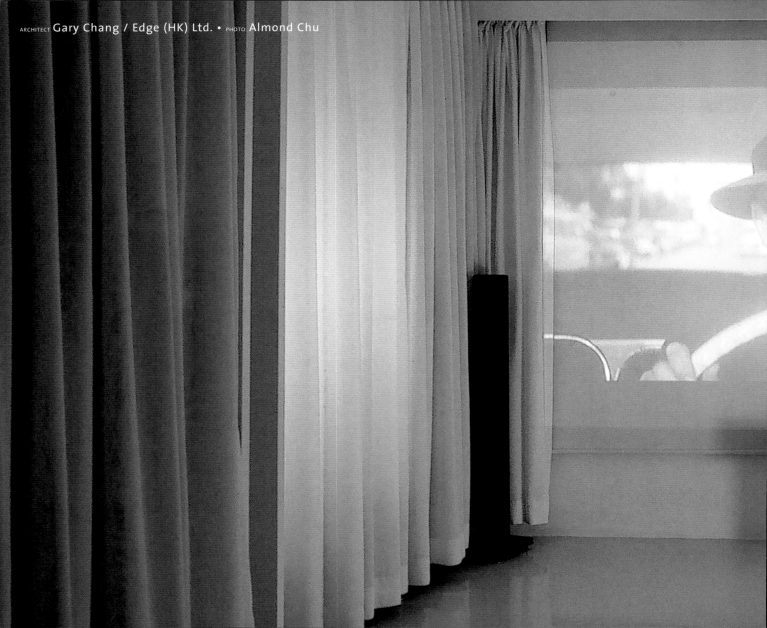

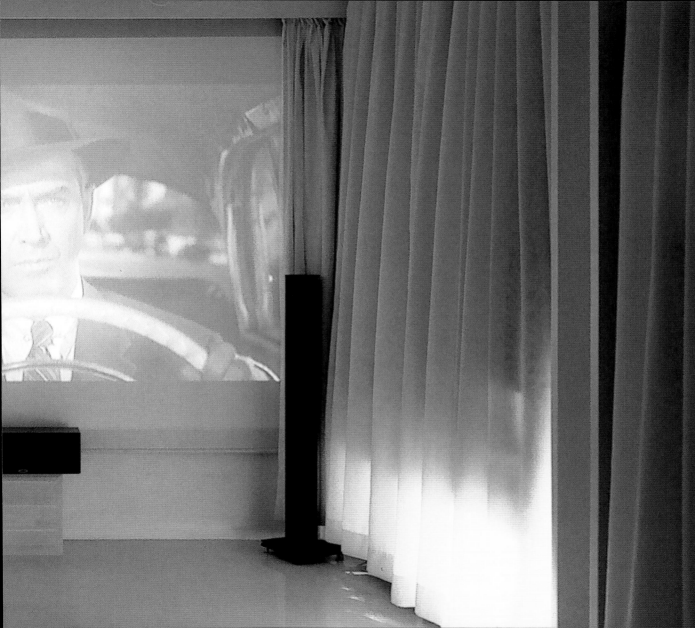

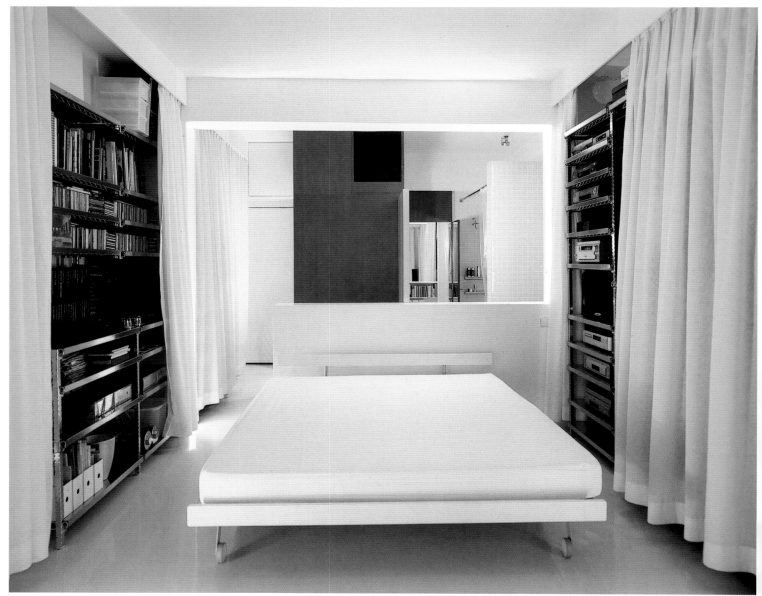

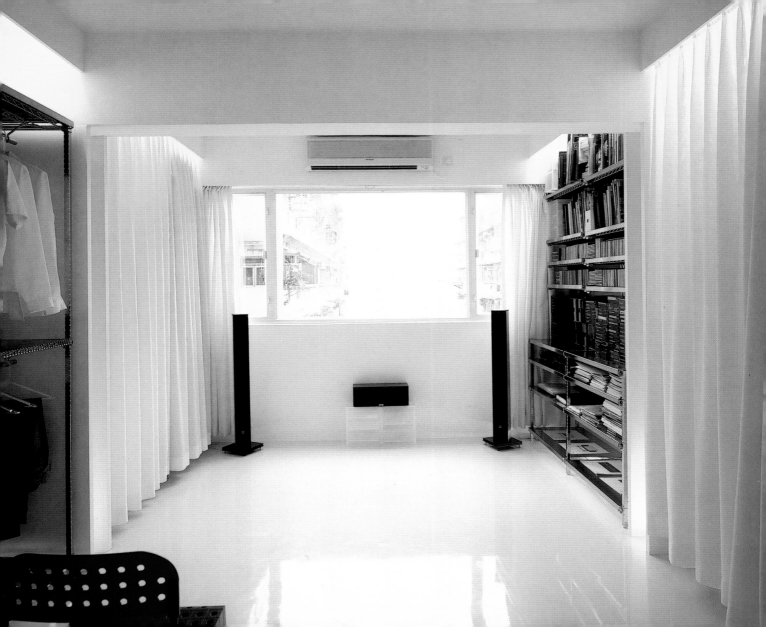

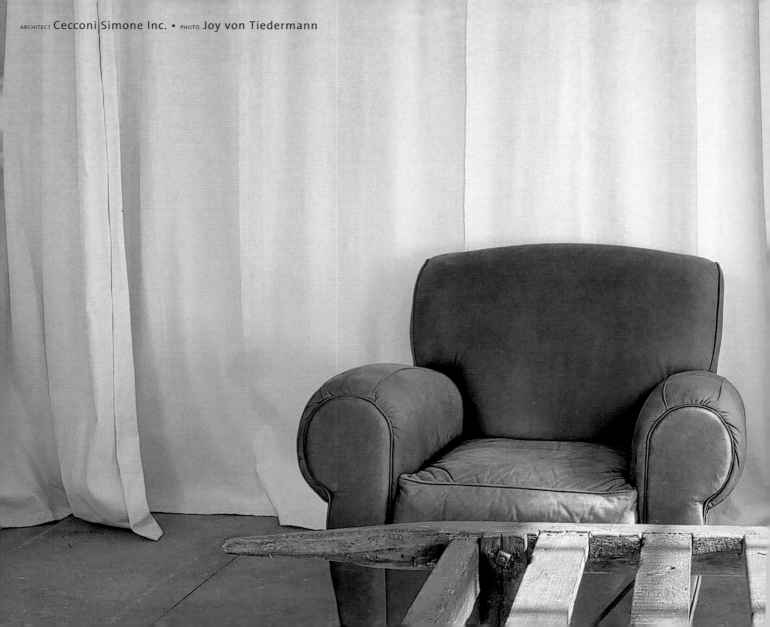

ARCHITECT Cecconi Simone Inc. • PHOTO Joy von Tiedermann

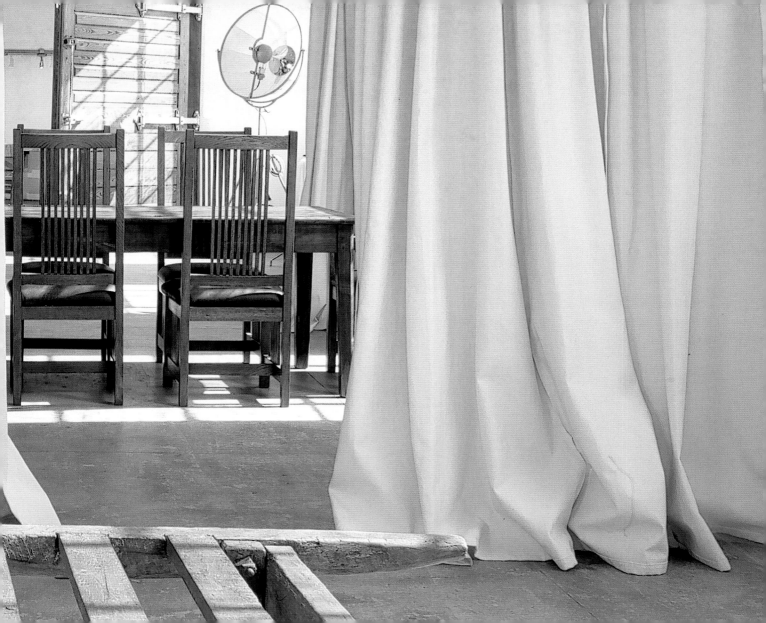

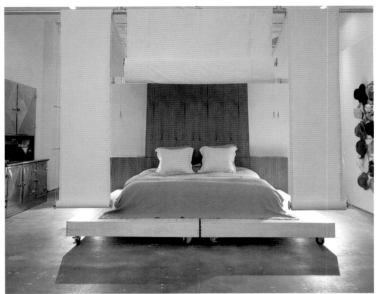
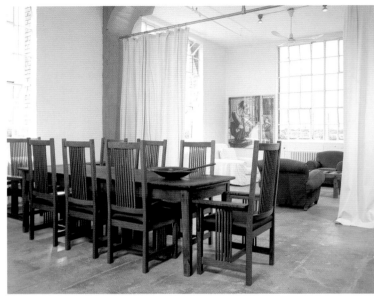
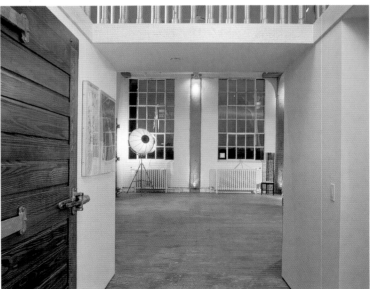
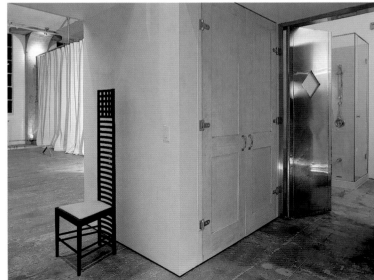

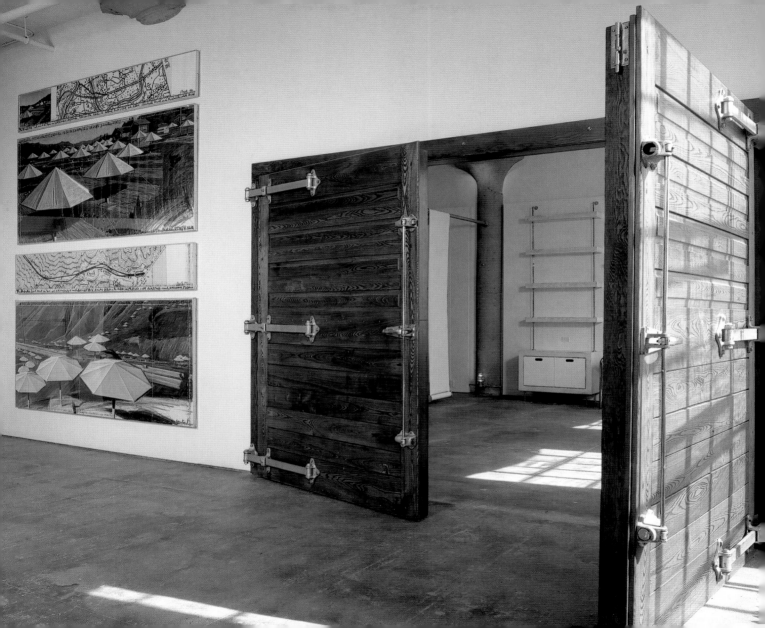

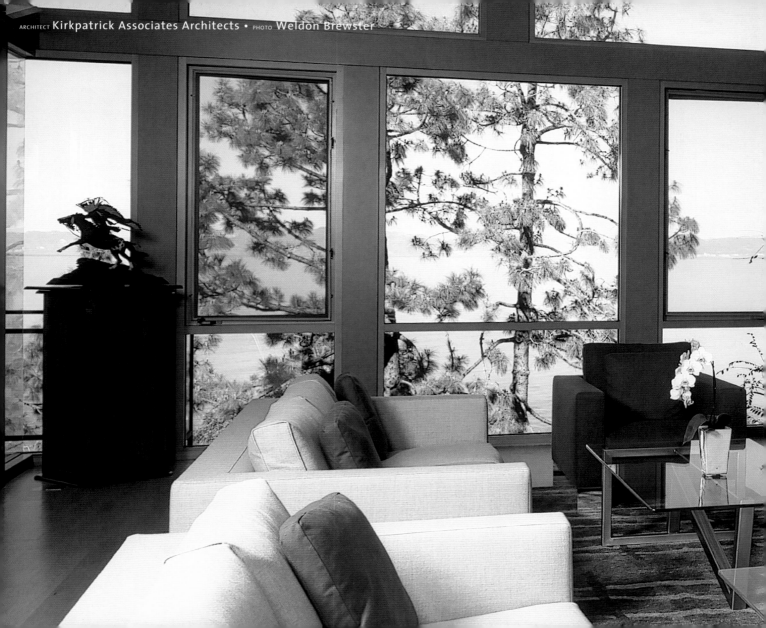

ARCHITECT **Kirkpatrick Associates Architects** • PHOTO **Weldon Brewster**

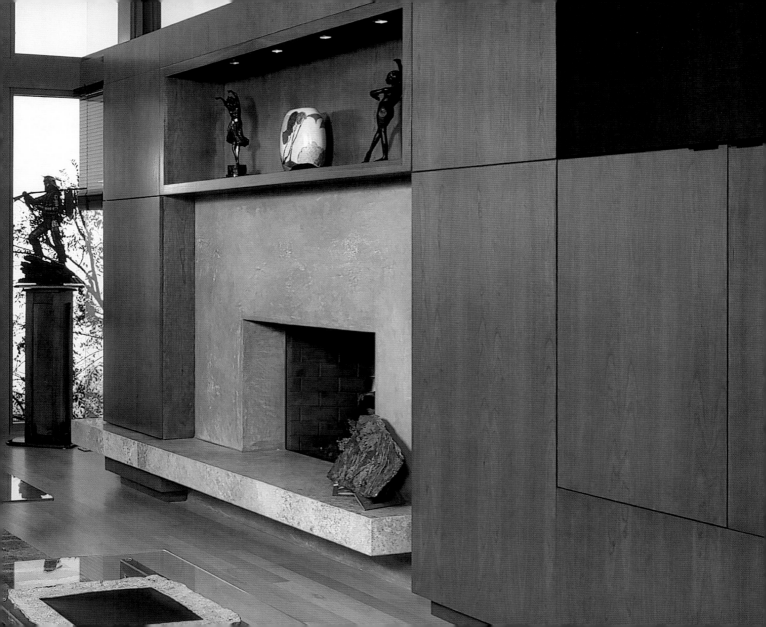

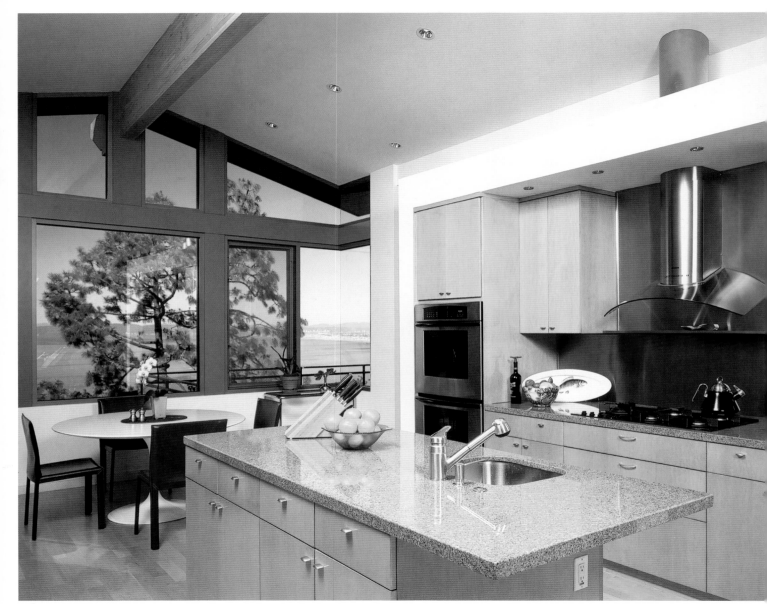

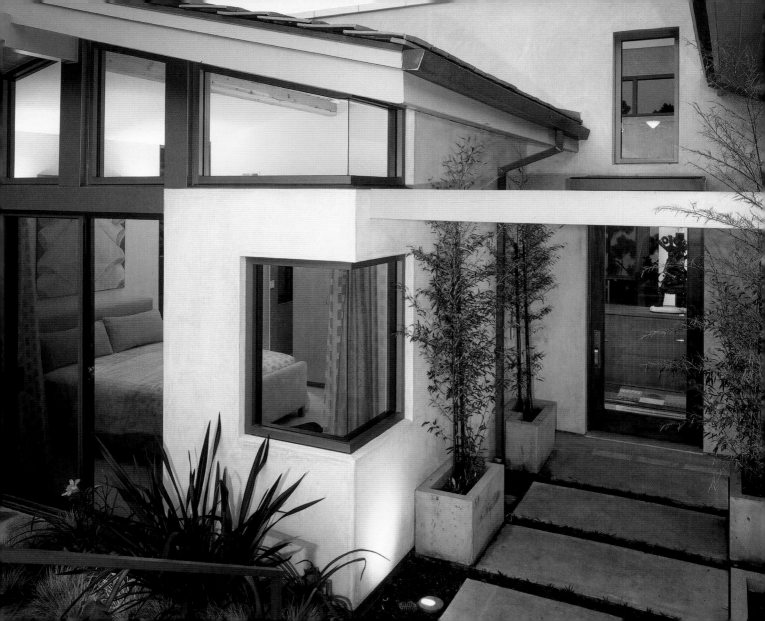

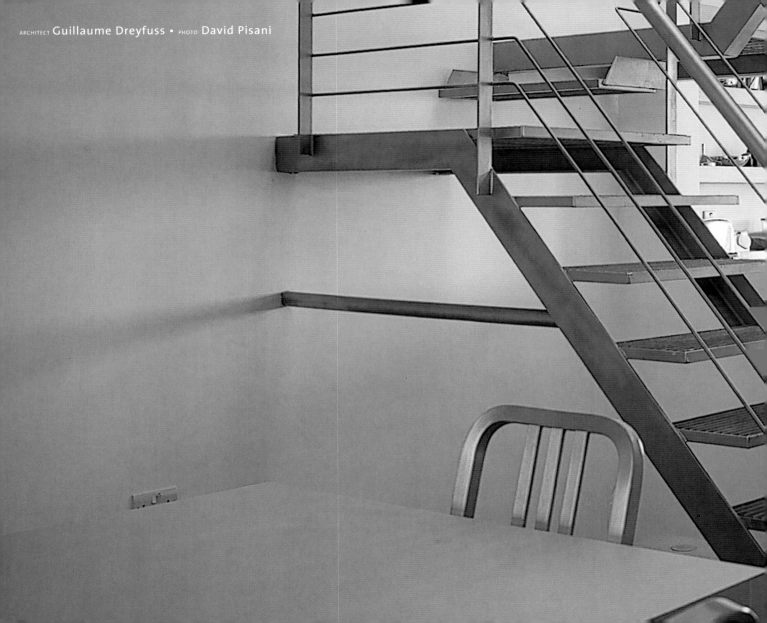

ARCHITECT Guillaume Dreyfuss • PHOTO David Pisani

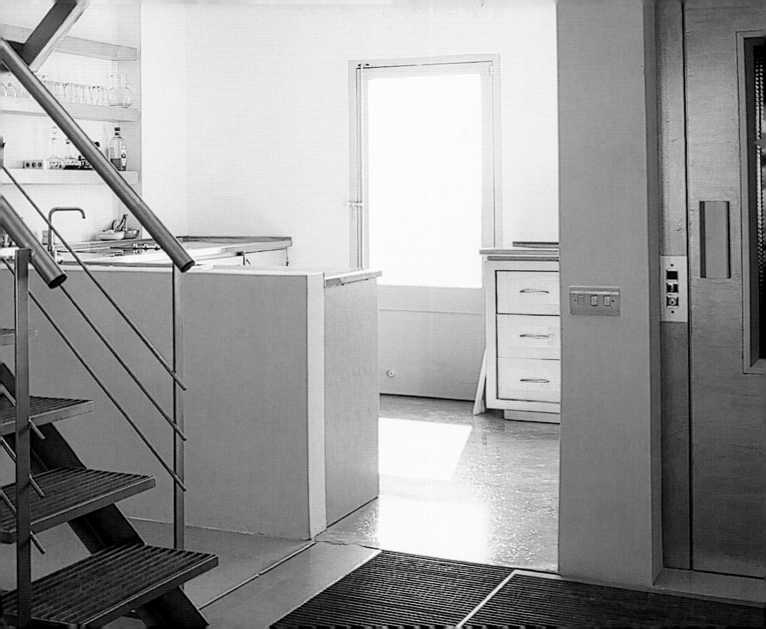

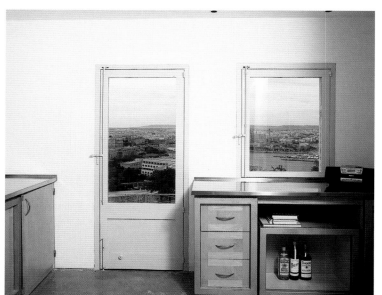
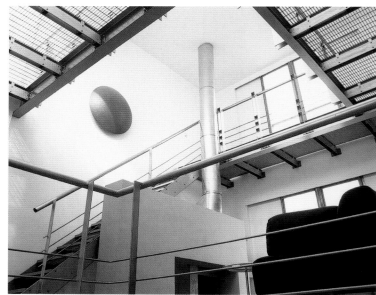
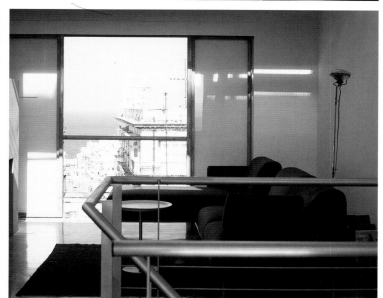
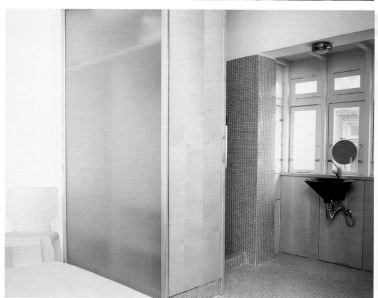

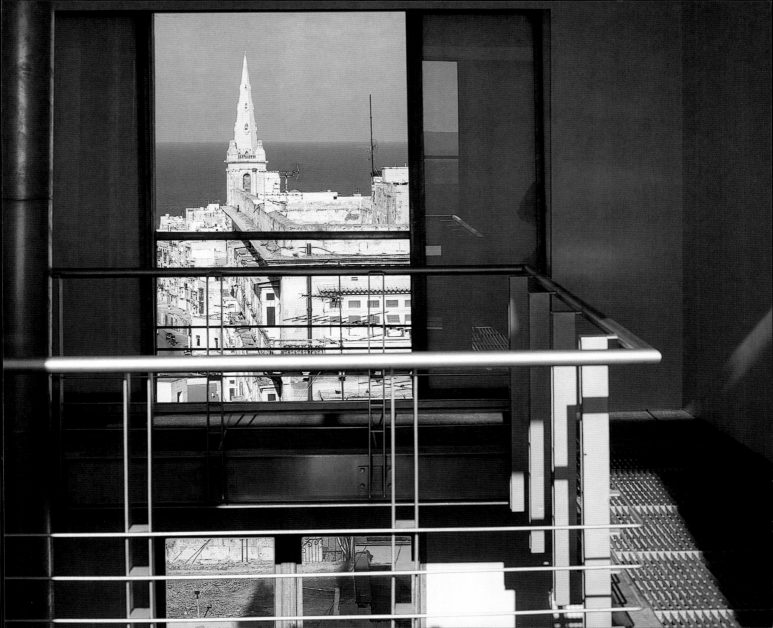

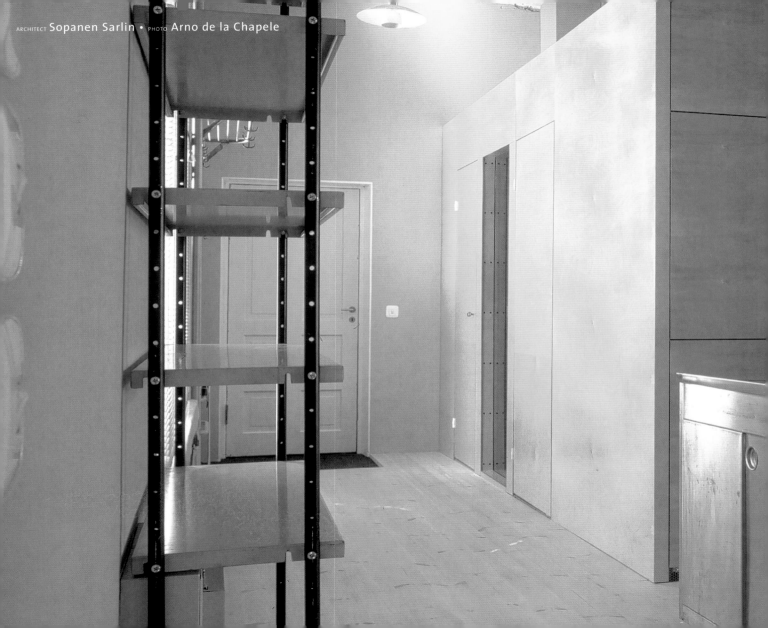

ARCHITECT Sopanen Sarlin • PHOTO Arno de la Chapele

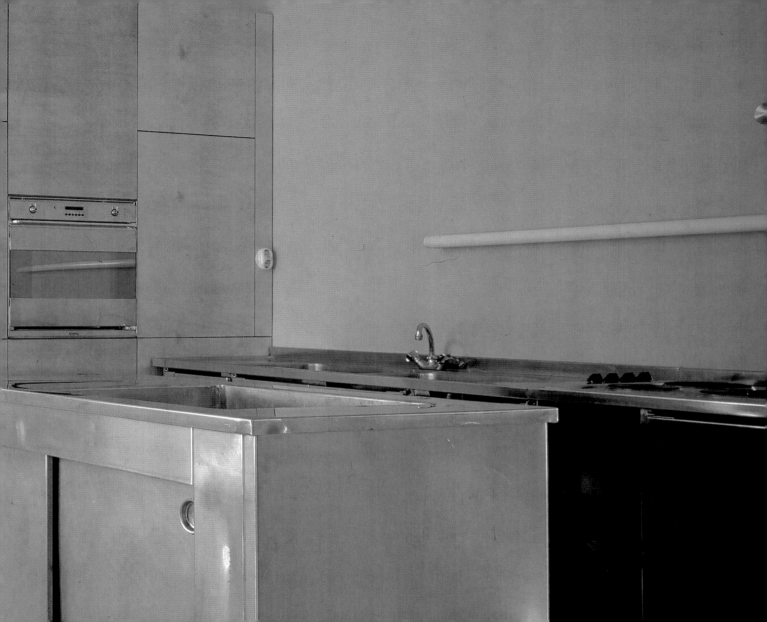

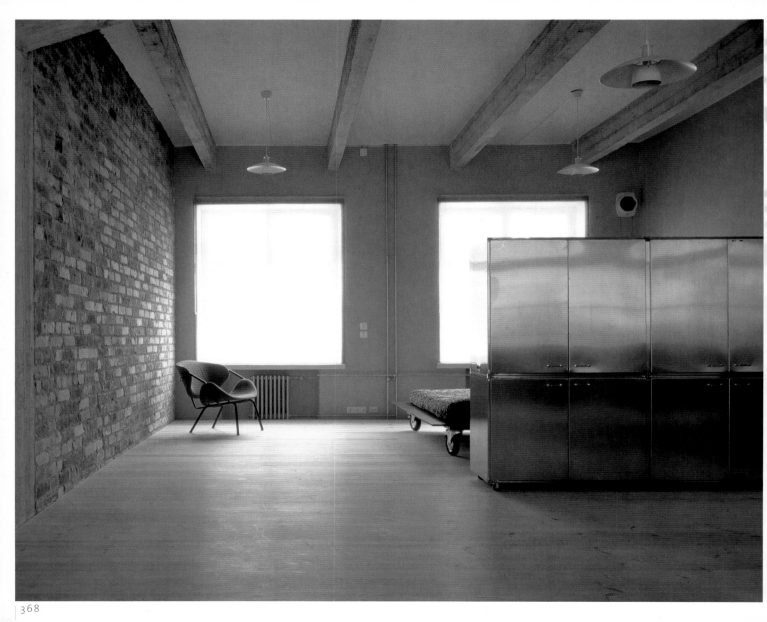

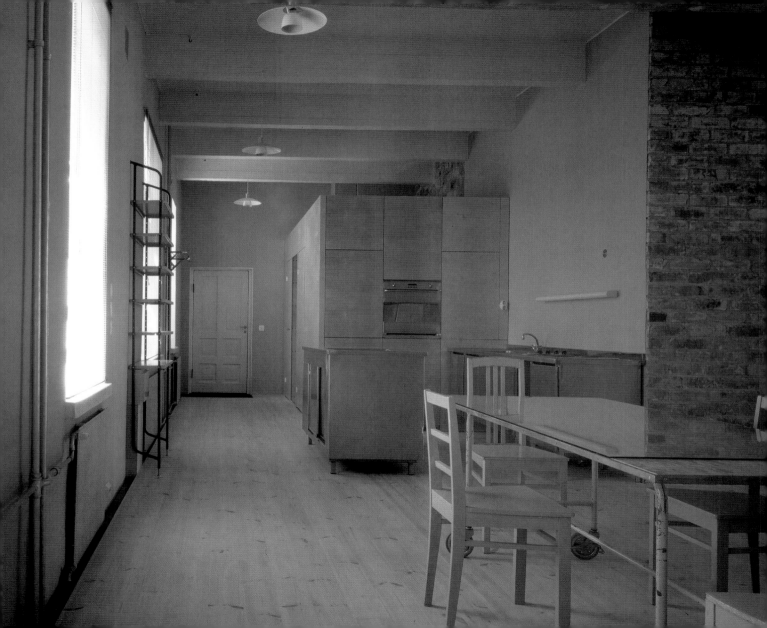

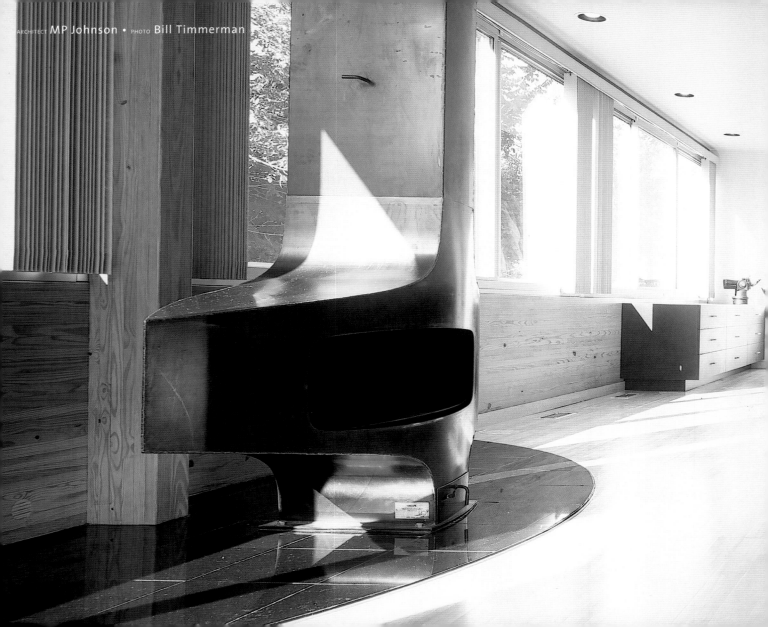

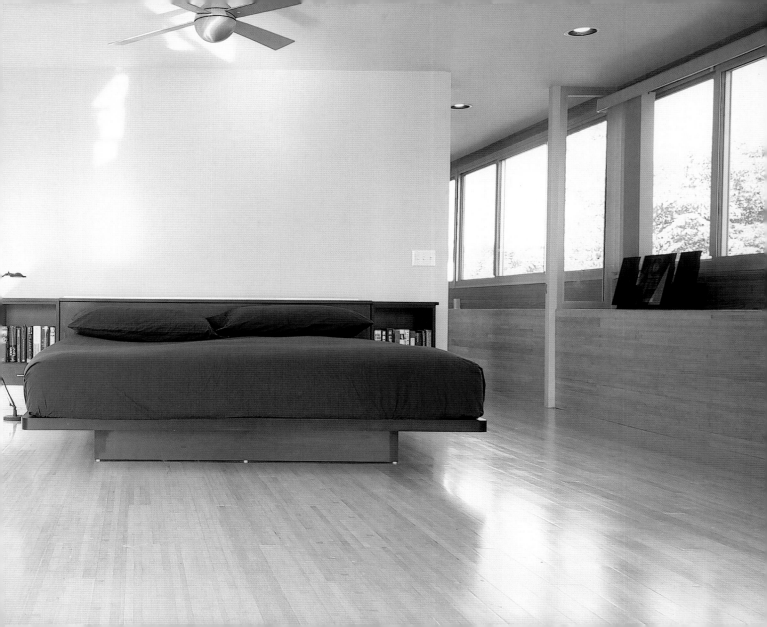

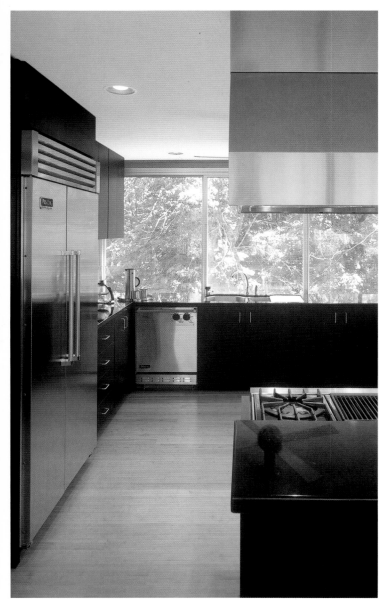
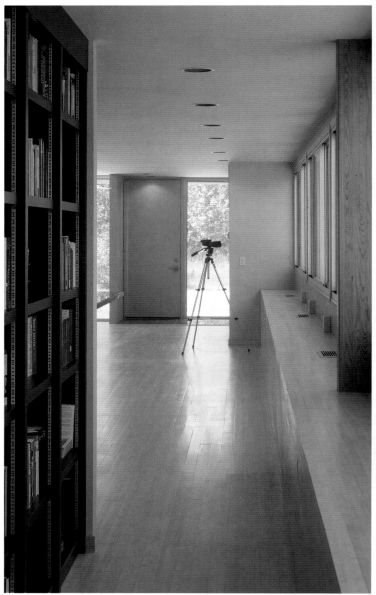

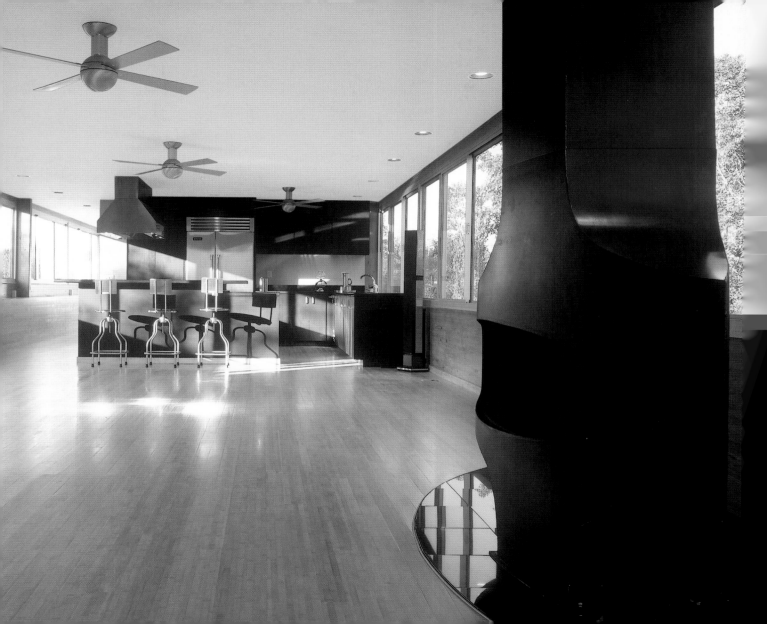

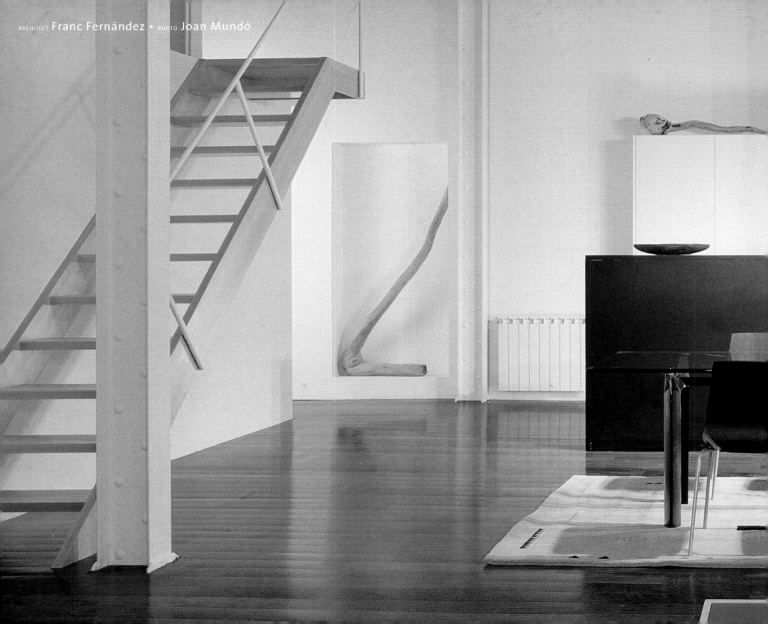

ARCHITECT Franc Fernández • PHOTO Joan Mundó

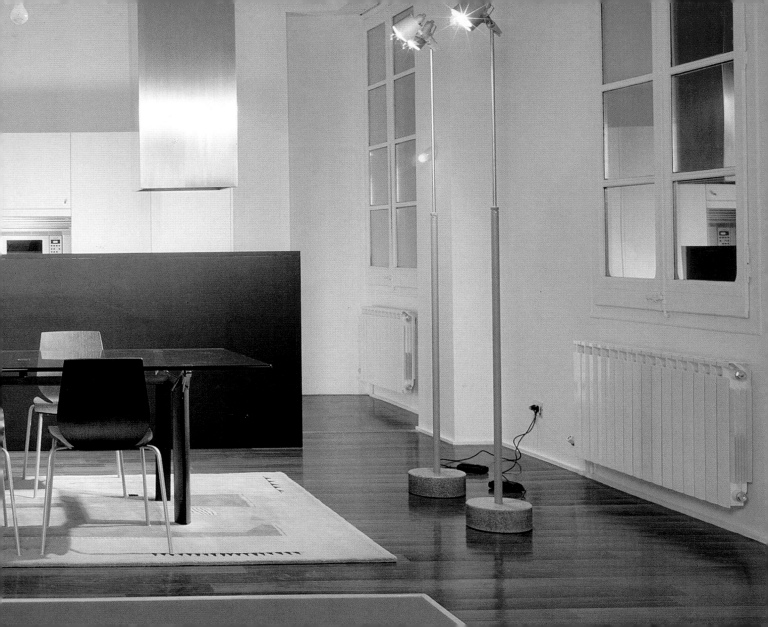

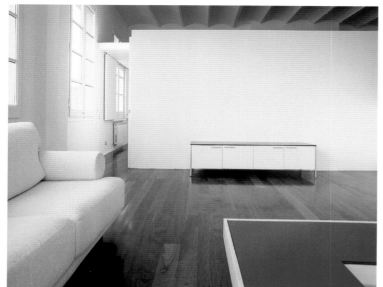
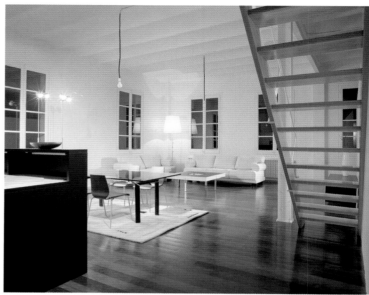
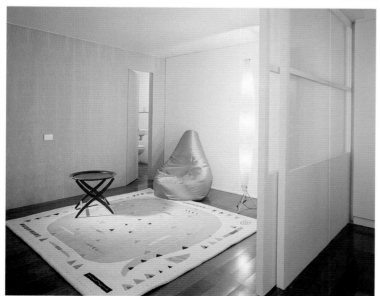
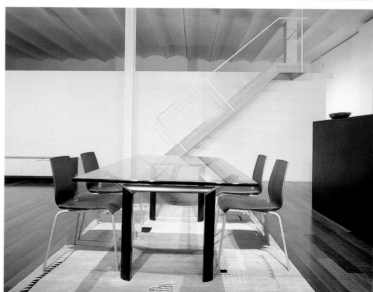

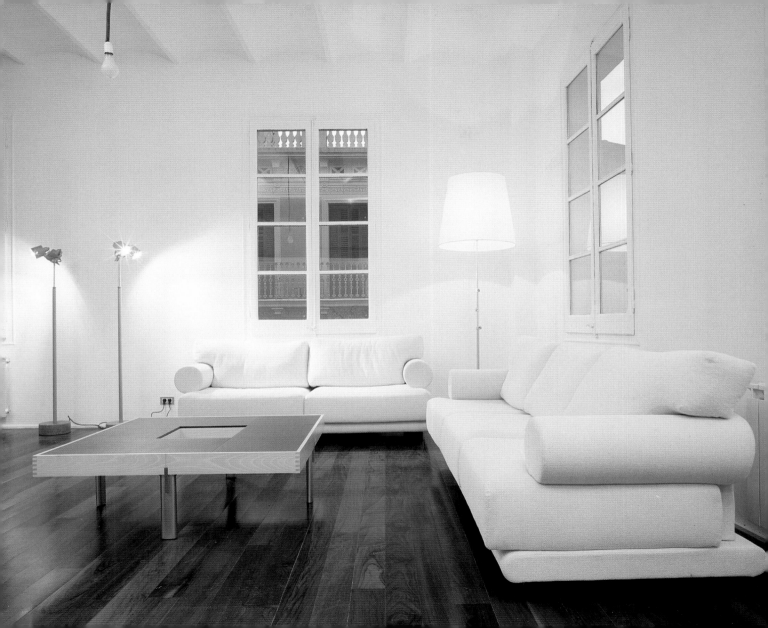

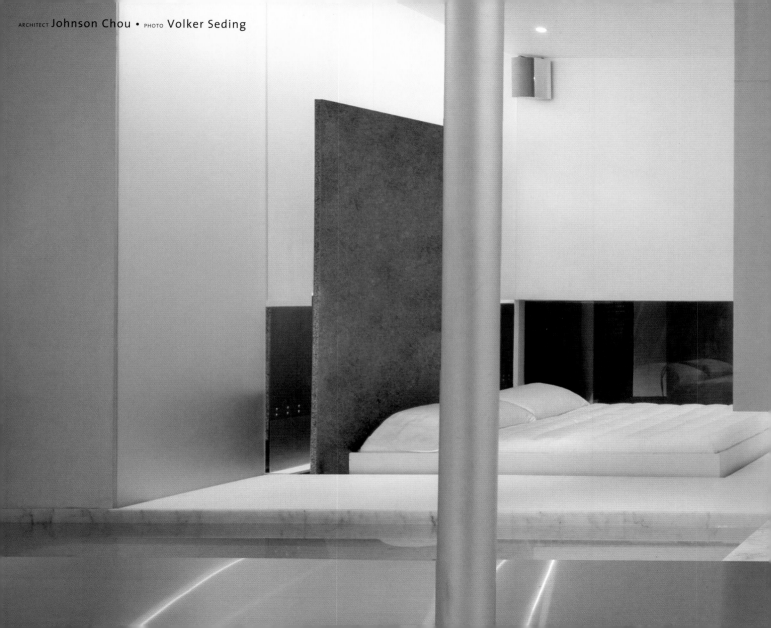

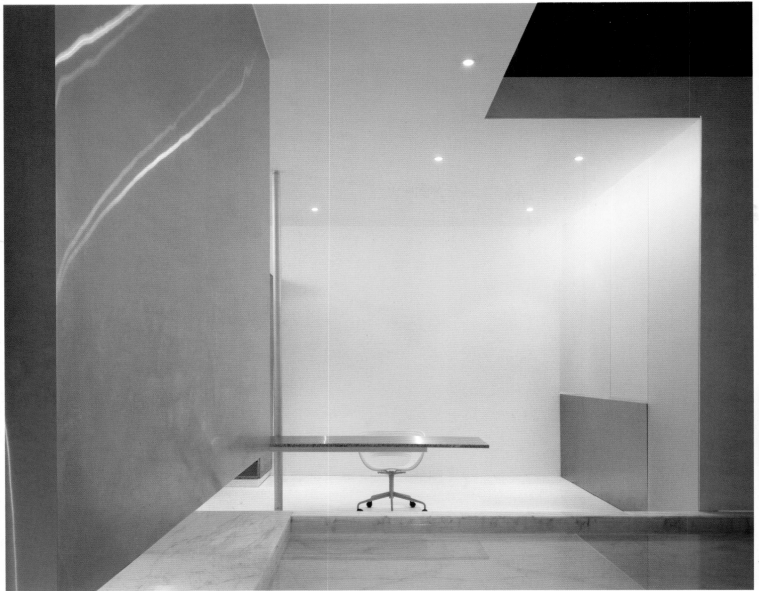

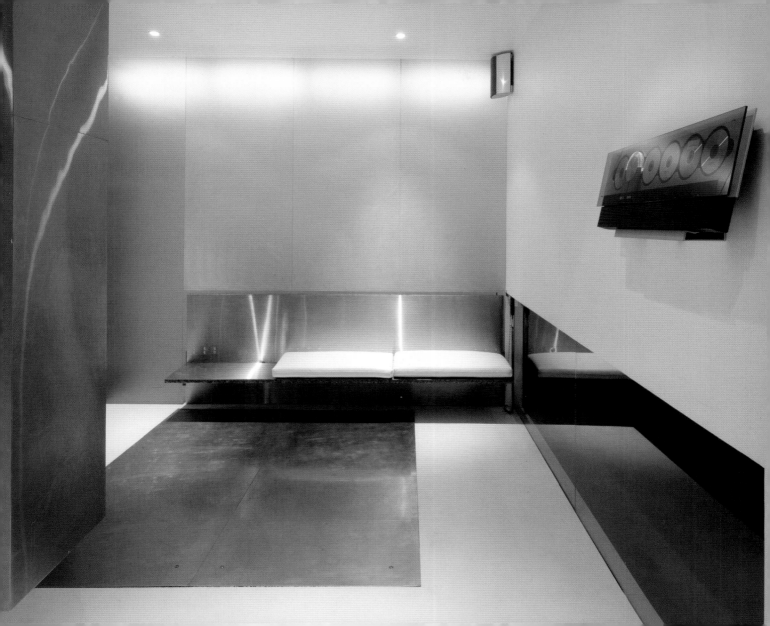